anatomica

LAURENCE KING

First published in Great Britain in 2020 by
Laurence King Publishing, an imprint of
The Orion Publishing Group Ltd,
Carmelite House, 50 Victoria Embankment,
London EC4Y 0DZ

An Hachette UK Company

10 9 8 7 6 5

A CIP catalogue record for this book is available
from the British Library.

ISBN: 978-1-78627-571-4
Design: Alexandre Coco
Copy-editing: Trish Burgess
Proofreading: Belinda Curwen

Origination by DL Imaging, UK
Printed in China by C&C Offset Printing Co. Ltd.

www.laurenceking.com
www.orionbooks.co.uk

This book is dedicated to
Marie Dauenheimer and Michael
Sappol, without whose knowledge,
passion, research and generosity
it would not exist.
– Joanna Ebenstein

Dedicated in loving memory of my
father Richard Dauenheimer.
– Marie Dauenheimer

anatomica

The Exquisite and Unsettling Art of Human Anatomy

Joanna Ebenstein

Medical editor
Marie Dauenheimer, MA, CMI, FAMI

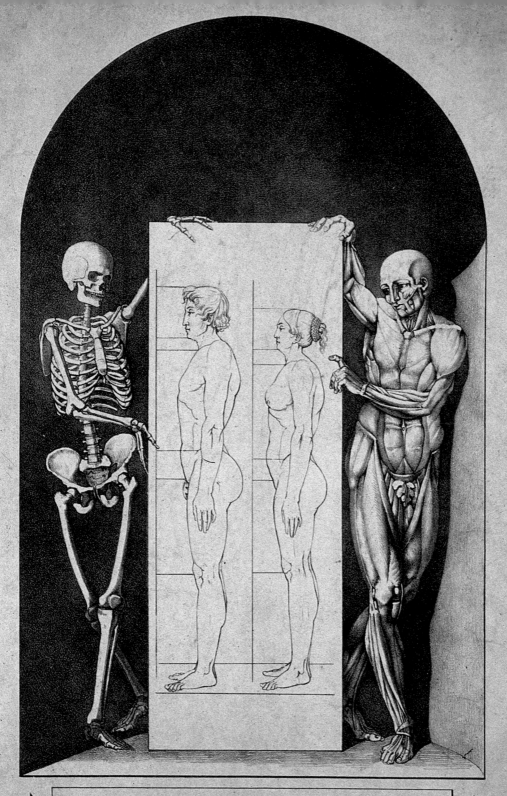

TRATTATO DI ANATOMIA PITTORICA

Fatto da Costantino Squanquerillo

ROMA MDCCCXXXIX

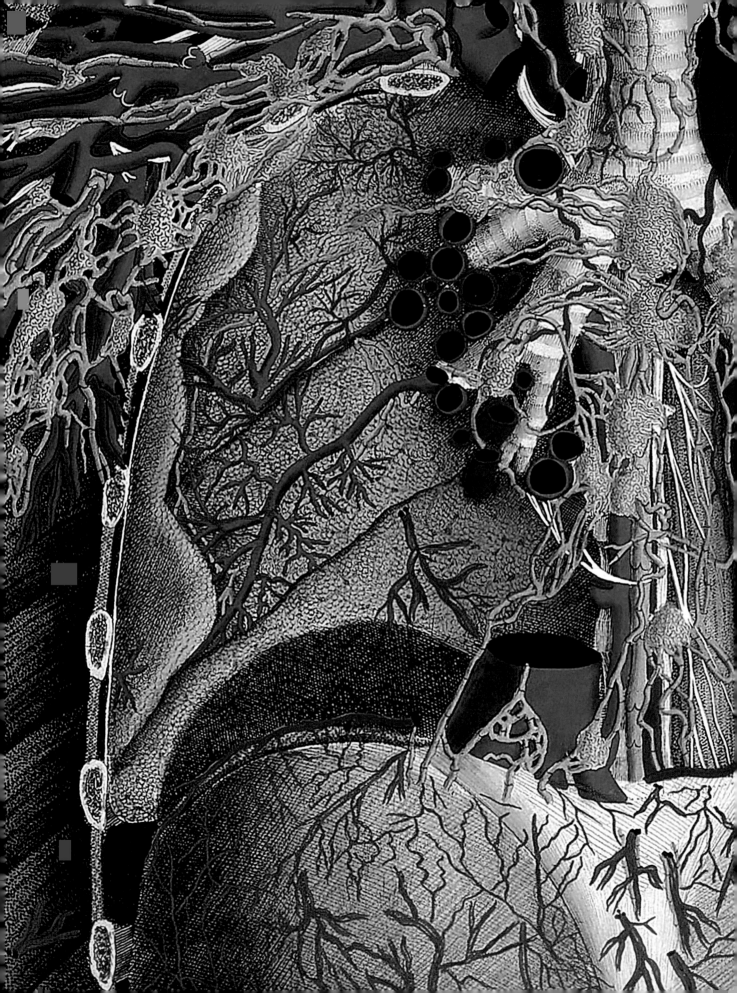

Introduction

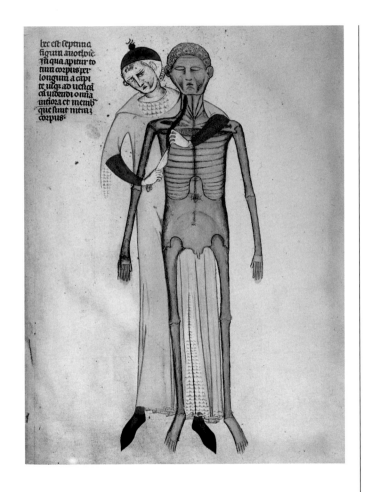

We each have a body, and our *inhabiting* of that body is a deeply ambivalent experience. Our bodies are simultaneously us and not us: intimately familiar, yet unfathomably mysterious. The body is a source of anxiety, desire, dread and intense fascination. Despite medicine's best efforts and our own dearest wishes, we know that our bodies will ultimately die and decay, tying us inextricably to the cycles of nature. And, at a time when so many of us live without a religion or mythology to make sense of the mysteries of corporeality, consciousness, and the nature of life and death, our bodies have come to function, more often than not, as a stand-in for our very identities. Meanwhile the doctors who claim mastery of this terrain fulfil the roles formerly afforded to shamans and priests. These ambivalences and contradictions resonate in the body and in our attempts to control, aestheticize, transcend, penetrate – and depict – its secrets.

During the Renaissance, the study of the human body became both a popular science and a *visual* one. The earliest anatomical atlases, such as Andreas Vesalius's *De humani corporis fabrica*, 1543 (On the Fabric of the Human Body), were large-scale, lavish productions which utilized new printing technology to disseminate accurate illustrations based on direct observation. These depictions were also artistic masterpieces. Highly collectable and expensive, you would be as likely to find such books in a gentleman's cabinet as in the study of a medical student. A fascination with the secrets of the body motivated scientist, artist and layman alike. Not only anatomists such as Vesalius, but also great artists such as Leonardo da Vinci and Michelangelo, conducted their own human dissections. The source of most anatomical knowledge was the systematic dissection of corpses, usually those of executed criminals, the poor and the vulnerable. Long girded with taboo, the dark, messy and transgressive reality behind anatomical study was often carefully veiled – or highly aestheticized – by its illustrators. Familiar metaphors and artistic tropes were used to make these presentations more accessible and less repugnant to the general public.

We are encouraged to regard science and its material culture as neutral, above reproach, outside human agency – but the truth is, of course, not that simple. Anatomical artworks, like all scientific artworks, are artefacts of the human, cultural meaning-making activity called 'science'. As such,

← Detail of a hand-coloured engraving of the human viscera by Antonio Serantoni, as featured in Italian anatomist Paolo Mascagni's *Anatomia Universa*, 1823–32, (Universal Anatomy). One of the great masterworks of anatomical art, this atlas took around thirty years to produce, and features forty-four exquisitely rendered plates.

↑ This hand-painted illustration shows a well-dressed man dissecting a cadaver. It was featured in Guido da Vigevano's *Anothomia Philippi septimi*, 1345 (Anatomy for King Philip VII). Da Vigevano was a 14th-century Italian physician and inventor. He was a pioneer in the use of anatomical drawings to illustrate texts.

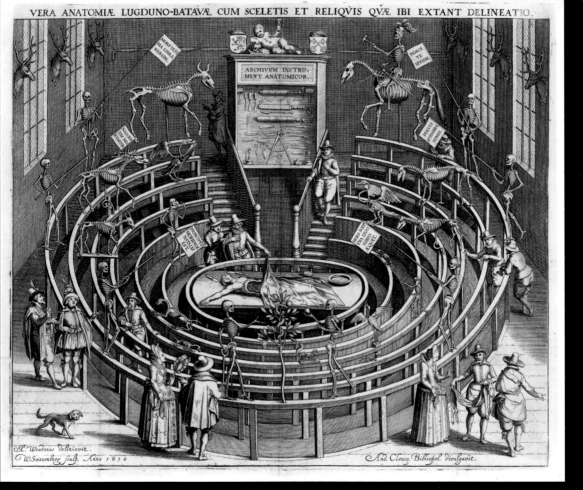

VERA ANATOMIÆ LUGDUNO-BATAVÆ CUM SCELETIS ET RELIQVIS QVÆ IBI EXTANT DELINEATIO.

↑ An engraving of the
Leiden anatomical
theatre, dating from
1625. People would
attend these theatres
to see dissections.
This theatre was
decorated with animal
and human skeletons,
some of which hold
banners emblazoned
with *memento mori*
mottoes such as *ultima
linea rerum* (Death,
the final boundary
of things) and *mors
sceptra ligonibus
aequat* (Death
makes sceptres

→ Hand-coloured
woodcut by Shukuya
Aoki from Shinnin
(Shien) Kawaguchi's
Kaishihen (Complete
Notes on the Dissection
of Cadavers), 1772. This,
and the other 23 images
in this book, document
what was only the
third recorded human

they function not only as instructional diagrams, but also as products of culture and history, and reflect the world views of their creators. In this way, anatomical illustrations provide a window through which we can view shifting beliefs about the ideal versus the pathological body, the imposition of social hierarchies – including those of race and gender, notions of our place in the universe, and the appropriate conventions for scientific imagery.

Today we think of art, science and religion as separate and even conflicting categories, but this was not always the case. For the vast majority of our history, the human body was understood to be more than simply matter. Most of the images in this book were created in the Western world, which was for centuries dominated by the Christian idea that the human body was God's masterwork, crafted in His own image, and a microcosm of the universe. These images demonstrate, then, not only scientific concepts but also beliefs about the human body's link to the divine, our place in the universe, and the meaning of life and death. By tracing their trajectory, we can witness the cultural shift from an ensouled, metaphysical, holistic world view to a contemporary rationalist scientism.

Given this divergence, it is not surprising that we find so many of the images in this book strikingly unusual, challenging, even bizarre. We expect anatomical illustrations to be sterile, diagrammatic, and to contain no extraneous detail. However, the historical images I selected, on the contrary, possess a rich liveliness, beauty, and range of expression. In them, we find a heady marriage of what we may now regard as incompatible opposites – life and death, the sacred and profane, science and art, detachment and pathos, education and titillation, death and beauty.

I have always seen anatomical illustrations as artworks dealing – consciously or unconsciously – with our attempts to come to terms with the tragedy and wonder of being born into a body, and the certainty of our own death. This puts our current scientific medicine into perspective, revealing that it is merely the latest of a very long line of strategies intended to cheat death, cure illness, and reduce suffering.

It also reminds us that, for all medicine's implicit promises, death remains a fearful mystery that links us to nature and the greater web of life. In this context, the powerfully affecting images that follow might be seen as science-age *memento mori* – objects created to encourage viewers to meditate on their death and rise above human vanity. They might also be considered talismans, affirming our belief in a universe where powers – be they mystical or professional – can intervene on our behalf to save us from sickness, suffering and death.

I chose the images in this book on the basis of their aesthetic and expressive qualities, because I find them the most compelling, beautiful, bizarre, or confounding of their kind. The book does not follow chronological order, but is organized by body part or system in order to highlight the rich variety of approaches – metaphorical, artistic and stylistic – to understanding and depicting the human body. The illustrations are sourced from the past 500 years, largely from the Western tradition, in which anatomical study shifted from the humoural traditions of Ancient Greece and Rome to the dissection of cadavers. The Eastern tradition has its own unique customs, stemming from Taoist concepts of yin and yang and its system of correspondences between the elements and parts of the body, and only later adopting Western ideas.

By presenting all of these diverse, inventive, challenging and powerful images in one place is to demonstrate that the body is never *just* the body; it is always, because of our intimate and mysterious relationship to it, including our strongly ambivalent emotional connection, something more. This book might itself serve as a *memento mori* of sorts: an invitation to a gentle contemplation of our own mortality, an appreciation of the beauty and fragility of the body and our own brief and inscrutable lives. It is my hope this collection will act as an inspiration to artists, armchair anatomists and those who remain ever curious about the body they live in and the ways in which it continues, despite our rationalist culture, to resonate, to fascinate, and to *mean*.

Discovery timeline

The following list broadly covers the dates of the artworks featured in this book, and notes significant advances in medicine, anatomy and art over that time.

- ■ Ancient (3100–850 BCE)
- ■ Classical (850 BCE–476 CE)
- ■ Medieval (500–1400)
- ■ Renaissance (1400–1527)
- ■ Mannerism (1527–1600)
- ■ Baroque (1600–1750)
- ■ Neo-classical (1750–1850)
- ■ Romanticism (1780–1850)
- ■ Realism (1850–1900)
- ■ Modern (1900–today)

c.2600 BCE
Emperor Huangdi (attrib.) compiled *Huangdi neijing* (Inner Classic of the Yellow Emperor). This book, which probably dates much later, to c.300BCE, was prized among practitioners of traditional Chinese medicine. The basic premise, rooted in Taoist philosophy, is that a balance of yin and yang energies is vital to health.

c.460 BCE
Hippocrates, known as 'The father of medicine', believed that good health lay in the balance between the four humours – blood, phlegm, black bile and yellow bile. His reputation and ability ensured this theory remained influential until the mid 19th century, and the oath of ethics sworn by new doctors is named after him.

300 BCE
Diocles wrote the first known anatomy book, using animals for his dissections. Only fragments of his writings survive.

1231
The Holy Roman emperor Frederick II (1194–1250) issued a decree that at least one human cadaver should be dissected every five years, and that anyone wishing to practise medicine or surgery was obliged to attend it.

1315
Public dissections were conducted in Bologna on the body of executed criminals. In these demonstrations, the professor would read from a text, while a barber surgeon – a lower-ranking occupation – would perform the actual dissection.

1347–51
The peak years of the Bubonic plague, commonly known as the Black Death or Great Plague. It decimated populations around the world, killing as many as two thirds of the population in some areas.

1400
Public dissections were legally performed in Venice and Florence in Italy, and in Montpellier, France.

c.1450
The universities of Perugia, Padua and Florence required students of medicine to attend at least one dissection in order to receive their doctorate.

1456
Johann Gutenberg produced the first printed Bible using movable metal type.

1517
Martin Luther published his 95 theses denouncing certain practices in the Catholic Church, an act which ultimately led to the Protestant Reformation.

1519
Leonardo da Vinci died, having dissected around 30 cadavers in his lifetime, and leaving behind hundreds of drawings for a planned anatomical atlas that was never realized.

1540
Thomas Raynalde published *The Birth of Mankynde: Otherwyse Named the Womans Booke*, an important work on midwifery.

1541
Michelangelo completed his fresco of *The Last Judgment* for the Sistine Chapel in Rome.

1543
Andreas Vesalius published his revolutionary *De humani corporis fabrica libri septem* (On the Fabric of the Human Body in Seven Books), initiating the era of modern anatomy.

1543
Nicolaus Copernicus published *De revolutionibus orbium coelestium* (On the Revolutions of the Heavenly Spheres), which argued that the Earth revolved around the sun rather than vice versa.

1605
Caspar Bauhin, a Swiss anatomist, and engraver Theodor de Bry published *Theatrum anatomicum* (Anatomical Theatre).

1613
Johann Remmelin published *Catoptrum Microcosmicum, suis aere incisis visionibus splendens, cum historia, et pinace, de novo prodit* (A Mirror of the Microcosm, illustrated with copper engravings, and including an explanatory description and tables, a new edition).

1627
Giulio Casseri published *Tabulae Anatomicae* (Anatomical Tables)

1628
William Harvey published *Exercitatio anatomica de motu cordis et sanguinis in animalibus* (An Anatomical Study of the Movement of the Heart and Blood in Animals), in which he postulated the modern understanding of blood circulation and resolved the dispute about whether the heart or liver was the prime mover of bodily functions.

1642
Invention of the mezzotint (halftone), a labour-intensive form of printing that allowed colour reproduction and smooth gradations of tone.

1665–6
The Great Plague of London, the last large-scale outbreak of bubonic plague, wreaked havoc in the capital.

c.300 BCE

The first known human dissections were conducted in Alexandria, Egypt.

130 CE

The Roman physician Galen was born. His writings formed the foundation of medical knowledge for over 1,000 years. Although he advocated dissection, he had to make do with working on animals because it was forbidden to dissect humans. This led to many errors, which were discovered and corrected during the Renaissance.

610

Chao Yuanfang published *Zhubing Yuanhou Lun* (General Treatise on the Causes and Manifestations of All Diseases).

984

Yasuyori Tanba published *Ishinpo* (Remedies at the Heart of Medicine).

1041

Movable type, made from baked clay, was invented in China. This facilitated the dissemination of knowledge, not least in medical matters.

1088

The first university was established in Bologna, Italy.

1469

Lorenzo de' Medici, patron of scholars and artists such as Michelangelo and Botticelli, became ruler of Florence.

c.1478

Sandro Botticelli painted his masterwork *Primavera*.

1491

Joannes de Ketham published *Fasciculus medicinae* (literally 'little bundle of medicine').

c.1495

The process of etching was developed by metalsmith Daniel Hopfer in Augsburg, Germany. It greatly improved the quality of medical illustration.

1500–07

Leonardo da Vinci produced the portrait known as the *Mona Lisa*.

1513

Niccolò Machiavelli published *The Prince*, the first book of political science, which led to his being branded amoral and atheistic.

1545

Charles Estienne and Étienne de la Rivière published *De dissectione partium corporis humani* (On the Dissection of Parts of the Human Body).

1545–63

The Council of Trent met in response to Protestant attacks on the Catholic Church, and its decisions established the Counter-Reformation, in which Catholics reaffirmed key elements of dogma, driving the development of baroque art.

1564

Ambroise Paré published *Dix livres de la chirurgie* (Ten Books of Surgery).

1590

Zacharius Jannssen, a Dutch spectacle maker, invented the microscope.

1594

The first anatomical theatre was built for public anatomical dissections by Hieronymus Fabricius ab Aquapendente at the University of Padua in Italy.

1595–1604

Anatomical theatres were established at the universities of Bologna (Italy), Leiden (the Netherlands) and Paris (France).

1681

John Browne published *A Compleat Treatise of the Muscles: as they appear in humane body, and arise in dissection; with diverse anatomical observations not yet discover'd*.

1685

Govard Bidloo published *Anatomia humani corporis* (Anatomy of the Human Body).

1694

William Cowper published *Myotomia reformata: or An Anatomical Treatise on the Muscles of the Human Body*.

1695

Anton van Leeuwenhoek is the first to describe and accurately render red blood cells, using a microscope lens of his own creation.

1698

William Cowper published *The Anatomy of Humane Bodies, With Figures Drawn After the Life. By Some of the Best Masters in Europe, and Curiously Engraven in One Hundred and Fourteen Copper Plates, Illustrated with Large Explications, Containing Many New Anatomical Discoveries, And Chirurgical Observations*.

c.1700

Gaetano Giulio Zumbo, better known as Zumbo, crafted the first wax anatomical model in collaboration with French anatomist Guillaume Desnoues.

1733

William Cheselden published *Osteographia, or The Anatomy of the Bones.*

1738

Official excavation of the ancient Roman city of Herculaneum began, revealing bodies encased in lava.

1747

Bernhard Siegfried Albinus (Weiss) published *Tabulae sceleti et musculorum corporis humani* (Illustrations of the Skeleton and Muscles of the Human Body).

1748

Joseph Guichard Duverney published *Anatomie de la tête en tableaux imprimés* (Illustrated Anatomy of the Head).

1751–72

Denis Diderot and J. Le Rond d'Alembert published *Encyclopédie, ou dictionnaire raisonné des sciences, des arts et des métiers* (Encyclopedia or Systematic Dictionary of the Sciences, Arts and Crafts).

1752

Jacques-Fabien Gautier d'Agoty published *Anatomie générale des viscères et de la neurologie, angéologie et ostéologie du corps humain* (General Anatomy of the Organs, Nervous System and Blood Vessels in the Human Body).

1796

Edward Jenner developed the first vaccine for smallpox.

1798

Franz Joseph Gall's theory of 'cranioscopy', later called 'phrenology', first appeared in print. Despite being debunked as a pseudo-science, it continued to be influential throughout the 19th century.

c.1800

Charles Stanhope, the third Earl Stanhope, built the first iron-framed press, capable of printing 200 impressions per hour.

1818

James Blundell achieved the first successful human blood transfusion.

1818–19

The painter Théodore Géricault utilized bodies from morgues to paint anatomical still lifes, and as research for his masterly work *The Raft of the Medusa.*

1822–6

John Lizars published *A System of Anatomical Plates of the Human Body, Accompanied with Descriptions and Physiological, Pathological, and Surgical Observations.*

1836–42

Jones Quain published *A Series of Anatomical Plates ... Illustrating the Different Parts of the Human Body.*

1839

Jones Quain and Sir Erasmus Wilson published *The Nerves of the Human Body.*

1842

Crawford W. Long first used ether as a general anaesthetic.

1844

The pulping of wood for producing paper was introduced, making the printing of books and newspapers much more affordable and leading to a boom in printed works.

1844

Richard Quain published *The Anatomy of the Arteries of the Human Body and its Applications to Pathology and Operative Surgery with a Series of Lithographic Drawings.*

1847

Ignaz Semmelweis discovered how to prevent the transmission of disease through hand washing; unfortunately, having no theory to back up his observations, his work was ignored.

1867

Joseph Lister developed antiseptic surgical methods and published his *On the Antiseptic Principle of the Practice of Surgery.*

1870

Robert Koch and Louis Pasteur established the germ theory of disease.

1873

The anti-obscenity Comstock Act made it a federal offence to disseminate birth control or 'obscene' materials through the mail or across state lines in the USA.

1883

Sir Francis Galton coined the term 'eugenics' for the science of improving a human population via controlled breeding.

1886

Linotype, the first successful automatic typesetting machine, was developed.

1893

Alphonse Bertillon published *Identification Anthropométrique: Instructions Signalétiques Album* (Identifying People by Bodily Characteristics: How to Read Signs).

1754
William Smellie published *Anatomical Tables with Explanations, and an Abridgement of the Practice of Midwifery.*

1774
William Hunter published *Anatomia uteri humani gravidi tabulis illustrata* (The Anatomy of the Human Gravid Uterus Exhibited in Figures).

1775–83
The War of American Independence took place. Dealing with the casualties of this war led to new practices in medicine, such as inoculating soldiers against smallpox.

1779
Jacques Gamelin published *Nouveau recueil d'ostéologie et de myologie dessiné d'après nature* (A New Collection of Osteology and Myology Drawn from Nature).

1789
The French Revolution began, contributing to the decline of rococo and the popularity of neo-classicism.

1793
Neo-classical painter Jacques-Louis David painted a portrait of the murdered French politician and physician Jean-Paul Marat, now popularly known as *The Death of Marat.*

1822–7
Jacques-Pierre Maygrier published *Nouvelles démonstrations d'accouchements ...*, produced in English under the title *Midwifery*, 1833.

1824
Sir Charles Bell published *Engravings of the Arteries.*

1828
William Burke and William Hare murdered at least 15 people and sold their bodies to medical schools for dissection.

1837
The printer Godefroy Engelmann patented the chromolithograph, which allowed cheap colour prints to be mass-produced.

1831–54
Jean-Baptiste Marc Bourgery published *Traité complet de l'anatomie de l'homme comprenant la médecine opératoire ... avec planches lithographiées d'après nature par N-H Jacob* (A Complete Treatise on Human Anatomy including Operative Medicine ... with lithographic plates drawn from nature by N-H Jacob).

1832
The Anatomy Act was passed by the British government, allowing anatomists to dissect not only executed criminals, but also 'unclaimed bodies', i.e. those who had died without any family coming forward to claim them for burial.

1850
Frederick Hollick published *The Male Generative Organs in Health and Disease, from Infancy to Old Age.*

1851
Joseph Maclise published *Surgical Anatomy.*

1853
Arthur Comte Gobineau published *An Essay on the Inequality of the Human Race,* in which he argued for the superiority of the Aryan race.

1858
Henry Gray published *Anatomy: Descriptive and Surgical, Anatomy of the Human Body,* later shortened to *Gray's Anatomy*. In revised form, it is still used today.

1859
Charles Darwin published his revolutionary *On the Origin of Species*, in which he introduced his theory of evolution and the principle of natural selection.

1865
French anthropologist Paul Broca created his 'table chromatique' for the classification of skin colour.

1895
Wilhelm Conrad Roentgen discovered X-rays.

1911
At Johns Hopkins University in Baltimore, Max Brödel established 'Art as Applied to Medicine', the first course of study in medical illustration.

1928
Sir Alexander Fleming discovered penicillin, the first true antibiotic.

1977
The last known case of smallpox, a disease that had existed for over 3000 years, was defeated by a global vaccination programme and declared completely eradicated in 1979.

1989
American surgeon and renowned medical illustrator Frank Henry Netter published his classic *Atlas of Human Anatomy.*

1995
German anatomist and provocateur Gunther von Hagens exhibits preserved, plastinated human cadavers in his first Body Worlds exhibition in Tokyo. He developed the technique in 1977.

The Full Body

The idea of the human body as primarily material and mechanical is quite new. For most of human history, the body had been awarded a special status with religious and symbolic significance, and with rites and rituals circumscribing its treatment after death. For many centuries, both in the West with the humours, and in the East with traditional Chinese medicine, the body was regarded as a microcosm of the world, the elements and the cosmos. In some systems of understanding, organs of the body correlated to different constellations and astrological signs; in others, the body was the home to energetic centres that, if correctly cultivated, could lead to enlightenment. For yet others, it was a way to understand the mind of God through what was not only His greatest work, but also made in His own image.

The corpse, skeleton and *écorchés* (flayed figures) were frequent subjects of fine and popular art long before there was an interest in accurate depictions of human anatomy. Even into the 19th century, anatomical illustrators routinely drew on the metaphors and iconography of these traditions. The line between science, art and metaphysics could sometimes be quite blurred, as *memento mori, danse macabre* and flayed satyrs blended seamlessly with scientifically accurate, instructional renderings of the body.

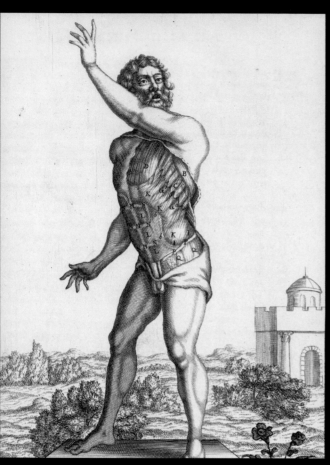

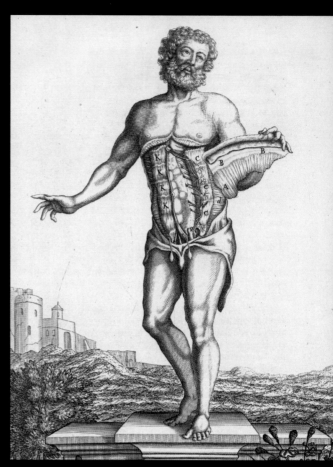

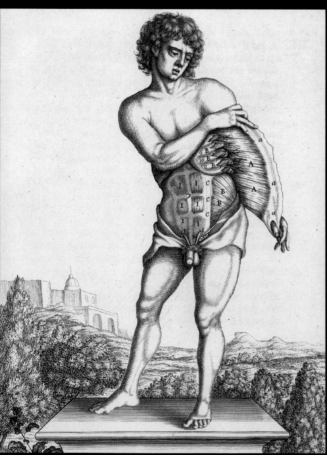

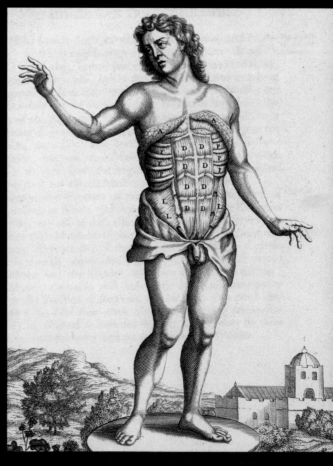

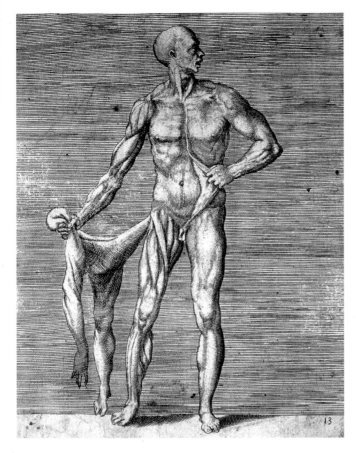

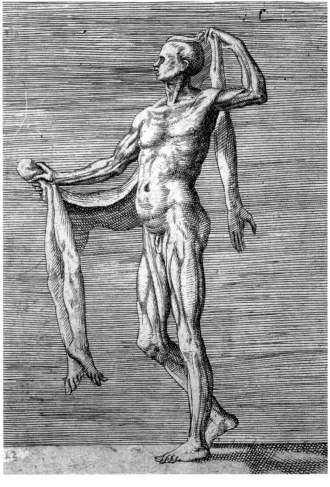

Here we see some playful *écorchés* demonstrating the musculature of the male body. *Écorchés* – or depictions of the body with the skin removed to display the muscles beneath – were popular not just in anatomy books, but also with fine artists as preparatory studies for final works. Indeed, until the 19th century, it was common for anatomical works to portray figures as if alive and free of pain, and displaying themselves with evident pleasure. Such conventions helped to make anatomical imagery suitable not only for doctors and medical students, but for a non-specialist audience too. They also served to mask the fact that anatomical knowledge was acquired via the dissection of corpses, many of them of condemned criminals.

↑ Two male *écorché* figures from a set of 14 anatomical engravings by Italian painter and engraver Giulio Bonasone (16th century).

← Depictions of male musculature from John Browne's *A compleat Treatise of the Muscles: as they appear in humane body, and arise in dissection; with diverse anatomical observations not yet discover'd*, 1681.

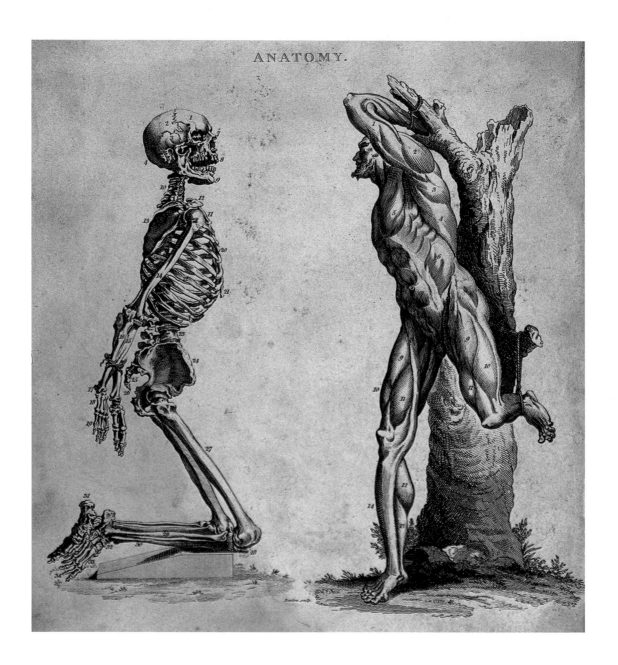

ANATOMY.

This engraving, from an unidentified encyclopedia produced around 1800, features images copied from William Cheselden's famous *Anatomy of the Human Body*, 1713. Anatomical illustrations routinely drew on fine art precedents for their iconography. For *écorchés*, one could turn to centuries of macabre renderings of St Bartholomew – believed to have been martyred by being skinned – or Marsyas, a satyr in Greek mythology, who was bound to a tree and flayed alive for daring to challenge the god Apollo to a musical contest. The figure on the right has much in common with popular renderings of that satyr, while the image on the left, kneeling as if in prayer, has a moralizing air, alluding to the relationship between death and Adam and Eve's original sin in the Christian world view.

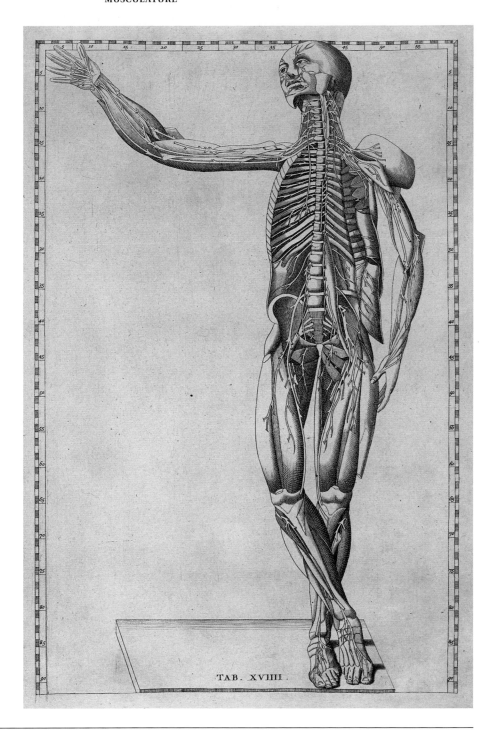

TAB. XVIIII.

This stylish *écorché* is from
*Tabulae Anatomicae Clarissimi
Viri Bartholomaei Eustachii, c.*1714
(Anatomical Tables of a Most
Illustrious Gentleman Bartholomeo
Eustachi) published over 100 years
after the anatomist's death in 1574.
A contemporary of the much better-
known Vesalius, Bartholomeo Eustachi
– also known as Eustachio and
Eustachius – taught anatomy in Rome,
and was a physician to luminaries such

as the Duke of Urbino and Cardinal
Giulio della Rovere. After his death, a
number of copperplates were found
for an unfinished anatomical book he
was planning. These plates, created
by Giulio de' Musi, were eventually
published, along with added text, in
1714. The numbered border around
the images was a clever device
for pinpointing the anatomical
structures referred to in the text.

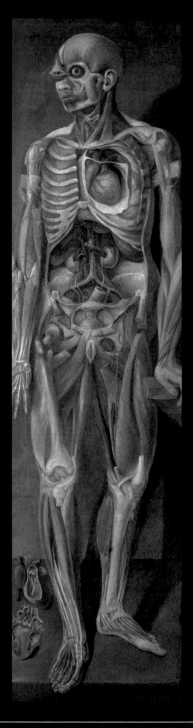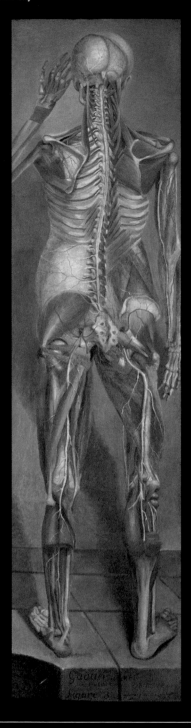

The dissected figures above were painted around 1764 by Jacques-Fabien Gautier d'Agoty, one of the most artful of all anatomical illustrators, with a decidedly romantic approach. He is best known for his mezzotints, for which he pioneered a unique printing technique combining plates of the three primary colours and black to create one full-colour image; in this, he expanded upon the technique developed by his mentor, the famous printmaker Jacob Christoph Le Blon. These techniques, based on Newtonian colour theory, are at the root of the CMYK four-colour method still used for colour printing today.

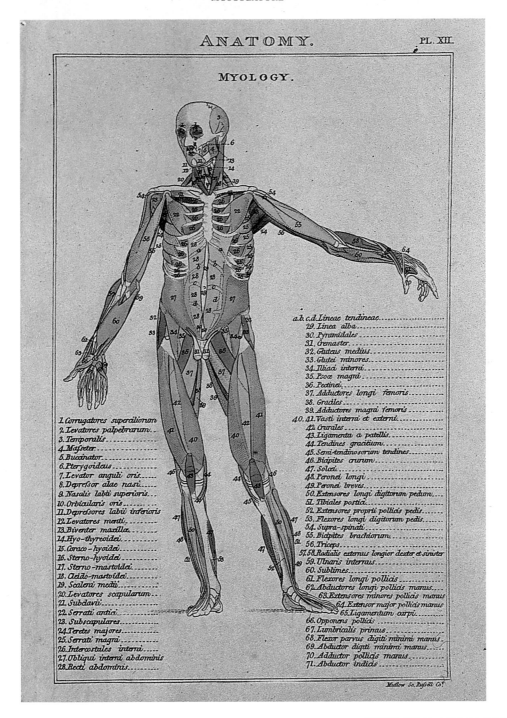

This coloured line engraving of a male *écorché*, with its muscles numbered and indicated in various colours, was created by Henry Mutlow for an unknown publication around 1800. It looks much more familiar to us than the previous images in this book, having a great deal in common with contemporary conventions of anatomical illustration: 'neutral,' diagrammatic and static. The pre-eminence of this style of illustration was really cemented with the popularity of *Gray's Anatomy* (originally titled *Anatomy: Descriptive and Surgical, Anatomy of the Human Body*), 1858, the seminal work by Henry Gray, with illustrations by Henry Vandyke Carter, that is still used by medical students.

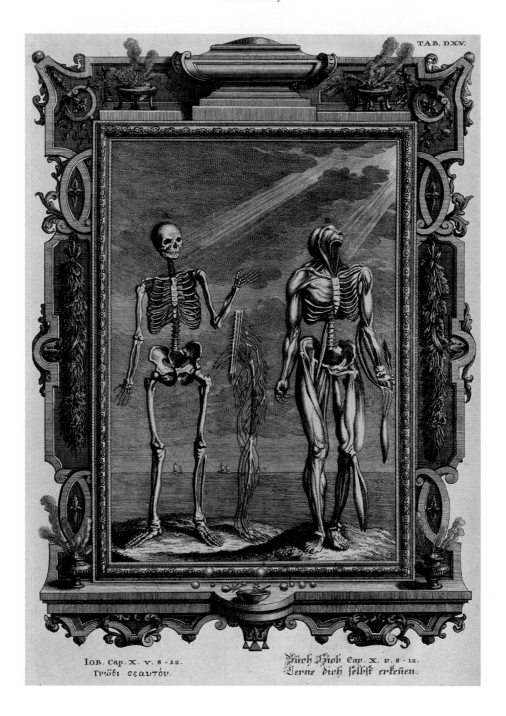

This image is one of more than 700 copperplate engravings from drawings by Johann Melchior Füssli from Johannes Jacob Scheuchzer's four-volume high baroque masterwork *Physica Sacra*, 1731–5 (Sacred Physics) in German referred to as the *Kupfer-Bibel* (Copper Bible) due to the quality and range of its illustrations.

Scheuchzer was a Swiss doctor and natural scientist. He believed, as did many scientists of his time, that the Old Testament provided a factual account of the natural world. Consequently, this work combines biblical allusions with natural history in a textual and visual investigation into the known world and its wonders. Scheuchzer personally oversaw the illustrations, which were drawn mainly from specimens in natural history cabinets, including his own and other famous European collections.

The caption at the bottom of the image cites the biblical passage Job 10:8–12. In it, Job, tormented by a seemingly arbitrary punishment ordered by God, laments his fate and asks why he is being made to suffer: 'Thine hands have made me and fashioned me together round about; yet thou dost destroy me; Remember, I beseech thee, that thou hast ... clothed me with skin and flesh, and hast fenced me with bones and sinews.'

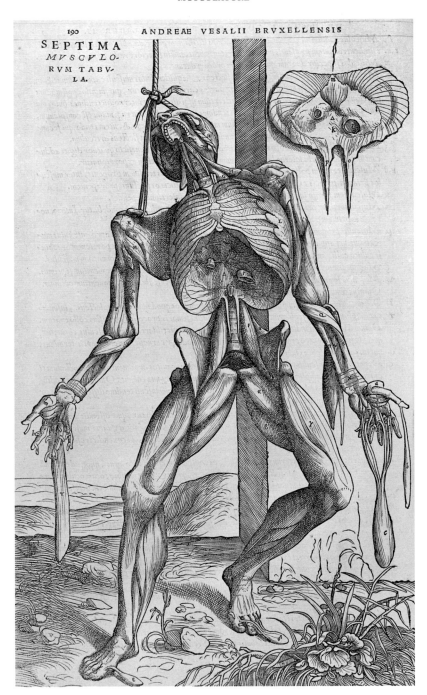

This woodcut engraving – probably by German-born Italian artist Jan van Calcar, a student of Titian – is one of the many beautiful and iconic images from the revolutionary and monumental *De humani corporis fabrica libri septem*, 1543 (On the Fabric of the Human Body in Seven Books) by Flemish anatomist and physician Andreas Vesalius. Published in the same year that Copernicus posited in *De revolutionibus orbium coelestium* that the earth orbited the sun rather than the other way around, it is considered to be the work that launched the modern study of human anatomy. It also made the 29-year-old Vesalius a legend, and the book a much-imitated classic.

Vesalius, unlike most of his contemporaries, conducted his own dissections, and in doing so developed the conviction that received knowledge about human anatomy, based on the teachings of the 2nd and 3rd century CE Roman physician Galen, contained many factual errors. Today we know that Galen's errors stemmed from having to base his teachings on the dissection of monkeys and pigs, because human dissection was illegal in Ancient Rome. By contrast, the image here, with its human cadaver hung from a rope, demonstrates that Vesalius's knowledge stemmed not from books, but from his own experiences with human dissection.

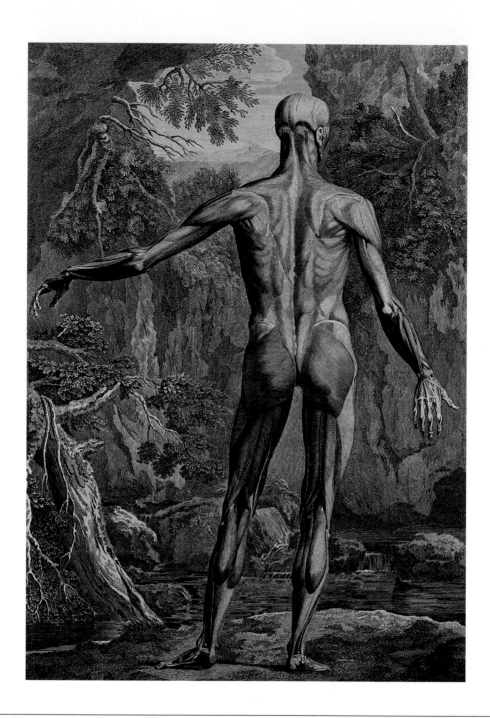

These handsome engravings by the Dutch artist Jan Wandelaar show two views of an idealized *écorché* figure. They are drawn from the magnificent *Tabulae sceleti et musculorum corporis humani*, 1747 (Illustrations of the Skeleton and Muscles of the Human Body) by the German-born Dutch anatomist Bernhard Siegfried Albinus (the last word being the Latinized form of his surname, Weiss). He was one of the most famous anatomists of the 18th century, and his book, after Vesalius's *De humani corporis*, was the most copied and influential of all medical atlases. In order to create the illustrations, Albinus worked closely with Wandelaar; in fact, they lived under the same roof until the artist died in 1759. Albinus was very concerned with scientific accuracy, and created his own system for achieving it via the use of nets with square webbing to create a grid pattern over the specimens, which could then be transferred to a corresponding grid pattern on the page. Alongside anatomy, Albinus was also interested in philosophy, and the two disciplines fed into the image of man he presented. It has been referred to by some scholars as 'homo perfectus', a view of man as a perfectible creature, according to Enlightenment thought at the time.

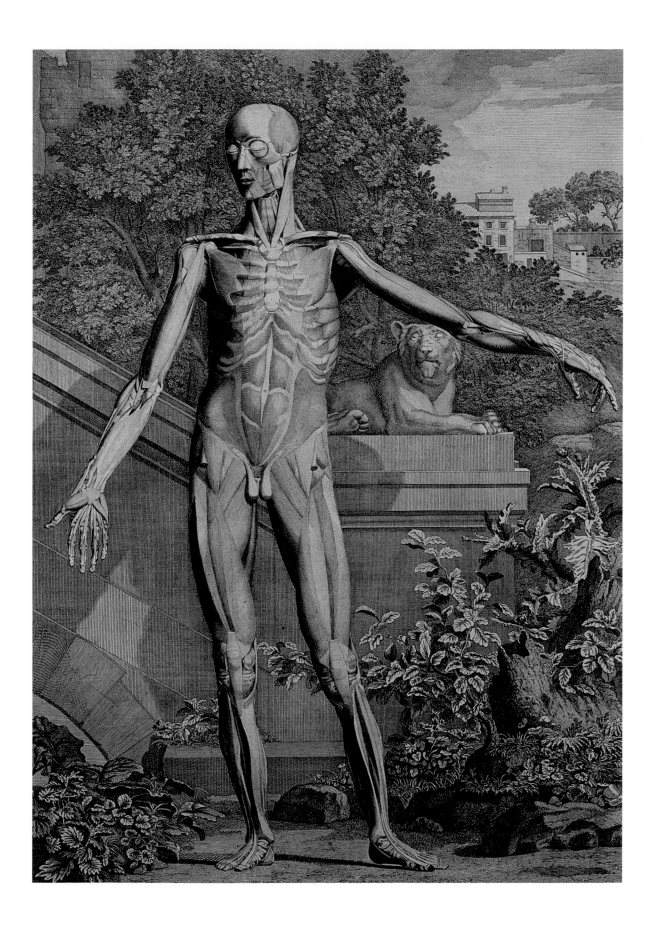

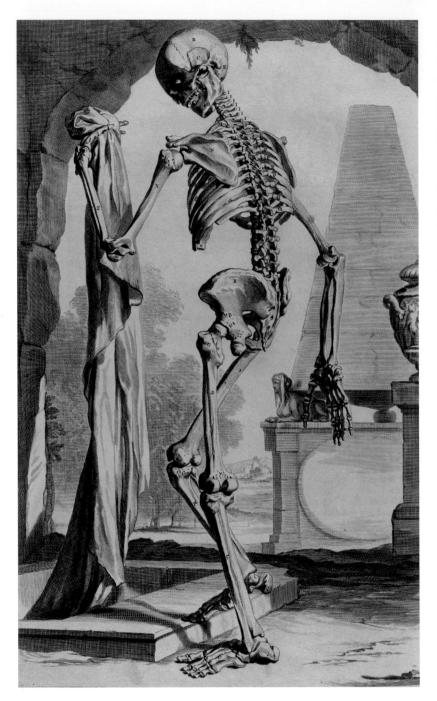

➜ This lithograph, featuring a skeleton and an *écorché* holding an illustration of the ideal anatomy for a man and a woman, is the half-title page from Costantino Squanquerillo's *Trattato di anatomia pittorica*, 1839 (Illustrated Treatise on Anatomy). This work was an anatomy book created for artists who, in a tradition going back to the Renaissance, were avid amateur anatomists, sometimes even to the extent of conducting their own dissections, as in the case of Leonardo da Vinci and Michelangelo.

In this iconic copperplate engraving by Dutch artist Gérard de Lairesse from Govard Bidloo's *Anatomia humani corporis*, 1685 (Anatomy of the Human Body), we see an anatomically correct skeleton peering coyly over his shoulder at the viewer, preparing to step into his grave while holding what appears to be his own funeral shroud. This image is one of only two such images in a book otherwise known for its scientific sobriety; it is a perfect blending of *memento mori* – works intended to remind the viewer of their own mortality in order to lead a good Christian life – and anatomical accuracy. It also evokes the merry skeletons of the *Danse Macabre*, or Dance of Death, a genre popular during the time of the Black Plague in which an anthropomorphized skeleton led people from all walks of life on a dance to the grave. Corpses, skeletons, and skulls were featured prominently in both *memento mori* and the *Danse Macabre*, and anatomical texts drew on this iconography until the 19th century.

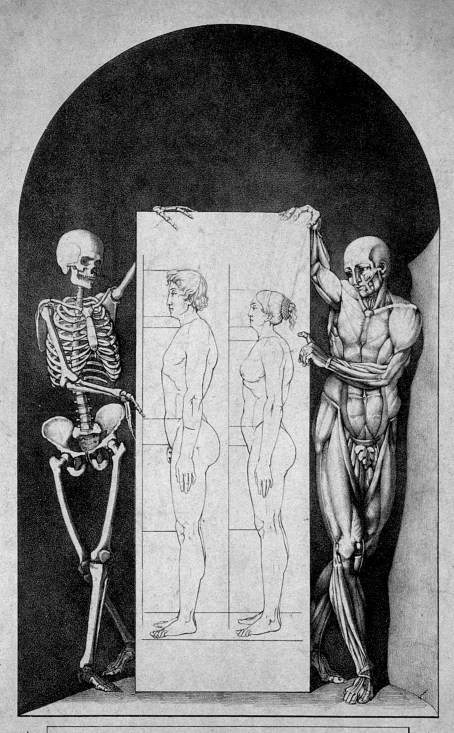

TRATTATO DI ANATOMIA PITTORICA

Fatto da Costantino Squanquerillo

ROMA MDCCCXXXIX

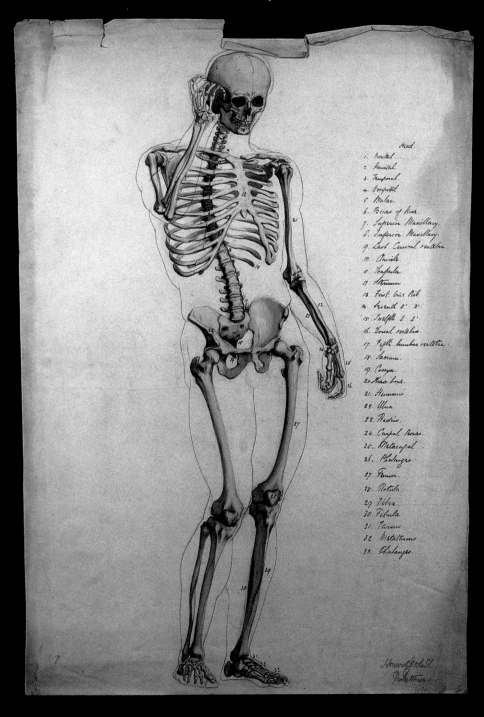

Head.
1. Frontal.
2. Parietal.
3. Temporal.
4. Occipital.
5. Malar.
6. Bones of Nose.
7. Superior Maxillary.
8. Inferior Maxillary.
9. Last Cervical vertebra.
10. Clavicle.
11. Scapula.
12. Sternum.
13. First true Rib.
14. Seventh do. do.
15. Twelfth do. do.
16. Dorsal vertebra.
17. Fifth lumbar vertebra.
18. Sacrum.
19. Coccyx.
20. Hand bone.
21. Humerus.
22. Ulna.
23. Radius.
24. Carpal bones.
25. Metacarpal.
26. Phalanges.
27. Femur.
28. Patella.
29. Tibia.
30. Fibula.
31. Tarsus.
32. Metatarsus.
33. Phalanges.

Little is known about this sensitive study of a pensive, anthropomorphized skeleton of a man. One of the unique treasures of London's Wellcome Collection, it was rendered in pen and ink with sepia wash by Howard Goodall around 1860. The bones are numbered, and a key to their names appears on the right. Under his signature at bottom right, the artist refers to himself as a probationer, so perhaps this illustration was created by an anatomist still in training.

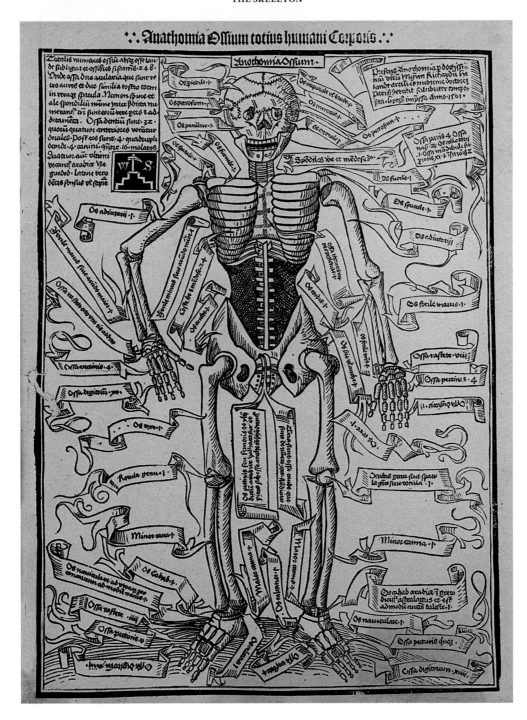

This woodcut of a skeleton was originally published by Ricardus Helain of Nuremburg in 1493. The text at the top translates as 'Bones of the human anatomy of the entire body', and the banners are emblazoned with the Latin names of the bones. This image, published before Vesalius's groundbreaking anatomical atlas, is more emblematic and diagrammatic than naturalistic or accurate.

Iconographically, it draws on earlier metaphorical uses of the skeleton in *memento mori* artworks.

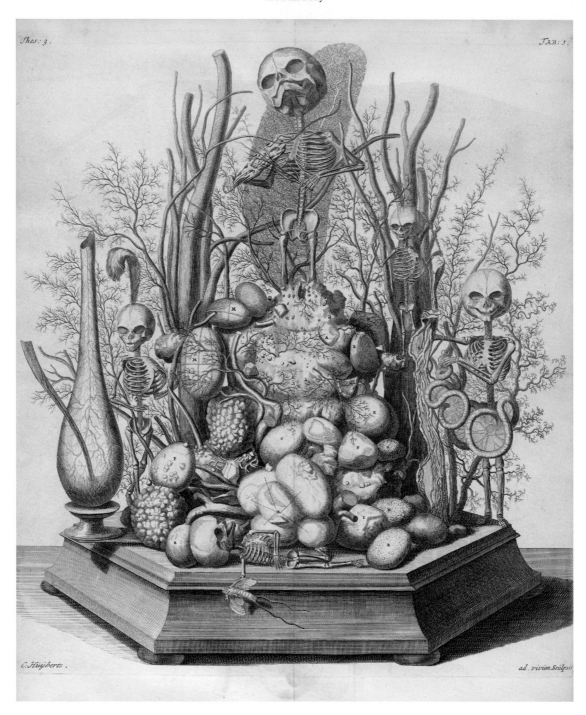

This etching by Cornelius Huyberts depicts a tableaux crafted of fetal and infant skeletons posed in a *memento mori* still life (note the skeleton swooning at the bottom is holding a mayfly, a common symbol for the ephemerality of life). The original piece was crafted by Dutch physician, botanist and anatomist Frederik Ruysch, and was featured in his *Thesaurus Anatomicus*, 1701–16 (Anatomical Thesaurus). Rusych exhibited several such assemblages straddling art, science and religion alongside numerous other inventive specimens in a museum he opened to the public in his Amsterdam home. His first collection was purchased by Tsar Peter the Great of Russia. None of his tableaux are believed to have survived.

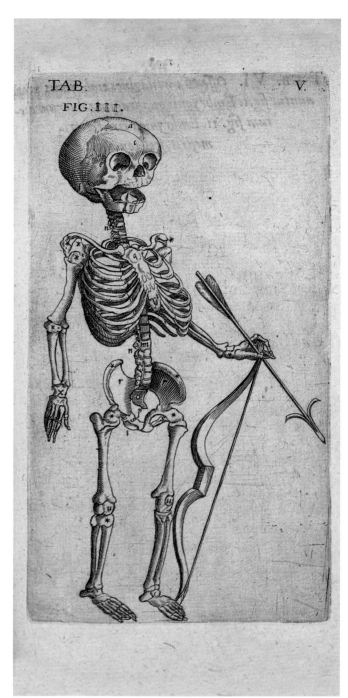

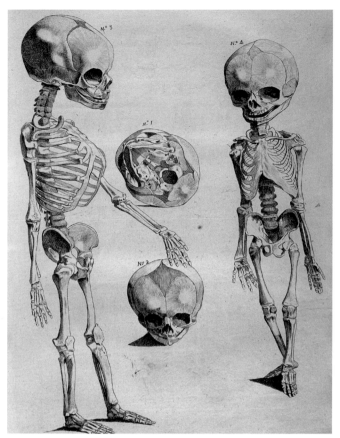

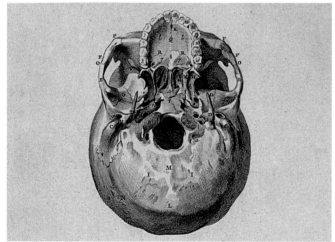

↑ A skeleton of a child with bow and arrow from *Theatrum Anatomicum*, 1605 (Anatomical Theatre) by Caspar Bauhin. The image is thought by some scholars to be a grim personification of Cupid, whose amorous inspirations led to the prematurely dead child forming the basis for the anatomical study.

↗ This etching by or after the French artist Jacques Gamelin comes from his *Nouveau recueil d'ostéologie et de myologie, dessiné d'après nature ... ,* 1779 (A New Collection of Bones and Muscles Drawn from Nature ... ,). The book was intended for both students of art and anatomy. The illustrations are made by the author's own dissections.

↓ An engraving by Robert Bénard focusing on the base of the skull, from Denis Diderot and J. Le Rond d'Alembert's *Encyclopédie, ou dictionnaire raisonné des sciences, des arts et des métiers,* 1751–72 (Encyclopedia or Systematic Dictionary of the Sciences, Arts and Crafts). The plates first appeared in 1762. The subversive and revolutionary book covered theology, the arts, and the sciences, including anatomy.

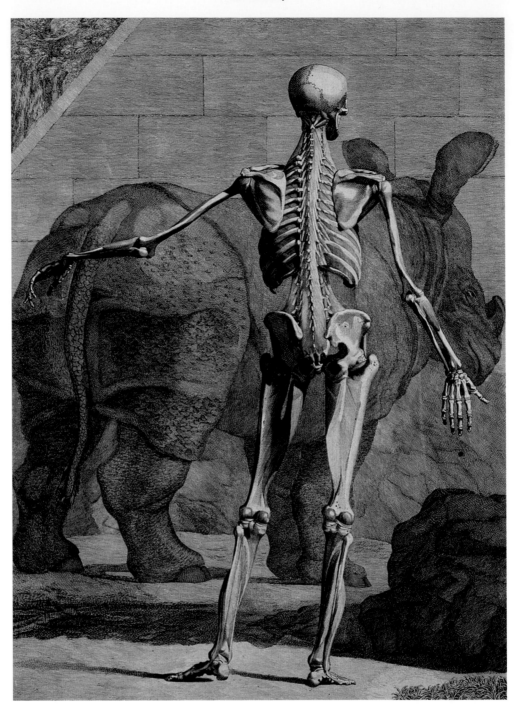

This line engraving, by Dutch artist Jan Wandelaar, comes from Bernhard Siegfried Albinus's *Tabulae sceleti et musculorum corporis humani*, 1747 (Illustrations of the Skeleton and Muscles of the Human Body). It shows the bones and a deep dissection of the muscles in an *écorché* figure seen from the back. He is posed in front of Clara, a famous rhinoceros of the time. Clara made a visit to Amsterdam in 1741 as part of a 17-year European tour. At the time, such tours were one of the few ways people could encounter exotic animals. Albinus explains in the book why he included Clara: 'On account of the rarity of the beast I thought that its form would be more pleasing than any other ornaments devised according to my own inclinations.'

The book's illustrations were known for their extreme anatomical accuracy, achieved through a novel grid system, and their pellucid neo-classical beauty, but were criticized by some for the fanciful and imaginative settings inhabited by the anatomies.

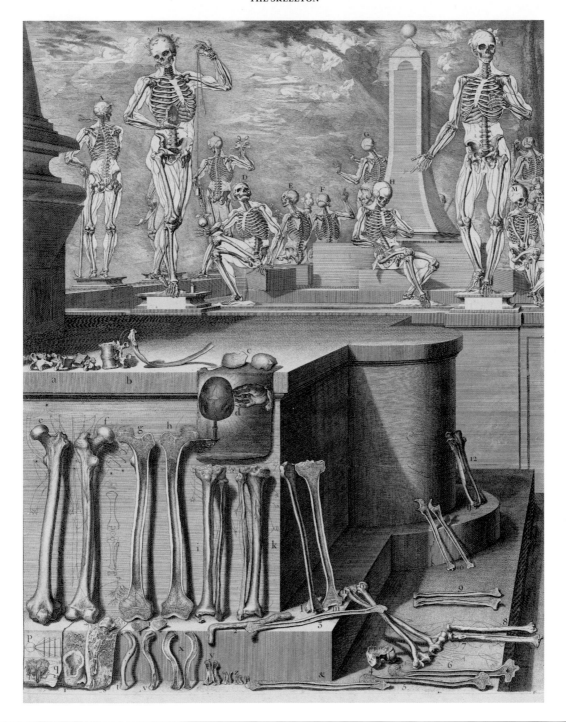

In this copperplate etching, at once scientific and metaphoric, we see bodies moving about a monumental landscape, their anatomically accurate skeletons clearly visible beneath. In the foreground we also see a number of bones, some with cutaway views revealing their interior. The plate was created around 1680 by Valencian artist and engraver Crisóstomo Martínez for an anatomical atlas. His intention

with the unpublished book was to demonstrate the relationship between different body parts, and how the body functioned. The images are the result of his work with new, high-powered microscopic lenses, and advanced print technologies that were able to provide more detail than ever before. The plates were found and printed in 1740, nearly 50 years after his death in 1694 as an exile of the Nine Years War.

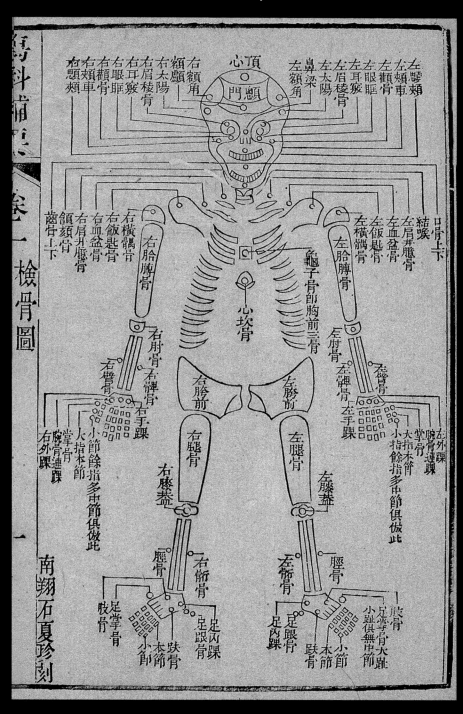

This Chinese woodcut from doctor Qian Xiuchang's *Shangke buyao*, 1818 (Supplemented Essentials of Medicine for Injuries) depicts an annotated diagram of the human skeleton. Qian's interest in anatomy began as a result of breaking his leg, after which he decided to study medicine with the doctor who had healed him; he ultimately went on to practise medicine himself. In 1808 he noted: 'When someone has a dislocated or fractured bone, the bone and joint are wrapped in flesh. Looking at it from the exterior, it is hard to get a clear understanding, and there is the danger of making an error.' He published his book as an attempt to provide – in an era before X-rays – the information necessary to properly heal internal injuries.

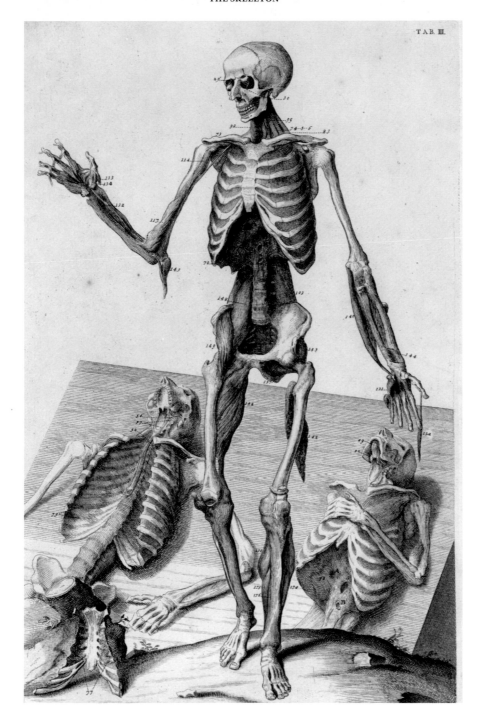

T.A.B. III.

This grim and lively collection of corpses is drawn from William Cowper's seminal *Myotomia reformata: or An Anatomical Treatise on the Muscles of the Human Body*, 1694. Cowper was a well-known English surgeon and anatomist, and a Fellow of the Royal Society.

In addition to instructional images such as this one, which is the third in a series showing a human dissection at various levels – the book also includes a number of macabre and embellished copperplate initial letters featuring scenes of cavorting cadavers and skeletons.

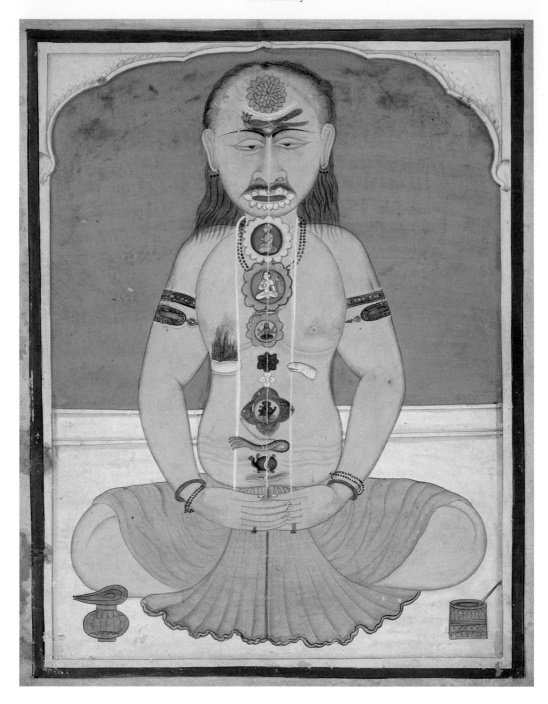

This undated painting of a meditating man offers a different approach to the anatomical body than we have seen thus far. In this tradition, prominent in certain forms of Hinduism and Tantric Buddhism, the body is understood to house energetic centres known as chakras and kundalini. Chakras are centres of spiritual power within the body. Kundalini, from the Sanskrit for 'snake', is the latent female energy believed to lie dormant at the base of the spine (the symbol for which can be seen peeking out below the right-hand breast). The figure above is shown in meditation, alluding to the fact that meditation and certain forms of yoga can be used to activate the kundalini and balance the chakras.

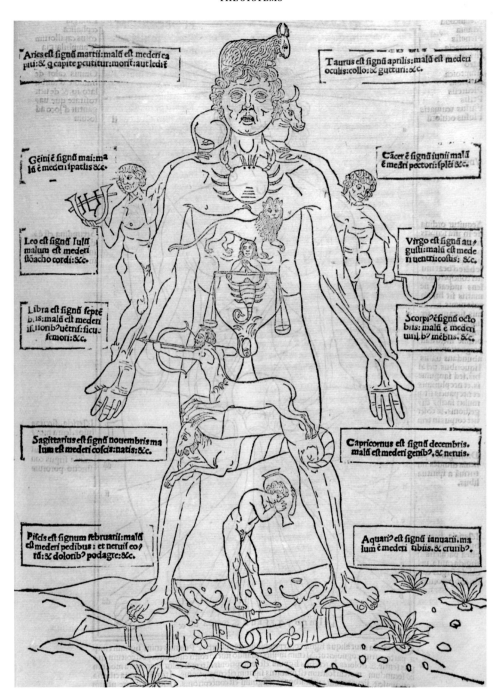

A woodcut illustration of a so-called 'Zodiac man' from Johannes de Ketham's *Fasciculus medicinae* (literally 'little bundle of medicine') originally published in 1491. This book, a collection of short pieces by a variety of authors, is famous for being one of the first illustrated medical books to take advantage of Gutenberg's new printing technology. It is also noteworthy for containing the first printed illustration of a human dissection. The book, which was reprinted many times, combines a new Renaissance humanist sensibility with a more traditional medieval world view, as evidenced by the inclusion of this figure, also commonly seen in medieval Books of Hours (Christian books for personal devotion). At that time, it was widely believed that the human body was a microcosm of the universe at large. In the same way that the weather influenced the planet, the movement of the stars was seen to influence the body. The body parts, as well as the four humours – black bile, yellow bile, blood and phlegm – were believed to be affected by correlated astrological signs. Charts like this one were used as guides to schedule medical interventions, as it was thought to be dangerous to undertake work on a body part when the moon was in the sign with which it was identified.

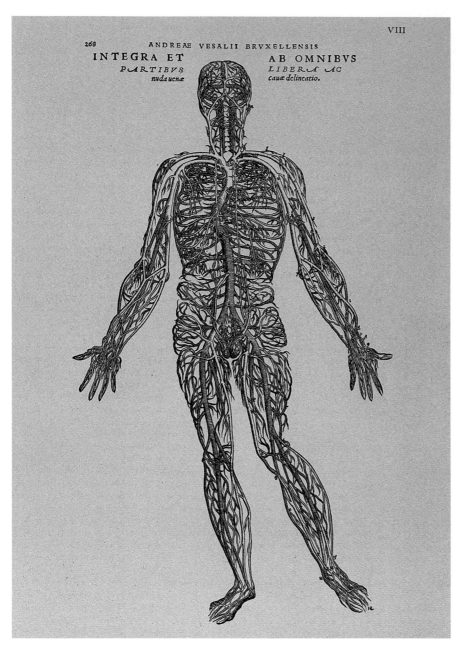

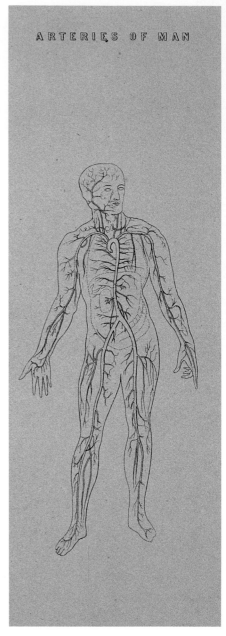

On these two pages, we see three different approaches – Eastern and Western, 16th century and 19th century – to visualizing the system of veins and arteries in the human body.

↖ A woodcut illustration from *De humani corporis fabrica libri septem*, 1543, (On the Fabric of the Human Body in Seven Books) by Andreas Vesalius.

↗ A line engraving from an English reference book of around 1850.

↘ A Persian figure from an 18th-century manuscript using Shikasta Nasta'liq script to show the arteries and viscera.

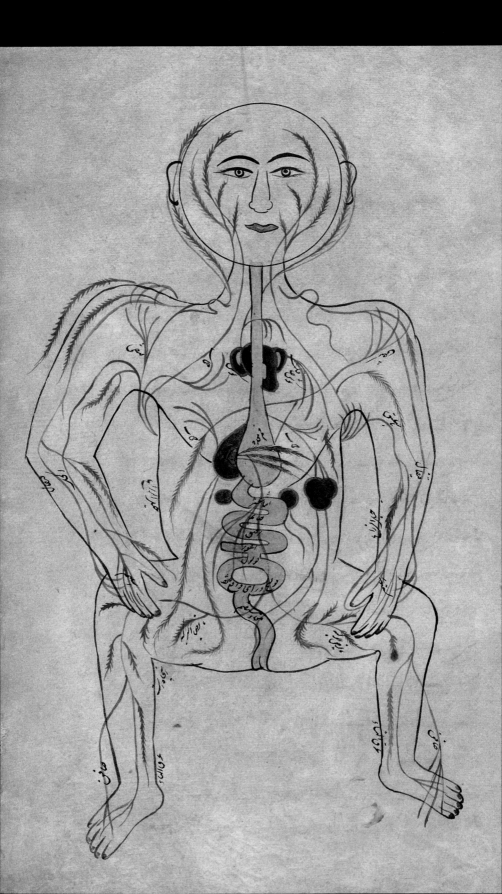

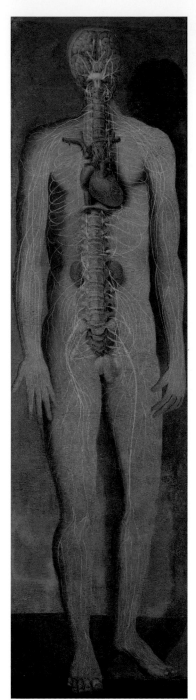

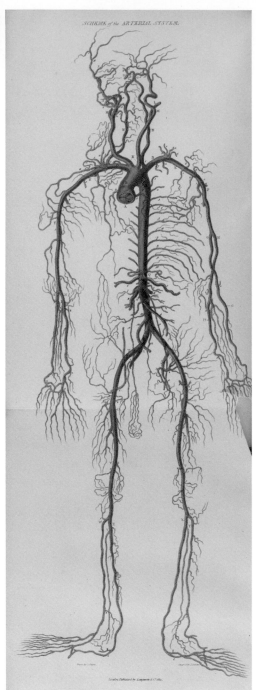

↑ This eerie, ghostlike image – a life-sized painting from 1765 by artist and amateur anatomist Jacques-Fabien Gautier d'Agoty – shows a body rendered transparent, displaying the brain, spinal column, nerves, kidneys and heart beneath the skin.

↑ A hand-coloured engraving by Thomas Medland from *Engravings of the Arteries*, 1824, by the Scottish surgeon and anatomist Sir Charles Bell. It was copied from a drawing by Bell, who had studied art before turning to medicine, and therefore drew the originals for the illustrations in his books. He was also a subscriber to the idea of natural theology, a popular philosophy of his time, which held that by studying nature – especially God's supreme creation, man – it was possible to understand the divine order of the universe.

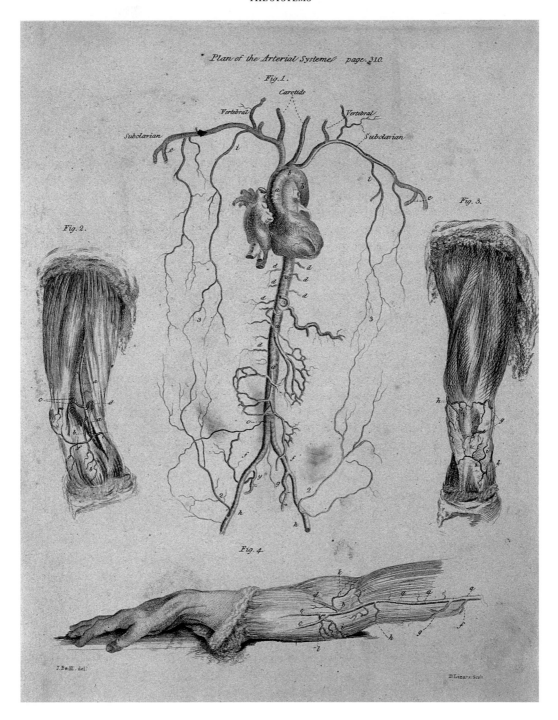

Plan of the Arterial Systeme page. 310.

This image, entitled 'Plan of the Arterial Systeme', shows the heart and arteries along with dissections of the arm and leg. It comes from *The Principles of Surgery*, 1801–8, by the surgeon and anatomist Sir John Bell (older brother of Sir Charles Bell), and the engraving, by Daniel Lizars, was based on a drawing by the author. John and Charles Bell were two of the rare anatomists who drew their own illustrations, often directly from dissected bodies. Sir John said, 'anatomy is to be learnt only by dissection: dissection is the first and last business of the student'. His images reflect his conviction; they are unromanticized, matter of fact, direct and extremely cadaverous.

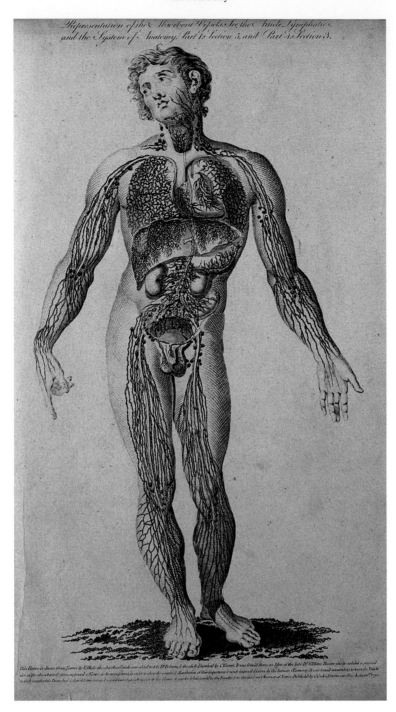

Taken from W.H. Hall's *The New Royal Encyclopaedia; or, Complete Modern Dictionary of Arts and Sciences*, 1788–95, this line engraving shows the vessels and glands in the lymphatic system of a man. Its inclusion in a book of general knowledge for a popular audience gives some indication of the wide appeal of anatomy at the time.

The text below the figure reads: '... It was form'd from an idea of the late Dr. William Hunter, who to exhibit a general view of the absorbent system, supposed a figure to be transparent, in order to show the course and distribution of this important and newly improv'd system in the human economy. It was deem'd unnecessary to trace the vessels to their numberless branches and ramifications, as it would introduce confusion in the figure and render it less useful to the faculty and to the curious observer of nature.' The 'absorbent system', now known as the lymphatic system, is an important part of the immune system.

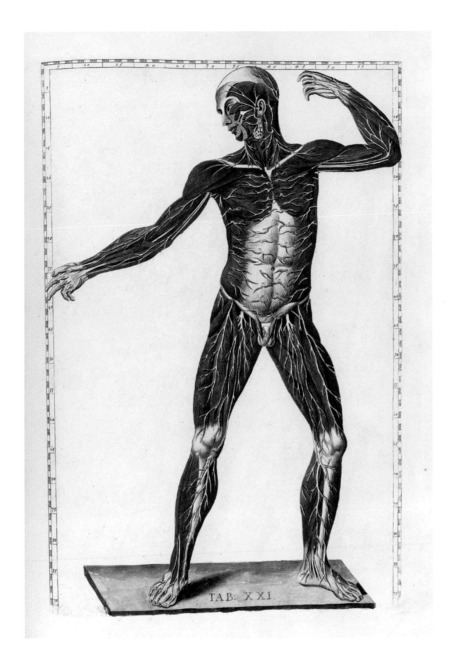

This lively *échorche*, along with
the image on page 19, comes from
*Tabulae Anatomicae Clarissimi Viri
Bartholomaei Eustachii*, 1714. These
plates were created during the Italian
physician and anatomist's lifetime
(*c*.1500?–74), but not published
until many years later. This hand-
coloured edition was published in
1783. Eustachi was a contemporary
of Vesalius, the man who changed
anatomical study forever by
discrediting Galen, a physician in 2nd
and 3rd-century Rome, whose writings
had for centuries provided the basis
of anatomical understanding. Unlike
Vesalius, Eustachi believed that
Galen was correct, and performed
many investigations to prove it.
The numbered frame around the
image works as a key for referring to
particular anatomical structures in
the text.

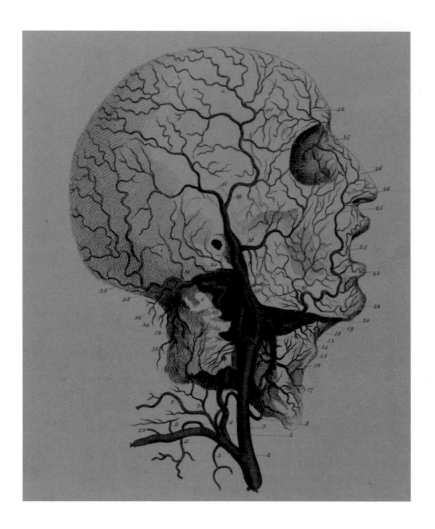

A powerful image from Sir Charles Bell's *Engravings of the Arteries*, 1824. The book, created as a text for surgical study, intended to 'present to the student at one glance the general distribution of the vessels and to fix them in his memory'. The hand-coloured engraving was rendered by Thomas Medland after the author's own drawings. Bell felt that accurate and accessible images were crucial in the study of anatomy; he started his training as an artist and only later came to medicine through his older brother, John.

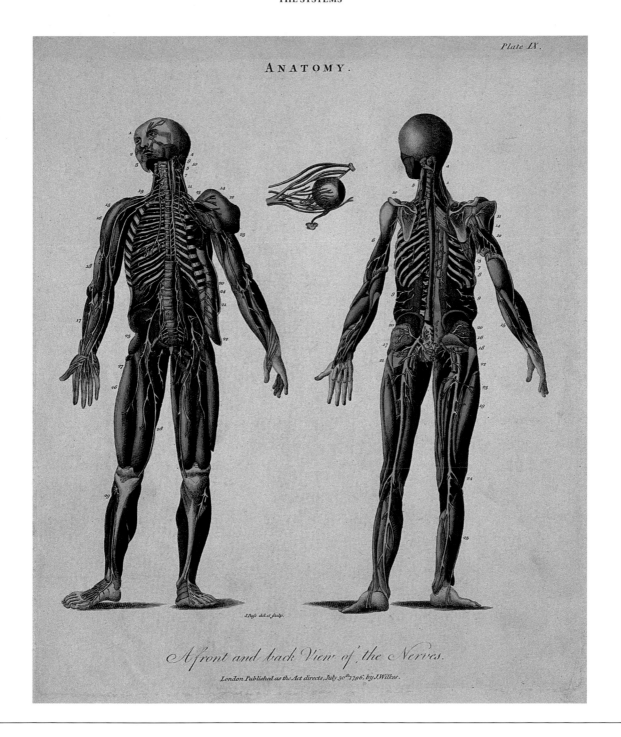

Plate IX.

ANATOMY.

A front and back View of the Nerves.

London Published as the Act directs, July 30th 1796, by J.Wilkes.

Here we see a pair of colourful *écorchés* that provide front and back views of the human nervous system, along with a detail of an eye. This coloured line engraving, by John Pass after W. Hewson, was included in the 24-volume *Encyclopaedia Londinensis, or, Universal Dictionary of Arts, Sciences, and Literature*, 1810–29.

Other topics covered in this 24-volume set included, as the subtitle goes on to detail, 'the mechanical arts, the liberal sciences, the higher mathematics, and the several branches of polite literature... selected from the acts, memoirs, and transactions, of the most eminent literary societies, in Europe, Asia, and America.'

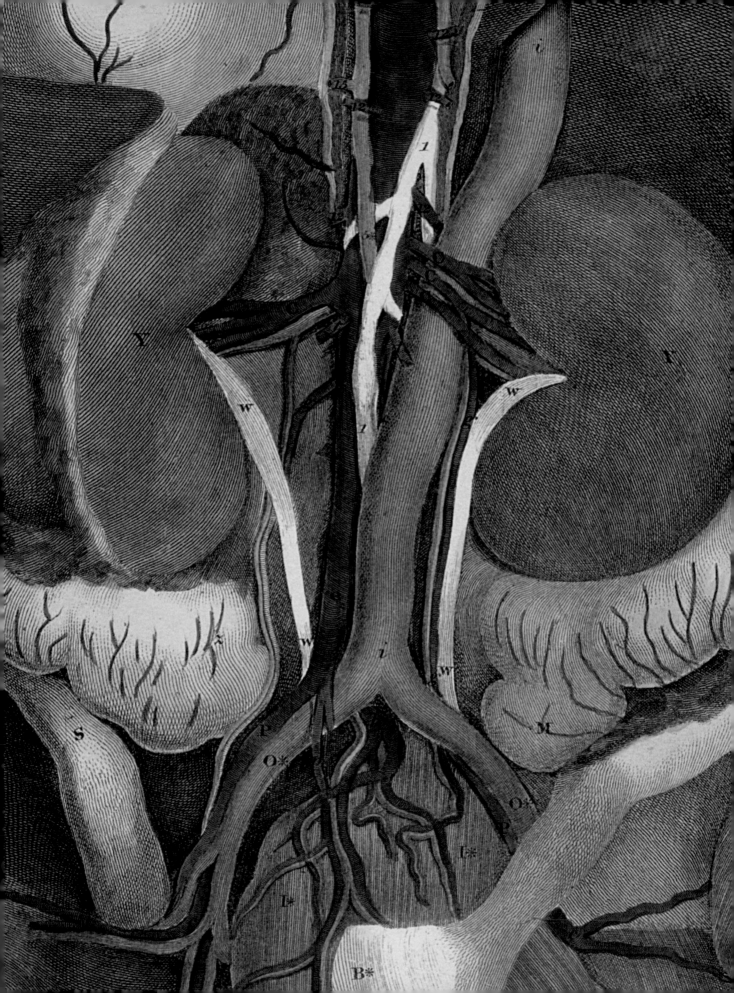

Looking Inside: The Dissected Body

Before X-rays and MRI scans, investigating the dead body was the main way to learn about the anatomy of the living one.

In the Renaissance, anatomy became a popular science, and dissection a common activity for both artists and anatomists. Most dissections at this time were conducted on the bodies of condemned criminals. This was believed not only to be a final indignity and punishment for their crimes, but also a way of transforming their wrongdoing into knowledge for the greater good. From the 15th century, dissections were also conducted for a paying public in anatomical theatres. They were often part of the festivities related to carnival celebrations, and might be accompanied by drinks and music.

By the 18th and 19th centuries, private medical schools needed more cadavers for teaching purposes than executed criminals could provide. The deficit was addressed by grave robbers, or 'resurrection men', who illegally sourced bodies from graveyards. Sometimes, as in the case of William Burke and William Hare in 1828, they even resorted to murder. The public outrage that such acts engendered led to a series of new laws legalising the dissection of unclaimed bodies and those of the poor.

Dissection was not just a medical training activity – it was also a metaphor for probing and uncovering the secrets of nature. As such, it was sometimes seen as a transgressive and hubristic act, disrupting traditional burial traditions, and going where humans were perhaps not meant to go. Nonetheless, it could not be denied that it was a means of allowing doctors to gain knowledge, and perhaps a necessary dark rite of passage into the brotherhood of medical professionals.

A Craſſa meninx, à cranio reuulſa.
B Locus cui inſidet aden colatorius.
C Quo in loco arteria carotis conſpicitur ad reti formem plexum deſerri.
D Locus in quo reperitur membrana ad aurem pertinens.
E Diuiſio nerui tertiæ coniugationis.
F Origo ſpinalis medullæ.
G Lacuna in palatum commeans, ad expurgandum cerebrum.
H Cauitas inſignis ſupra oculum, inter parietes oſſis coronalis côcluſa, ſub prominente ſupercilij tuberculo.
I Oculus oſſe detectus.

This image, from Charles Estienne's *De dissectione partium corporis humani: libri tres*, 1545, (On the Dissection of Parts of the Human Body parts: Book Three) focuses on the anatomy of the brain. Paris-born Estienne, also known by his Latin name, Carolus Stephanus, collaborated in the 1530s with surgeon, anatomist and artist Étienne de La Rivière. Unfortunately, the two men became embroiled in a legal battle over the work, which held up its publication, originally intended for 1539. Had it appeared as planned, it would have pre-dated the publication of the monumental *Fabrica* by one of his classmates, Andreas Vesalius.

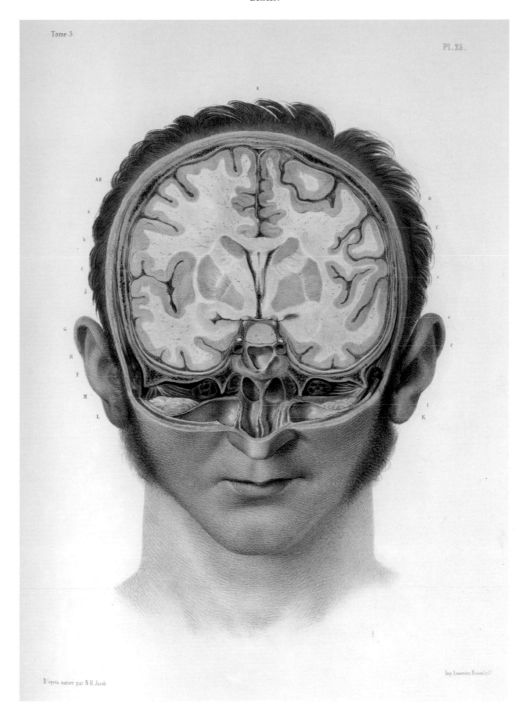

This lithograph showing a cross-section of the human brain is by Nicolas-Henri Jacob, and appeared in Jean-Baptiste Marc Bourgery's eight-volume *Traité complet de l'anatomie de l'homme comprenant la médecine opératoire … avec planches lithographiées d'après nature par N-H Jacob*, 1831–54 (A Complete Treatise to Human Anatomy including Operative Medicine … with lithographic plates drawn from nature by N-H Jacob). French physician and anatomist Bourgery began work on this book – considered one of the finest, most lavish anatomical atlases – in 1830. This monumental work, completed only after his death, boasted over 700 hand-coloured images by Jacob, a student of the eminent neo-classical painter Jacques-Louis David. Today we think of the brain as the seat of consciousness, but this was not always the case; in earlier times, consciousness was deemed to be located in the heart or liver.

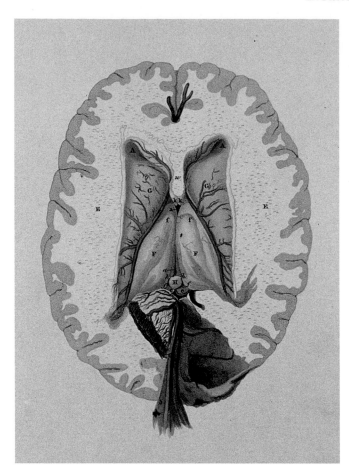

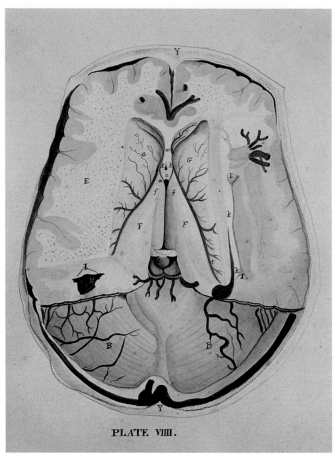

PLATE VIIII.

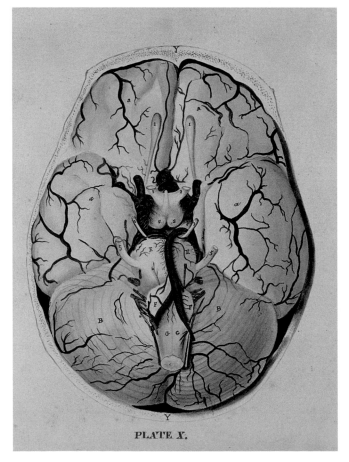

PLATE X.

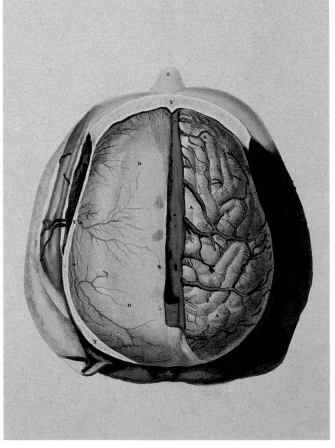

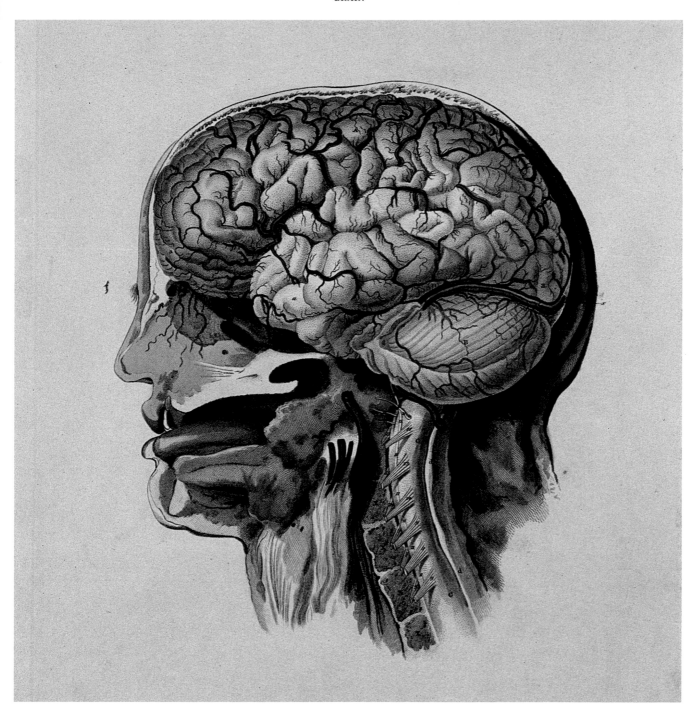

← Here is a series of watercolour-augmented line engravings of the human brain at various levels of dissection, drawn from *A System of Anatomical Plates of the Human Body, Accompanied with Descriptions and Physiological, Pathological, and Surgical Observations*, 1822–6, by the Scottish anatomist and surgeon John Lizars. The image at bottom right shows the top of the brain, with the *dura mater* (the thick membrane that surrounds the brain) covering the left hemisphere. By contrast, the right hemisphere is revealed to show the *gyri* (part of the system of the brains' folds and ridges). Until the 18th century, these folds were thought to be random, and not studied in detail. The book was not scientifically groundbreaking, but much appreciated for its beauty and elegance. The etchings were rendered by the author's brother, William Home Lizars, famous for his work on James Audubon's *The Birds of America*, 1827–38.

↑ Above is a dissection of the brain, showing a cross-section through the head and neck with a lateral view of the brain.

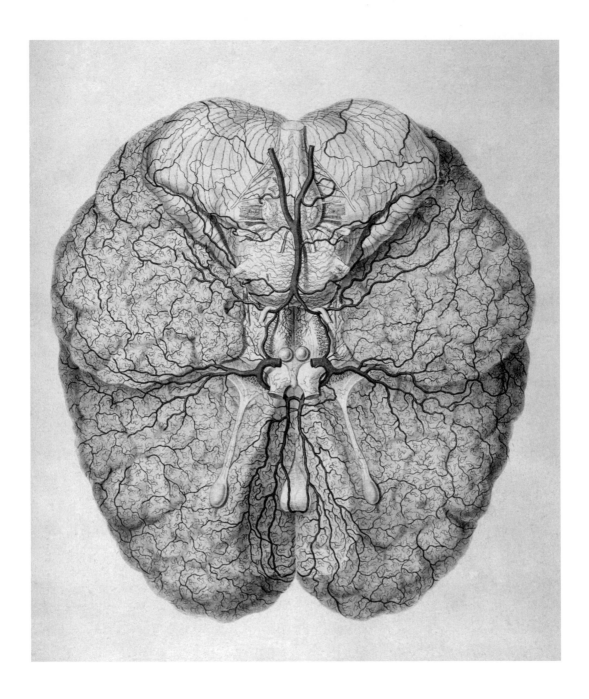

↑ A delicate coloured engraving of a dissection of the brain viewed from below, which comes from Félix Vicq d'Azyr's *Traité d'anatomie et de physiologie*, 1786 (Treatise on Anatomy and Physiology). Vicq d'Azyr was a famous French anatomist, who was also physician to Queen Marie-Antoinette. He made great strides in brain research through his pioneering use of coronal sections – vertical planes dividing front and back – as well as his use of alcohol to harden the brain for more effective dissections. The illustrations in *Traité d'anatomie* were by the well-known French engraver Alexandre Briceau, whom the author thanks for his stamina, skills and 'endurance of foul odours'. Vicq d'Azyr intended the book to be just one part of a 'grand tableau' of all the animals, culminating in man, but never achieved his aim due to the events of the French Revolution (1789–99).

→ This stipple engraving of the brain and spinal cord surrounded by views of the brain at different stages of dissection by Schmeltz, was made around 1830.

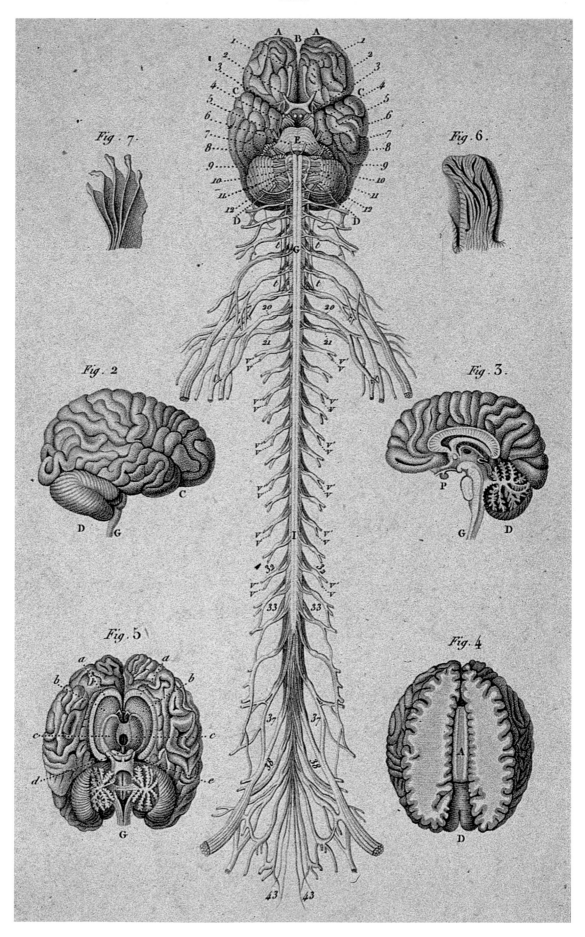

Fig. 7.

Fig. 6.

Fig. 2.

Fig. 3.

Fig. 5.

Fig. 4.

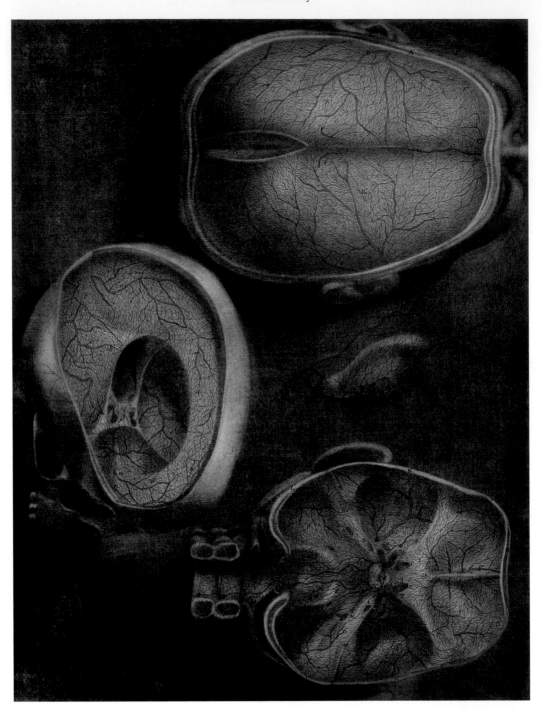

On this spread we have two atmospheric and oddly surreal mezzotints depicting dissections of the brain, both drawn after actual dissections. They are by Jacques-Fabien Gautier d'Agoty, illustrator of Joseph Guichard Duverney's *Anatomie de la tête...* (*Illustrated Anatomy of the head*, 1748). Gautier d'Agoty produced works on a variety of subjects, but was particularly interested in the natural sciences; he is best remembered today for his artistic and idiosyncratic studies of human anatomy. He also founded the first illustrated science journal in France.

↑ A dissection of the brain showing the blood vessels.

→ Two dissected heads, one with the scalp opened.

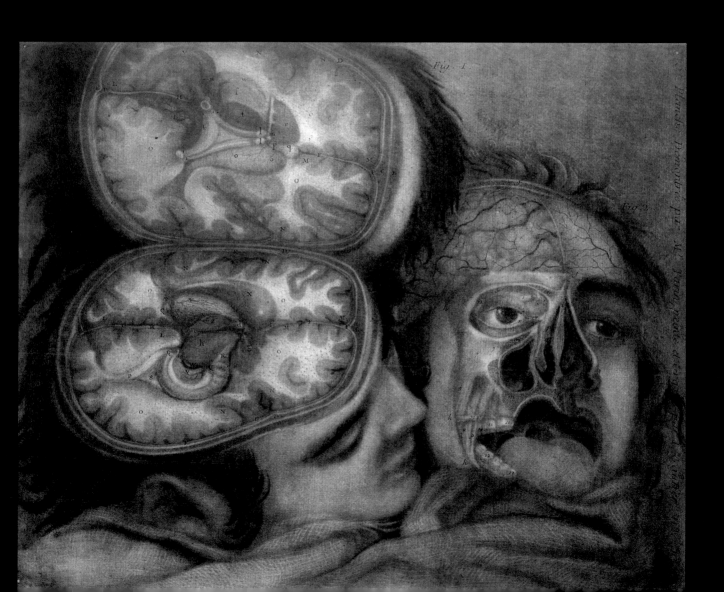

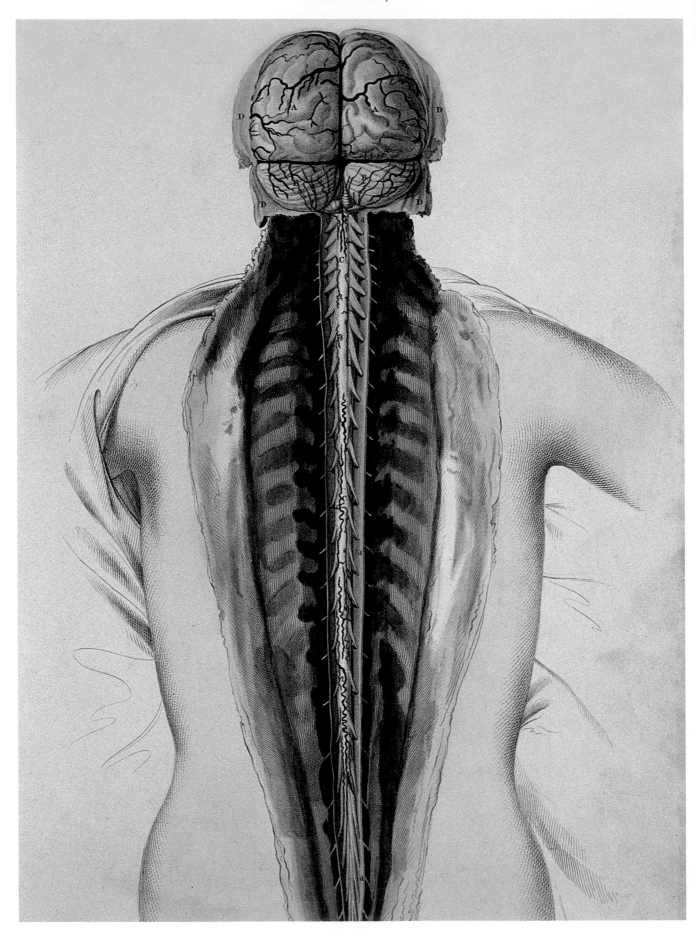

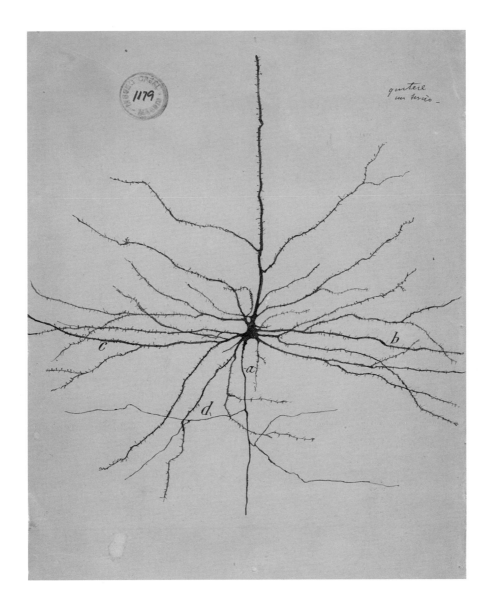

← This image is a hand-coloured line engraving created by William Home Lizars for his brother John's book, *A System of Anatomical Plates of the Human Body ...* , 1822–6. This illustration was created by engraving on copper, then using acid to remove the background, leaving the positive image in relief. It pictures a dissection where the flesh is pulled back to reveal the brain and spinal cord.

↑ This lovely pencil and ink drawing is of the pyramidal neuron of the cerebral cortex (the thin layer of the brain covering the outer part of the cerebrum). It was rendered in 1904 by famed Spanish histologist and 'father of modern neuroscience' Santiago Ramón y Cajal. Though once determined to be an artist, Cajal was persuaded by his anatomist father to enrol in medical school. He created

this – along with hundreds of similarly delicate, complex images – from his own close observations under the microscope to illustrate his scientific articles. He was awarded the Nobel Prize in Physiology or Medicine in 1906, along with the Italian physician and pathologist Camillo Golgi, famous for discovering the eponymous Golgi apparatus of the cell.

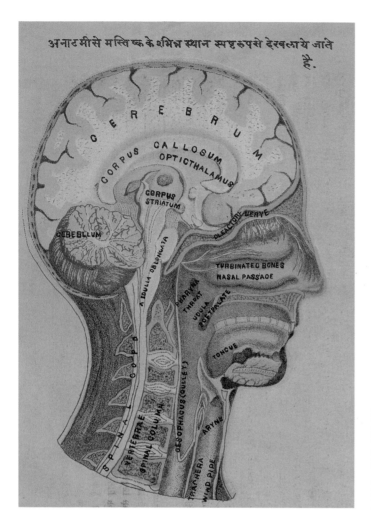

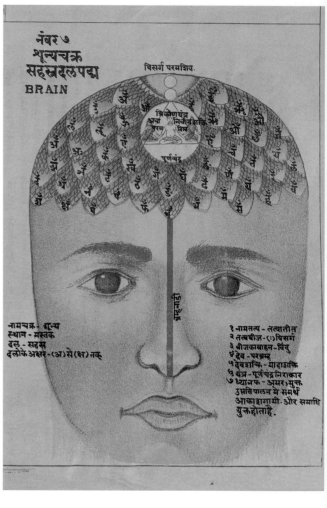

Above are two of eight coloured plates illustrating the chakra system, from Svami Hamsasvarupa's *Svāmiham̐ sasvarūpakr̥tam Ṣaṭcakranirūpaṇ acitram : bhāṣyasamalaṃkr̥taṃ bhāṣāṭīkopetañ ca = Shatchakra niroopana chittra with bhashya and bhasha containing the pictures of the different nerves and plexuses of the human body with their full description showing the easiest method how to practise pranayam by the mental suspension of breath through meditation only.* Published in the early 20th century, it is notable for illustrations synthesising the yogic and traditional Western anatomical views of the brain and body.

↖ One of the chakras – the fifth chakra – is located in the throat, and is believed to be related to expression and communication.

↗ The *sahasrara*, or crown chakra, is located at the top of the head. This chakra symbolizes the highest spiritual level, and is represented by a thousand-petalled lotus, as suggested by this illustration.

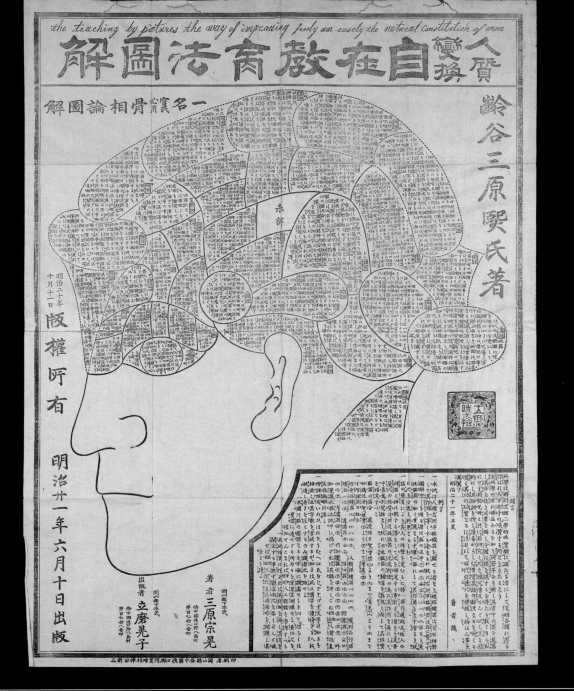

This 1888 woodcut by Muneaki Mihara comes from a work entitled *Jizai Kyōikuhō Zukai*, which is loosely translated at the top of the image: 'The teaching by pictures the way of impraving freely an easely the natural constitution of man' [sic]. The illustration depicts a brain divided into 35 labelled cells, each representing human faculties, and these in turn are divided into four groups: deliberation, comprehension, opinion and taste. This system was probably inspired by phrenology, a pseudo-science developed by Franz Joseph Gall in the 19th century, which correlated certain areas of the brain with particular character traits. Phrenologists believed that the bumps and depressions on a person's head could be read as a map of their character; more developed areas of the brain would be large, while less developed areas would be smaller, and both (it was thought) led to changes in the shape of the skull.

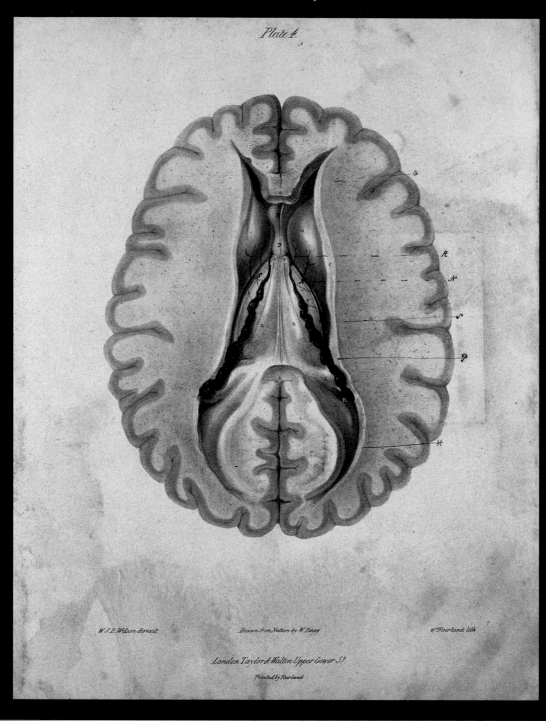

Plate 4.

W.J.E.Wilson direxit. Drawn from Nature by W.Bagg W.Fairland lith.

London Taylor & Walton Upper Gower S.t.

Printed by Fairland.

These coloured lithographs are from *The Nerves of the Human Body*, 1839, a work by the Irish anatomist Jones Quain and the English surgeon Sir Erasmus Wilson. Both were rendered by the British artist and engraver William Fairland, who studied with the Anglo-Swiss artist Henry Fuseli, famous for his iconic and influential painting *The Nightmare*, 1781. The originals, as the text explains, were 'drawn from nature by W. Bagg'.

↑ The lateral ventricles of the human brain.

➔ Two figures of the brain and spinal cord, with a cutaway diagram below them.

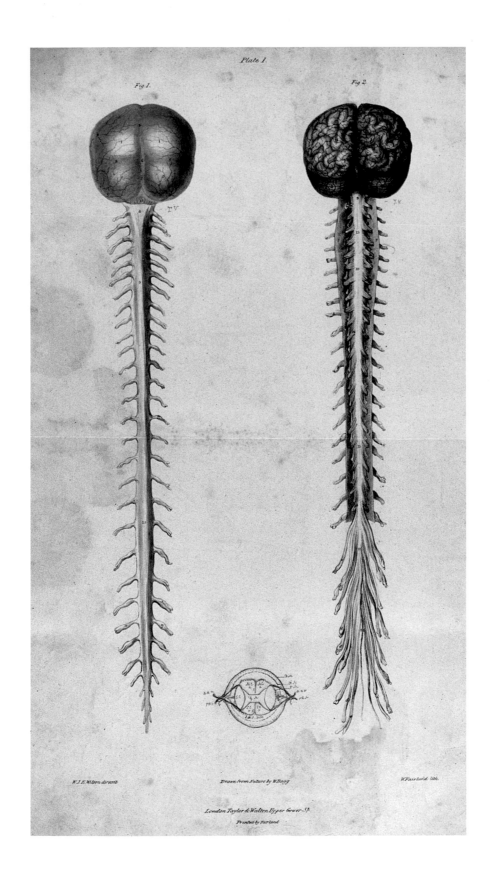

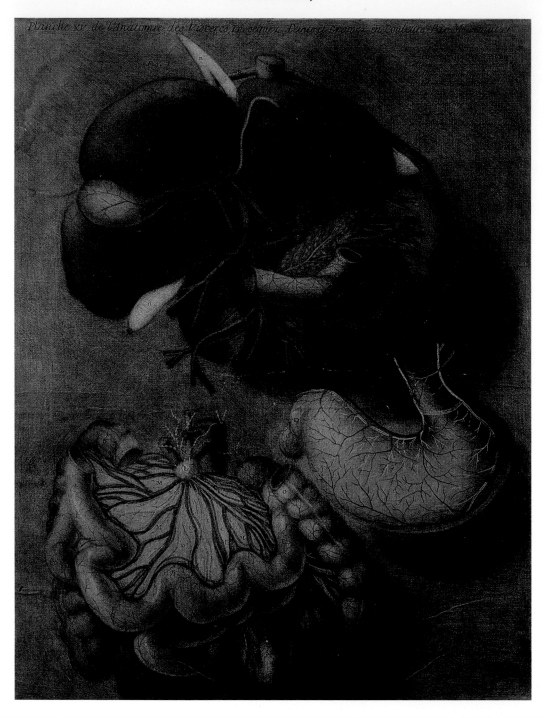

Planche XV de l'Anatomie des Viscères Disséquez, Peints et Gravez en Couleurs Par Mr. Gautier

↑ A colour mezzotint of the digestive system, with dissections of the mesentery (a fold of membrane attaching the intestine to the abdominal wall), intestines and related arteries and blood vessels, as seen in Jacques-Fabien Gautier d'Agoty's *Anatomie générale des viscères et de la neurologie, angéologie et ostéologie du corps humain*, 1752 (General Anatomy of the Vital Organs and the Neurology, Angiology and Osteology of the Human Body). Most of the images in this book were rendered by the author and illustrator from his own dissections.

→ This haunting mezzotint portrays a man whose upper body has been partially dissected to reveal his internal organs. The ghostly arm to the right showcases the superficial veins and brachial artery. The image is drawn from French artist and anatomist Jacques Gautier d'Agoty's *Anatomie des parties de la génération de l'homme et de la femme* ..., 1773 (Anatomy of the Organs of Reproduction of Men and Women).

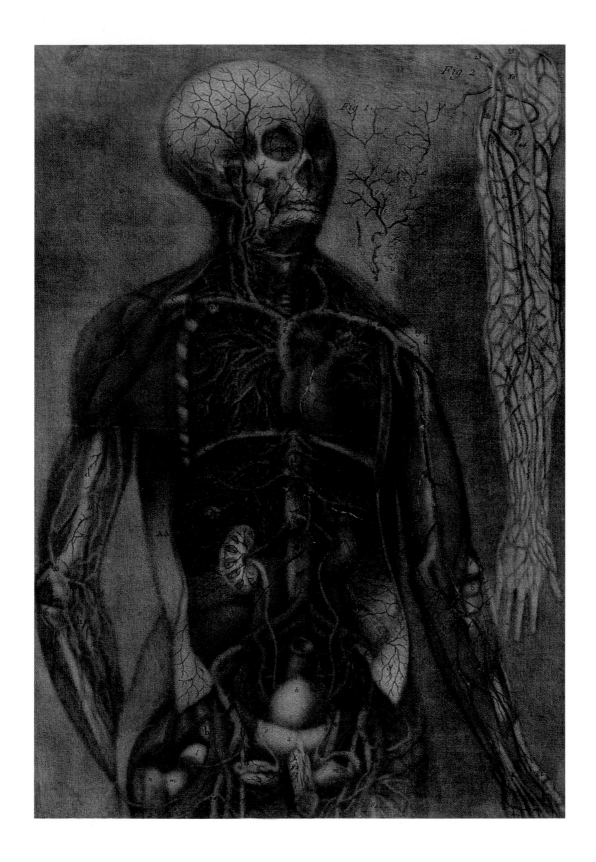

↑ An anatomical woodcut showing the intestines and abdomen of a woman, this illustration comes from *De dissectione partium corporis ...* , 1545, by French surgeon Charles Estienne (also known as Carolus Stephanus). The square surrounding the dissected elements makes it clear that, perhaps to save time and money, Estienne utilized illustrations from other sources. He originally intended to publish the book in 1539, but it was delayed due to a lawsuit in which Étienne de La Rivière accused him of using his artwork without credit.

↑ A highly stylized and valorized view of the intestines framed by Roman armour from Valverde de Hamusco's *Historia de la composicion del cuerpo humano*, 1556 (Account of the Composition of the Human Body).

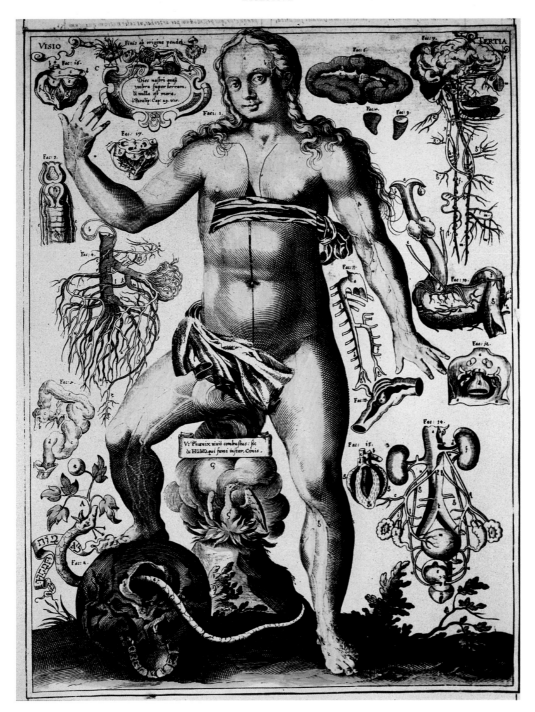

Here we have an engraving that depicts the divinely created Eve, the first woman from the Book of Genesis in the Hebrew Bible, with her foot resting on a human skull. Through the skull winds a serpent bearing a twig from the tree of knowledge. This image, which blurs the symbolic with the material, theological with anatomical, is from German physician Johann Remmelin's *Catoptrum*

Microcosmicum... , 1613 (A Mirror of the Microcosm). This early anatomical flap book – so called because flaps of paper can be moved so that the reader is able to virtually dissect the bodies – is an evocative combination of anatomical imagery with alchemical symbols and enigmatic inscriptions, as well as strong Protestant moralistic messages. The figures of Adam and Eve were commonly utilized in early

anatomical illustrations because they were fashioned by God in his own image and therefore represented bodily perfection, before the introduction of sickness and death resulting from The Fall. Flap books were generally aimed at a popular audience, and part of their appeal might have been the sort of striptease element they offered, especially when it came to the sexual organs.

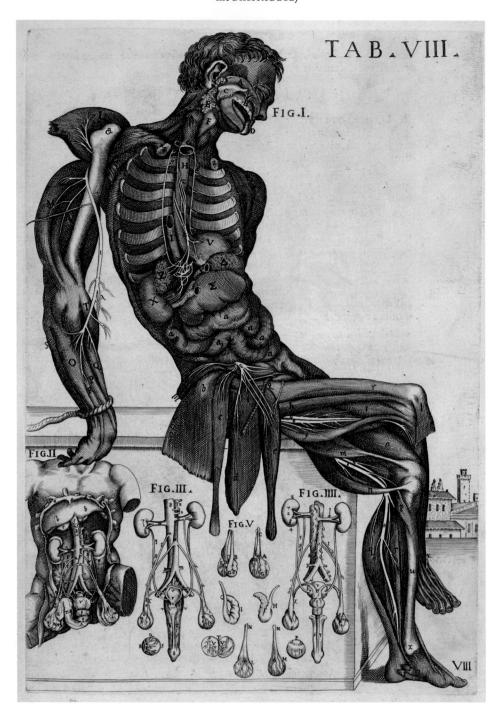

This image of a partially dissected man seated on a structure decorated with dissected anatomies is from *Tabulae anatomicae*, 1741 (Anatomical Illustrations) by the Italian high baroque artist and architect Pietro Berrettini da Cortona. It was published over 70 years after the artist's death. A contemporary of the renowned sculptor Lorenzo Bernini, Cortona was a very famous artist in his own right, producing frescos for the Pitti Palace in Florence, as well as other prestigious locations. The element marked Figure II seems to have been influenced by illustrations in Vesalius's *De humani corporis fabrica ...*, and shows the male urogenital system *in situ*.

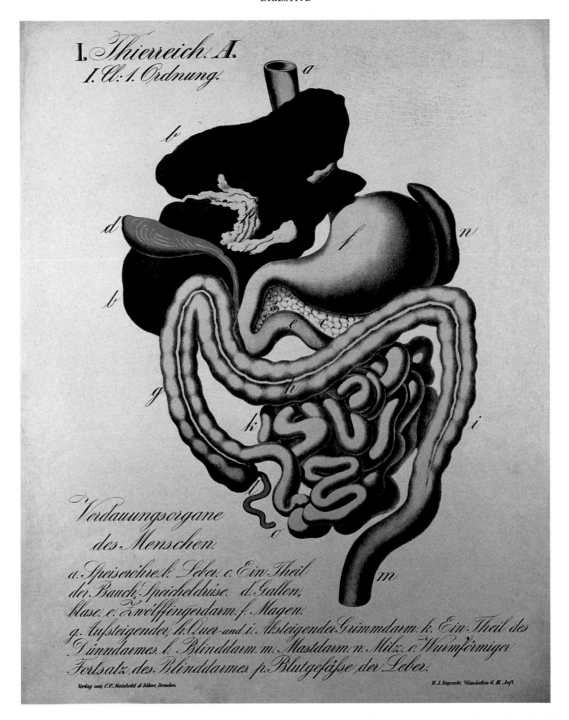

I. *Thierreich.* A.
I. Cl. 1. Ordnung.

Verdauungsorgane
des Menschen.

a. Speiseröhre. b. Leber. c. Ein Theil
der Bauch-Speicheldrüse. d. Gallen-
blase. e. Zwölffingerdarm. f. Magen.
g. Aufsteigender, h. Quer- und i. Absteigender Grimmdarm. k. Ein Theil des
Dünndarmes. l. Blinddarm. m. Mastdarm. n. Milz. o. Wurmförmiger
Fortsatz des Blinddarmes. p. Blutgefäße der Leber.

Verlag von C.C. Meinhold & Söhne, Dresden.

H. J. Ruprecht, Wandatlas 6. III. Aufl.

This colour lithograph of the gastrointestinal system is drawn from H.J. Ruprecht's *Wandatlas für den Unterricht in der Naturgeschichte alle drei Reiche, c.*1872 (Wall Board to Wall Atlas for Teaching Natural History in All Three Realms). The gastrointestinal system is the major part of the digestive system, and includes the oesophagus, liver, stomach, duodenum, colon and pancreas. The relation between the duodenum (first part of the small intestine [e]) and the pancreas (a gland that secretes digestive hormones into the duodenum [c]) has been described by anatomists as 'romantic' or 'sensual', as they seem to be embracing.

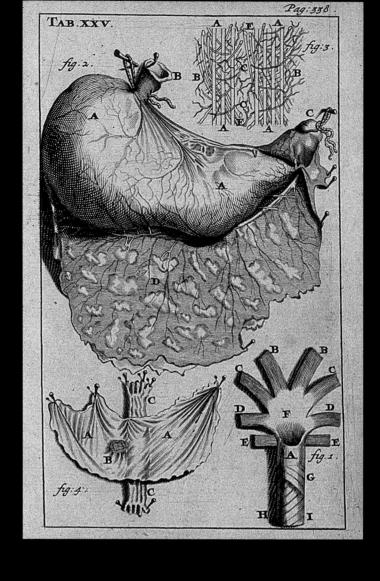

This engraving of the stomach (fig. 2), peritoneum (fig 3 and, falsely 4) and oesophagus (fig. 1) is from Dutch physician Steven Blankaart's *De nieuw hervormde anatomie ofte ontleding des menschen lichaams*, 1686 (The Newly Reformed Anatomy or Dissection of the Human Body). The book utilized – without credit – a variety of previously published illustrations, a practice not unusual at the time. This image was copied from a copperplate engraving by Gérard de Lairesse for Govard Bidloo's *Anatomia humani corporis*, 1685 (Anatomy of the Human Body). Blankaart was not only a physician, but also an iatrochemist – one who approached medicine, the body and illness in terms of chemistry. This branch of study, which was popular in the Netherlands during the 16th and 17th centuries, had its roots in alchemy, the precursor to chemistry. Among other things, alchemists sought to discover the elixir of life, a panacea that would cure all disease and provide eternal life and/or youth.

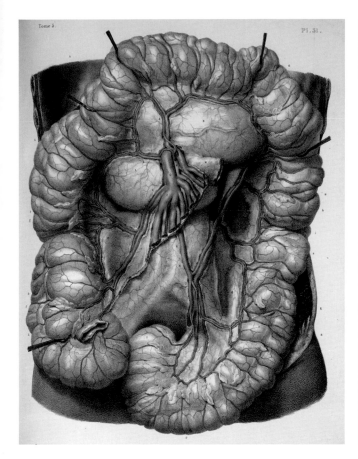

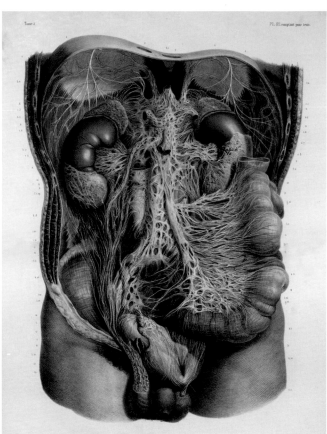

These two beautifully detailed chromolithographs, made from drawings by Nicolas-Henri Jacob, are from Jean-Baptiste Marc Bourgery's *Traité complet de l'anatomie de l'homme comprenant la médicine opératoir ...* , 1831–54, *(Complete Treatise of Human Anatomy)* Published in eight volumes, this magnificent work is considered the apogee of colour lithography in anatomical illustration. Both images depict the dissected abdomen of a man. The image on the left features the colon, which lines the perimeter. The white, textured structures on the red and blue blood vessels are the nerves and lymphatics. The illustration on the right shows a deeper dissection of the same torso; the dome-like structure at the top is the diaphragm – the muscle that serves as dividing point between thorax and abdomen – beneath which you can see the kidneys with the adrenal glands.

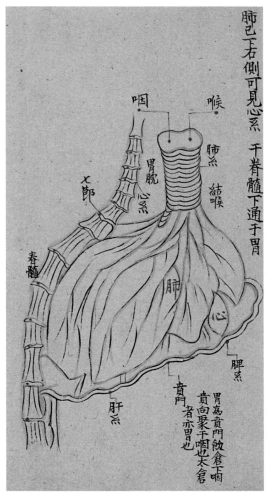

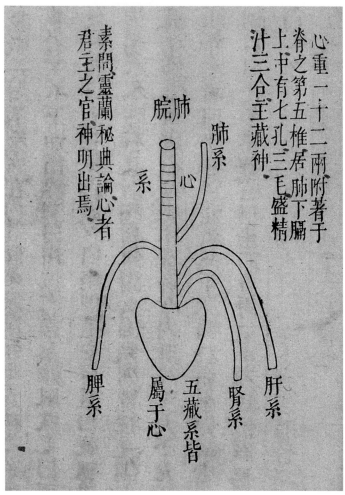

↖ This Chinese ink drawing of the lungs and heart nexus from a Qing period manuscript (1644–1911) illustrates an idea presented in *Huangdi neijing*, *c*.300 BCE (Inner Classic of the Yellow Emperor), that the heart had two nexuses – one that ascends to connect with the lungs, and another that descends to the kidneys. This idea from Chinese traditional medicine reflects the Taoist world view that the keys to health and longevity are in following Tao, or the natural way of the universe. This seeks to balance yin (the principle seen as feminine, passive and receptive, associated with earth, dark and cold) and yang (the principle seen as masculine and creative and associated with heaven, heat, and light). It also takes into account the influences of the five elements – earth, fire, water, wood and metal – on the organs.

↑ This Chinese woodcut illustrating the form and position of the heart comes from Wang Siyi's Ming era (1368–1644) *Sancai Tuhui – Shenti* (Illustrations of the Three Powers – Body). The heart (*xin* in Chinese) was called 'commander of blood', and was thought to house the *shen* – consciousness, mental functioning, memory and thinking. The heart, like all the other organs, was also related to an emotion: in this case, joy.

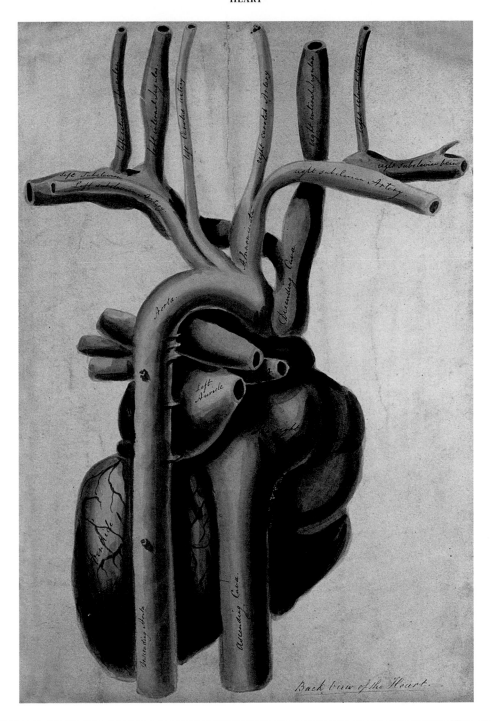

Back view of the Heart.

This watercolour showing the posterior view of a dissected heart was created by an unknown artist, probably sometime in the 19th century. Clearly labelled, it emphasizes the descending aorta and the inferior vena cava as they leave the heart and move down towards the abdomen. At the top, we see the three branches of the aortic arch, which take blood to the upper limbs, head and neck. The painting shows a sophisticated understanding of the heart that could not have been gleaned simply by observing a cadaver; it was possibly created by an artist as a study for an anatomical textbook.

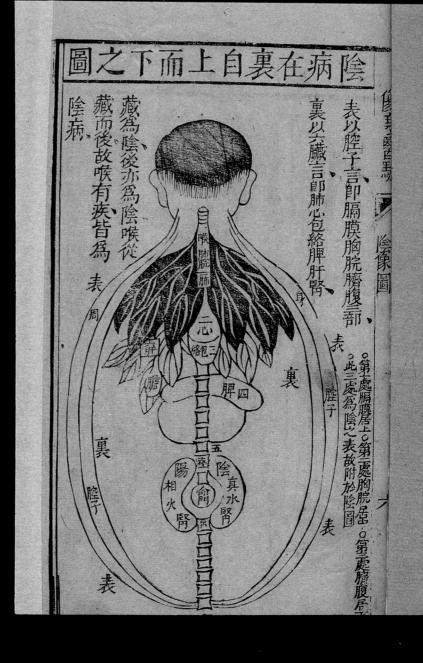

A Chinese woodblock print from 1738, showing the downward transmission process of yin (negative force) diseases in the body's interior from above to below. The lettering points out the body's features as understood in Chinese traditional medicine. In this system, yin diseases are related to *zang* viscera, namely, the heart, liver, spleen, lungs and kidneys. The heart is understood to be governor of these organs, although they are all interdependent and work together to maintain vital activities within the body.

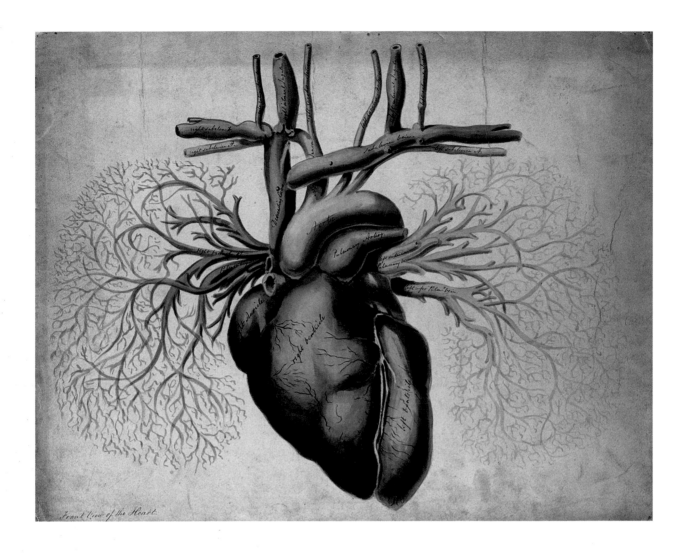

Created by an unknown artist, most likely during the 19th century, this watercolour shows a frontal view of the heart, along with the arteries and blood vessels. The artist – probably the same one who created the illustration on the previous spread – has labelled the individual arteries and areas of the heart in ink. Today we think of the heart as the symbolic centre of love and the emotions, but in many parts of the ancient world – such as Egypt, Greece and Rome – it was understood to be the centre of consciousness, the will and morality. It was not until the 17th century that the brain was identified as the centre of consciousness.

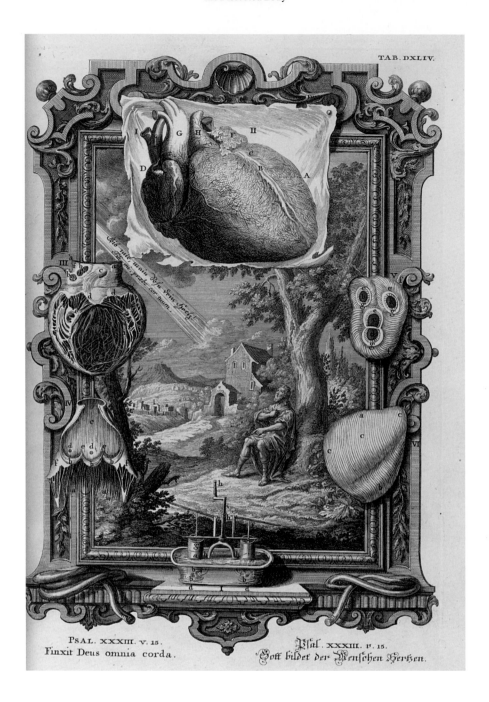

TAB. DXLIV.

PSAL. XXXIII. v. 15.
Finxit Deus omnia corda.

Psal. XXXIII. v. 15.
Gott bildet der Menschen Hertzen.

This image, depicting the heart as a pumping machine, is one of the hundreds of fine copperplate engravings created by Johann Melchior Füssli for Johannes Jacob Scheuchzer's *Physica sacra* ..., 1731–5. The image responds to – and quotes – Psalm 33:15, which reads: 'He fashioneth their hearts alike; he considereth all their works.' The Latin text translates as: 'God forms every heart.' *Physica sacra* used the Bible as a frame for an exploration of the world, nature and mankind. The elaborate baroque frame around the image is decorated with anatomically accurate human hearts – whole and dissected – while a more figurative, biblical view of the heart, as suggested by the Bible passage and text, is presented within.

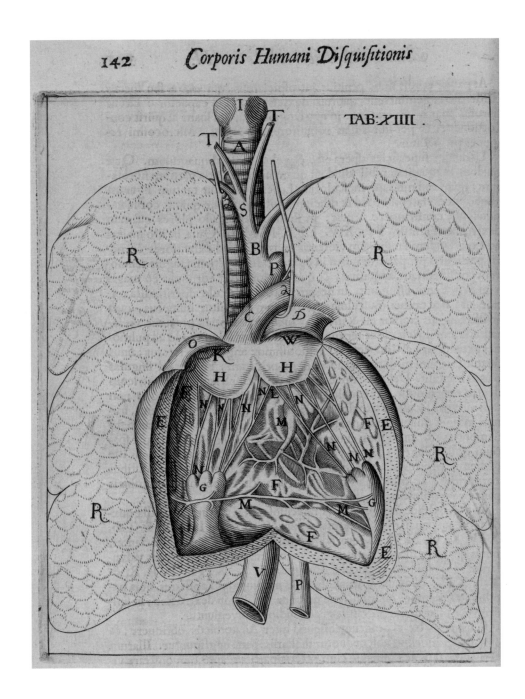

142 *Corporis Humani Disquisitionis*

TAB: XIIII.

An engraving of the human heart as seen in British surgeon Nathaniel Highmore's *Corporis humani disquisitio anatomica*, 1651 (A Disquisition on the Anatomy of the Human Body). This book was dedicated to English physician William Harvey, who, 23 years earlier, had published his theory of the circulation of the blood in his ground-breaking book *Exercitatio anatomica de motu cordis et sanguinis in animalibus* (An Anatomical Study of the Motion of the Heart and of the Blood in Animals). Highmore agreed with Harvey that the heart's relationship to the body echoed the relationship of the sun to the natural world, linking the microcosm of the human body to the macrocosm of the universe. This was a core principle of natural philosophy, the way in which people sought to understand the universe before the development of science as we now know it. Highmore's book was the first anatomical work to support Harvey's theory positing that the blood flows through the heart in a circle (hence the name 'circulation'), with the heart acting as an 'engine'.

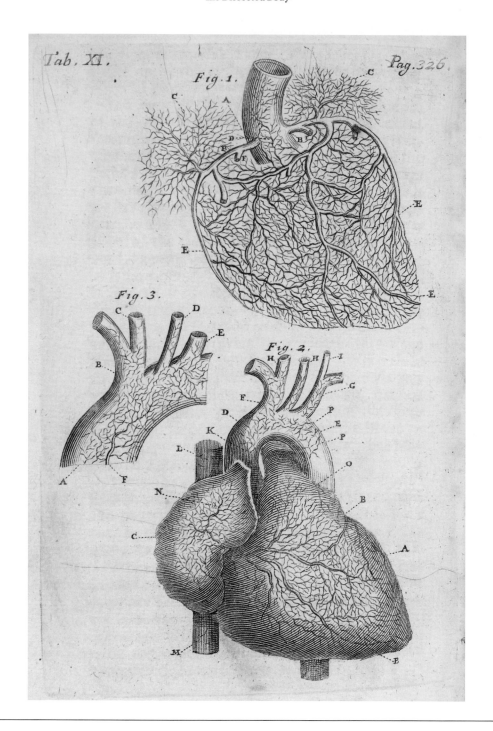

Tab. XI.

Fig. 1.

Pag. 326.

Fig. 3.

Fig. 2.

↑ Taken from Thomas Gibson's *The Anatomy of Humane Bodies Epitomized*, 1703, this image presents various diagrams of the heart. Fig. 1 shows the ascending aorta with the two coronary arteries branching off above the aortic valve; Fig. 2 also focuses on the coronary arteries and their branching, with more attention paid to the vasa vasorum – the small network of blood vessels that supply large blood vessels such as the aorta.

→ A coloured etching showing a front and back view of the heart attributed to Sir Charles Bell. Fig. 1 is an anterior (front) view of the heart, with an enlarged and exaggerated venous system. Fig. 2 shows a posterior (back) view of the heart, with the pulmonary veins branching into the lungs.

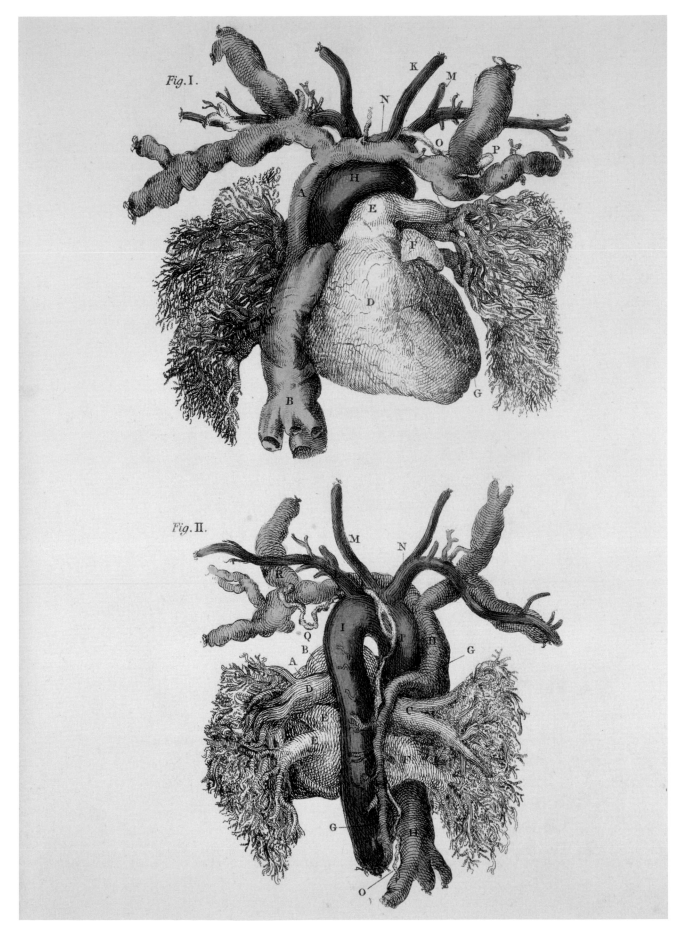

*Fig.*I.

*Fig.*II.

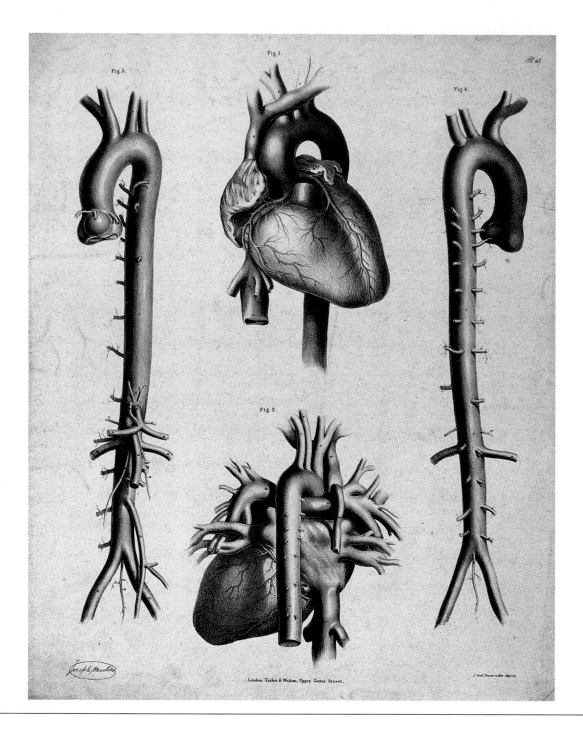

The coloured lithographs we see here are by Joseph Maclise and are found in Richard Quain's *The Anatomy of the Arteries of the Human Body and its Applications to Pathology and Operative Surgery with a Series of Lithographic Drawings*, 1844.

↑ The image here shows, in figs 1 and 2, the anterior and posterior views of the heart respectively, with the posterior view illustrating the relationship of the great vessels in beautiful detail, while figs 3 and 4 show the aorta and aortic valve.

→ Opposite we see 13 variations in the branching of the arteries from the aortic arch of the heart.

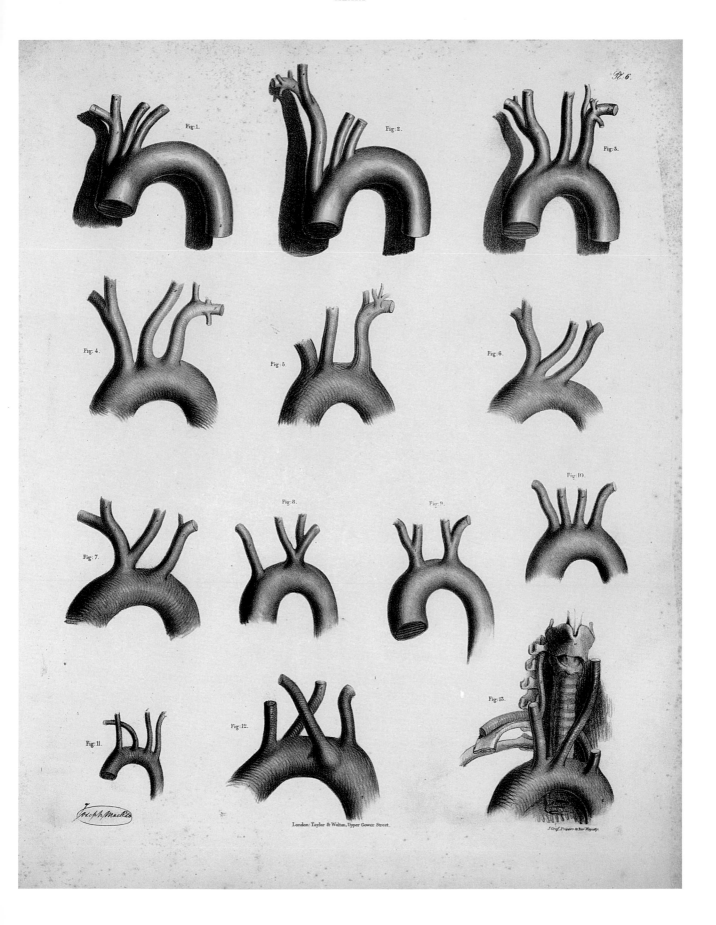

Fig:1.

Fig:2.

Pl:6.

Fig:3.

Fig:4.

Fig:5.

Fig:6.

Fig:10.

Fig:8.

Fig:9.

Fig:7.

Fig:13.

Fig:11.

Fig:12.

Joseph Maclise

London: Taylor & Walton, Upper Gower Street.

J. Graf, Printer to Her Majesty.

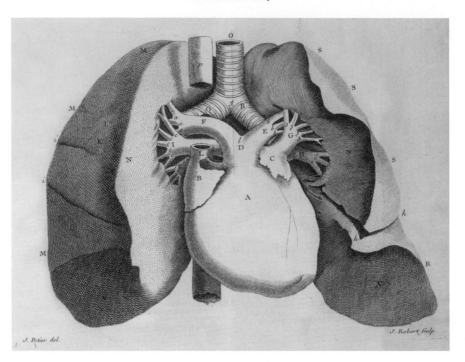

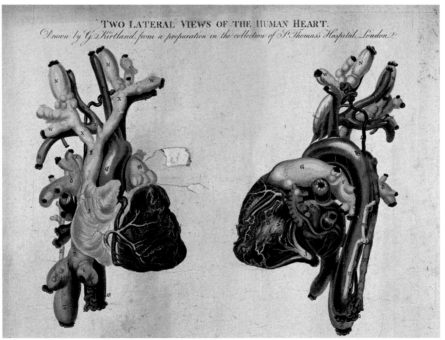

↑ An image of the heart with lungs and arteries from French physician Jean-Baptiste de Sénac's *Traité de la structure du coeur, de son action, et de ses maladies,* 1749 (*Treatise on the Structure of the Heart, its Action, and its Diseases*). This book was based largely on autopsies conducted by the author himself. Later in life – probably due to the success of this book – Sénac became personal physician to King Louis XV.

↓ Drawn by George Kirtland and published in 1806, this coloured engraving shows two lateral views of the heart from a preparation (the scientific name for a preserved body part) found in the collection of St Thomas' Hospital, London.

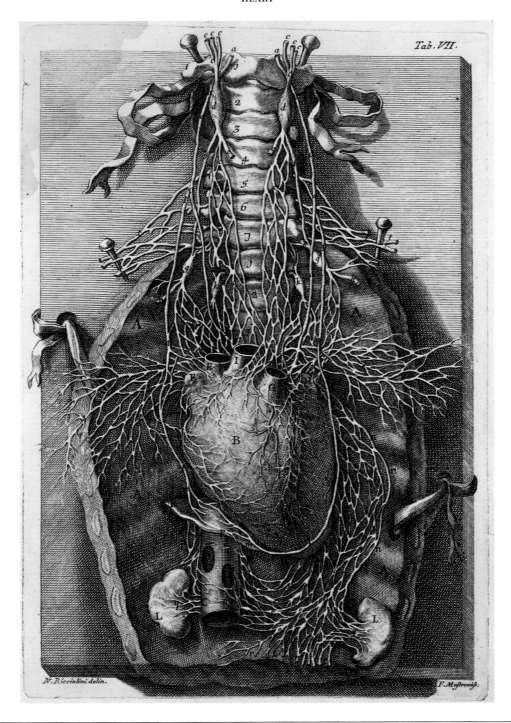

Tab. VII.

N. Ricciolini delin.

F. Mustroiss.

This evocative engraving of the heart with its related nerves is from *De motu cordis et aneurysmatibus* (On the Motion of the Heart and on Aneurysms, 1728) by Italian clinician and anatomist Giovanni Maria Lancisi. This book is noteworthy not just for the elegance and stateliness of its illustrations – note the ribbons that attach the specimen to its block – but also for containing the first clinical description of syphilis of the heart. Lancisi was an important figure in his time, serving as personal physician to Popes Innocent XII and Clement XI.

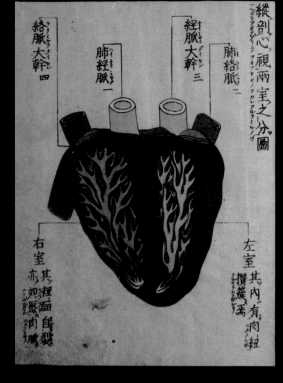
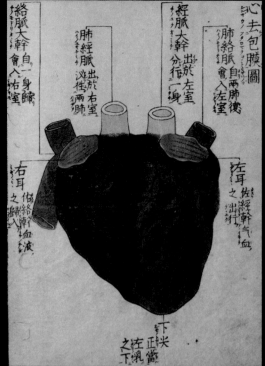

↑ Two colour woodcuts from *Kaitai hatsumo*, 1813 (Explanation of Human Anatomy) by Koki Mitani. This book documents three dissections conducted in Kyoto, Japan, in the late 18th and early 19th centuries, and analyses them in the context of both Western and traditional Chinese medicine. For many centuries, Japan

followed the dictates of traditional Chinese medicine. By the end of the 18th century, however, the government was actively promoting the adoption of Western medicine. Mitani's was the first comprehensive Japanese anatomy book based on dissection and observation; it was also the first to include extensive colour illustrations.

→ A coloured lithograph showing the opened chest of a man, with arteries indicated in red. Drawn by Jakob Wilhelm Roux, it comes from *Tabulae arteriarum corporis humani*, 1822 (Illustrations of the Arteries in the Human Body) by the German doctor Friedrich Tiedemann.

Tab.I.

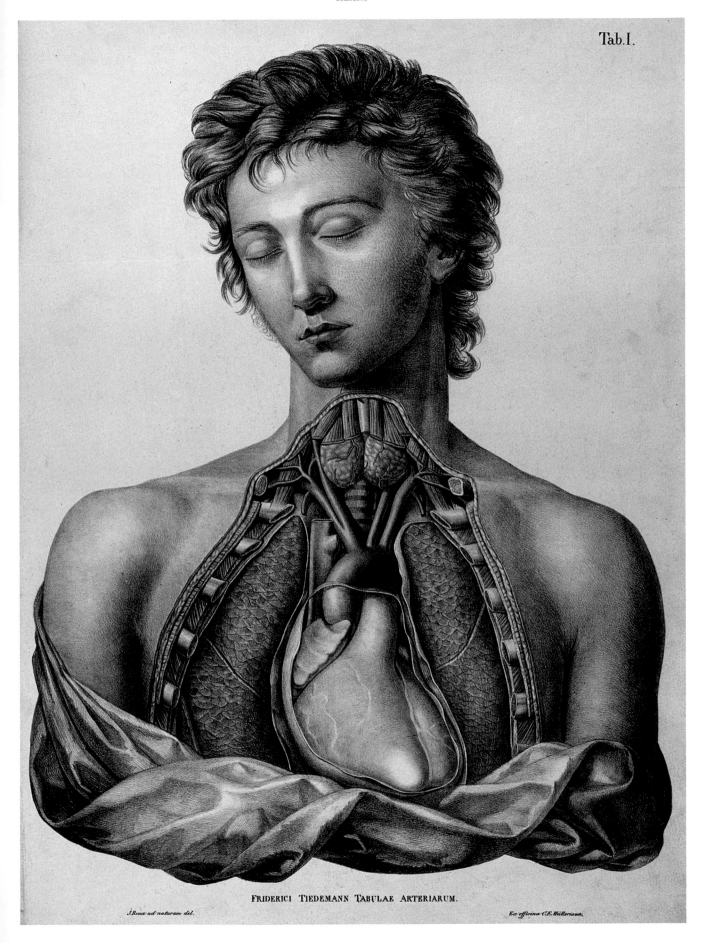

FRIDERICI TIEDEMANN TABULAE ARTERIARUM.

J.Reux ad naturam del.

Ex officina C.F.Mülleriana.

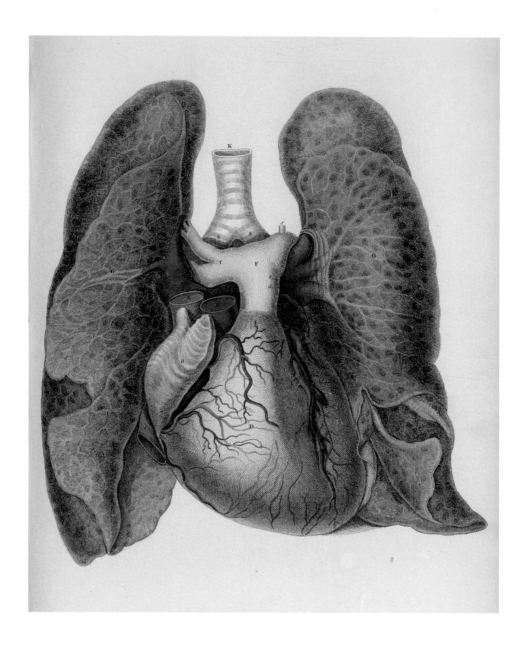

↑ A colour copperplate engraving by William Home Lizars for his brother John Lizars' book *A System of Anatomical Plates of the Human Body*, 1822–6. It shows the heart and lungs in isolation, plus the trachea and blood vessels, the aorta, superior and inferior vena cava, pulmonary veins, and coronary arteries and veins.

→ An image from the same book, showing a dissection of the thorax, abdomen and pelvis. Like all the other illustrations, this one was a copperplate engraving coloured by hand with watercolours. John Lizars studied with the anatomist John Bell, and went on to teach anatomy himself; one of his most famous students was Charles Darwin. His book was originally published in multiple parts by his father's publishing and engraving firm.

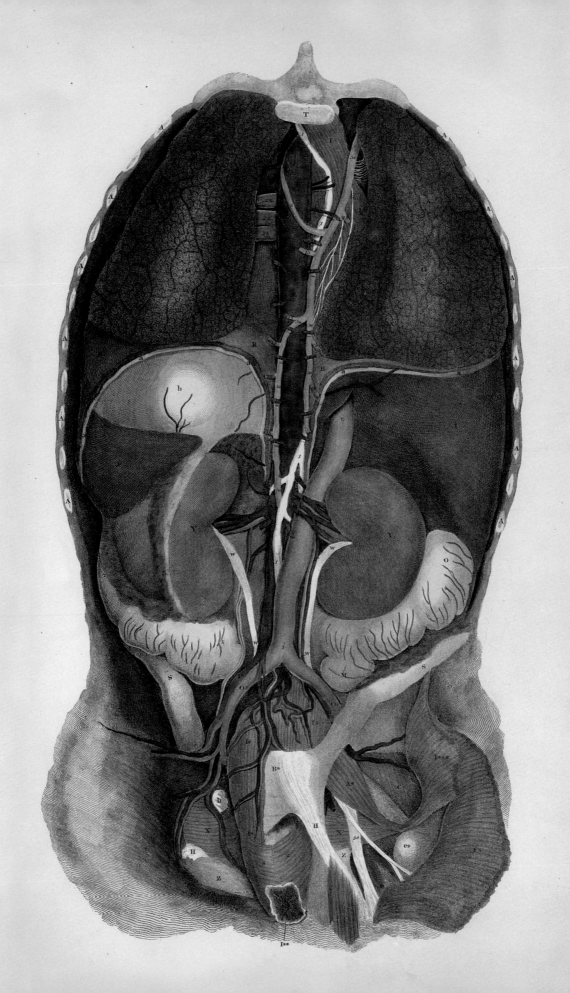

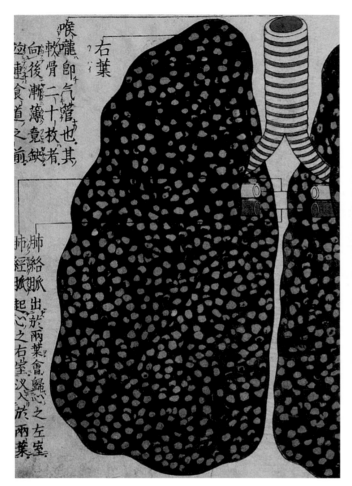

This image of the lungs is from Soshu Mitani's *Kaitai hatsumo*, 1813 (Explanation of Human Anatomy). The author's intention with this book was to persuade readers that Western anatomical and physiological knowledge was superior to that of Japan, which still relied on traditional Chinese medicine. Like the Western anatomical treatises that inspired it, Mitani's book featured images drawn from actual dissections. The first Western-style anatomy book published in Japan was *Kaitai shinsho*, 1774, a translation of Johann Adam Kulmus's *Anatomischen Tabellen*, 1722 (Anatomical Tables). It too repudiated the primacy of pre-Western Japanese medicine.

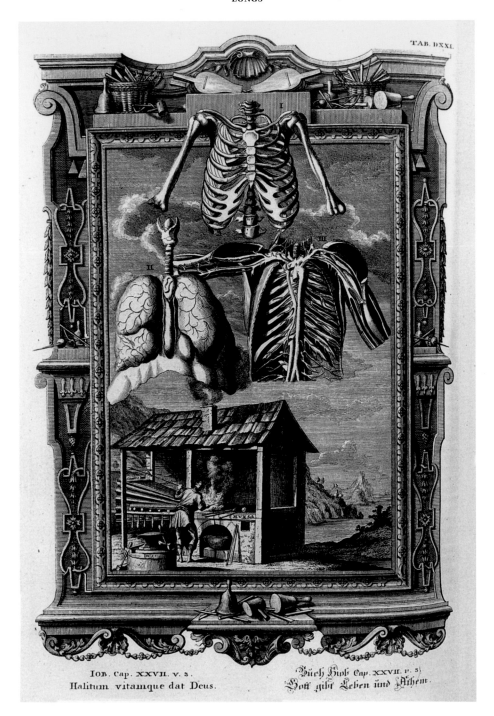

TAB. DXXI.

IOB. Cap. XXVII. v. 3.
Halitum vitamque dat Deus.

Buch Hiob Cap. XXVII. v. 3.
Gott gibt Leben und Athem.

This image from Jacob Scheuchzer's *Physica sacra*, 1731–5, explores the nature of breath and the mechanisms of breathing. The Bible verse cited at the lower left is Job 27:3 – 'All the while my breath is in me, and the spirit of God is in my nostrils', while the Latin text underneath the citation translates as 'God gives life and breath'. In a characteristic marriage of the theological and the scientific, we see a naturalistic analysis of breath via the anatomical imagery of the ribs, chest and lungs, while a metaphorical conception of breath comes from the inclusion of bellows at the top of the frame and in the forge image at lower left. This work of natural theology saw the natural world – and especially the human body – as proof of the works of the Creator, and, considered understanding the natural world as a way to know God.

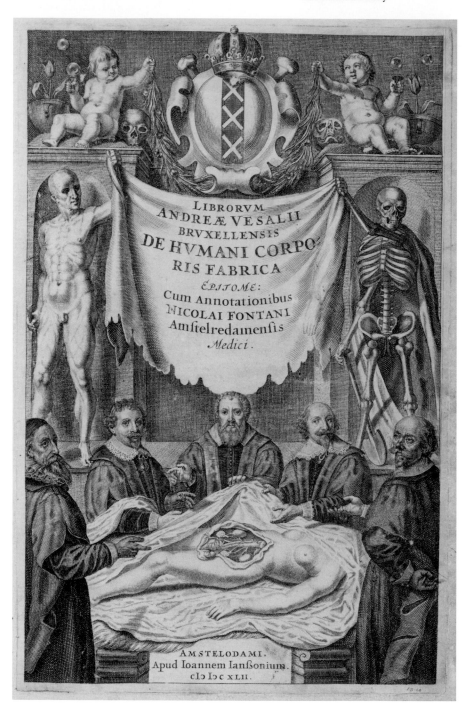

← This image, from Andreas Vesalius's *Epitome* shows anatomists in the midst of their practice. They are overseen by a skeleton and a flayed cadaver holding a banner – perhaps crafted from the skin of the latter – emblazoned with the book's title. The book was published in Amsterdam, hence the inclusion of the city's coat of arms.

These two title pages from 17th-century anatomical treatises remind us of the source of all anatomical knowledge: the dissected cadaver. For many centuries, the vast majority of bodies used for dissections were those of executed criminals, which added a moralising element to the imagery: the criminals died for their crimes against the state, but were redeemed, to a degree, by being used to increase anatomical learning. From the 16th century onwards, dissections were often performed for a paying public in what were called 'anatomical theatres', sometimes even as part of carnival festivities.

→ An image from *Encheiridium anatomicum et pathologicum*, 1649 (An Anatomical and Pathological Handbook) by Jean Riolan the Younger. Overseeing the dissection are Greek gods Hygieia, the personification of health, and Asclepius, god of healing, truth and prophesy.

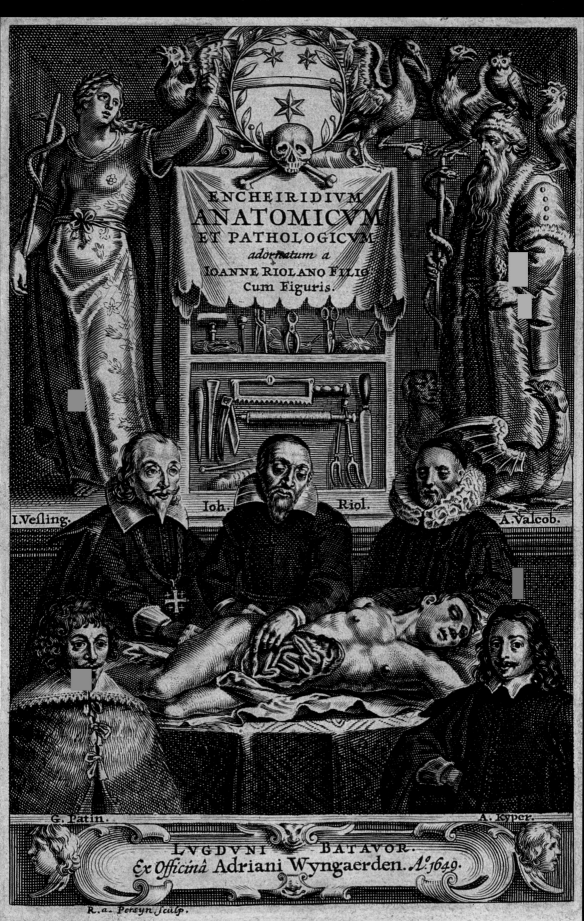

ENCHEIRIDIVM
ANATOMICVM
ET PATHOLOGICVM
adornatum a
IOANNE RIOLANO FILIO
Cum Figuris.

I.Vesling.

Ioh.

Riol.

A.Valcob.

G. Patin.

A. Kyper.

LVGDVNI BATAVOR.
Ex Officinâ Adriani Wyngaerden. A.º 1649.

R. a. Persyn Sculp.

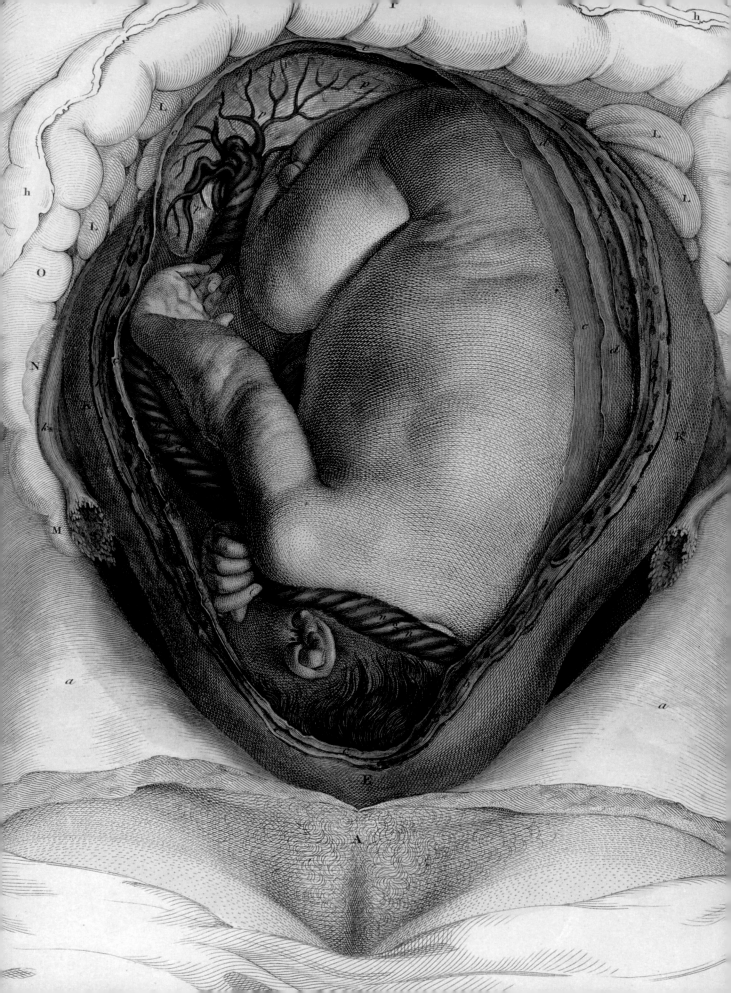

Procreation

For many centuries, procreation and gestation were mysteries understood in the context of the divine. In agricultural societies, it was clear that the continuation of life was dependent on fertility – the crops growing and children being born. Many religions and mythologies also understood sexuality and its procreative function as sacred. Even after the rise of Christianity, conception and the development of the infant in the womb were still believed to be among God's most mysterious and awe-inspiring wonders. In the ancient world, depictions of female genitalia were often used symbolically in relation to fertility or the worship of goddess figures. Images of the erect male organ symbolized the power of creation and were used to adorn protective charms.

From the 4th century bce to the 16th century ce, the assumption was that women's bodies were defective; after all, God had handcrafted Adam, while Eve was merely created from a bone in Adam's body. Male anatomy was therefore seen as 'regular' or the norm. Women's bodies were usually only included in anatomical atlases to illustrate what differentiated them from men's bodies – namely, the ability to conceive, gestate and nurture new life. Cadavers of female bodies – especially pregnant ones – were uncommon, and so the uterus and its relationship to the fetus remained something of a mystery until the 18th century.

Debates about the nature of embryological development and the roles of the male and female in reproduction continued into the 19th century. At this time, viewing the naked human body was highly policed. Art – in the form of the nude – and science, such as the study of human anatomy, were legitimizing activities that sanctified the viewing of the unclothed human body. Nevertheless, the line of acceptability could be obscure, and some of the images shown in this section were condemned as pornographic at the time of their publication.

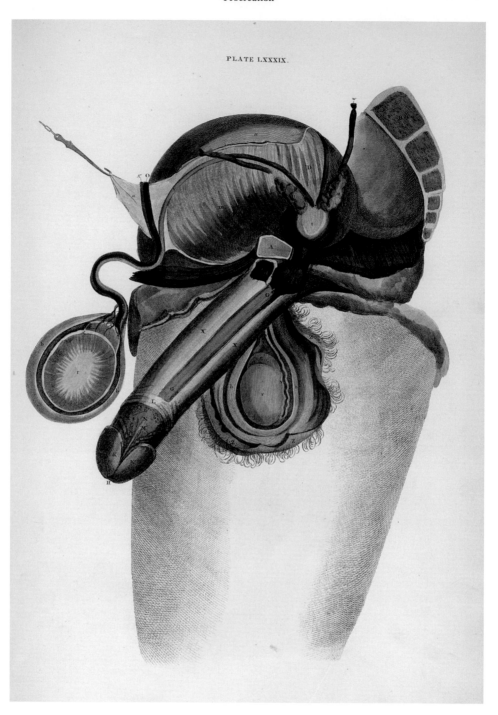

PLATE LXXXIX.

A hand-coloured engraving of the male urogenital system, with the pelvis viewed in sagittal section (vertical crosssection) dividing left from right. It was rendered by William Home Lizars and is included in his brother John's book *A System of Anatomical Plates of the Human Body*, 1822–6. This image, in its iconic simplicity, evokes earlier symbolic, mythological and religious images of the erect male sexual organ, which represented creative force, vitality and fertility. In Ancient Rome, amulets and figurines of erect penises were used as charms for protection. The penis was not an object of scientific study until the Renaissance, and sexual anatomy was not drawn with any real accuracy until end of 17th century.

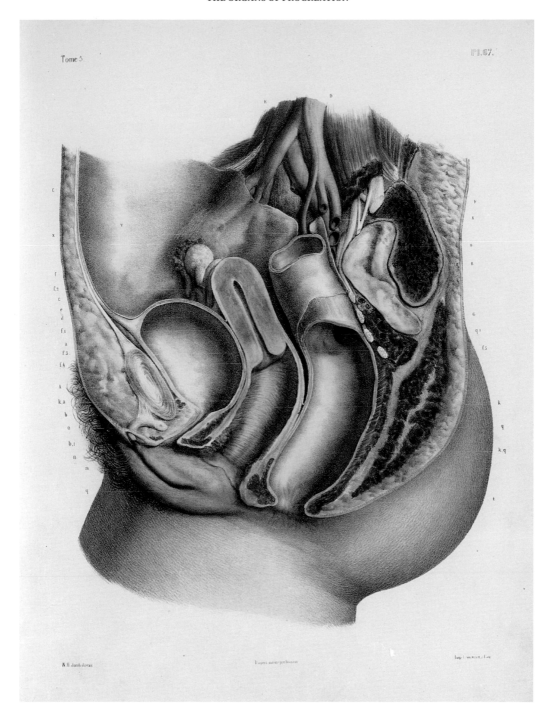

Tome 5.

Pl.67.

This chromolithograph, showing a dissection of a female pelvis that reveals the urogenital system, was created by French artist Nicolas-Henri Jacob for Jean-Baptiste Marc Bourgery's *Traité complet de l'anatomie de l'homme comprenant la médicine opératoir ... ,* 1831–54. In anatomical atlases, the vast majority of illustrations depict the male body, which was seen as the norm. The female body was not generally included unless the focus was on those parts that made woman unique: namely, the breasts and reproductive organs. The thinking at the time, which can be traced back at least to Aristotle in the 4th century BCE, was that the female body was simply a defective version of the male.

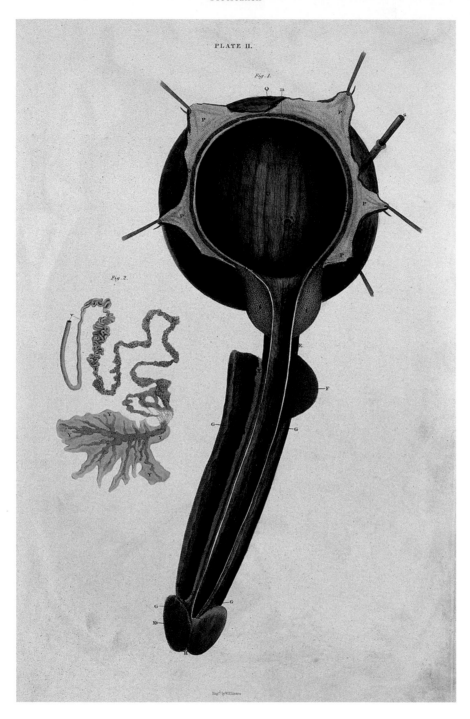

PLATE II.

The two images on this spread are from John Lizar's *A System of Anatomical Plates of the Human Body*, 1822–6. Both are hand-coloured line engravings by William Home Lizars, the anatomist's brother.

↑ Here we see the male genital organs shown in isolation, with the bladder (top) opened up to reveal the interior. The penis is also depicted in a cutaway view showcasing the urethra. The small inset illustration to the left shows a dissection of the epididymis (a duct behind the testes) and the seminiferous tubules, the place in the testes where the sperm cells develop.

→ This elaborate and somewhat stylized illustration shows an opened male torso, featuring the lymphatic system (1–16), appendix (29); small intestine (k), heart (d), liver (I), gall bladder (e), colon (o), penis (x) and testicles (r).

PLATE X.

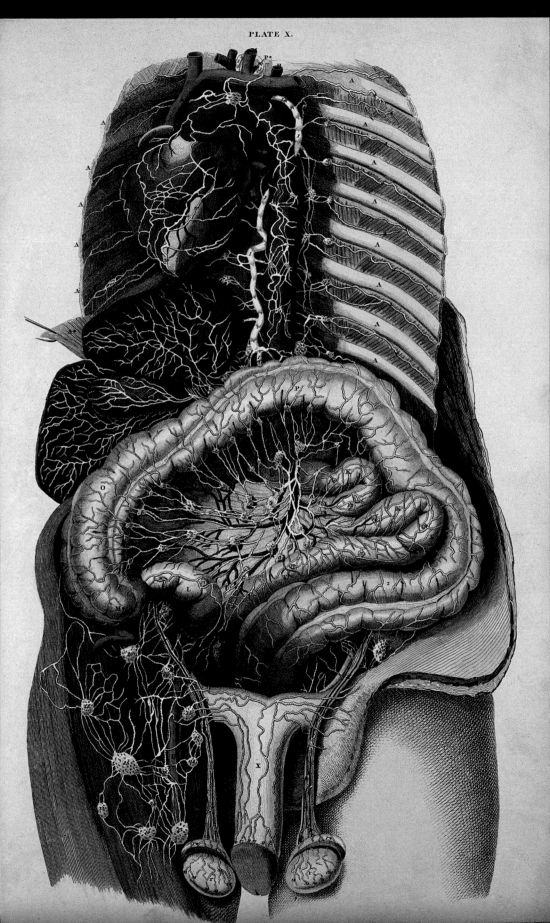

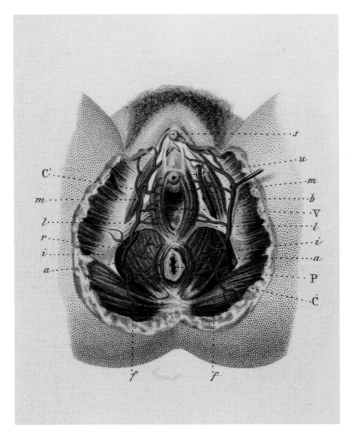

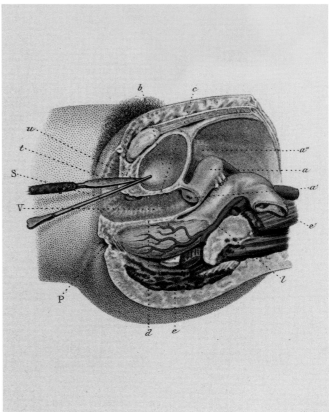

Here we see two dissections showing the female reproductive organs, as seen in French physiologist Claude Bernard's *Précis iconographique de médecine opératoire et d'anatomie chirurgicale*, 1848 (Precise Illustrations of Operative and Surgical Anatomy). The left image depicts an inferior view – or a view from below – of a dissected female pelvic floor. The right shows a sagittal section through a female pelvis, a common viewpoint used in surgical text to demonstrate proper positioning of instruments. Bernard was a very important figure in his field, and did a great deal to make medicine more scientific and objective. He was a proponent of vivisection (live dissection) of animals, and it was using this controversial method that he made many of his discoveries. His wife ultimately divorced him and became an anti-vivisection crusader. He, however, went on to be the first scientist in France to be given a state funeral.

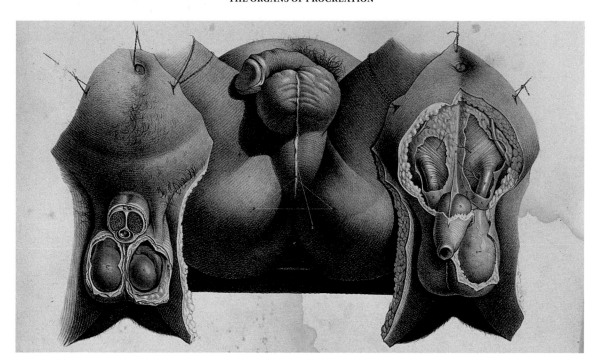

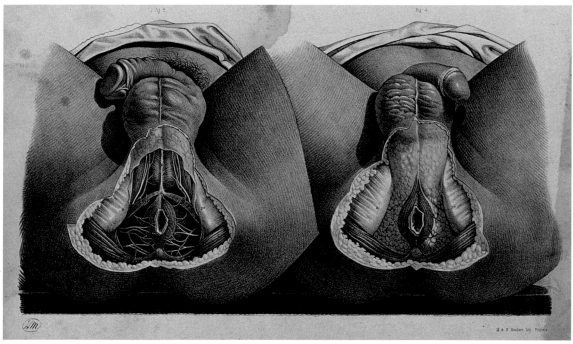

These two hand-coloured lithographs document the dissection of a man, with a focus on the perineum, scrotum, penis and anus, as seen in Joseph Maclise's *Surgical Anatomy*, 1851. This Irish anatomist and artist drew these images from his own dissections of the bodies of criminals, the very poor, and people from foreign lands who had died far from home. He is famous for including both white and black bodies as illustrations of normal anatomy, a controversial practice at a time when black bodies were commonly compared to white ones to demonstrate supposed biological differences and white racial superiority. In the United States, where slavery was still legal, the illustrations depicting black bodies were removed from the book before publication. Maclise is well known for endowing his figures with a dignified beauty, and his work has been compared to that of his brother Daniel, a well-known fine artist.

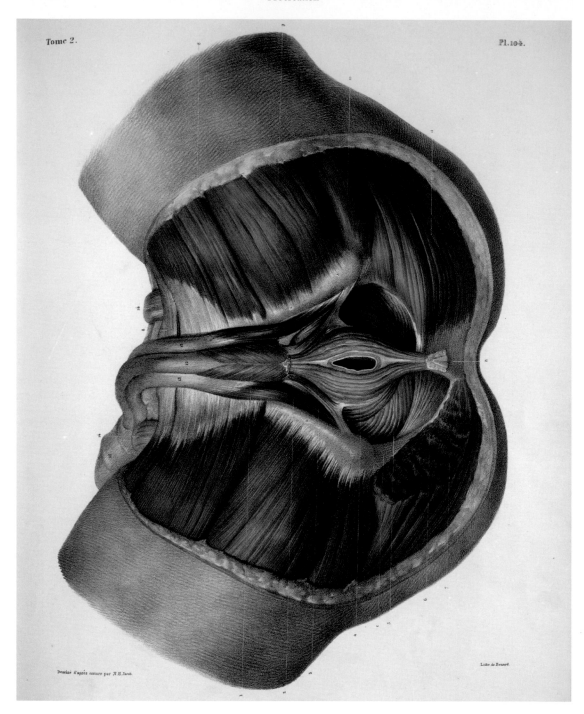

Tome 2.

Pl.104.

Dessiné d'après nature par N.H.Jacob.

Litho de Benard.

This beautiful, richly detailed coloured lithograph by Nicolas-Henri Jacob, presents a superficial dissection of the male perineum, the area between the anus and scrotum, from Jean-Baptiste Marc Bourgery's eight-volume *Traité complet de l'anatomie de l'homme comprenant la médicine opératoir ...* , 1831–54. The scrotum has been removed, and we can see a variety of muscles including those of the pelvic floor, the leg adductors, and the gluteals.

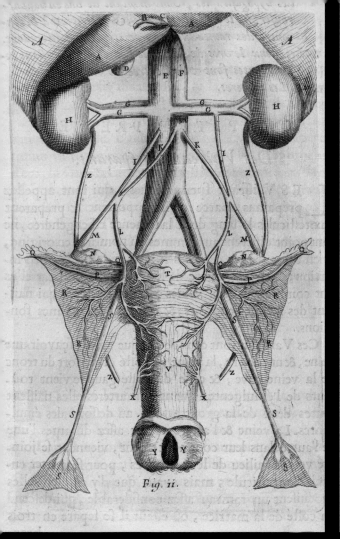

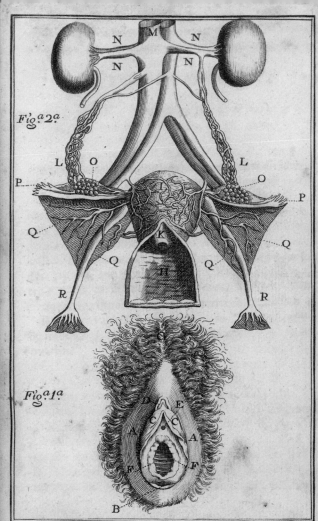

◄ A diagram of female internal organs, including kidneys and vagina, from French surgeon François Mauriceau's *Des Maladies des femmes grosses et accouchées*, 1668 (Diseases of Women Who Are Pregnant and Have Given Birth). This book was important in helping to establish obstetrics as its own branch of medicine. In it, Mauriceau advocated that women should deliver supine in bed – what came to be called the 'French position' – rather than in the traditional seated position. This popular and influential book, which also describes the anatomy 'of the Parts of a Woman destin'd to Generation', was republished many times. This image evokes the erroneous belief, tracing back at least to Galen, that the female organs of generation were an inversion of those of the male. Even Vesalius, famous for correcting so many of the ancient Roman physician's errors, supported this theory.

↗ These two illustrations of the female reproductive organs, with a focus on the blood supply of the ovaries, kidneys and uterus, are by Antonio Ponz, from Spanish surgeon José Ventura Pastor's *Preceptos generales sobre las operaciones de los partos*, 1789 (General Precepts about the Operations of Childbirth).

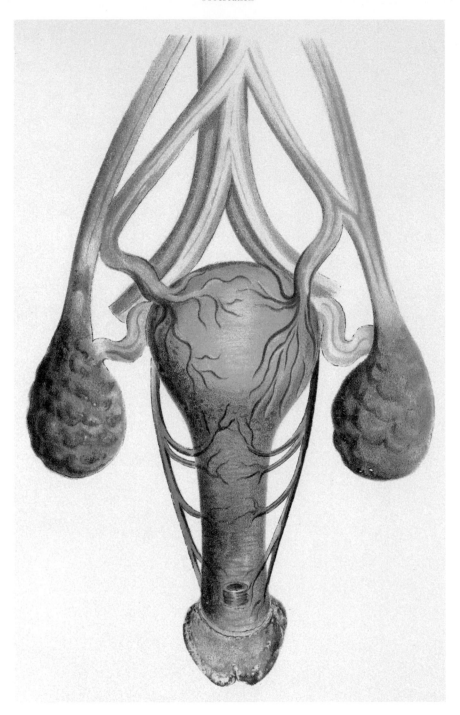

↑ This stylized image (with the ovaries much larger than in life) is from Fritz Weindler's *Geschichte der gynäkologisch-anatomischen Abbildung*, 1908 (A History of Gynaecological Anatomical Illustrations). It shows the ovaries, the abdominal aorta and inferior vena cava and their branching (bifurcation) into the iliac arteries and veins. The bladder had been removed in order to better see the vagina; in the lower portion of the image is a sectioned urethra.

→ Here we see a variety of studies of the dissected male urogenital system from Jean-Baptiste Marc Bourgery's *Traité complet de l'anatomie de l'homme comprenant la médicine opératoir...*, 1831–54 . In the top image, we see the inferior view of the penis and bladder with the central cavity of the urethra

exposed. The second image reveals the underside of the penis and its attachment to the bony pelvis. The last image presents a posterior view of the penis, bladder, and testicles. The smaller illustrations at the bottom show a cross section of the penis and a ventral view with the urethra dissected out.

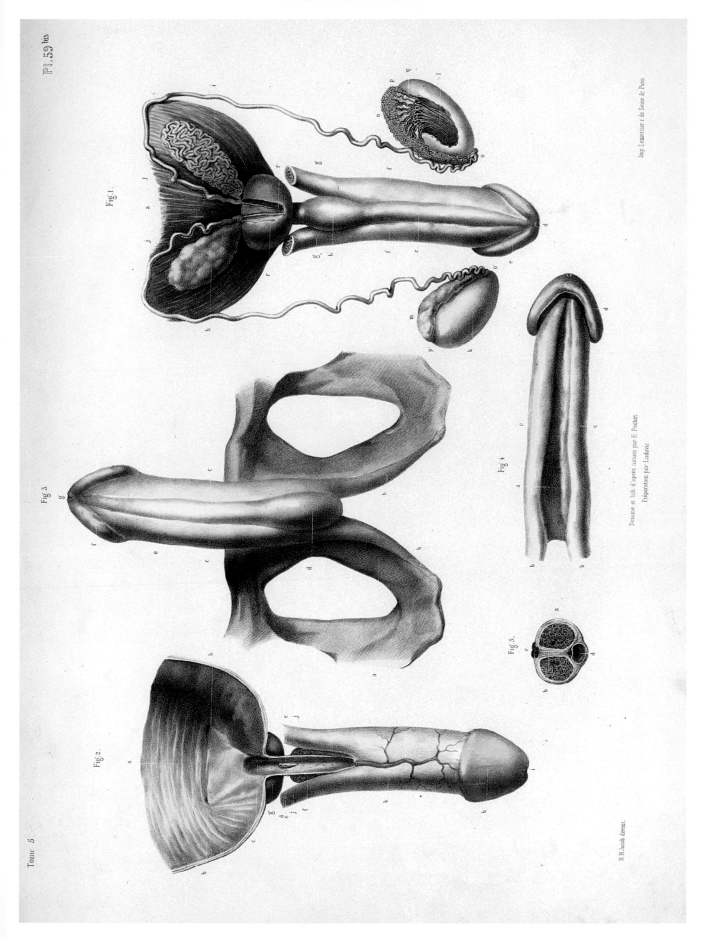

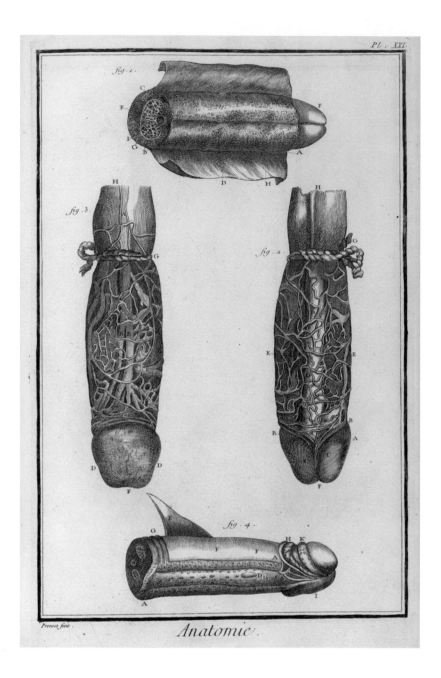

This copper engraving of the male reproductive organs was made by Robert Bénard and appears in Denis Diderot's *Encyclopédie, ou dictionnaire raisonné des sciences, des arts et des métiers ...* , published in many volumes between 1751 and 1772. Diderot, a prominent figure of the French Enlightenment, was a philosopher, writer and art critic. The encyclopedia is one of his best-known achievements. In true Enlightenment spirit, it aimed to change the way people thought by giving them access to all worldly knowledge in a secular fashion (in France at that time, the Jesuits largely controlled education). He organized the encyclopedia into sections on the sciences, theology and the arts via a novel tree of knowledge system, in which the primary branches were memory, philosophy and imagination. Controversially, he presented theology as a branch of philosophy. The encyclopedia was widely attacked and censored, and its provocative take on politics and religion was part of the intellectual ferment that led to the French Revolution of 1789–99.

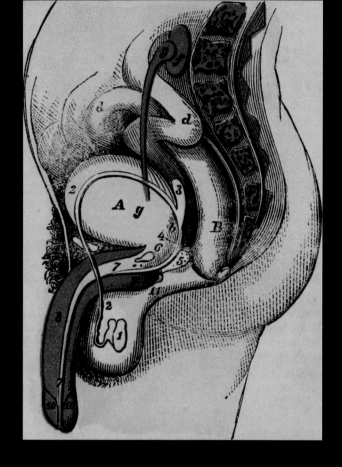

This colourful image of a sagittal section of the male reproductive anatomy is drawn from *The Male Generative Organs in Health and Disease, from Infancy to Old Age*, 1850, by American physician and sex educator Frederick Hollick. Its aim, as stated in the subtitle, was to be a 'practical treatise on the anatomy and physiology of the male system adapted for every man's own private use'. Hollick was committed to bringing sex education to the people, a controversial philosophy during the sexually repressive Victorian era. In one of his most famous books, *The Marriage Guide*, 1850, he lauded the use of aphrodisiacs, and openly discussed legal prostitution and multiple orgasms in women. He was also clear in his belief that sex was an important part of life and essential to health. In addition to writing numerous books on sex education, he gave lectures, which he illustrated with lifelike papier-mâché models.

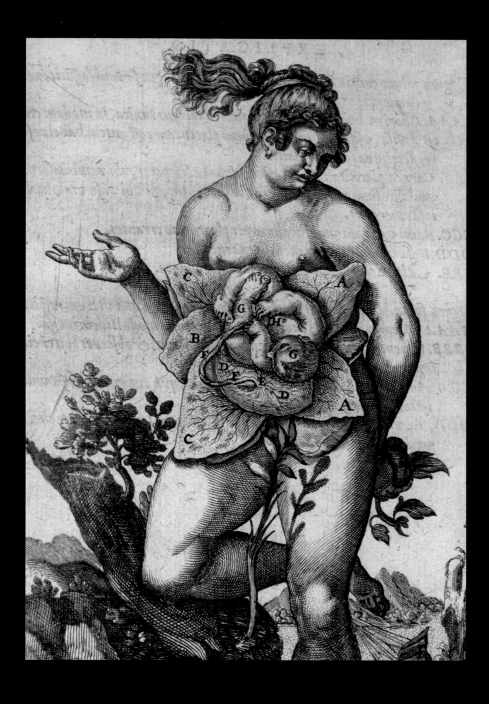

Here we have a remarkable image of a pregnant woman with her womb opened like a flower to reveal the fetus within. It was rendered by the Italian mannerist artist Odoardo Fialetti, who had worked in the studio of the great master Tintoretto. The image comes from *De formato foetu liber singularis*, 1626 (A Monograph on Fetal Development) by Brussels-born

physician Adriaan van de Spiegel and Italian physician Giulio Cesare Casseri. The book was published after the death of both stated authors by the former's son-in-law, Liberale Crema, who combined an unpublished text from his father-in-law with images commissioned by Casseri for an unpublished anatomical atlas. The placement of the leafy branch

between the figure's legs creates the illusion that her open womb is a flower bearing the fruit of a human life, reminding us that, at this time, pregnancy was largely understood in a religious context, and that conception and the plant-like growth of the fetus were some of God's most awe-inspiring and mysterious wonders.

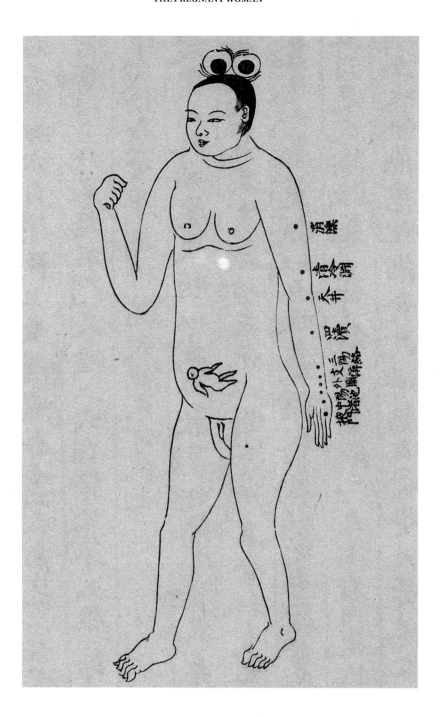

This chart, detailing acupuncture prohibitions related to pregnancy, is from Japanese physician Yasuyori Tanba's *Ishinpo* (Remedies at the Heart of Medicine), originally published in 984, making it the oldest extant Japanese medical text. The book, which includes information about acupuncture, *daoyin* (therapeutic movement), and guides to diet and health, was based in part on Chao Yuanfang's *Zhubing Yuanhou Lun* (General Treatise on Causes and Manifestations of All Diseases, 610), an important book of traditional Chinese Medicine. The chart details the places in the arm where, during the fourth month of pregnancy, acupuncture is forbidden. The points have poetic, evocative names such as 'Celestial Well,' 'Dispersing Luo River' and 'Clear Cold Abyss'.

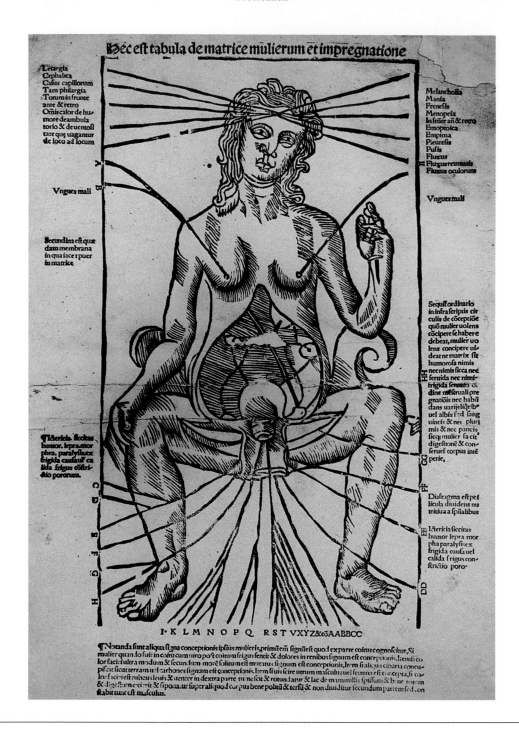

The images on this spread show two seated, dissected 'gravida' (pregnant women), with their anatomical parts clearly labelled. Both draw their iconography from Byzantine and early Renaissance depictions of the Madonna enthroned, reminding us that conception and gestation were at this time medical mysteries, usually apprehended through the lens of religion.

↑ A mid 16th-century woodcut illustration based on a similar image in Johannes de Ketham's *Fasciculus de medicinae*, 1491.

→ A painting from a mid 15th-century hand-rendered manuscript. Note the inclusion of the tiny, preternaturally adult-looking baby in the vagina.

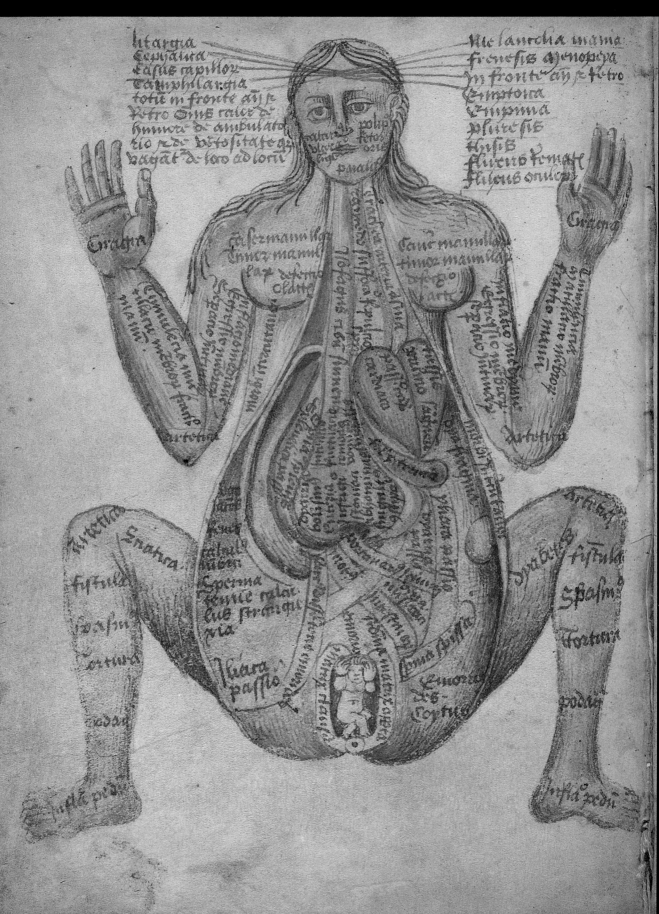

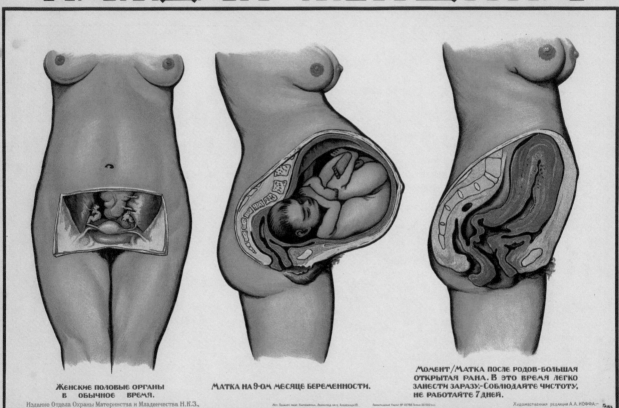

ЧТО ДОЛЖНА ЗНАТЬ
КАЖДАЯ ЖЕНЩИНА.

ЖЕНСКИЕ ПОЛОВЫЕ ОРГАНЫ
В ОБЫЧНОЕ ВРЕМЯ.

МАТКА НА 9-ОМ МЕСЯЦЕ БЕРЕМЕННОСТИ.

МОМЕНТ / МАТКА ПОСЛЕ РОДОВ-БОЛЬШАЯ
ОТКРЫТАЯ РАНА. В ЭТО ВРЕМЯ ЛЕГКО
ЗАНЕСТИ ЗАРАЗУ.-СОБЛЮДАЙТЕ ЧИСТОТУ,
НЕ РАБОТАЙТЕ 7 ДНЕЙ.

Издание Отдела Охраны Материнства и Младенчества Н.К.З.,

Художественная редакция А.А.ИОФФА.–

This colour lithograph poster of the
female genital organs before, during
and after pregnancy was drawn by O.
Griùn in the Soviet Union around 1925.
The images show, left to right, a woman
before pregnancy, a pregnant woman
at full term, and a lateral view of the

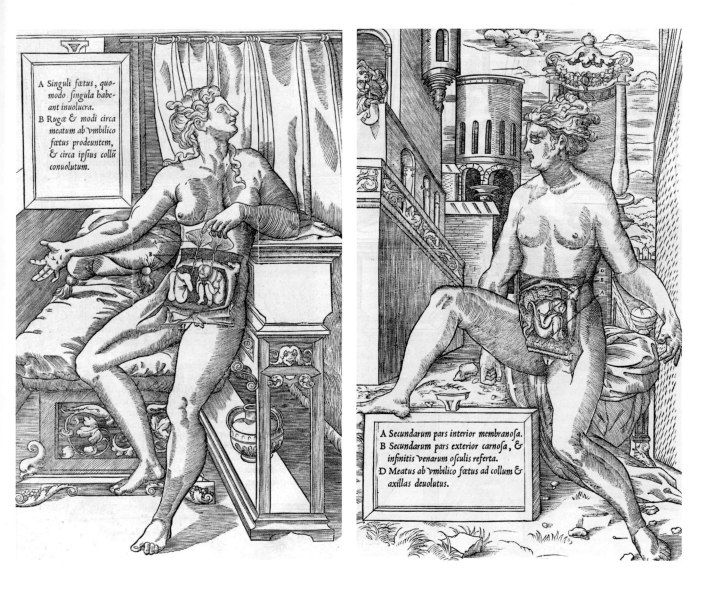

A Singuli fœtus, quo-
modo ſingula habe-
ant inuolucra.
B Rugæ & modi circa
meatum ab vmbilico
fœtus prodeuntem,
& circa ipſius collū
conuolutum.

A Secundarum pars interior membranoſa.
B Secundarum pars exterior carnoſa, &
infinitis venarum oſculis referta.
D Meatus ab vmbilico fœtus ad collum &
axillas deuolutus.

⋏ These two images are drawn from Charles Estienne's *De dissectione partium corporis humani* ... , 1545. The image on the right – along with several others in this book – was repurposed from a series of erotic prints entitled *Gli amori degli dei* (The Loves of the Gods), engraved by Gian Giacomo Caraglio after drawings by Perino del Vaga and Rosso Fiorentino. The original erotic work from which it was copied pictured an intimate encounter between Pluto, the god of the underworld, and Proserpina who became the queen of the underworld after he seized her against her will and brought her to his lair.

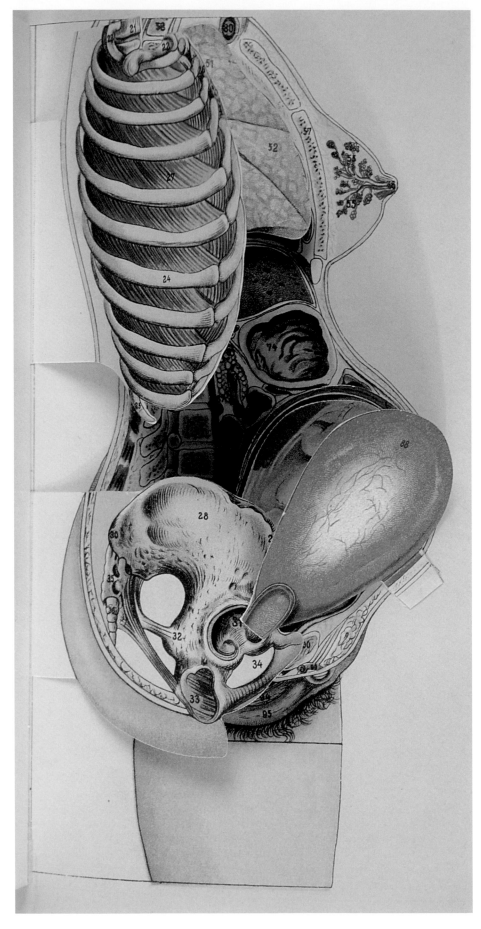

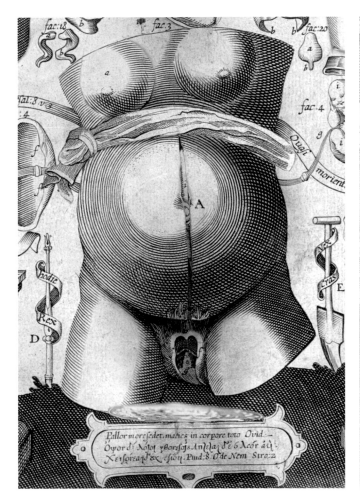

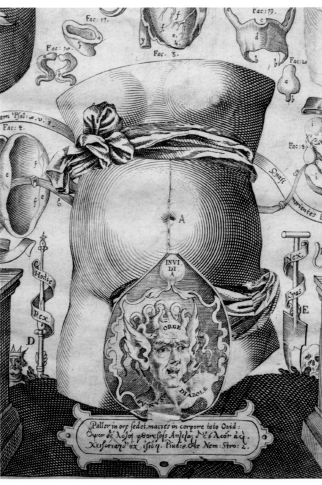

← A dissectible paper woman from Frederick Hollick's *The Origin of Life and Process of Reproduction*, *c*.1902. Following the publication of this image, Dr Hollick, a famous American physician, lecturer and sex educator, was charged with obscenity. For many years, books containing graphic bodily images like this were sold in sealed envelopes to avoid legal prosecution, as the US Comstock laws of 1873 made it a punishable offence to send anything deemed obscene through the mail system.

↑ The dissectible womb of Eve, from Johann Remmelin's famous flap book *Catoptrum Microcosmicum* ... (A Mirror of the Microcosm ...), originally published in 1613. The blurred area directly above the label at the bottom of the left-hand image is a flap in the form of a devil's head, which must be pulled back to reveal the genitalia. This serves to remind us of the link in the Judeo-Christian world between women and death, sin and sexuality. This link has firm foundations in the figure of Eve in the Bible's Book of Genesis, because she, in defiance of God's will, is driven by curiosity to taste the apple of the tree of knowledge. The result is a loss of innocence, expulsion from paradise, and the genesis of death and suffering for humanity, including the dangers and agony of childbirth for women.

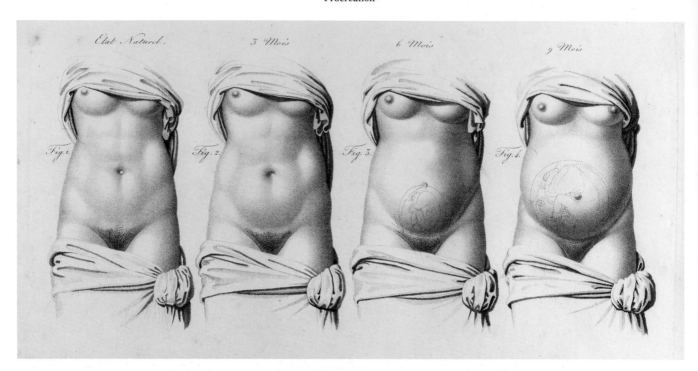

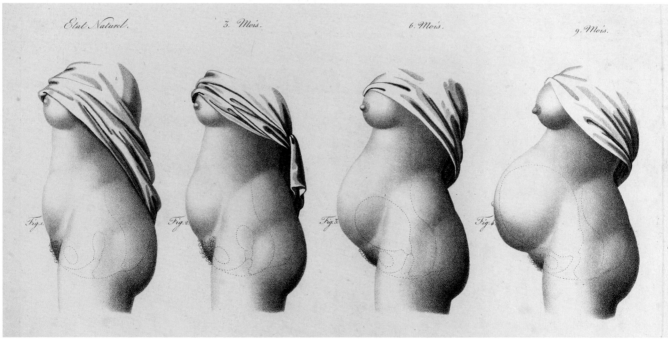

↑ The striking images on this page come from *Nouvelles démonstrations d'accouchements...*, 1822–7, by the French doctor Jacques-Pierre Maygrier. The book was published in English under the title *Midwifery*, 1833, and was highly acclaimed. These front and side views show the normal state of the womb, then its growth at three, six and nine months' gestation.

→ An image from the German anatomist and physiologist Michael Pius Erdl's *Die Entwickelung des Menschen und des Hühnchens*, 1845 (The Evolution of Man and of Chickens). The book is filled with otherworldly images, including this one of a 12-week-old human fetus enclosed in its amniotic sac, the membrane that protects it. Erdl was also a trained artist and drew his own plates. The image has a somewhat devotional quality, in tune with his intention with this book to create an offering for those who wished to 'worship and adore the omnipotence, wisdom and goodness of the Creator through the contemplation of His works'.

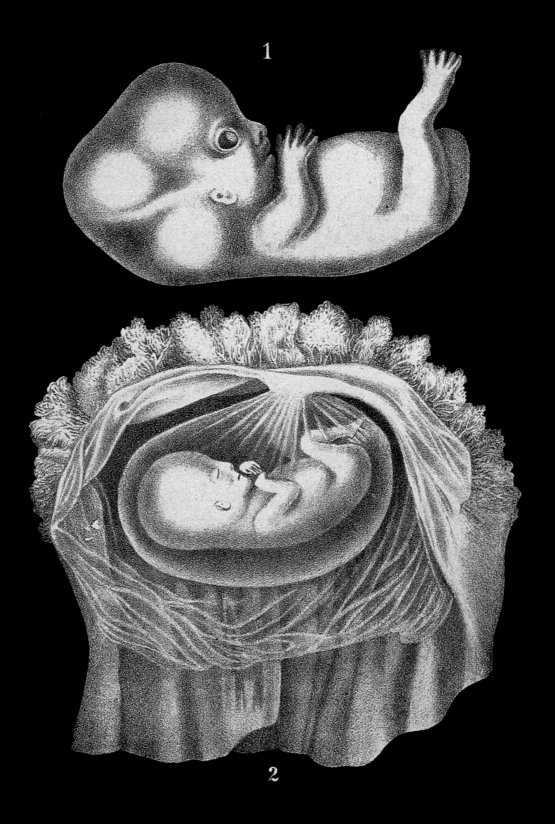

1

2

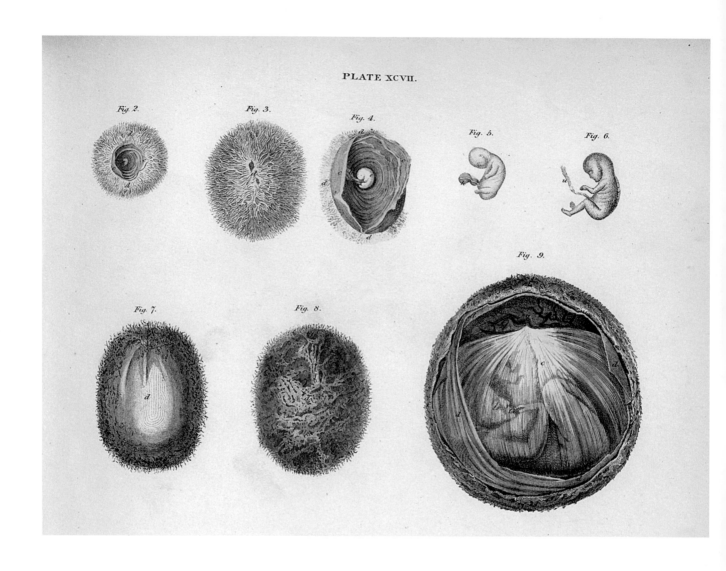

PLATE XCVII.

These images are from a hand-coloured engraving of dissections demonstrating fetal development. They appear in John Lizars' *A System of Anatomical Plates of the Human Body*, 1822–6.

↑ This image shows the comparative development of a fetus from around 3–4 weeks to full term.

→ This work depicts the placenta in situ in the uterus, with the umbilical cord, surrounded by the amniotic sac and uterine wall.

Fig. 1.

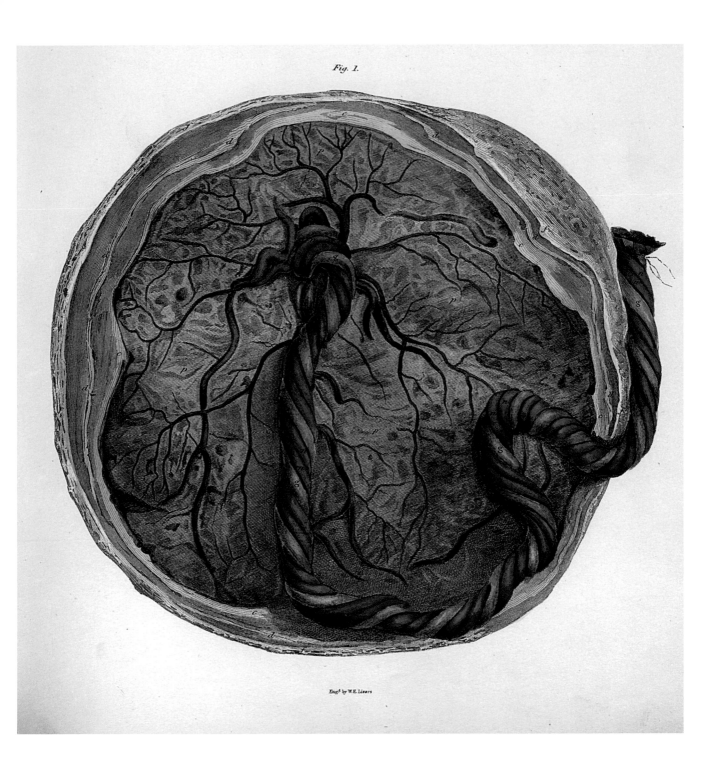

Eng.ᵈ by W.H. Lizars

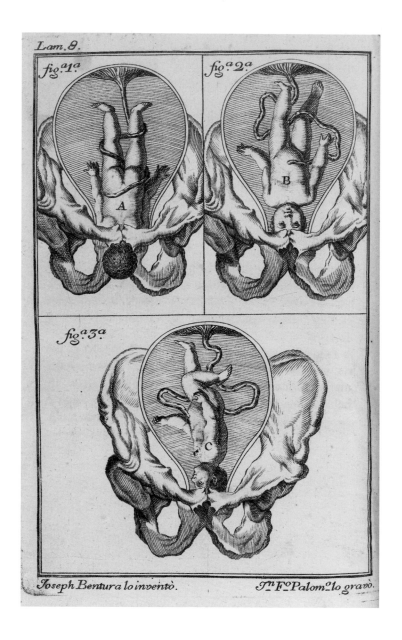

This illustration of a fetus with the head engaged for birth is by Antonio Ponz. It comes from José Ventura Pastor's *Preceptos generales sobre las operaciones de los partos*, 1789 (General precepts about the operations of childbirths), a textbook intended for surgeons and other medical practitioners. This elegant image demonstrates a 'fetus' (inaccurately represented as a toddler or older child) in a variety of possible birth positions. For most of history, women giving birth were attended not by doctors, but midwives. Their credentials usually stemmed from the fact they had given birth themselves; some were also skilled with herbs and could provide other forms of medical assistance. By the early 18th century, 'man-midwives' and doctors were actively competing with traditional midwives. They used books such as this one – and other signifiers of technical superiority and systematic training – to try to claim the realm of childbirth as their own.

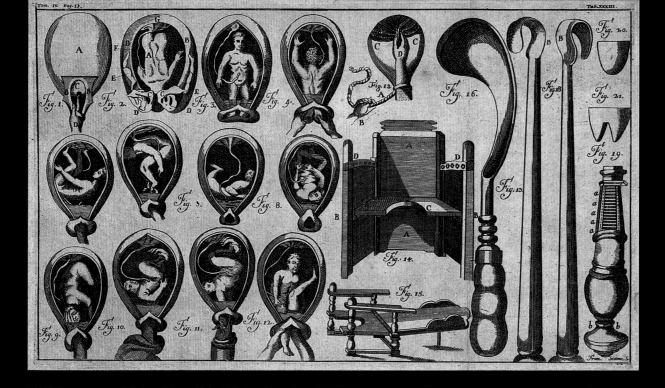

Tab.XXXIII.

An illustration by F. Sesone from German anatomist, surgeon and botanist Laurentius Heister's *Institutiones chirurgicae*, 1731 (Surgical Instructions). It shows babies ready to leave the womb in a variety of positions, along with birthing chairs and instruments such as forceps.

Forceps were a huge leap forward in the technology of childbirth. They were invented in the 1600s, but were kept a professional secret until the 1730s. Innovative delivery tools such as these were instrumental in doctors eventually triumphing over traditional midwives. The babies we see here, with

their curiously adult-like demeanour, evoke the homunculus theory. This was an idea dating back to the 16th century that babies existed as perfectly formed miniature humans within the egg or sperm and, once fertilized, grew to full size. There was much debate around this idea.

Tome 7.

Pl. 77.

Fig. 1.

C A B

E

Fig. 2.

C

A

D

E

D

Fig. 3.

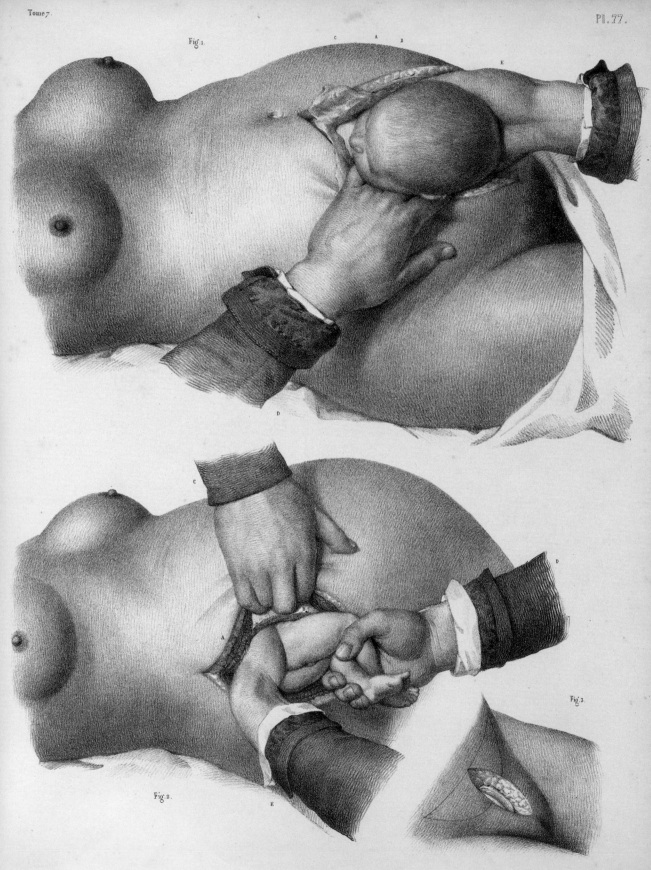

N. H. Jacob direxit.

d'après nature par Léveillé.

Imp. Lemercier, Bénard et C.ⁱᵉ

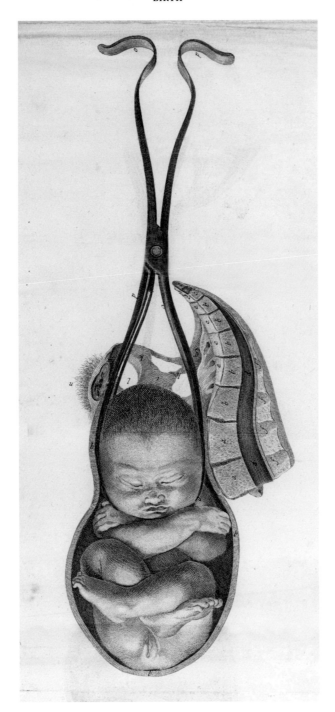

← An illustration of childbirth via caesarean section, from Jean-Baptiste Marc Bourgery's *Traité complet de l'anatomie de l'homme comprenant la médicine opératoir...*, 1831–54. Caesarean sections, or C-sections, were once quite dangerous, with a high mortality rate for the mother, only to be performed if all other options had been exhausted. Developments such as the introduction of stitching the uterine and abdominal cuts, improved anaesthesia and better hygienic procedures eventually made caesareans much safer.

↑ This image of a forceps-assisted birth comes from the French obstetrician Jean-Louis Baudelocque's *L'Art des accouchements*, 1781 (The Art of Childbirth). 'Le grand Baudelocque', as he was sometimes called, was the leading obstetrician in France at this time.

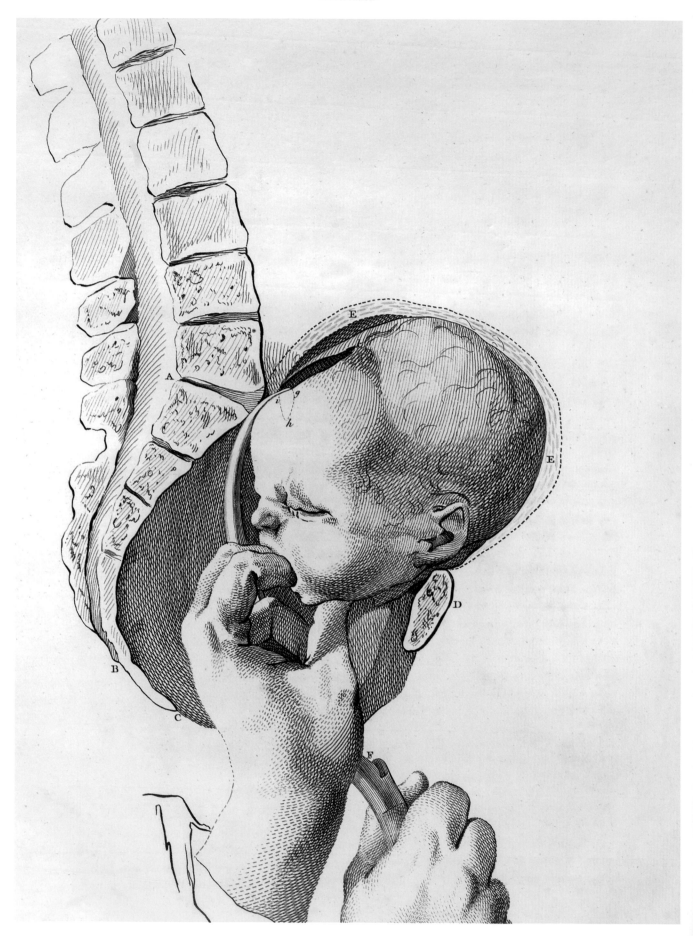

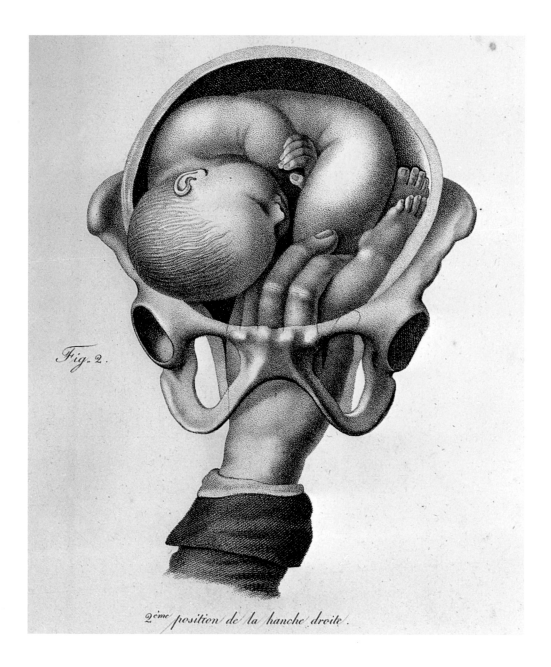

Fig. 2.

2ᵉᵐᵉ position de la hanche droite.

← A cutaway view of the pelvis during an assisted birth, taken from Scottish obstetrician William Smellie's *Anatomical Tables with Explanations, and an Abridgement of the Practice of Midwifery*, 1754. Smellie was the most prominent and wealthy English 'man-midwife' – a male doctor who took the place of a female midwife. The image shows the method of using a 'curved crotchet' to assist a difficult birth, where the fetus was too large or the pelvis too narrow. Smellie created his own forceps in order to 'avoid this loss of children which gave [him] great uneasiness'.

↑ An image showing the technique for turning a child in the womb to better position it for birth from *Nouvelles démonstrations d'accouchements*, 1822–7, by the doctor Jacques-Pierre Maygrier.

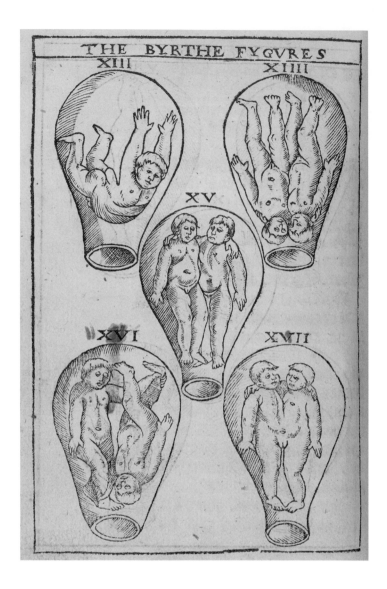

Here we have a variety of pre-birth fetal positions, some including twins, from *The Birth of Mankynde: Otherwyse Named the Womans Booke*, 1540, the most important English midwifery book of the 16th century. Based on German physician Eucharius Rösslin the Elder's *Der schwangern Frauwen und Hebammen Rosengarten*, 1513 (literally, Pregnant Women and Midwives Rose Garden), the second English translation by Thomas Raynalde was a huge success, going through many editions and translations. At this time, childbirth was largely the realm of women, and pregnancy and birth – understood as great mysteries of God – had a secret and sacred aspect, one that was not seen as fit to be shared, much less written about. The fetuses here look more like older children.

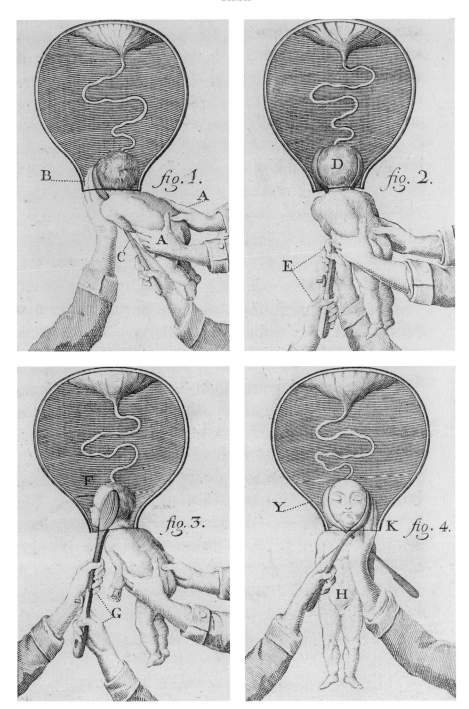

This remarkable series of images of a physician using forceps to attend what is called a breech birth – in which the baby is positioned foot first for delivery – is from José Ventura Pastor's *Preceptos generales sobre las operaciones de los partos*, 1789. Note the elegant sleeves of the physician, reminding us that, at the time this book was published, modern ideas about sterilization were as yet unknown. It was not until around 1850 that Hungarian doctor Ignaz Semmelweis posited a correlation between hand washing and the mortality rates of women giving birth. Because he had no theory to back it up except for the vague notion of 'cadaverous particles', his ideas were not taken seriously. Later that century, French biologist and chemist Louis Pasteur legitimized Semmelweis' findings via more rigorous experiments that were accepted by the scientific community. In the 1870s, British surgeon Joseph Lister introduced and promoted the use of carbolic acid for sterilization during surgeries, winning him the title of 'father of modern surgery'.

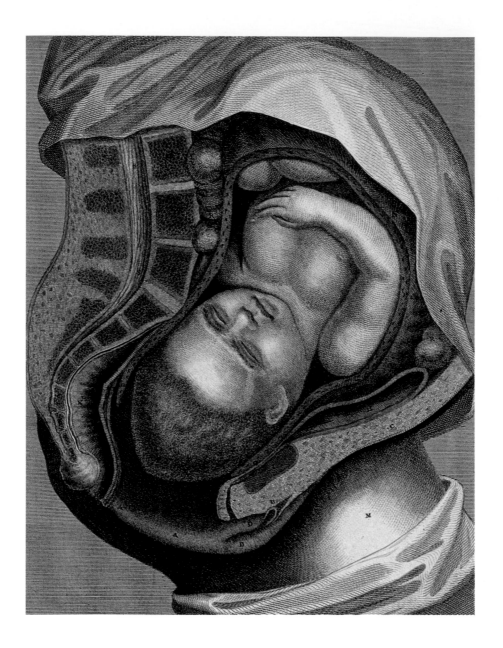

Copperplate engraving by J. Chapman, depicting a sagittal section of a pregnant woman's torso just before giving birth. To the left you can see the sectioned vertebral column with the spinal cord and what is called the 'cauda equina' (horse's tail), a bundle of spinal nerves and spinal nerve rootlets. To the right, you can see the bladder being compressed against the pubic symphysis – the cartilage that joins the bones of the pubic bone – and anterior abdominal wall. The image comes from John Wilkes's *Encyclopaedia Londinensis, or, Universal Dictionary of Arts, Sciences and Literature*, published in 24 volumes between about 1810 and 1829.

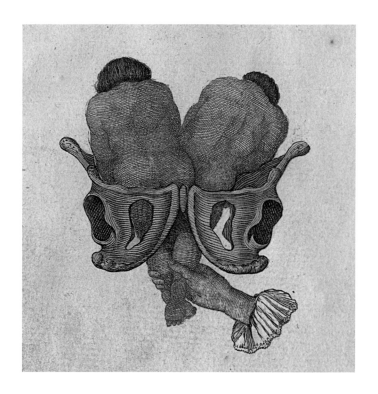

↑ Angélique Marguerite Le Boursier du Coudray, better known as Madame du Coudray, was a French midwife of the 18th century. She was enlisted by King Louis XV to travel into the French countryside to train rural midwives in order to decrease the high rates of infant mortality. She never married; the title Madame in this case designates her profession of *sage-femme*, or wise woman, the French word for midwife. She is also famous for her obstetrical 'machine' – a life-sized model of a pregnant female torso complete with a cloth and leather fetus, which could be used to train other midwives in the art of delivery. This image is drawn from her famous book *Abrégé de l'art des accouchements*, 1759 (The Art of Obstetrics), which consisted of a collection of her lectures for midwives.

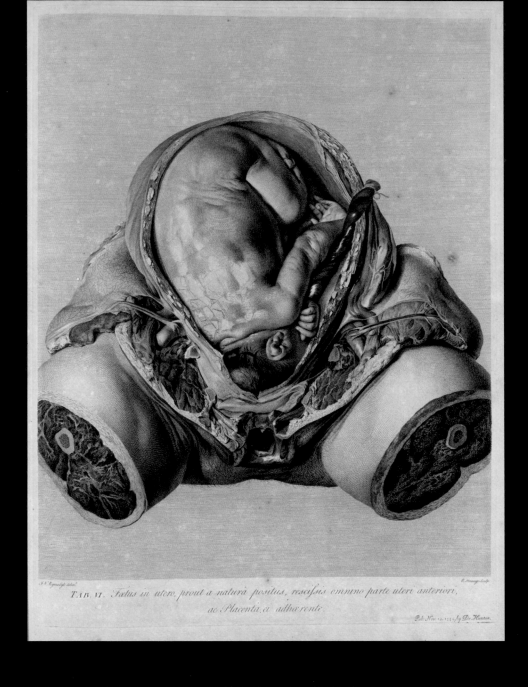

TAB. VI. *Fœtus in utero, prout a naturâ positus, resecsis omnino parte uteri anteriori, ac Placentâ ei adhærente.*

This image of the gravid (pregnant) uterus at nine months is an engraving from a drawing by Dutch artist Jan Van Rymsdyk. It was published in William Hunter's *Anatomia uteri humani gravidi tabulis illustrata*, 1774 (The Anatomy of the Human Gravid Uterus Exhibited in Figures), the best known and most important obstetrical atlas of its era. Hunter decided to produce this atlas when, in 1750, he made a

rare acquisition – namely, the cadaver of a woman who was nine months pregnant. At this time, when most cadavers were sourced from executed criminals, female bodies, especially pregnant ones, were extremely rare. The book took over 20 years to complete and, by the time it was finished, William and his brother John had together dissected 11 more cadavers. The book is famed for the breadth

of its content and its exceptional illustrations, drawn (and printed) at the size of life, directly from dissections. Like the work of Bidloo and Lairesse, these are portraits of individual dissections rather than idealized composites. This image in particular – with its meat-like, amputated thighs – has a rawness and immediacy evoking a real, unembellished dissection.

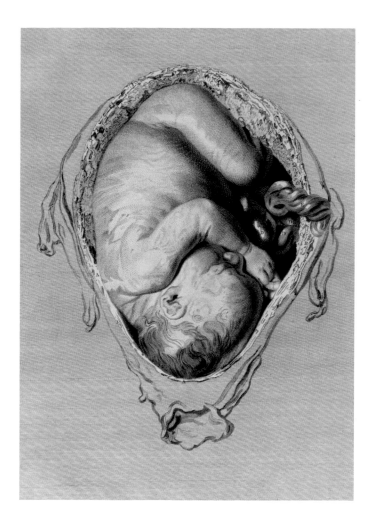

A delicate and sensitive copperplate engraving by J.C. Bryer after Jan Van Rymsdyk shows a uterus containing an eight-month-old fetus, the head positioned towards the vagina, from William Hunter's famed *Anatomia uteri humani gravidi tabulis illustrata*, 1774. For an unknown reason, perhaps a dispute between author and artist, Van Rymsdyk was not credited or even mentioned by name in the publication. The book was one of only two medical books published by the famous printer John Baskerville, after whom the classic Baskerville typeface is named.

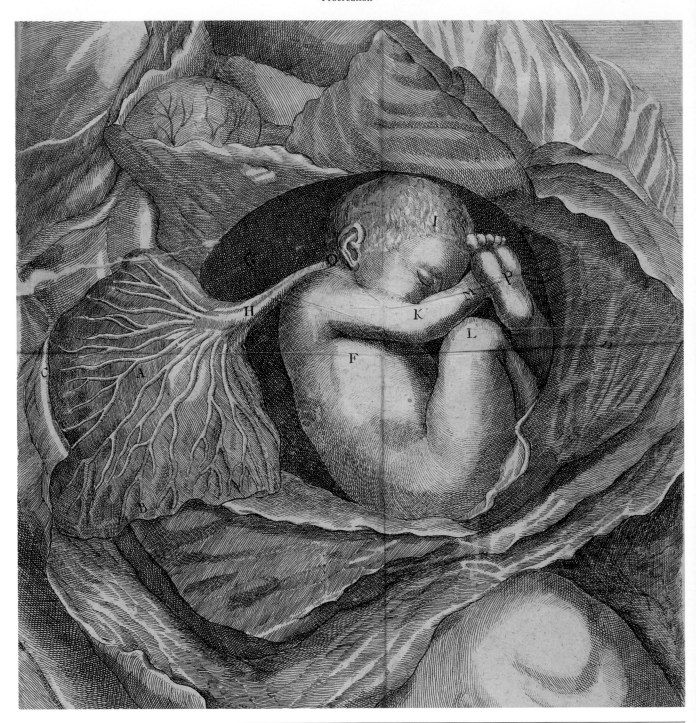

Here we have a tender copperplate engraving of a tranquilly curled fetus in a womb peeled back like a cradle of leaves. It comes from Silesian midwife Justine Dittrich Siegemund's *Die Chur-Brandenburgische Hoff-Wehe-Mutter*, 1690 (The Court Midwife of the Electorate of Brandenburg). Siegemund, also known as Siegemundin, became interested in midwifery when she had the misfortune of being attended by a poorly trained midwife. She subsequently educated herself on the topic, and eventually became the best-known practitioner. She was midwife to the Court of the Elector in Brandenburg, but also provided free midwifery to those in need. This book was a practical manual for midwives, presenting common problems one might encounter attending a birth and how they might be solved.

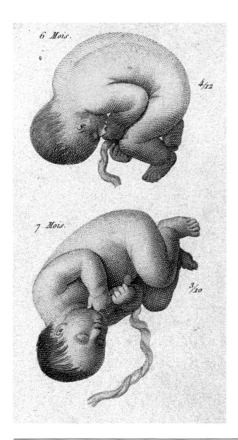

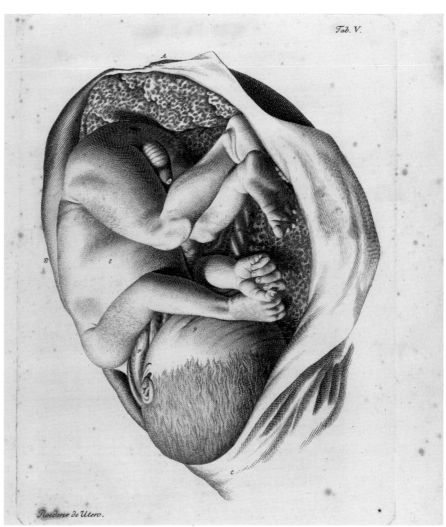

↑ A watercolour-
augmented etching
from an unknown
publication, showing
fetal development at six
and seven months.

↑ An image of a
curled fetus exposed
in the womb, from
German physician and
obstetrician Johann
Georg Roederer's
*Icones uteri humani
observationibus
illustratae*, 1759
(Images of the
Human Womb,
with Explanatory
Observations). It
appears that the
umbilical cord is
wrapped around
the fetus' neck, a
potentially dangerous,
if not fatal, situation.

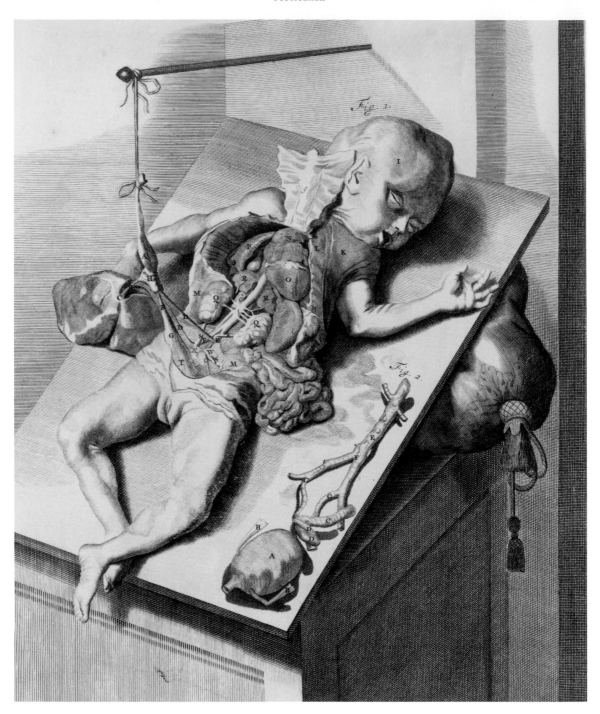

↟ This grim image of a newborn girl with her thorax and abdomen dissected was originally created by Gérard de Lairesse for Govard Bidloo's *Anatomia humani corporis*, 1685, and republished, without credit, in William Cowper's *The Anatomy of Humane Bodies*, 1698. The sternum and part of the ribs are reflected upward to reveal the heart and right lung, and the liver has been removed and set to the child's right side. The organ pulled out and suspended from the pole might be the bladder.

→ An illustration of a male fetus with placenta from the same publication. These illustrations, portraits of actual dissections, are renowned for their lack of idealization or sentimentality.

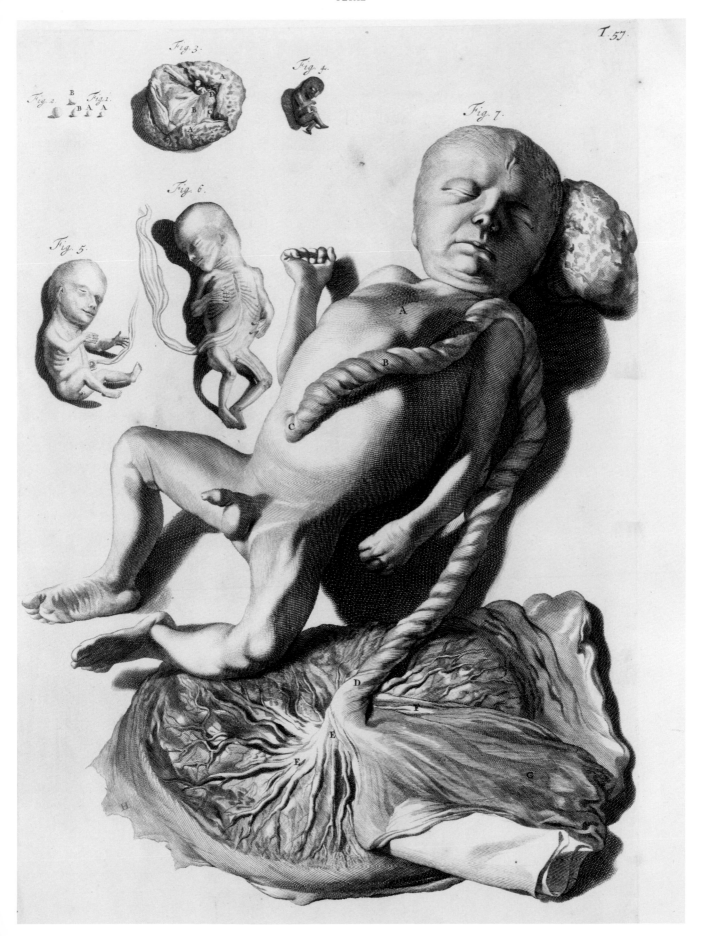

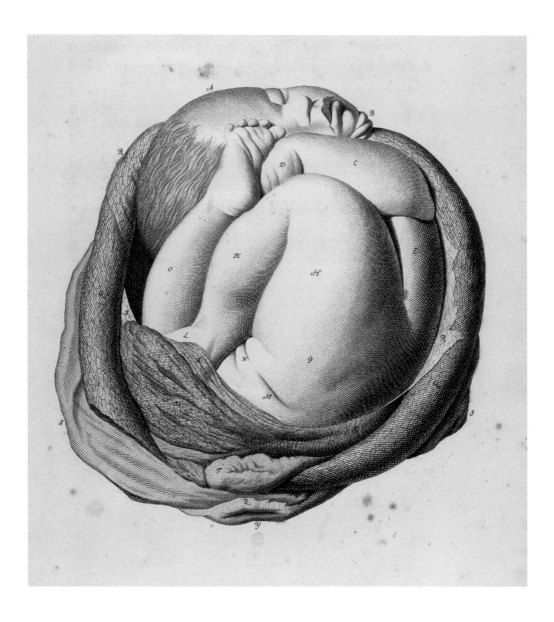

↑ This image, of a fetus curled snugly within the amniotic sac, is drawn from Johann Georg Roederer's *Icones uteri humani observationibus illustratae*, 1759 (Images of the Human Womb, with Explanatory Observations). The letter (B) calls out the umbilical cord wrapped around the fetus' neck; (Q) is the uterine wall; (R) the cut wall of the amniotic sac; (S) the anterior (or frontal) abdominal wall; (T) the bladder; (U) the placenta, and (Y) is the cervix.

→ Here we have a characteristically sensitive hand-coloured line engraving by William Home Lizars of a dissection of the uterus in the later stages of pregnancy, showing the fetus, in position for delivery, with the uterine wall, umbilical cord and placenta in stunning detail. It was published in John Lizar's *A System of Anatomical Plates of the Human Body*, 1822–6. The image calls out the anatomical features with letters; some of the most noteworthy: (a) is the anterior abdominal wall pulled back to allow for a better view, (P) is the transverse colon; (O) is the ascending colon; (E) is the cervix; (*p*) is the placenta; (M) is the caecum, a pouch connected to the junction of the small and large intestines; (K) is the uterine wall and what seems to be marked (K*) are the fallopian tubes.

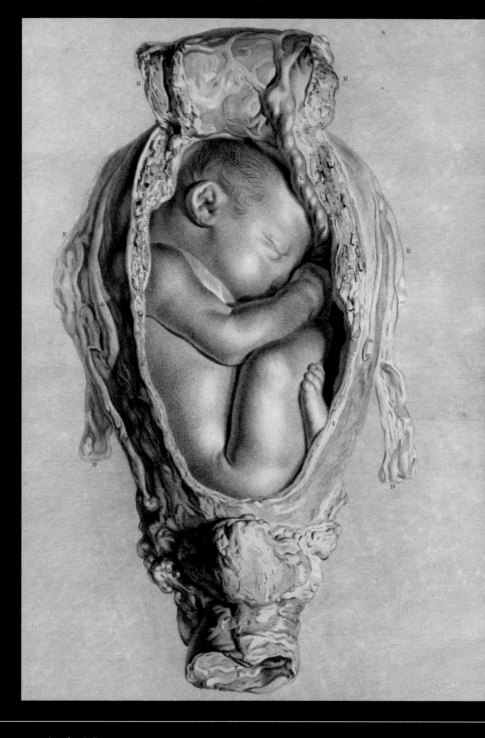

This copperplate engraving by J.C.
Bryer after a drawing by Dutch artist
Jan Van Rymsdyk shows a dissection
of a pregnant uterus containing a
nine-month-old fetus, its head facing
upwards. It is drawn from an 1851
reprint of William Hunter's *Anatomia*

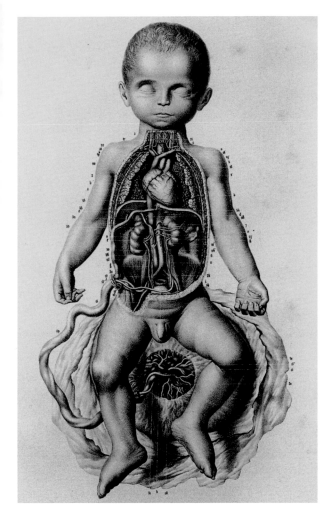

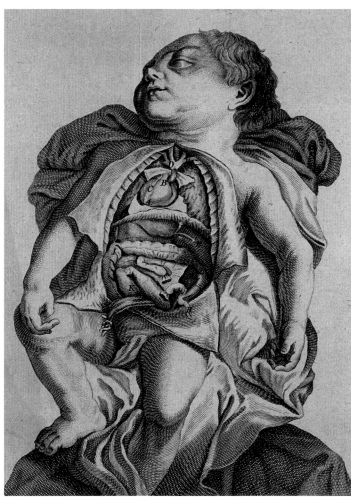

↑ Drawn by Nicolas-Henri Jacob for Jean-Baptiste Marc Bourgery's *Traité complet de l'anatomie de l'homme comprenant la médicine opératoir...*, 1831–54, this illustration shows a male fetus with the thorax and abdomen opened. The heart, lungs, diaphragm, kidneys (with adrenal glands on top) are beautifully drawn. The great vessels of the heart, along with the inferior vena cava and abdominal aorta and their branches, are emphasized. The umbilical cord and placenta are also shown. The placenta has been sectioned to allow a better view of its interior vasculature.

↗ A post-mortem dissection of a child born with reversed viscera, a congenital condition in which the major organs have developed mirrored, or reversed, from their usual positions. This illustration comes from the polymath Comte de Buffon's 44-volume *Histoire naturelle, générale et particulière, avec la description du cabinet du Roi,* 1749–1804 (Natural History, General and Particular, with a Description of the King's Cabinet).

Upper Body

The upper body is the home of our internal organs and protective ribcage. Crowning this magnificent structure is the head, which not only conveys our individuality and personality via the face and its expressions, but also is home to four out of five of our sense organs: the mouth, the nose, the ears, and the eyes. Along with the skin, which covers our entire body, these senses are the means of internalizing our experience of the world. It is no wonder, then, that the Ancient Greeks and Romans thought that the head contained immortal life, while many ancient cultures saw it as the realm of power, soul and vitality, along with the essential spirit.

The features of the face, the head and the hands have also served as the basis for systems that attempt to 'read' a person's character, from physiognomy to phrenology, eye charts to chiromancy, or palm reading.

In the adult female body, the upper body is also the site of the breast, ancient symbol of fecundity and the powers of sustaining life, and today a focus of erotic fascination. As the chief source of infant nutrition, female breasts and nipples are crucial structures of anatomy, but their first comprehensive depiction did not come until the mid 19th century.

FIG. 5.

↑ Here we have a diagram of teeth, which includes the deciduous (milk) teeth (1) – incisors (a), canines (b) and molars (c); tooth germ (2 and 3). At the bottom is the jaw of a six-year-old (6), which shows the adult teeth below the milk teeth and almost ready to displace them. The illustrations were perhaps made by a printmaker and forensic medical scholar.

↑ Another illustration showing the milk teeth and how they relate to the underlying permanent teeth developing in the jaws. This image comes from George Read Matland's *The Teeth in Health and Disease*, 1902.

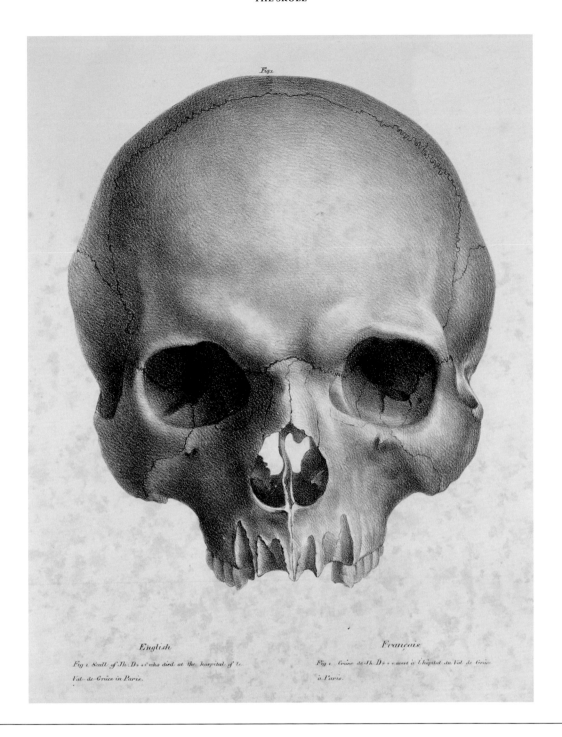

Fig.1

English

Fig 1 Skull of Jh. D*** who died at the hospital of le
Val-de-Grâce in Paris.

Français

Fig 1 Crâne de Jh. D*** mort à l'hôpital du Val de Grâce
à Paris.

According to the caption, this is an illustration of the 'Skull of Jh D***, who died at the hospital of Le Val-de-Grâce in Paris'. It is taken from Joseph Vimont's *Traité de phrénologie humaine et comparée*, 1832–5 (Treatise on Human and Comparative Phrenology) which featured 120 life-sized lithographs of human and animal skulls. Phrenology – a pseudo-science in which the bumps and dents in the skull were 'read' to determine character traits – was being debunked by the late 1840s, but continued to be popular with the general public until the end of the 19th century. Vimont's book compares the skulls of people with various talents or mental issues; it also compares the skulls of different ethnicities, foreshadowing the scientifically corrupt work of the eugenics movement and the Nazis.

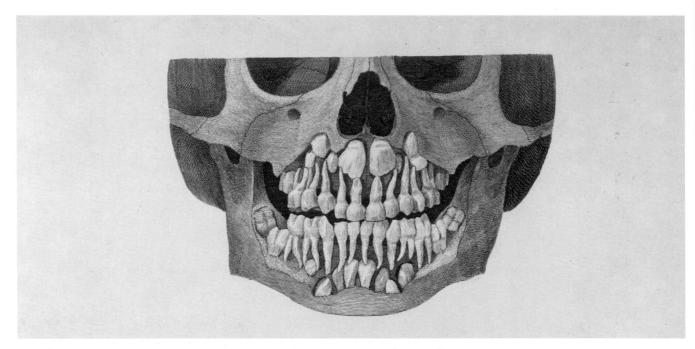

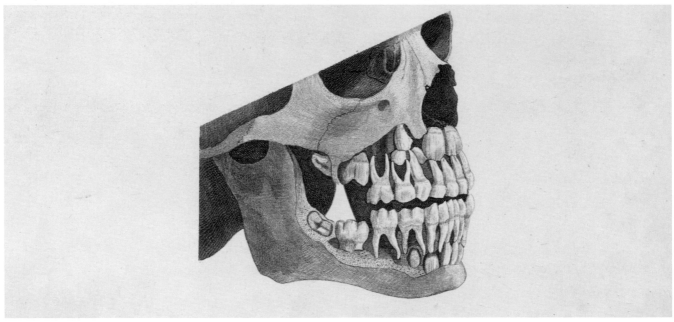

↑ Two views of the skull of a child between four and five years old, illustrating the growth of the teeth. It is drawn from Joseph Fox's *The Natural History and Diseases of the Human Teeth*, 1806. The upper image shows a frontal view of a child's skull, with the milk teeth erupted, and the permanent teeth pushing through behind them. The lower image depicts the same, but from a side view.

→ An illustration of a child's skull, showing the milk teeth erupted and the permanent teeth pushing through behind them.

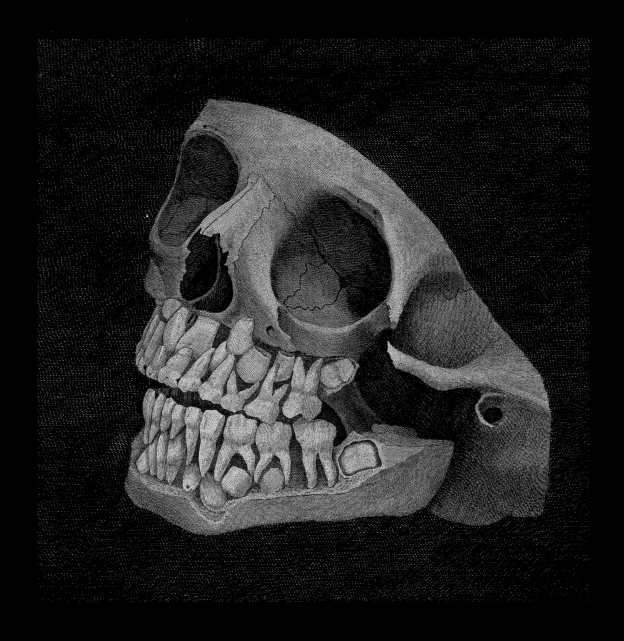

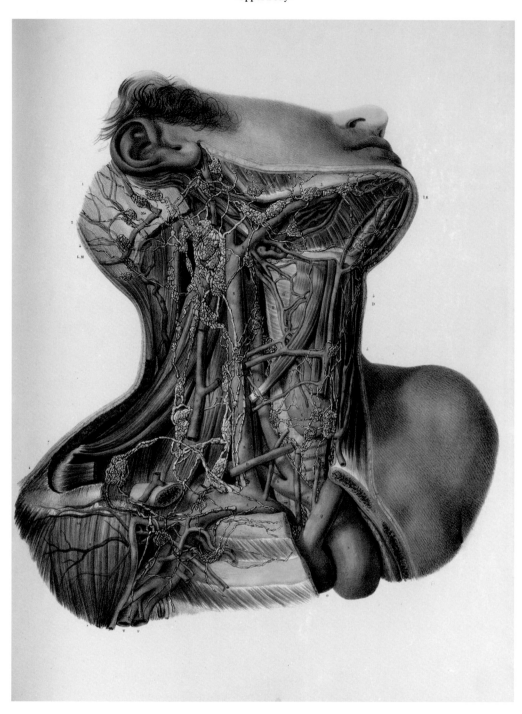

This stunning and highly detailed illustration of a head and neck dissection focuses on the lymphatic vessels and the veins. It was created by Nicolas-Henri Jacob and was featured in Jean-Baptiste Marc Bourgery's *Traité complet de l'anatomie de l'homme comprenant la médicine opératoir...* , 1831–54.

In the illustration, the thick blue jugular vein is prominently shown as it transitions into the brachiocephalic vein, which becomes the superior vena cava, entering the heart via the right atrium. The sternum seems to have been removed as the ribs are seen in cross-section, showcasing the aortic arch beneath.

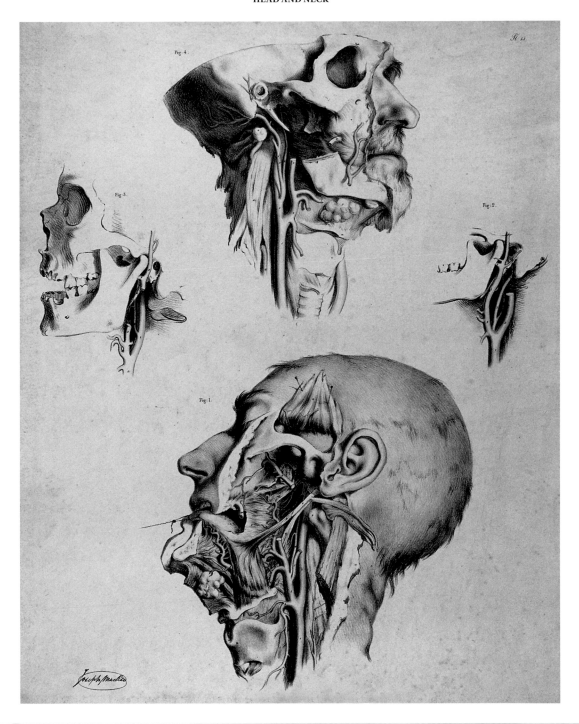

A coloured lithograph by Joseph Maclise of a crude dissection of the head showcasing the circulatory system of the face, with arteries and blood vessels signified by red watercolour detailing. It comes from Richard Quain's *The Anatomy of the Arteries of the Human Body ...* , 1844. The top illustration depicts a deep dissection of the head and neck, with the common carotid artery and part of the facial artery rendered in red. The bottom illustration shows a deep dissection of the head and neck, with the temporalis muscle (which aids chewing) lifted to reveal the temporal bone.

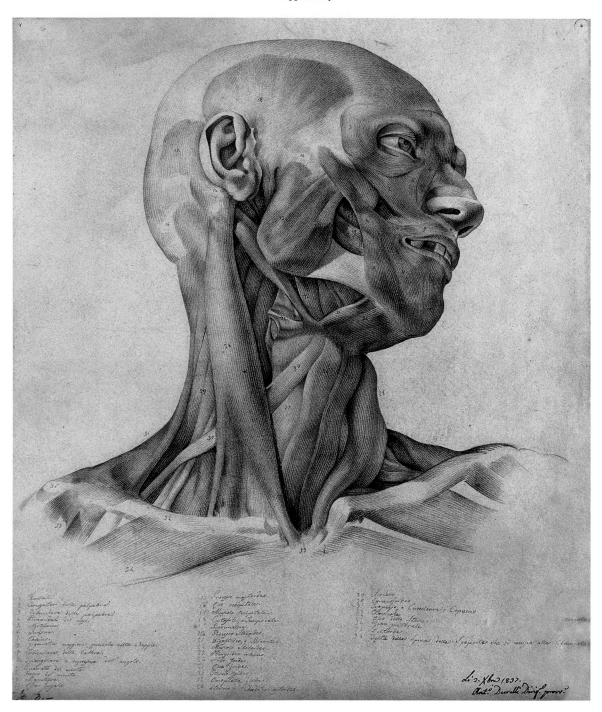

For most of human history, people have believed that the head contains their essential spirit or, in some cultures, their soul. It is certainly the part of the body through which we most strongly read the emotions and character of others. For this reason, mastering the anatomy of the head and face has been essential to representational artists since the Renaissance.

↑ In this extremely expressive chalk and pencil drawing from 1837 by the Italian artist Antonio Durelli, we see the *écorché* head of a man, revealing the muscles and tendons of the head and neck, possibly an anatomical study for one of the artist's finished pieces.

→ This is a richly coloured mezzotint by the French anatomist and printing pioneer Jacques-Fabien Gautier d'Agoty. The light-coloured structure in the skull is the *falx cerebri*, the thick section of *dura mater* that separates the two hemispheres of the brain. The *dura mater* (Latin for 'hard mother') is the thick

outermost covering of the brain and spinal cord. Below we can see the *corpus callosum* (literally 'tough body'), a thick nerve tract connecting the left and right sides of the brain and that allows them to communicate. The beautiful tree-like branching of the cerebellum is seen below. The frontal sinus, as the name

suggests, is visible at the front of the skull, and the sphenoid sinus is seen deep in the middle of the skull. These are among the many sinuses (air-filled spaces) found in the skull and are designed to make it lighter, while also producing mucus that brings moisture to the nose.

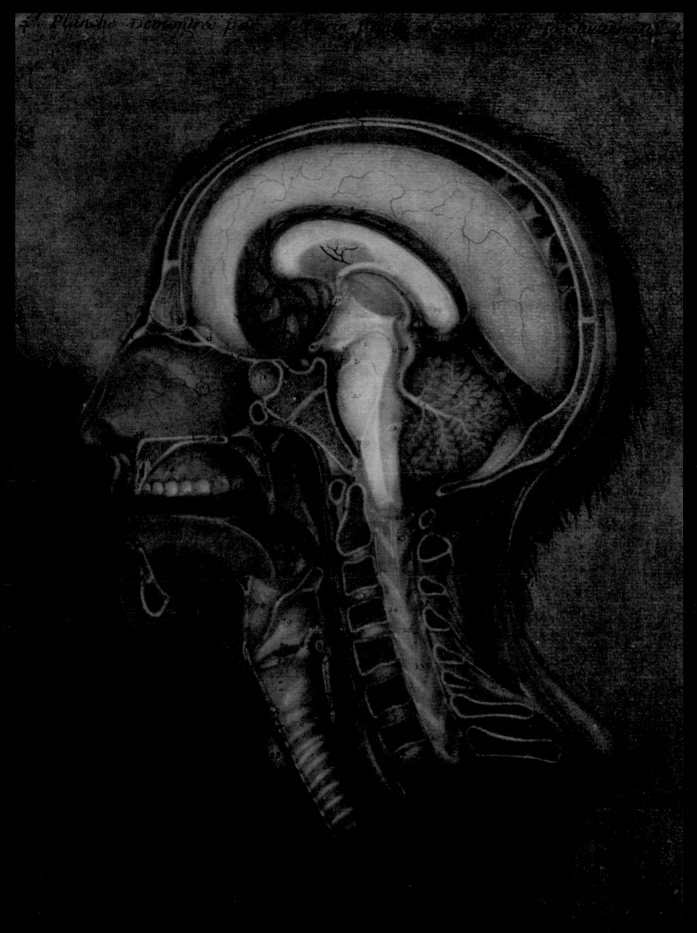

TAB XLVI. Part 3.

PL. 87.

Fig. 1.

Fig. 2.

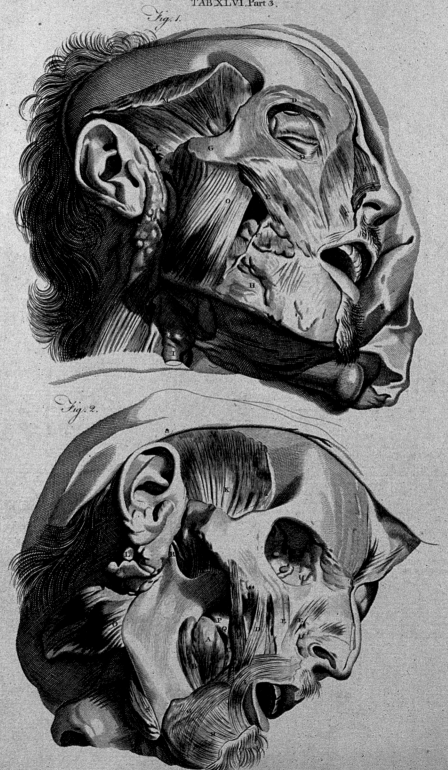

A.Bell. Prin. Wal. Sculptor fecit.

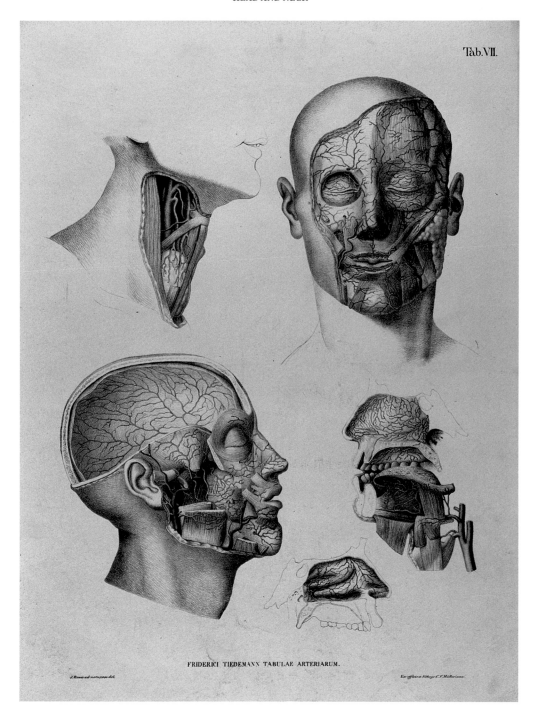

Tab.VII.

FRIDERICI TIEDEMANN TABULAE ARTERIARUM.

↞ These illustrations showcase two levels of a dissection of the head of a man, with a focus on the facial and masticatory muscles, and also showing the salivary ducts, external ear and parotid gland. They were drawn by Gérard de Lairesse for Govard Bidloo's *Anatomia humani corporis*, 1685.

↑ This striking lithograph depicts dissections of the face, neck and jaw of a man. The blood vessels have been added in red watercolour. It was rendered by the German artist Jakob Wilhelm Christian Roux for *Tabulae arteriarum corporis humani*, 1822, by Friedrich Tiedemann, a fellow countryman. Tiedemann is famous for his work on the anatomy of the brain, and for an article in which he contested contemporary scientific assertions that the brains of black people were smaller than those of whites.

This Japanese woodcut chart, showing the moxibustion points on the head and face, comes from an 1807 work by the Japanese physician Hara Masakatsu. Moxibustion is a therapy that treats acupuncture points with heat rather than needles. The points have very poetic names, including 'Upper Star', 'Portal of Muteness', 'Connecting with Heaven' and 'Jade Pillow', reminding us that Chinese medicine, from which this therapy was drawn, is all about correspondences between parts of the body, and between the body and the universe.

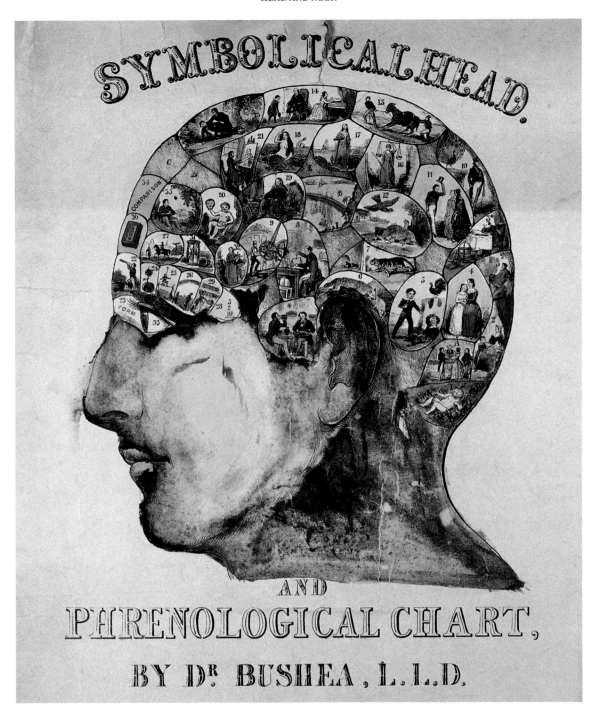

Here we have a phrenology chart by self-proclaimed Dr Bushea, after O.S. Fowler, from around 1845. Phrenology was the creation of German physiologist and neuroanatomist Franz Gall. Phrenologists believed that a person's characteristics were compartmentalized in certain areas of the brain; the parts used most would grow larger, and the skull would grow to accommodate them. They believed it was possible to 'read' the resultant bumps and valleys of the head as a way of discerning character and temperament. Although considered a pseudo-science today, modern neuroscience confirms that phrenology's core idea of localized brain function was correct. Gall drew some of his ideas from the writings of Swedish polymath and mystic Emanuel Swedenborg. The lettering and numbering keyed to the image was explained thus: 'the design of this cut is to show the natural language of the mental organs situated in the various parts of the brain. For example – Veneration is represented by a devotional attitude; Benevolence, by the good Samaritan; Destructiveness, by the tiger destroying his prey; Sublimity, by the Niagara Falls; Acquisitiveness, by the miser weighing and counting his money; Causality, by Newton philosophizing on the falling of the apple ...'.

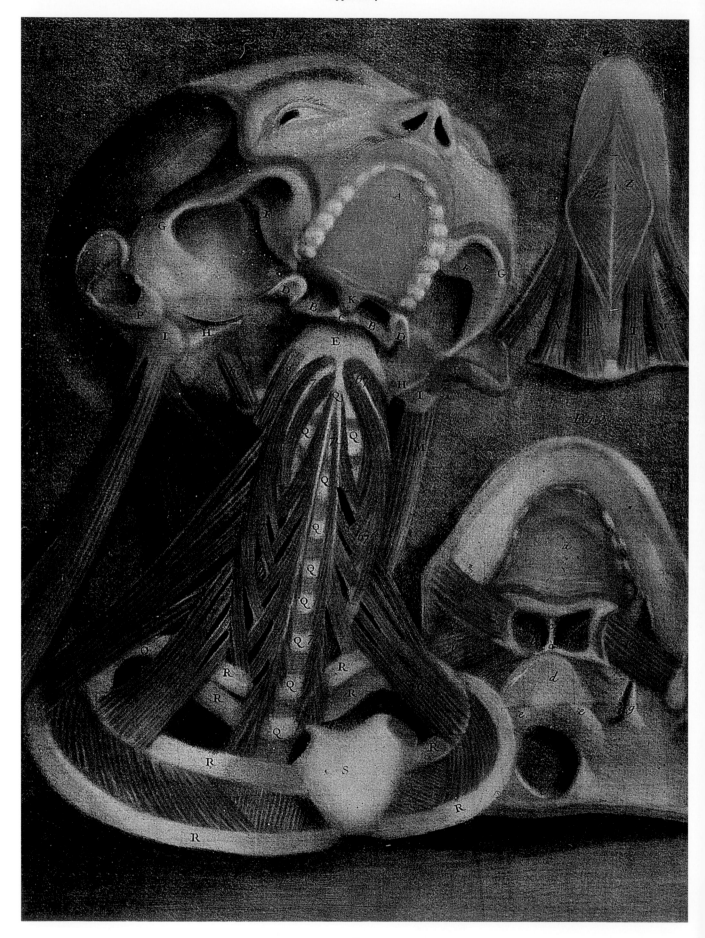

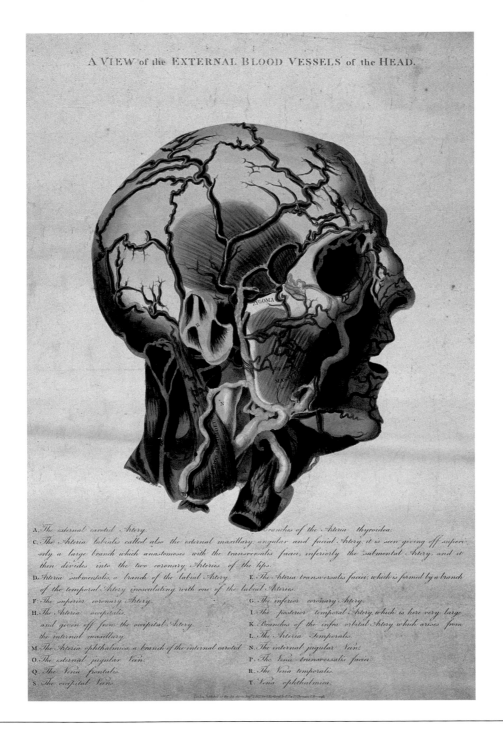

A VIEW of the EXTERNAL BLOOD VESSELS of the HEAD.

A. The external carotid Artery.

B. Branches of the Arteria thyroidea.

C. The Arteria labialis called also the external maxillary, angular and facial Artery: it is seen giving off superiorly a large branch which anastomoses with the transversalis faciei, inferiorly the sublmental Artery; and it then divides into the two coronary Arteries of the lips.

D. Arteria sublmentalis, a branch of the labial Artery.

E. The Arteria transversalis faciei, which is formed by a branch of the temporal Artery inosculating with one of the labial Arteries.

F. The superior coronary Artery.

G. The inferior coronary Artery.

H. The Arteria occipitalis, and given off from the occipital Artery the internal maxillary.

I. The posterior temporal Artery, which is here very large.

K. Branches of the infra orbital Artery which arises from the internal maxillary.

L. The Arteria Temporalis.

M. The Arteria ophthalmica, a branch of the internal carotid.

N. The internal jugular Vein.

O. The external jugular Vein.

P. The Vena transversalis faciei.

Q. The Vena frontalis.

R. The Vena temporalis.

S. The occipital Vein.

T. Vena ophthalmica.

← An atmospheric mezzotint of a dissection, showing the muscles of the neck, tongue and jaw, by Jacques-Fabien Gautier d'Agoty. This image was published in a book he co-authored with French anatomist Joseph Guichard Duverney, *Essai d'anatomie en tableaux imprimés ...* , 1746 (Illustrated Essay on Anatomy). D'Agoty's works, many of which were life-sized and augmented with hand-painted details, were intended for a general audience interested in human anatomy. The figure on the upper right depicts a dissection of the muscles of the posterior aspect of the pharynx (throat). These muscles function to push food into the oesophagus. On the lower right is an inferior (from below) view of the skull and jaw. The circular hole is the foramen magnum (literally 'big hole'), where the brain exits the skull and transitions into the spinal cord.

↑ Created by George Kirtland in 1815, this expressive and stylized line engraving with watercolour highlights shows the external blood vessels of the head. In it we can see some musculature, but the focus is on the arteries (in red) and the veins (in yellow) of the head and neck. This is unusual, as anatomical illustrations generally identify the veins in blue rather than yellow.

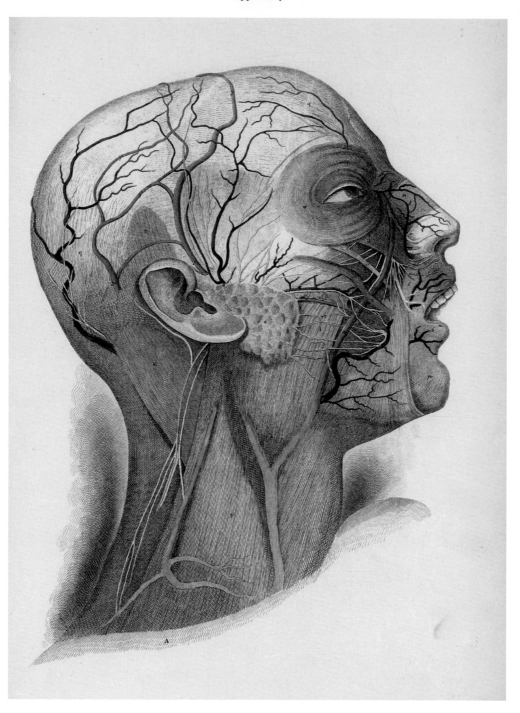

↑ This illustration shows a dissection of the head, with the arteries identified using red watercolour and the veins shown in blue. In it, we can see muscles of facial expression, including the frontalis, orbicularis oculi, nasalis, zygomaticus major and minor, and depressor anguli oris. Other larger muscles shown are the masseter, platysma, sternocleidomastoid and trapezius. The honeycomb-like structure beside the ear is the parotid gland, the largest of the salivary glands. This image was rendered by William Home Lizars for his brother John's book *A System of Anatomical Plates of the Human Body*, 1822–6.

→ This sensitive illustration of the pensive, skinless head of a man showcases the facial nerves and the muscles of facial expression.

The latter are beautifully drawn, as are the muscles of the neck. The nerves are depicted in white, and are shown elegantly branching to innervate the muscles of the head and neck. This illustration was published in Jones Quain's *A Series of Anatomical Plates ... Illustrating the Structure of the Different Parts of the Human Body*, 1836–42.

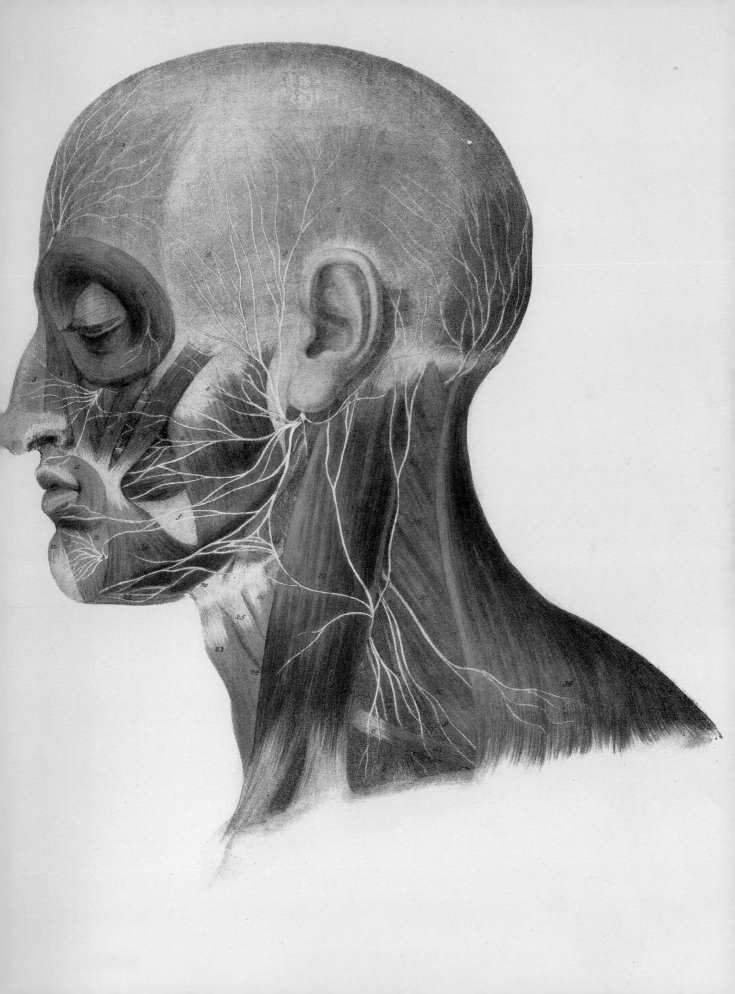

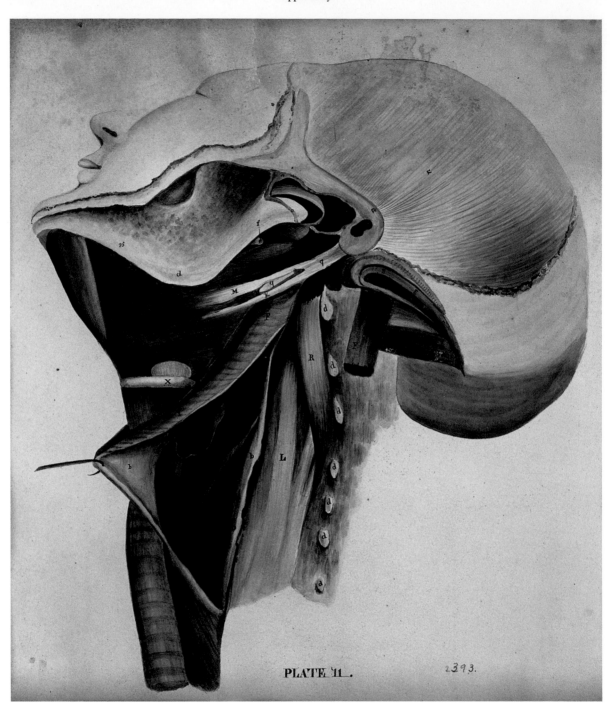

PLATE 11.

2393.

This highly stylized 19th-century watercolour shows a dissection of the head and part of the face, revealing the bones beneath. Its provenance is unknown, but it was possibly painted after a dissection by J. Lebaudy for the *Journal des connaissances médico-chirurgicales* (Journal of Medico-surgical Knowledge). In the image, we can see the jaw, from which the masseter muscle has been removed.

The small hook on the left side of the drawing seems to be pulling back the muscles of the pharynx. Inside the dark opening we can see the cut surface of the oesophagus, while on the front of the throat is the trachea (the long tube structure with striations). The light yellow structure labelled (X) is probably the hyoid bone, which supports the tongue.

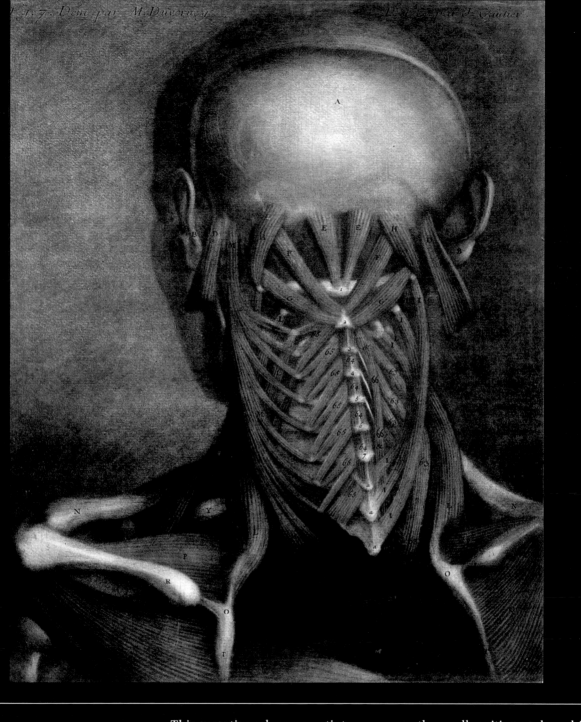

This evocative colour mezzotint, showing a dissection of the muscles of the head, neck and shoulders seen from behind, is the work of French artist and printmaker Jacques-Fabien Gautier d'Agoty, from *Essai d'anatomie en tableaux imprimés ...* , 1746, a book he co-authored with French anatomist Joseph Guichard Duverney. In it, we see the small capitis muscles, which, originating from the cervical spine and attaching to the occipital bone, act to rotate the head. Two of the four rotator cuff muscles can be seen on the scapula-supraspinatus and infraspinatus; these allow for rotation of the shoulder joint.

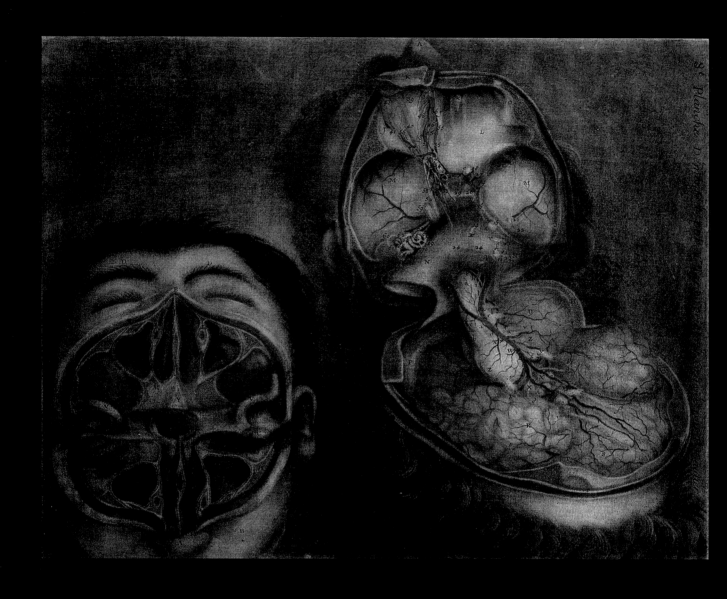

This mezzotint, featuring two human heads sliced open, was rendered by the artist, anatomist and printmaker Jacques-Fabien Gautier d'Agoty from dissections by M. Duverney for his book *Anatomie de la tête ...* , 1748 (Illustrated Anatomy of the Head).

↖ A cross-section through the head, revealing the inside of the large maxillary sinuses and the nasal concha. The masseter muscle (one of the muscles of mastication) is seen sectioned in terracotta red.

↗ A head sectioned at the level of the middle of the forehead, revealing the basicranium and the cut surfaces of the cranial nerves. The lower part of the illustration shows the inferior surface of the brain and brainstem. The vasculature is revealed in beautiful

detail and includes the Circle of Willis, named after the British physician Thomas Willis. This is the circulatory anastomosi – a connection or opening between two things, especially cavities or passages – that supplies blood to the brain.

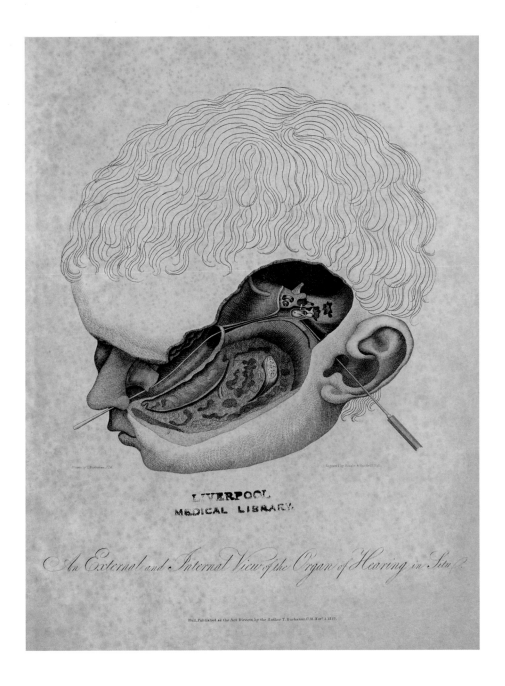

The face of a child, with a cutaway showing the internal structure of the ear. This illustration comes from Ernst Friedrich Wenzel's *Anatomischer Atlas über den makroskopischen und mikroskopischen Bau der Organe des menschlichen Körpers*, 1874 (Anatomical Atlas on the Macroscopic and Microscopic Structure of the Organs of the Human Body).

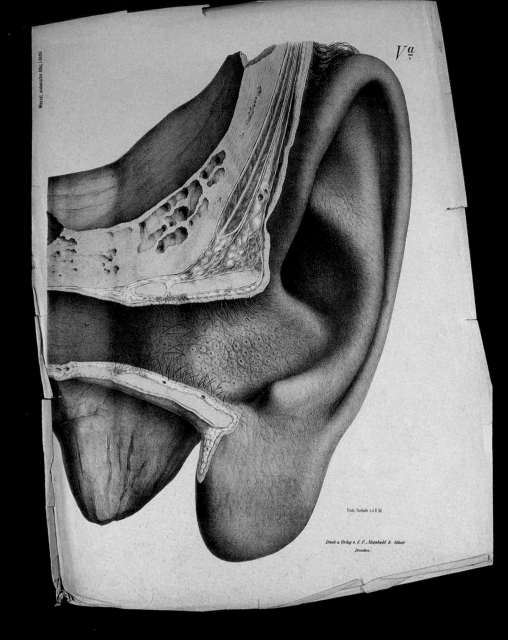

The ear was often considered the seat of memory, receptivity and inquisitiveness. In this colour lithograph, we see the external structure rendered in great detail, showcasing the anatomy of the ear canal, its associated cartilages, and the temporal bone, including the mastoid process (the large lump at bottom left), and the sectioned out temporal muscle (seen in red). It was featured in Ernst Friedrich Wenzel's *Anatomischer Atlas über den makroskopischen und mikroskopischen Bau der Organe des menschlichen Körpers*, 1874.

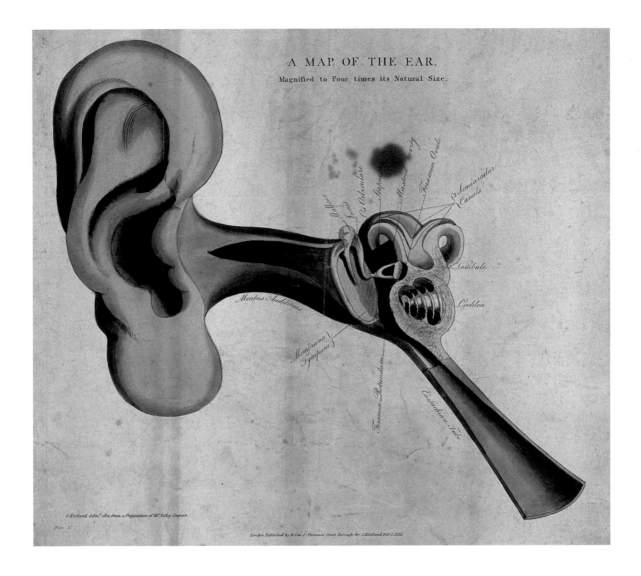

A MAP OF THE EAR.
Magnified to Four times its Natural Size.

Drawn by George Kirtland in 1801 and published in 1815, this highly stylized coloured line engraving of the human ear shows both its inner and outer parts. Its subject is similar to the one on the page opposite, but shows more detail, with the inclusion of the tympanic membrane (eardrum), middle and inner ear structures and Eustachian tube. It was drawn from a medical preparation (a preserved specimen) prepared by the famous English surgeon and anatomist Sir Astley Cooper, and the text specifies that it was magnified to four times its natural size.

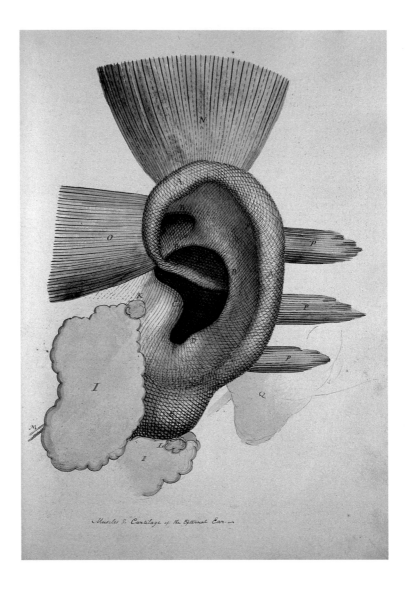

Muscles & Cartilage of the External Ear

↑ An ink and watercolour drawing of the ear, showcasing its muscles and cartilage. In it we see the external ear structures, including the helix (A), tragus (C), antitragus (D) and lobule (E). The yellow structure (I) is a simple representation of the parotid gland (the largest salivary gland). The striated structures surrounding the ear are the auricular superior (N), anterior (O) and posterior (P) muscles, which enable the ears to be wiggled. The faint structure behind the ear (Q) is the mastoid process of the temporal bone, which houses the middle and inner ear. The drawing is by an unknown maker and dates to sometime in the 19th century.

→ This detailed engraving features the anatomy of the inner ear, and the vestibular apparatus or labyrinth, which helps us to establish a sense of balance. These complex structures include the cochlear labyrinth and the three semicircular canals (these looping structures are part of the cochlea). The engraving was created by Thomas Milton, and comes from an 1808 series of images depicting human and animal anatomy.

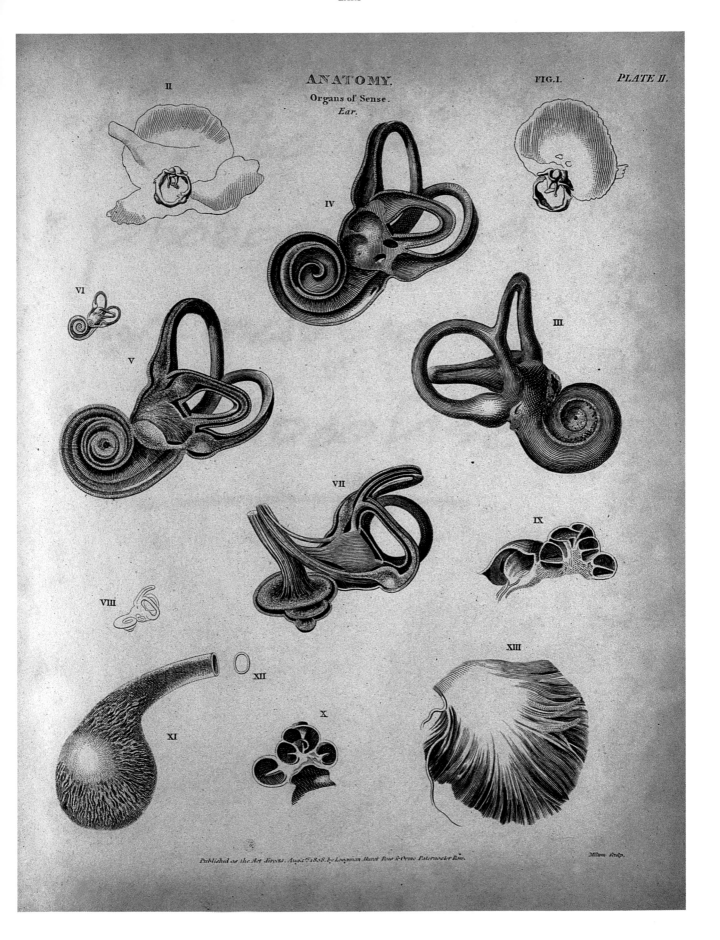

ANATOMY.
Organs of Sense.
Ear.

FIG.I.

PLATE II.

II

IV

VI

V

III

VII

IX

VIII

XIII

XII

XI

X

Published as the Act directs, Aug.t 1.st 1808. by Longman Hurst Rees & Orme Paternoster Row.

Milton Sculp.

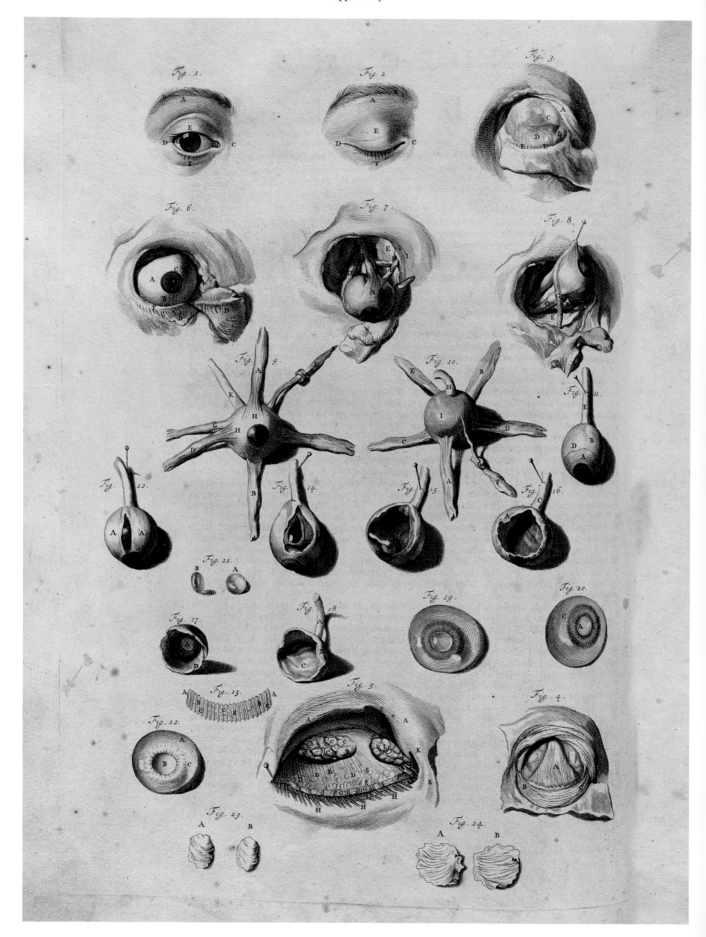

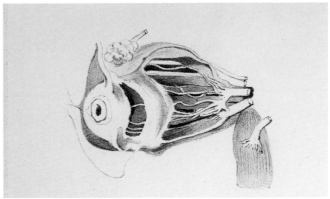

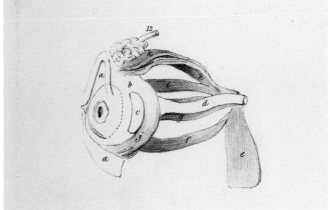

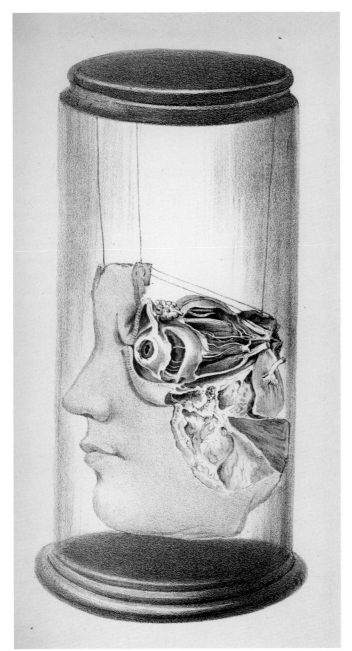

← Taken from Andrew Bell's *Anatomia Britannica: a system of anatomy ...* , 1798, this image shows the eye from different perspectives and in various dissections. The plate starts in the upper left with an undissected eye drawn both open and closed, and slowly progresses through a series of increasingly deep dissections. Figures 21 and 22 illustrate the lenses removed from the eyes. The book reproduced hundreds of illustrations gathered from a variety of well-known medical atlases. The image seen here was taken from William Cowper's *The Anatomy of Humane Bodies*, 1698.

↑ Here we have a wet preparation (specimen preserved in fluid), of a child's face dissected to highlight the structure of the eye. Taken from *The Transactions of the Provincial Medical and Surgical Association*, 1833, it shows the globe of the eye in situ within its orbit, and we can see the iris, sclera, optic nerve and extrinsic muscles of the eye, with the oculomotor nerve and its branches. The lacrimal gland, which creates tears, is visible on top of the eye globe.

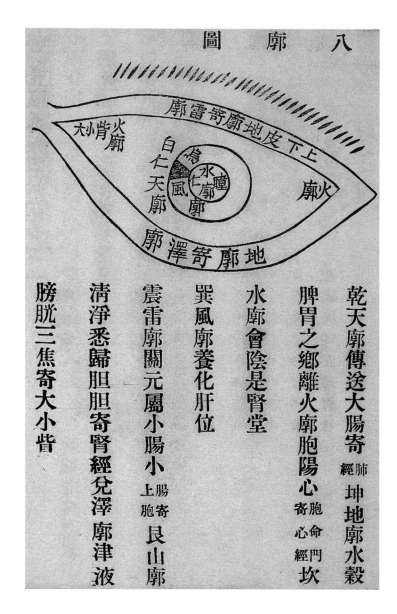

The woodcut shown here comes from *Yan ke zuan yao* (Compiled Essentials of Ophthalmology), published in the newly founded Chinese Republic in 1914. The accompanying text labels the regions of the eye and notes their correspondences, an essential part of holistic traditional Chinese medicine. The white of the eye belongs to the heaven region, and corresponds to the lung and large intestine. The upper and lower eyelids are of the earth, thunder and marsh or lake regions, and correspond to various organs, including the spleen, stomach, small intestine and bladder. The places where the upper and lower lid meet are of the fire region, and correspond to the heart, pericardium (heart envelope) and right kidney, considered to be the 'Portal of Life'. The cornea is of the wind region, and corresponds to the liver. Finally, the pupil is of the water region, and corresponds to the kidney.

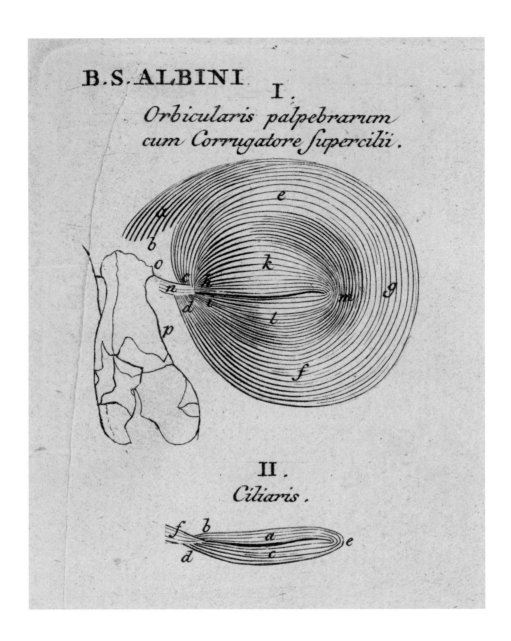

Detail showing the muscles of the eye, an illustration from *Tabulae sceleti et musculorum corporis humani*, 1747, by Bernhard Siegfried Albinus. This simple illustration beautifully showcases the relationship between the muscles of facial expression that surround the eye. The largest is the sphincter muscle, *orbicularis oculi*, which allows the eye to open and close. This muscle can also allow for voluntary action, such as winking and squinting. The smaller muscle corrugator is called the 'frowning' muscle because it draws the eyebrows downward. Many of the muscles of facial expression interdigitate, meaning that their fibres overlap and intertwine with nearby muscles. This in turn implies that many facial expressions depend on numerous muscles working in concert.

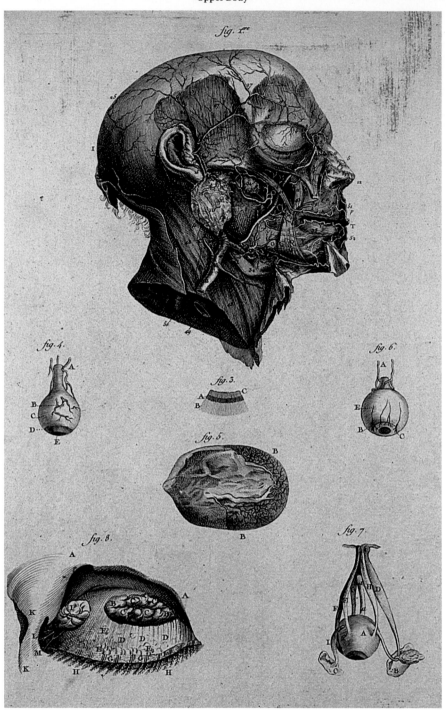

↑ An image of a dissected human head, along with some studies of the eye, as seen in Denis Diderot's influential *Encyclopédie, ou dictionnaire raisonné des sciences, des arts et des métiers*, 1751–72.

→ A surreal and macabre colour mezzotint showing the musculature of the face, created in 1773 by Arnaud-Éloi Gautier d'Agoty, whose father, Jacques-Fabien, pioneered coloured anatomical artwork. The illustration was one of many that Arnaud created for *Cours complet d'anatomie*, 1773

(Complete Anatomy of the Body) by J.B.H. Leclerc. In an eloquent summation of the paradox at the heart of artistic anatomy, Arnaud observed, 'For men to be instructed, they must be seduced by aesthetics, but how can anyone render the image of death agreeable?'

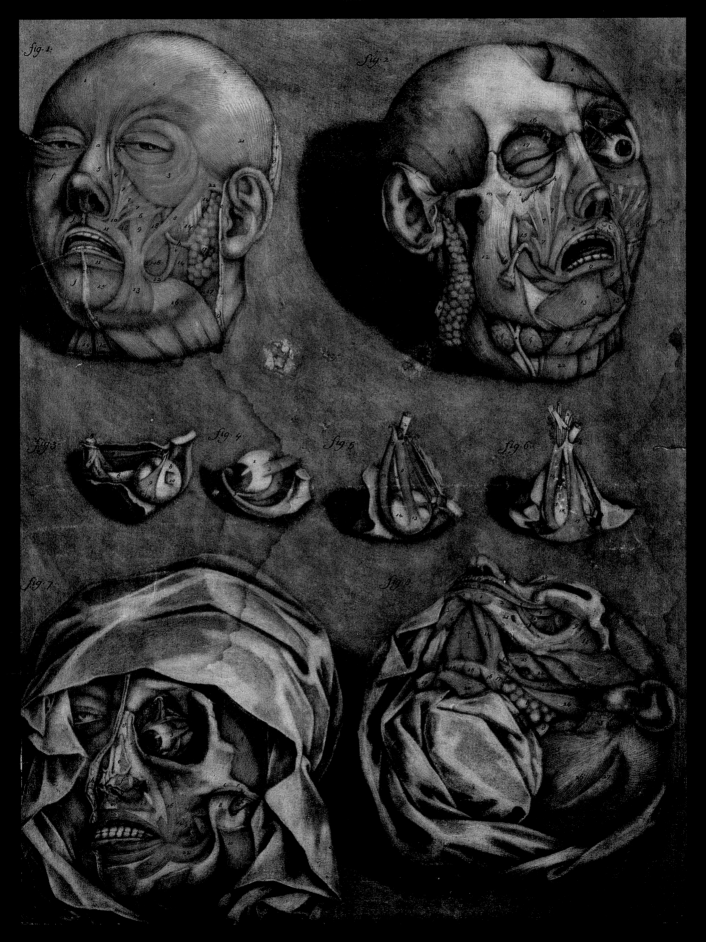

A famous chart published by the French policeman, criminologist and anthropologist Alphonse Bertillon. Bertillon was frustrated by the police force's inability to track repeat offenders by anything but their names, which could of course be easily changed. He therefore devised what he called 'anthropometry', a scientific system for recording the proportions and defining characteristics of the human body for use in criminal investigation. 'Bertillonage', as it came to be known, was widely used from 1882, until it was superseded by fingerprinting. This chart, entitled 'Tableau des nuances de l'iris humain' (Table of Shades of the Human Iris) was a fold-out insert in his book *Identification Anthropométrique: Instructions Signalétiques Album*, 1893 (Identifying People by Bodily Characteristics: How to Read Signs), which was intended to help readers make systematic observations of eye colour.

S de l'IRIS HUMAIN

tation jaune-orange d'après la Méthode

ERTILLON

LISTE DES ABRÉVIATIONS ET SIGNES USITÉS
DANS LES FORMULES DESCRIPTIVES DE L'IRIS

Formes de l'auréole
- a auréole absente ou peu accentuée
- d » dentelée
- c » concentrique
- r » rayonnante
- d-c » dentelée-concentrique, etc.

Nuance fondamentale de la périphérie
- az. azurée
- i. intermédiaire (violacée)
- ard. ardoisée

Qualités du pigment
- j jaune
- or orange
- ch chatain
- mar marron

Ton de la nuance
- cl clair
- m moyen
- f foncé

v. verdâtre
id. indique que la pigmentation de la périphérie est de nuance identique à celle de l'auréole. (v. colonne R).

Le soulignement attire l'attention sur la prédominance tonale du terme souligné tandis que la parenthèse signifie que le qualificatif entouré ne figure là que pour mémoire, notamment pour les besoins de la classification. Le signe ≡ inscrit en avant de la troisième ligne indique au contraire que les deux zones analysées séparément, auréole et périphérie, ont dans la coloration générale de l'œil une importance chromatique égale.

CLASSE **4** : Pigmentation **châtain** CLASSE **5** : Pigmentation **marron en cercle** CL. **6** : Pigmⁿ **marron verdâtre** et Cl. **7** : **marron pur**

	K	L	M	N	O	P	Q	R
m.	4-5-6-3	4	5-4	5-6-4	5	6-4-5	6-7	7
cl.	r. ch. cl.	r. ch. m.	r. mar. cl.	r. mar. cl.	r. mar. m.	r. mar. cl.	r. mar. m.	r. mar. m.
	ch. v. m.	= j. v. cl.	= j. v. cl.	≡ ch. cl.	= j. v. m.	= mar. j. v. cl.	mar. (j. v.) m.	id.
	4-5	4-6	5-4	5	5-6	6-5	7-6	7
cl.	r. ch. m.	r. ch. m.	r. mar. m.	r. mar. m.	r. mar. m.	r. mar. m.	r. mar. f.	r. mar. f.
	or. (v.) m.	ch. (j.) cl.	ch. j. v. m.	= j. v. m.	j. v. m.	j. v. m.	mar. (j. v.) m.	zone ext. nacrée
f.	4	4-5	5	5	5-6	6-7	6-7	7
m.	r. ch. m.	r. ch. f.	r. mar. m.	r. mar. f.	r. mar. f.	r. mar. f.	r. mar. f.	r. mar. tr. f.
	ard. j. v. f.	= ard. j. v. f	ard. v. m.	= ard. j. v. m.	ard. v. tr. f.	mar. j. v. f.	mar. (j.) f.	id.

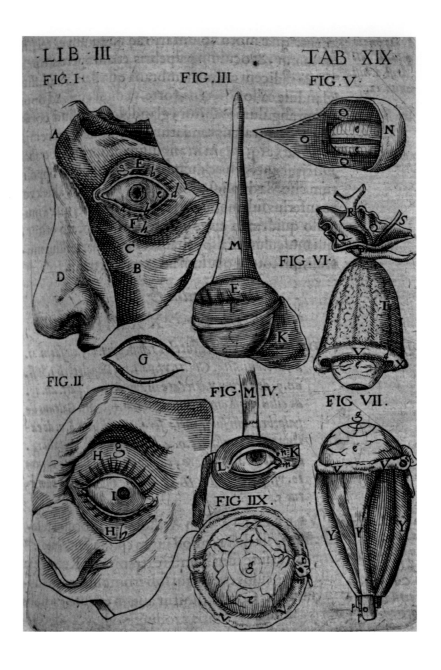

The eye has been called 'the window to the soul', and a single isolated eye is a common symbol in many different cultures. In ancient Egypt, the 'Eye of Horus', god of the sky, was used as an amulet for health and protection. In the Christian tradition, it represented the all-seeing eye of God – the 'Eye of Providence'. When enclosed in a triangle, it represents the Holy Trinity. It is also used to symbolize the idea of spiritual insight, intuition or wisdom.

↖ This illustration is from Swiss anatomist, botanist and physician Caspar Bauhin and engraver Theodor de Bry's *Theatrum anatomicum*, 1605. This popular book was valued as the most comprehensive of its time, notable for its systematic approach and its practical illustrations. Bauhin is famous for having introduced a new nomenclature for anatomical naming, partly still in use today, which made the identification of anatomical structures much easier. The images show dissections of the eye both in situ and extracted from the body.

→ This illustration, containing ten views of the human eye, comes from an 1809 album of engravings on human and animal anatomy by the English artist Thomas Milton.

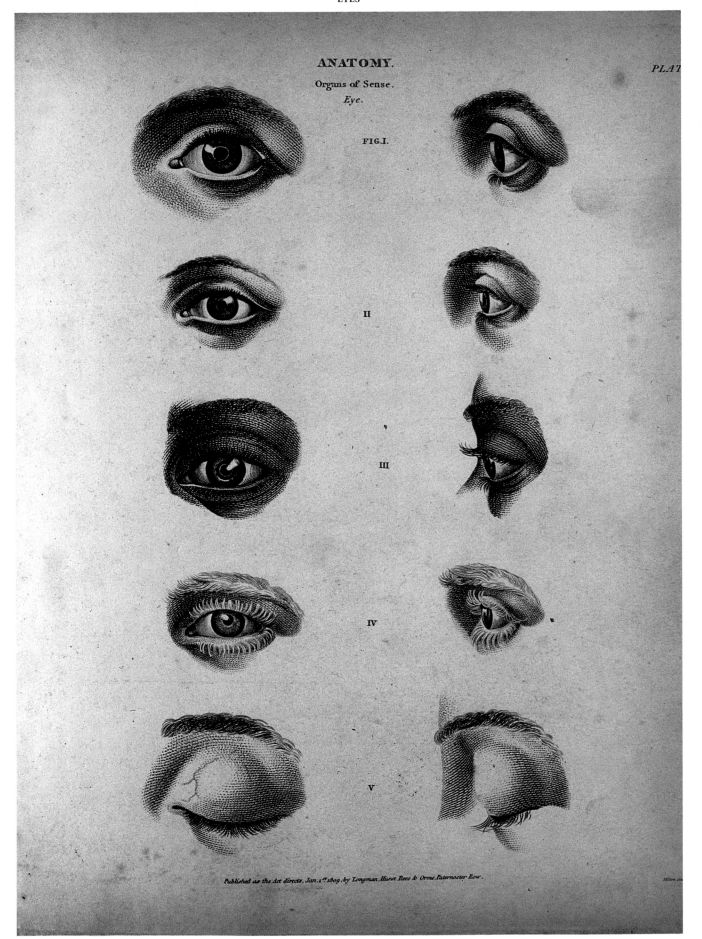

ANATOMY.
Organs of Sense.
Eye.

FIG.I.

II

III

IV

V

PLAT

Published as the Act directs, Jan.1.st 1809, by Longman.Hurst Rees & Orme.Paternoster Row.

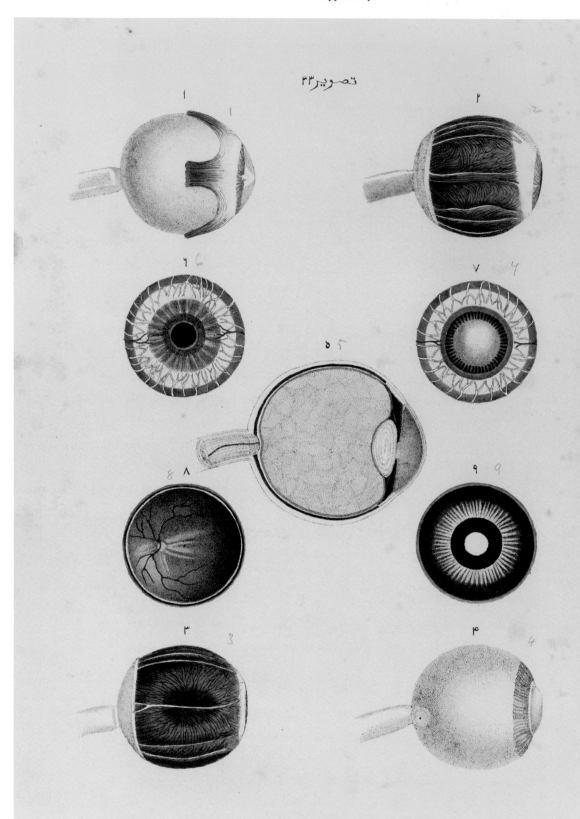

تصویر ۳۳

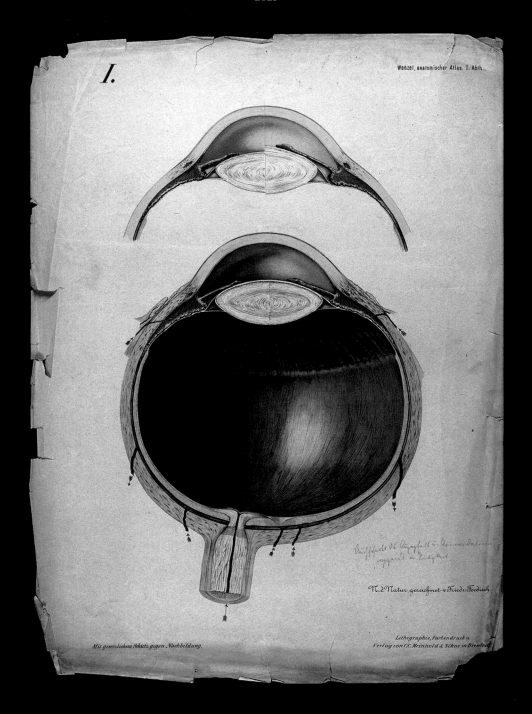

I.

Wenzel, anatomischer Atlas. I. Abth.

Mit gesetzlichem Schutz gegen Nachbildung.

Lithographie, Farbendruck u.
Verlag von C.C.Meinhold & Söhne in Dresden.

← Taken from *An Atlas of Anatomical Plates of the Human Body*, 1849, by Frederic J. Mouat, this plate illustrates various views of the human eye removed from the orbit and in various stages of dissection. The first figure in the upper left affords a lateral view of the eye globe with the extrinsic muscles of the eye attached, the sclera (white of the eye) and the severed optic nerve.

The illustration to the right shows the sclera dissected off, revealing the dense vascular tunic layer – the blood vessels that supply the eye. The large image in the centre is of a sagittal section through the eye globe, showcasing the three layers of the eye, along with the cornea, lens and vitreous humour. The sectioned optic nerve with its blood vessels can be seen at the back of the eye.

↑ This colour lithograph, showing a sagittal section of the eye, is from Ernst Friedrich Wenzel's *Anatomischer Atlas über den makroskopischen und mikroskopischen Bau der Organe des menschlichen Körpers*, 1874. The larger image displays, in exquisite detail, the various layers and structures of the eye.

These two colour lithographs are illustrations to works by the German ophthalmologist Richard Liebreich. The first is from around 1861, and the second is from his *Atlas der ophthalmoscopie*, 1870 (Atlas of Ophthalmoscopy). These images all show the eye as seen through an ophthalmoscope, an instrument that reveals the interior back of the eyeball. Liebreich was a pioneer in its use, and was committed to finding an accurate way to transmit what he saw via this instrument. Later in life, he went on to research the pigments and varnishes used by Renaissance painters.

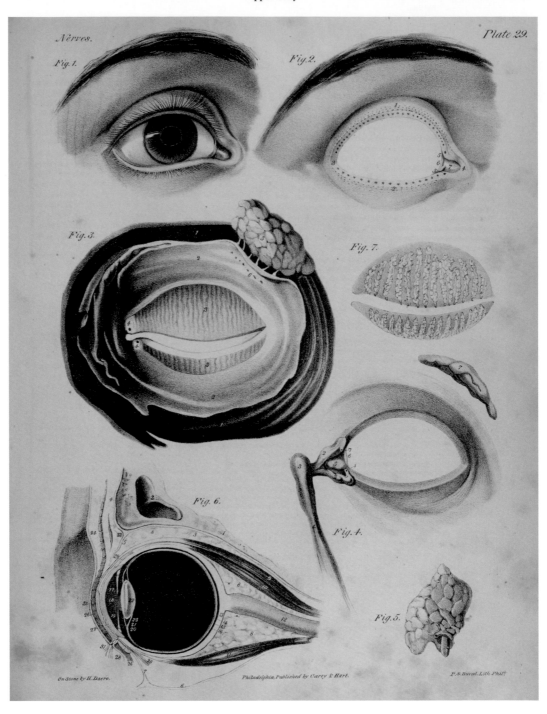

This illustration of the structures of the eye – some seen from behind – is from Jones Quain's *A Series of Anatomical Plates ... Illustrating the Structure of the Different Parts of the Human Body*, 1836–42. Fig. 1 shows the eye *in situ*, with a focus on the pupil, iris, sclera and canthus (corner of the eye, where the upper and lower lids meet). Fig. 2 reveals the superficial structure with the eye removed. Fig. 3 shows the *orbicularis oculi* muscle, as seen from the view of the skull. The almond-shaped structure consisting of small lobules in the corner is the lacrimal (tear) gland. Fig. 7 highlights the tarsal glands in the eyelids, which produce an oily substance that prevents evaporation of the eye's tear film. Fig. 4 illustrates the lacrimal apparatus seen from the back. This apparatus includes the lacrimal gland, sac and duct from the skull point of view. Fig. 5 is a detailed illustration of the lacrimal gland. Fig. 6 is a classic sagittal section of the eye *in situ* in the orbit.

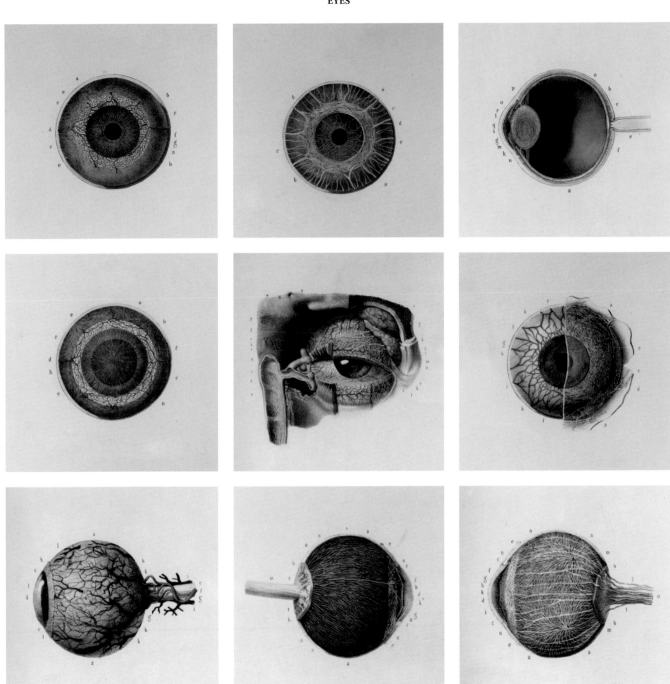

These gorgeously detailed colour
lithographs of the anatomy of the
eye were drawn by Nicolas-Henri
Jacob and come from Jean-Baptiste
Marc Bourgery's *Traité complet de
l'anatomie de l'homme comprenant
la médicine opératoir ...,* 1831–54,
published in eight volumes.

黑圈舌　黑尖舌　紅星舌　生斑舌

宜大承氣湯　傳經過不解　承氣湯下之　如大熱宜調胃　調之用竹葉石膏湯　又茵陳五苓散　將發黃茵陳湯　葛根湯化班湯　宜玄參升麻湯

This perplexing image is a Chinese tongue diagnosis chart, featuring illustrations of the tongue that can be read to reveal a variety of pathologies. By analysing the tongue of the patient against this chart, the reader would be advised of the proper medical course to pursue. For example, if the tongue had a black tip, as seen second from left, the advice was to treat it with bamboo leaf and gypsum. However, if the patient was feverish, another measure would need to be taken first. The image comes from a manuscript copy of *Shang han dian dian jin shu* (The Gold-dust Book of Cold Damage), originally published in 1341.

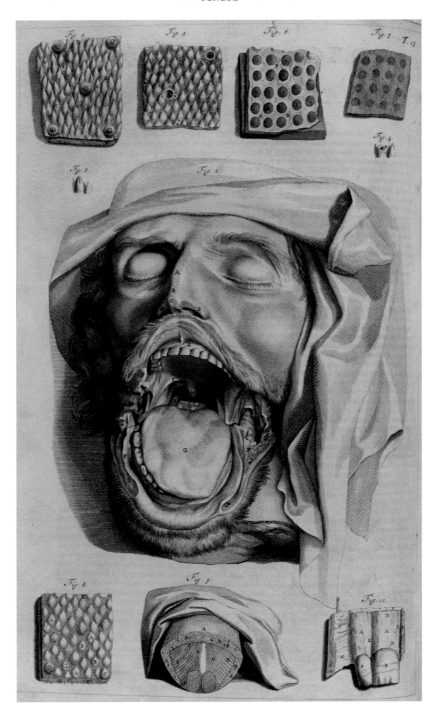

Here we have a line engraving of the dissected head of a man with the mouth open to reveal the inner anatomy, including the tongue, tonsils and other parts of the mouth and throat. It was drawn by Gérard de Lairesse for Govard Bidloo's *Anatomia humani corporis*, 1685. Fig. 1 displays the oral cavity, with (K) marking the gum covering the maxilla (upper jaw); (L) the palatoglossal arch; (H) the uvula; (G) the tongue; and (E) the palatine tonsil. Fig. 2 shows a very stylized coronal section of the tongue muscles, with (G) marking the genioglossus muscle (which some anatomists suggest is the strongest muscle in the body); (B) the superior and inferior longitudinal muscles; and (A) the dorsum (back) of the tongue. Fig. 5 illustrates a palatine tonsil, and fig. 3 seems to show two teeth and the gingiva (gums) covering the bone of the maxilla (upper jaw).

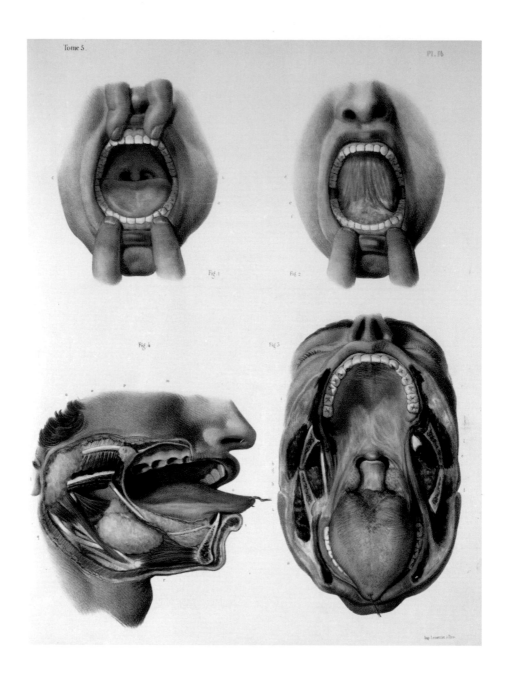

↑ Four views of the oral cavity and mouth, drawn by Nicolas-Henri Jacob for Jean-Baptiste Marc Bourgery's *Traité complet de l'anatomie de l'homme comprenant la médicine opératoir...*,1831–54. The top two illustrations depict an oral cavity examination; the one on the right showing the bottom of the tongue with the frenulum, which connects the tongue to the bottom of the mouth.

→ This stunning full-colour lithograph illustrates a very detailed dissection of the tongue and oral cavity. The grey branches indicate the greater palatine nerve, which innervates the palate. The uvula – a fleshy extension that hangs above the throat, keeping food and drink from ascending to the nose – is clearly visible, and the very dark area behind it is the pharynx, the passageway to the oesophagus and larynx. On either side of the pharynx are the palatine tonsils. The tongue is revealed in exquisite detail, with an emphasis on the lingual nerve and its branches, as well as the small sensory bumps known as papillae. This illustration comes from the same book as above.

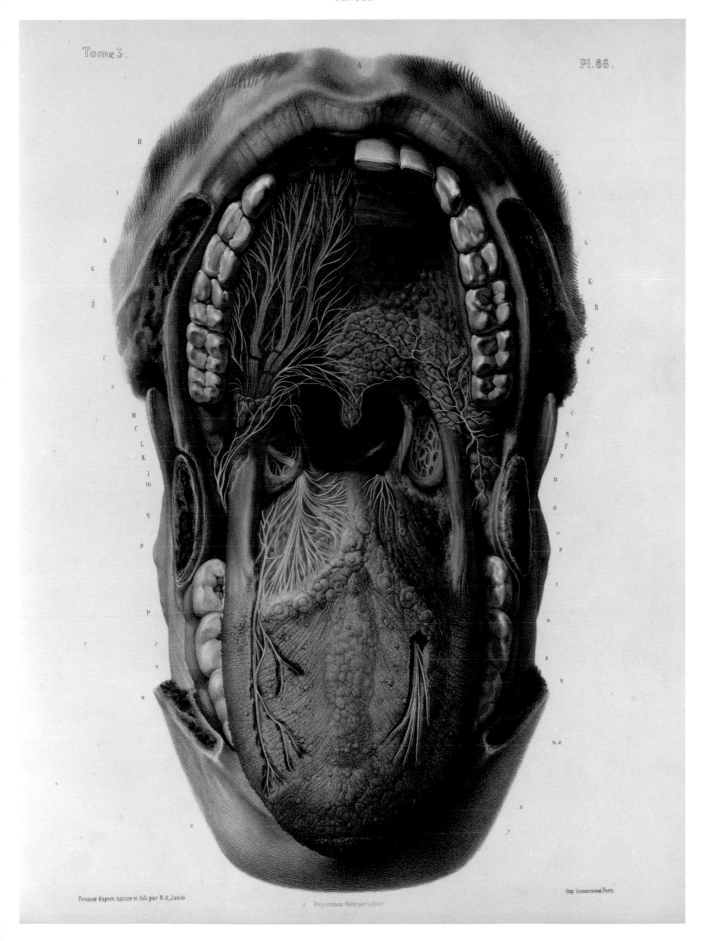

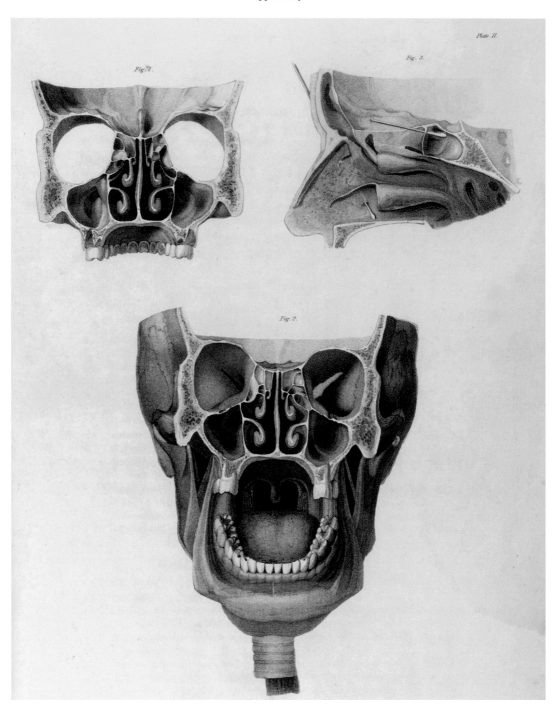

This engraving demonstrates the nasal concha, or upper chambers of the nasal cavity. The two large, rounded structures on the first illustration are the maxillary sinuses, which are susceptible to sinus infections that can lead to pain below the eyes and above the upper teeth. The figure at top right shows a sagittal (vertical) section through the nasal concha. The bottom illustration depicts a frontal section through the skull, showcasing the curved nasal concha and the oral cavity, complete with uvula, soft palate, tongue and teeth. The engraving was created by James Hopwood from original drawings by Thomas Baxter, a member of the RAA, and appeared in *Anatomico-chirurgical Views of the Nose, Mouth, Larynx, & Fauces*, 1809, by John James Watt, with additions by Sir William Lawrence. The latter was an English surgeon, who went on to become president of the Royal College of Surgeons, and surgeon to Queen Victoria.

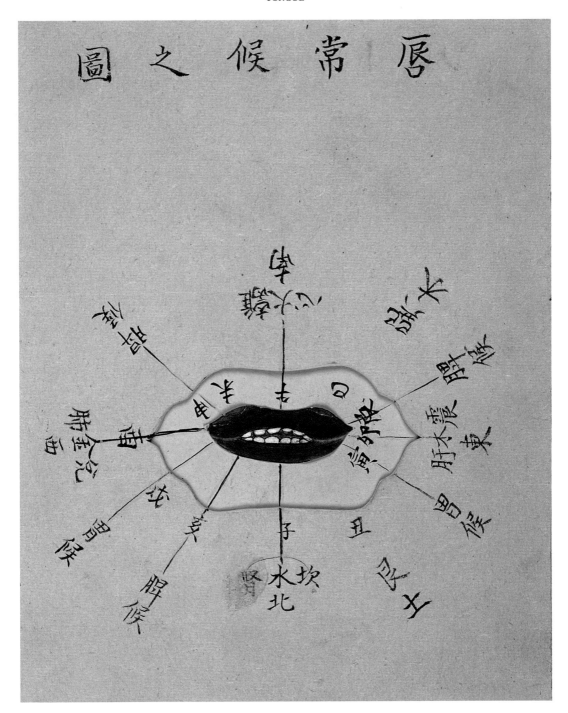

This hand-rendered illustration is from *Tōsō shinzetsuzu* (Illustrations of Smallpox on the Lips and Tongue), a handwritten Japanese manuscript created by Ikeda Zuisen in 1795. The illustration shows a healthy mouth, and the text details the areas of the lips that relate to conditions in other parts of the body. The book is filled with illustrations showing the ways in which smallpox lesions manifest on the lips and tongue. Japanese medicine was based on traditional Chinese medicine, which believed, as did early Western medicine, in a system of correspondences between the elements and parts of the body. By the time of this book's publication, however, that medical approach was under attack in Japan by proponents of Western medicine.

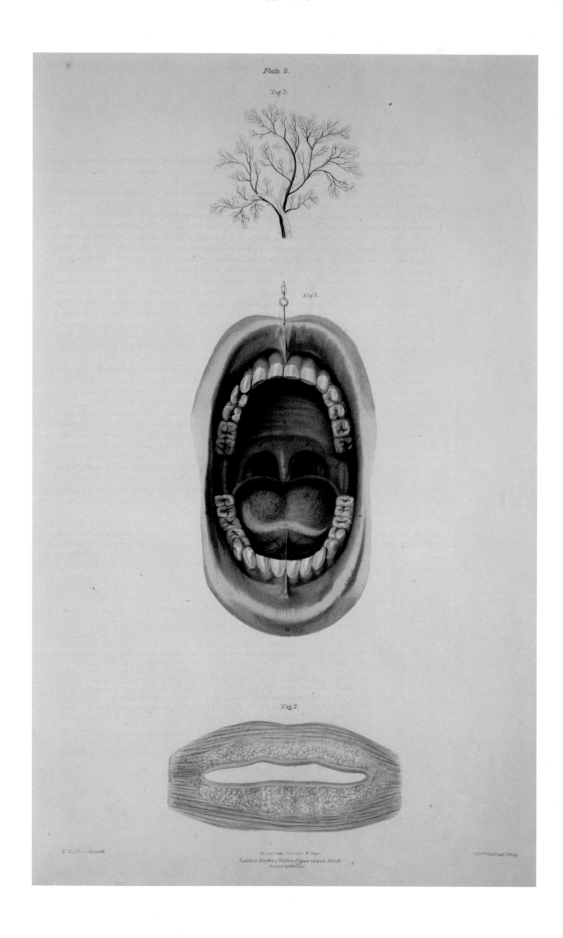

Plate 2.

Fig 3.

Fig 1.

Fig 2.

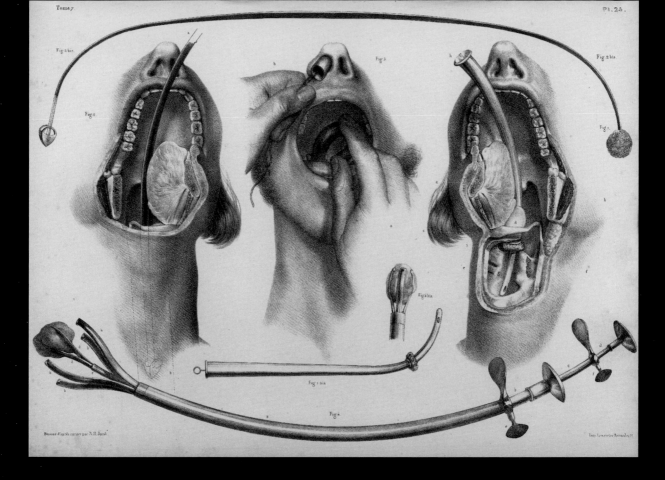

← The top image shows the artery and salivary duct from the parotid gland of a fetal calf. The middle illustration depicts a human mouth and oral cavity, including (from top to bottom) the frenulum of the upper lip, the upper teeth, soft palate, uvula, the palatine tonsils (tucked way back), the tongue, lower teeth and frenulum of the lower lip. The bottom illustration concentrates on the orbicularis oris muscle around the mouth (analogous to the orbicularis oculi muscle around the eye). This muscle of facial expression assists in pursing the lips, blowing a kiss and whistling. It comes from Jones Quain and Sir Erasmus Wilson's *The Viscera of the Human Body*, 1840.

↑ Rendered by Nicolas-Henri Jacob, this illustration shows a deep dissection of the oral cavity and neck, and the ways in which instruments can be used to remove foreign bodies, or to insert an artificial airway in the trachea. It comes from Jean-Baptiste Marc Bourgery's *Traité complet de l'anatomie de l'homme comprenant la médicine opératoir...*, 1831–54.

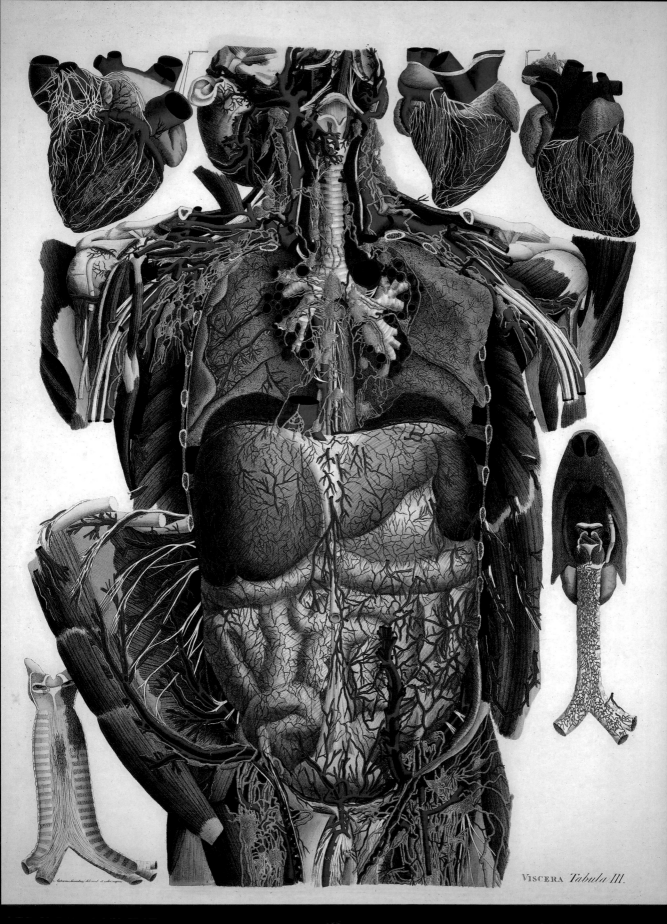

VISCERA *Tabula III.*

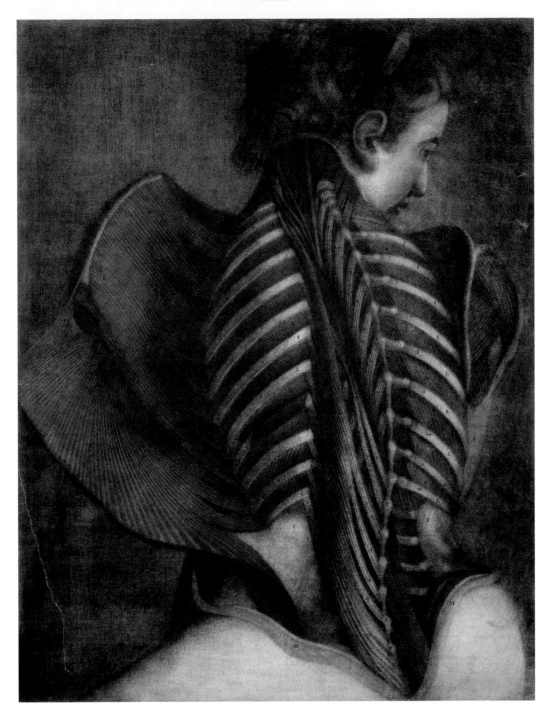

← A hand-coloured engraving by Antonio Serantoni of the human viscera in an 'exploded thorax', from *Anatomia Universa*, 1823–32, (Universal Anatomy) by the Italian anatomist and physiologist Paolo Mascagni. Referred to by some as the 'most splendid anatomy ever published', the book is filled with colourful, life-sized anatomical illustrations. The image vividly and dynamically presents the internal anatomy of the head, neck, thorax and abdomen, with emphasis on the vasculature as well as the lymphatic system (in yellow).

↑ This gorgeous colour mezzotint is the most iconic image by Jacques-Fabien Gautier d'Agoty. Fondly referred to as 'The Flayed Angel,' it was published in his *Essai d'anatomie en tableaux imprimés ...* , 1746 (Illustrated Essay on Anatomy). This startling and powerful image features an apparently alive and fashionably coiffed young woman with the skin of her torso flayed, seemingly lifting of its own accord like the wings of an angel, to reveal the bones and musculature beneath.

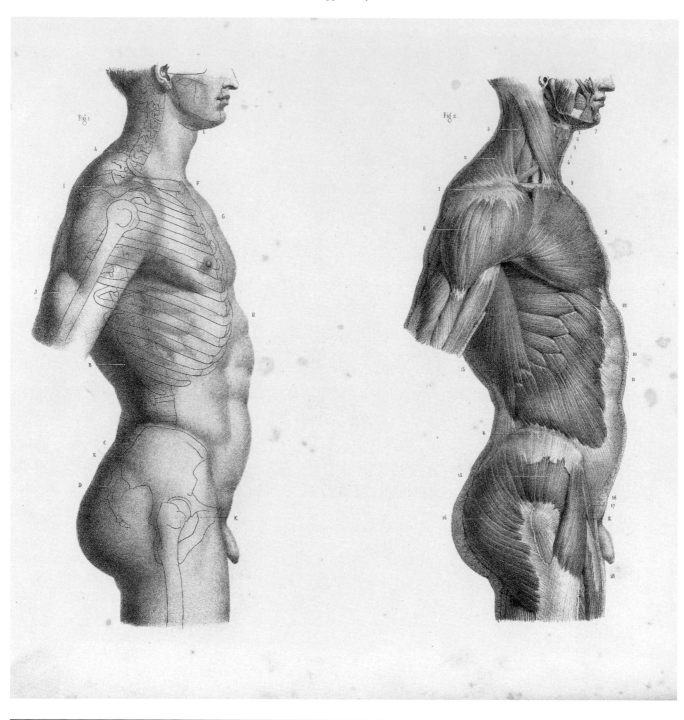

↗ These two images, depicting a man in profile with and without skin, are drawn from Julien Fau's *Anatomie artistique élémentaire du corps humain*, 1848 (*The Anatomy of the External Forms of Man: Intended for the Use of Artists, Painters and Sculptors*). Anatomy, especially of the muscles, was of great interest to artists seeking to perfect their skills at rendering the human form.

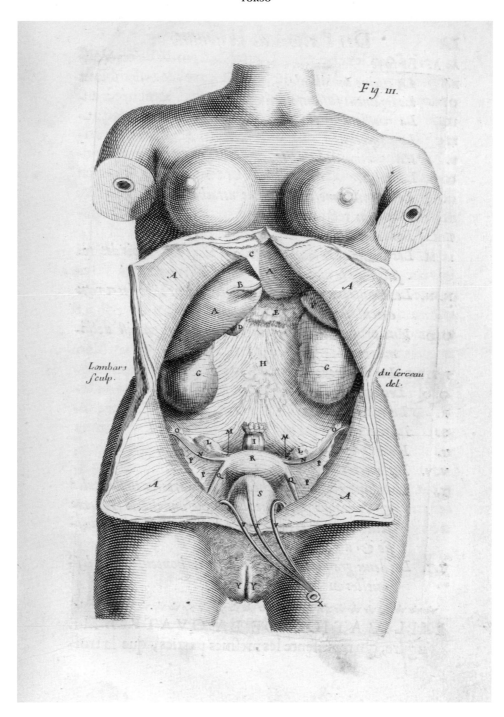

Fig. III.

Lombars sculp.

du Cerceau del.

This highly stylized illustration shows the torso of a woman with her abdomen opened and the muscles pulled back, with the colon and small intestine removed, to better show the uterus, fallopian tubes, ovaries, ligaments and bladder. The tube-like structures pulled out over the genitalia are the ureters (V), which connect the kidney to the bladder, and the urachus (T), a fibrous remnant of the canal that drains the bladder of the fetus. The image is drawn from *Des Maladies des femmes grosses et accouchées*, 1668 (Diseases of Women Who Are Pregnant and Have Given Birth), by the pioneering French obstetrician François Mauriceau. This book, a bestseller in its time, reflects the transition from traditional female midwifes to medically trained *accoucheurs*, or obstetricians, in the delivery of babies. The author, a well-known specialist in childbirth, advocated standardized training, the use of forceps, and for women to give birth in a reclining position rather than seated, as was standard practice at the time.

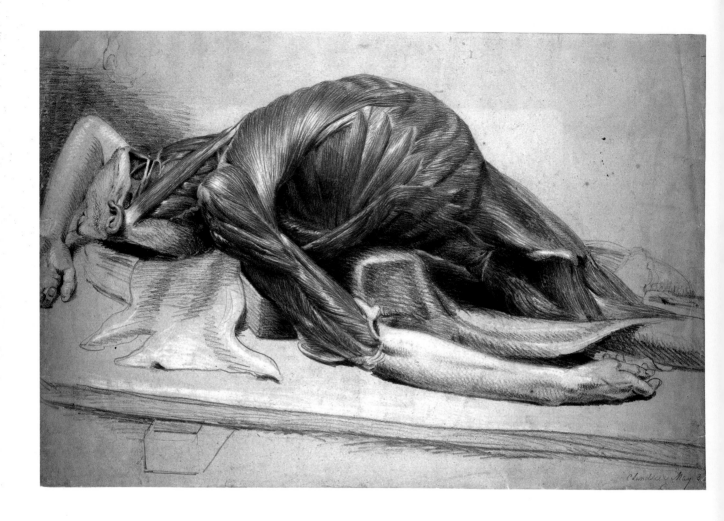

↑ This stunning chalk drawing, made by the English artist Charles Landseer around 1815, shows a graphic yet sensitive portrait of a flayed male corpse. Landseer studied art with Benjamin Haydon, an avid proponent of the study of anatomy by artists, which stemmed from his boyhood love for the work of Albinus. As part of his training, Landseer was sent to the anatomy theatre of Sir Charles Bell, where he made this illustration and a number of other life-sized chalk renderings directly from dissections. He went on to become a painter of historical subjects.

→ Unlike the image opposite, which shows the raw reality of dissection, this is an idealized and ordered take on the human body. It was rendered by Jacques Fabien Gautier d'Agoty and comes from his *Anatomie générale des viscères et de la neurologie, angéologie et ostéologie du corps humain*, 1752.

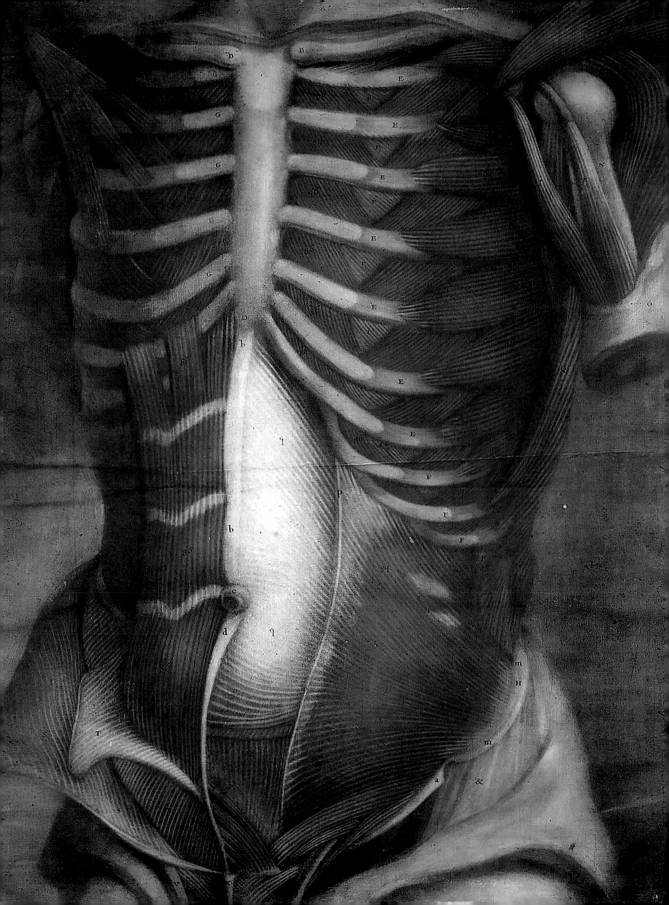

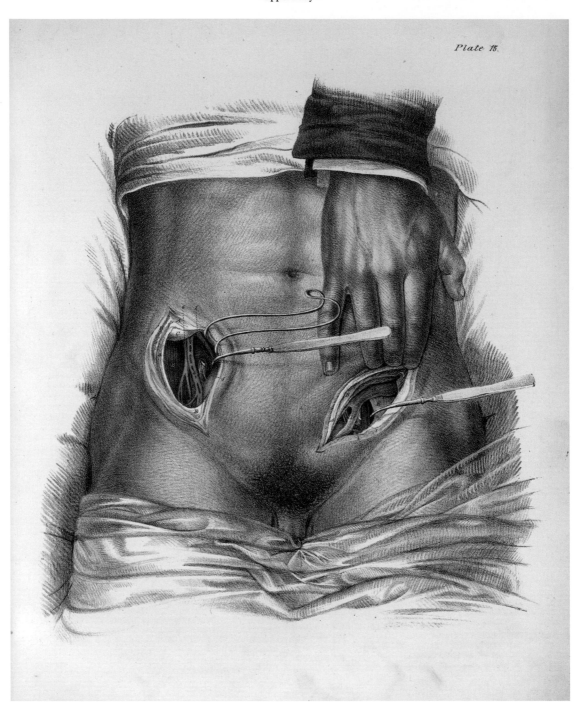

Plate 15.

Two surgical openings on the lower trunk of a man. The one on his right side is probably for an appendectomy, while the one on his left is most likely for an inguinal (groin) hernia repair. It is from American surgeon Joseph Pancoast's *A Treatise on Operative Surgery ...*, 1844.

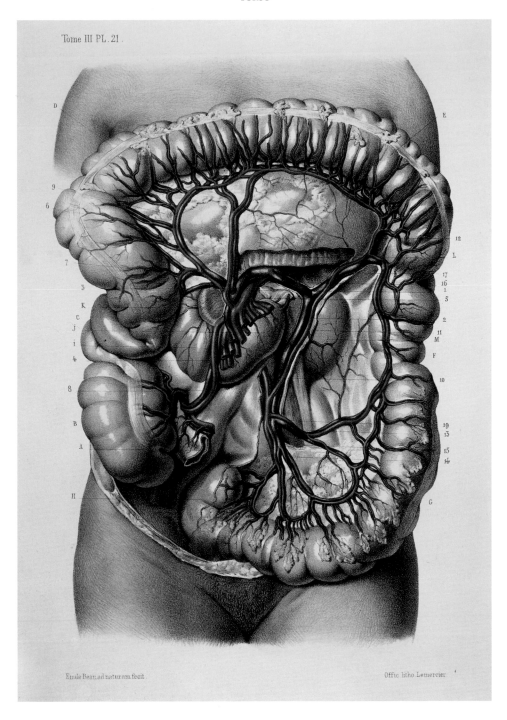

Tome III PL. 21.

Émile Beau ad naturam fecit.

Offic litho Lemercier

A striking, hand-coloured lithograph showcasing a beautifully rendered and very detailed view of the colon with its rich vasculature. It also shows the segmented haustra (to the lower left just above the hip), which is characteristic of the colon, as well as the ribbon of smooth muscle (taenia coli), the ribbon-like structure that runs along the entire colon.

The image comes from *Atlas d'anatomie descriptive du corps humain*, 1844–66 (Descriptive Atlas of Human Anatomy) by Constantin Bonamy, Paul Broca and Émile Beau. This work, published in four volumes, is renowned for the accuracy and beauty of its illustrations.

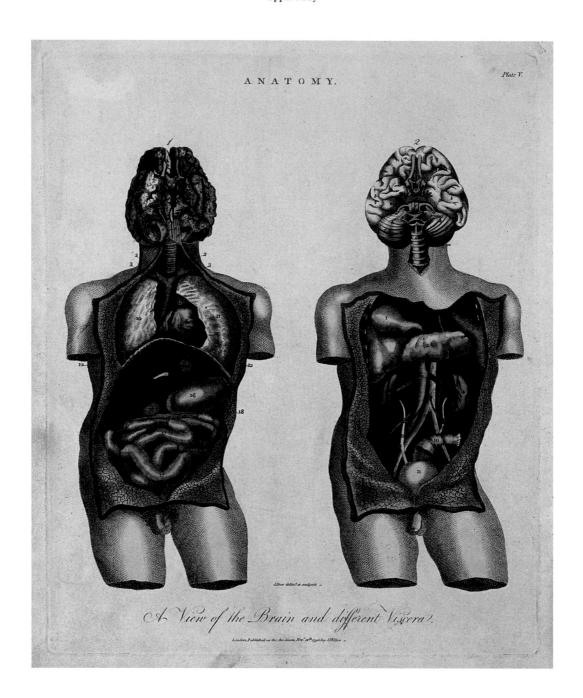

ANATOMY.

Plate V.

A View of the Brain and different Viscera.

↑ A bizarre line engraving, showcasing the brain and viscera of two figures with opened torsos. Rendered by John Pass, it is taken from John Wilkes's *Encyclopaedia Londinensis; or, Universal Dictionary of Arts, Sciences and Literature*, 1810–29 (24 vols). The image is titled 'A view of the brain and different viscera'.

→ A colour engraving by Antonio Serantoni of the muscles and blood-vessels of the head, neck, chest, arm and hand of an *écorché*. At top left and right are two details; the foot at top left seems somewhat incongruous. The image is drawn from Paolo Mascagni's *Anatomia per uso degli studiosi di scultura e pittura*, 1816 (Anatomy for Use by Students of Sculpture and Painting).

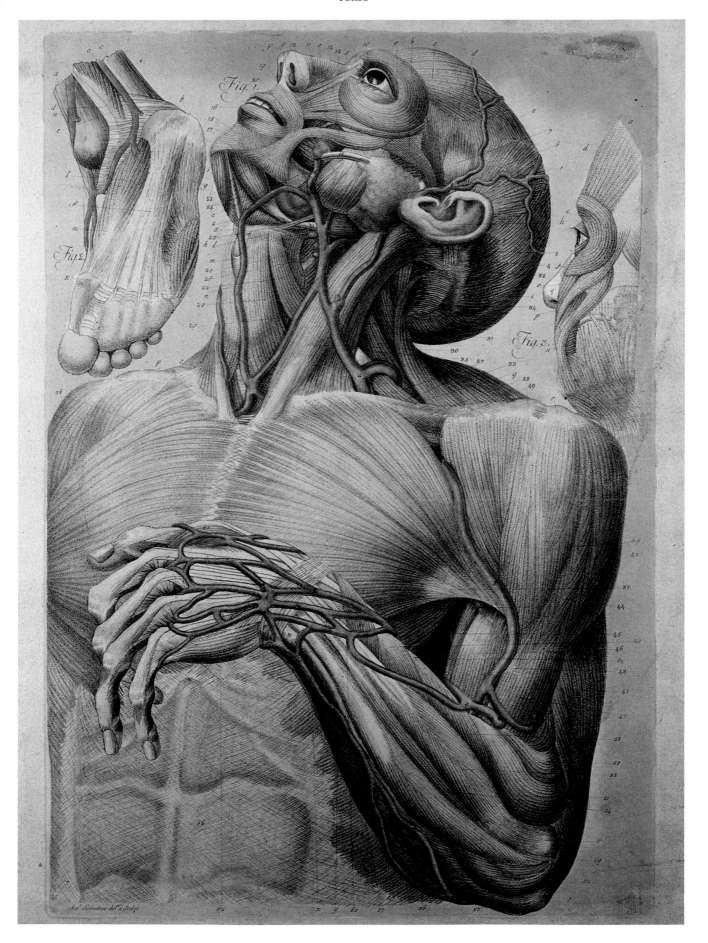

Fig. 1.

Fig. 2.

Fig. 3.

Ant. Serantoni del. e sculp.

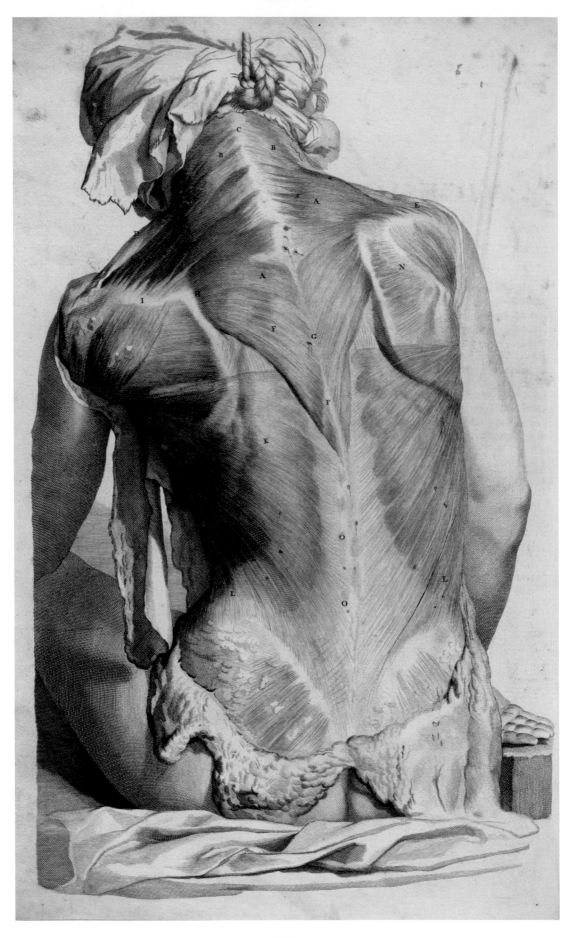

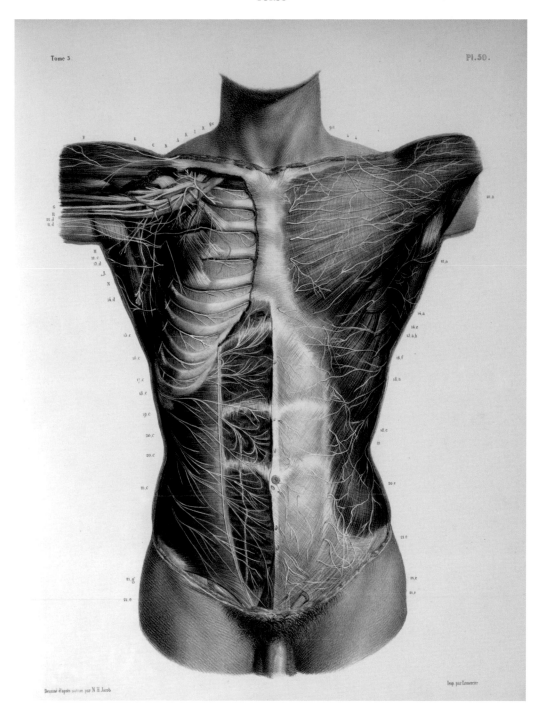

Tome 3.

Pl. 50.

Dessiné d'après nature par N.H. Jacob.

Imp. par Lemercier

← This sensitive, almost poignant engraving of a dissected woman is from a wash drawing by the Dutch artist Gérard de Lairesse, and comes from Govard Bidloo's *Anatomia humani corporis*, 1685. It has the feeling of a portrait in all but the lack of skin, and the rope around the subject's neck. Bidloo was unusual in using both female and male bodies to demonstrate regular anatomy; in his time it was customary to illustrate the bodies of women only when pointing out what made them different from men, namely the breasts and organs of generation.

↑ Drawn by Nicolas-Henri Jacob, this confident rendering of a neo-classical trunk shows different levels of dissection. It appears, along with other of his drawings, in Jean-Baptiste Marc Bourgery's *Traité complet de l'anatomie de l'homme comprenant la médicine opératoir ...*, 1831–54.

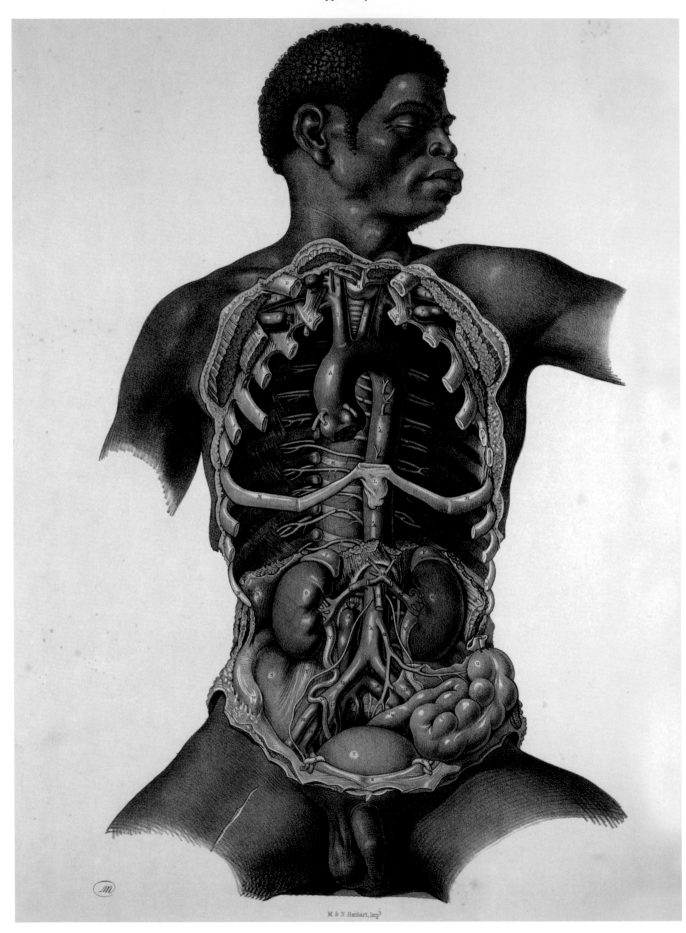

M & N Hanhart, Imp.

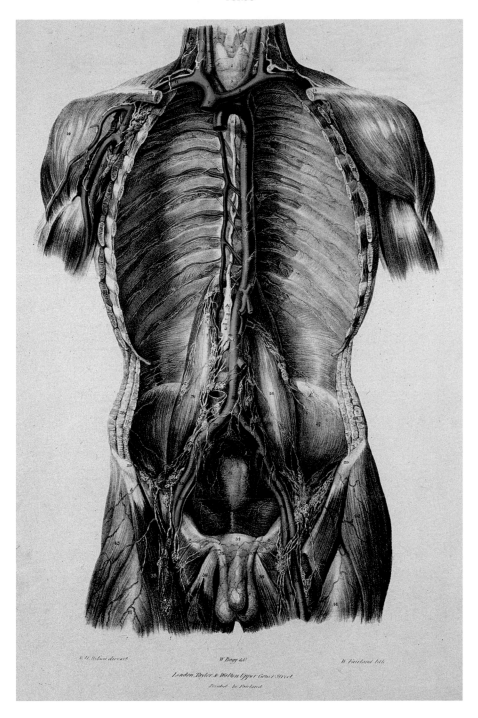

London, Taylor & Walton Upper Gower Street
Printed by Fairland

← A hand-coloured lithograph of a man with the trunk of his body open, showing the bones and organs within. Taken from Joseph Maclise's *Surgical Anatomy*, 1851, the print was made after a drawing from the author, who drew directly from cadavers. Unlike many anatomical atlases at the time, which emphasized biological differences between the races in order to demonstrate supposed Caucasian superority, Maclise's book included black bodies simply to demonstrate normal human anatomy. The plates depicting black men were removed from the edition published in the United States, where slavery was still legal and the idea of equality between black and white people was very controversial.

↑ A colour lithograph of a dissected male torso, showcasing the lymphatic and blood vessels. It comes from Jones Quain and Sir Erasmus Wilson's, *The Vessels of the Human Body*, 1837.

Fig. A. Fig. B.

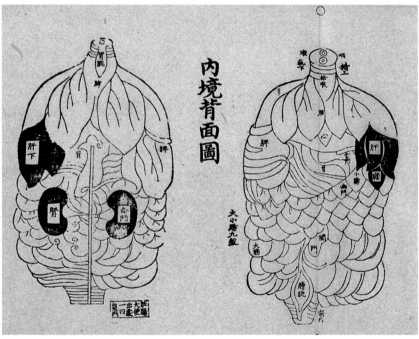

内境背面圖

↑ In the late 19th and early 20th centuries, there was a lively public health debate about the dangers of corsets, which had been *de rigueur* for European and American women for decades. The top left illustration demonstrates the ill effects of tight corsetry on women's bodies, and was featured in an issue of *La Culture Physique* (Physical Culture, 1908). This journal, committed to 'health, beauty, strength', was founded in 1904 by Edmond Desbonnet, a French academic, photographer and popularizer of physical fitness.

↓ This woodblock illustration of the *neijing* (internal topography of the body) is drawn from *Zhengtong daozang* (Taoist Canon compiled during the Zhengtong reign period [1436–49] of the Ming Dynasty), a collection of important Taoist works compiled by monks in the 15th century. It points out essential traditional Chinese medicine concepts, such as the throat being the place where *jing* (essence) ascends and *qi* (life force) descends, and the right kidney being the 'portal of life'. In traditional Chinese medicine, health depends on achieving balance between the different *yin/yang* (negative/positive) systems that make up the body.

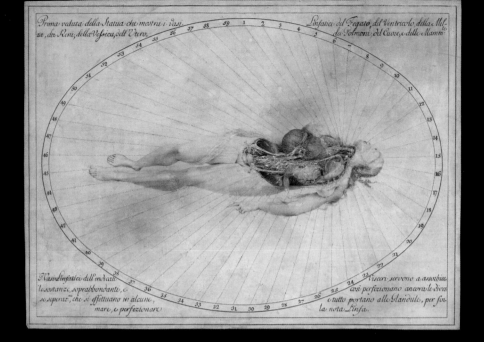

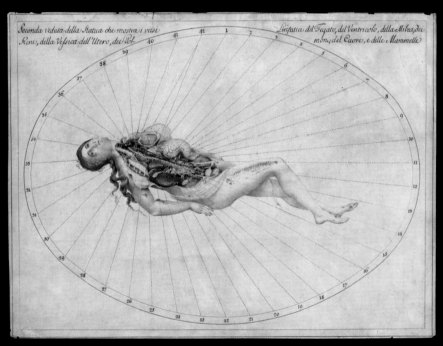

These watercolour and gouache illustrations were painted around 1785 in the Florentine workshop of natural philosopher Felice Fontana and the artist Clemente Susini. They were created as guides to illustrate the anatomical features of two 'Anatomical Venuses' – beautiful, life-sized, anatomized wax women created to teach human anatomy at the Museum for Physics and Natural History, better known as La Specola, in Florence, Italy. They were housed in drawers within the cases holding the models so that people could learn without a lecturer or book. The model on which they were based showcased the lymphatic system. Both are part of the collection at Vienna's Josephinum Museum, a collection created by the Specola workshop for Emperor Joseph II, who commissioned copies of the Florentine originals to train his army surgeons.

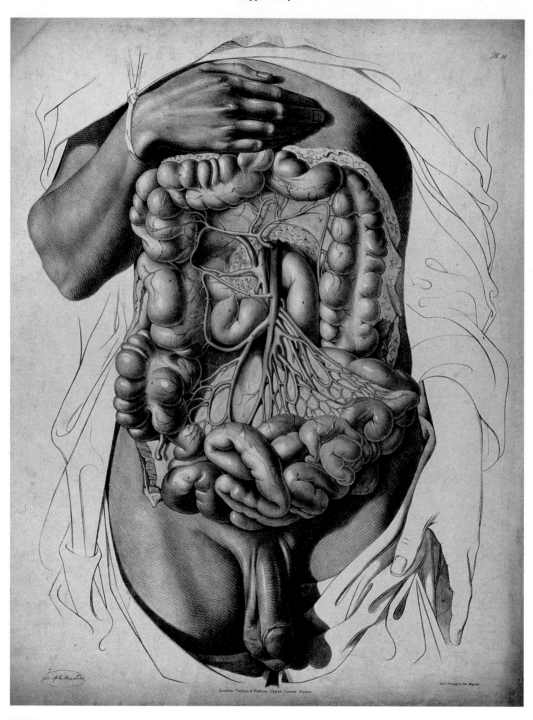

Both of the coloured lithographs on this spread were drawn by Joseph Maclise for a work by the Irish physician Richard Quain – *The Anatomy of the Arteries of the Human Body ...*, 1844.

↑ Here we see a dissection of the abdomen with the colon reflected up towards the hand, and the small intestine, in the lower portion of the figure, hanging from its mesentery. The mesentery is the large fold of peritoneal tissue that attaches the small intestine and colon to the posterior abdominal wall. In the mesentery are seen the vasculature, including the superior mesenteric artery and vein and all their branches.

→ While this dissection is similar to the one opposite, it has deeper structures, including the abdominal aorta (large red vessel at upper centre). The small intestine is shown in the lower left portion of the drawing, while the cut layers of the anterior abdominal wall appear at the lower right.

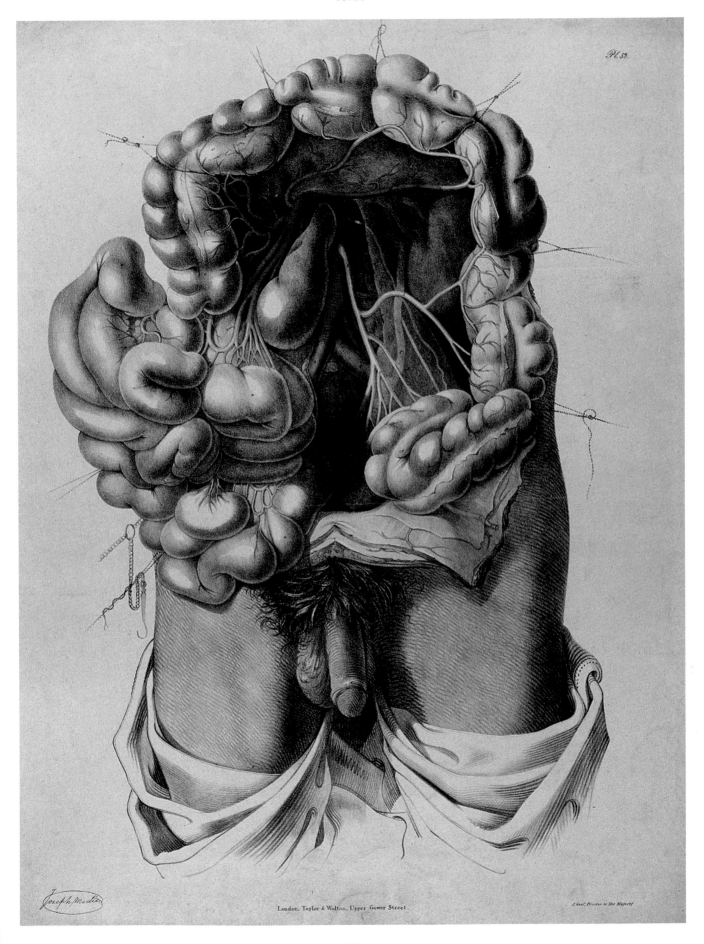

Pl. 52.

London, Taylor & Walton, Upper Gower Street.

J. Graf, Printer to Her Majesty.

Joseph Maclise

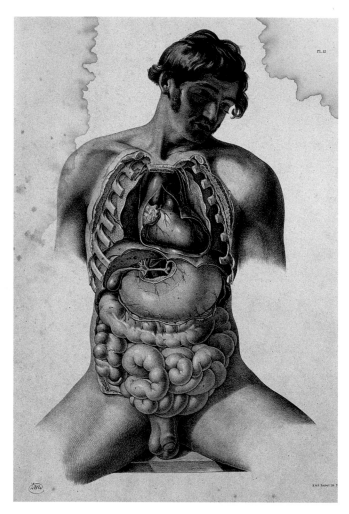

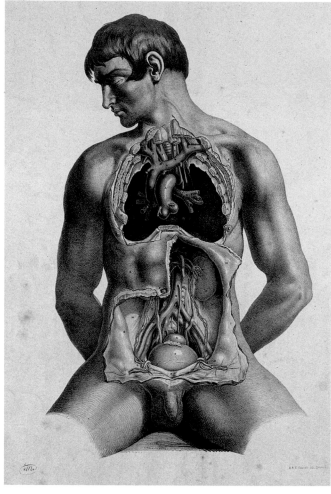

These two male bodies were both dissected and drawn by the British surgeon and artist Joseph Maclise, and featured in his book *Surgical Anatomy*, 1851. The left-hand image shows a superficial dissection of the thorax and abdomen, with the ribs cut and the anterior portion of the ribcage, costal cartilages and sternum removed to better display the heart. The lungs have been pulled back, while the heart is seen in its pericardial sac (F), and the gall bladder (N) hangs by its cystic duct. We also see the stomach (O) and transverse colon (S), while the ascending colon (unlabelled), descending colon and the small intestines (T) are visible in the middle of the abdomen. The right-hand image depicts a deep abdominal dissection, revealing the abdominal aorta and inferior vena cava bifurcating into the iliac veins.

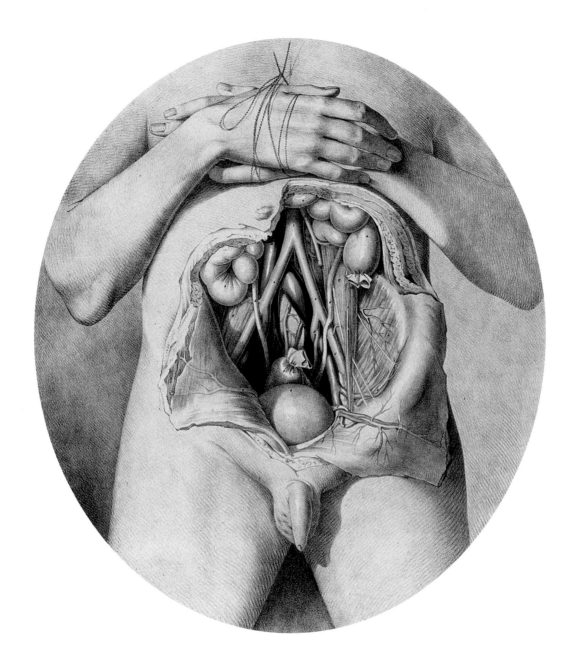

Another illustration by Maclise, this one comes from Richard Quain's *The Anatomy of the Arteries of the Human Body* ..., 1844. In this beautiful lithograph, Maclise uses a limited palette to showcase the abdominal aorta (red) and the inferior vena cava (blue) as they bifurcate into the common iliac arteries and veins respectively. The abdominal contents (small intestines and colon) have been removed to best visualize these deep blood vessels. Portions of the small intestine are visible near the top of the dissection, and the descending colon and rectum have been tied off. The urinary bladder with its ureters (which come from the kidneys) are visible, as are the deep muscles of the pelvis such as iliacus and psoas major.

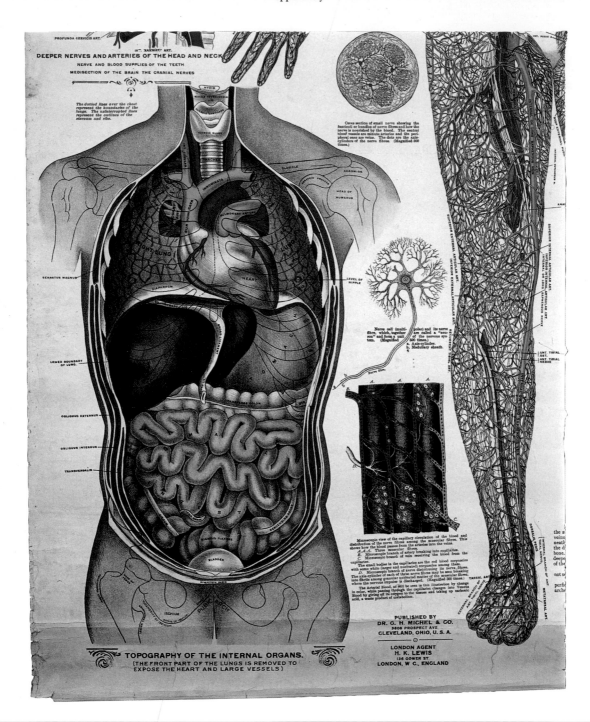

A chromolithographed wall chart for teaching students of human anatomy. The illustration on the left depicts an opened torso and its internal organs, with part of the lungs removed to better see the heart and large blood vessels. On the right is a leg, showing the arterial, venous and nervous systems of the human body. The flower-like structure between the two main images is a very enlarged nerve cell. The chart was published by Gustave H. Michel in 1910. He also created similar charts of the muscular and skeletal systems.

This coloured lithograph, from Jean-Léon Soubeiran and Claude-Philibert Dabry de Thiersant's *La Médecine chez les Chinois* (Chinese Medicine, 1863), shows the acupuncture points of the head, arm and body. Dabry de Thiersant was a French officer and diplomat, who immersed himself in Chinese language and culture. He held roles at the French consulates of Shanghai and Canton, and published many books on

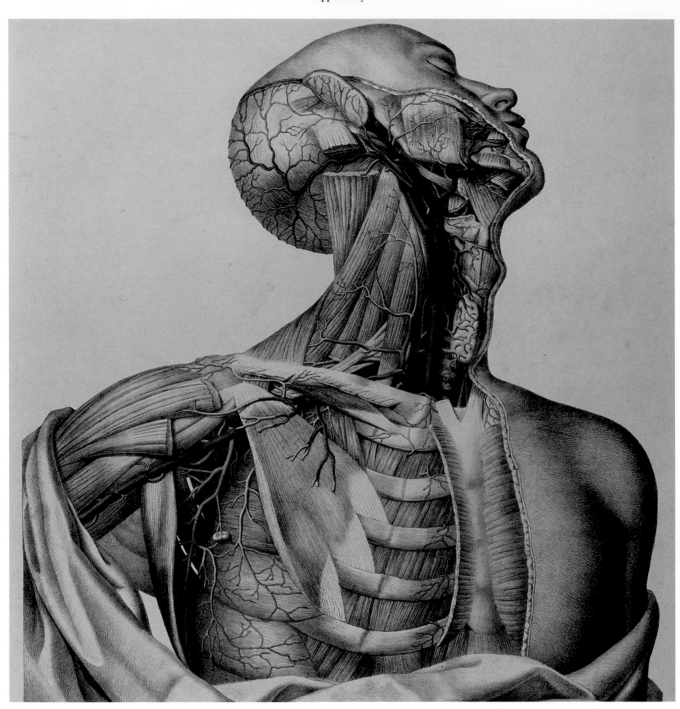

The two elegant lithographs on this spread are by Jakob Wilhelm Christian Roux and come from *Tabulae arteriarum corporis humani*, 1822, by the German biologist and anatomist Friedrich Tiedemann. The image on the left shows the head, neck, shoulder and chest of a partially dissected man; the image on the right presents the same figure from behind. In both, the arteries and blood vessels are hand-painted red. Tiedemann was among the first scientists to refute scientific racism. In 1836, he published an article in which he demonstrated that the common assertion that black people had smaller brains was not accurate.

Tab. IX.

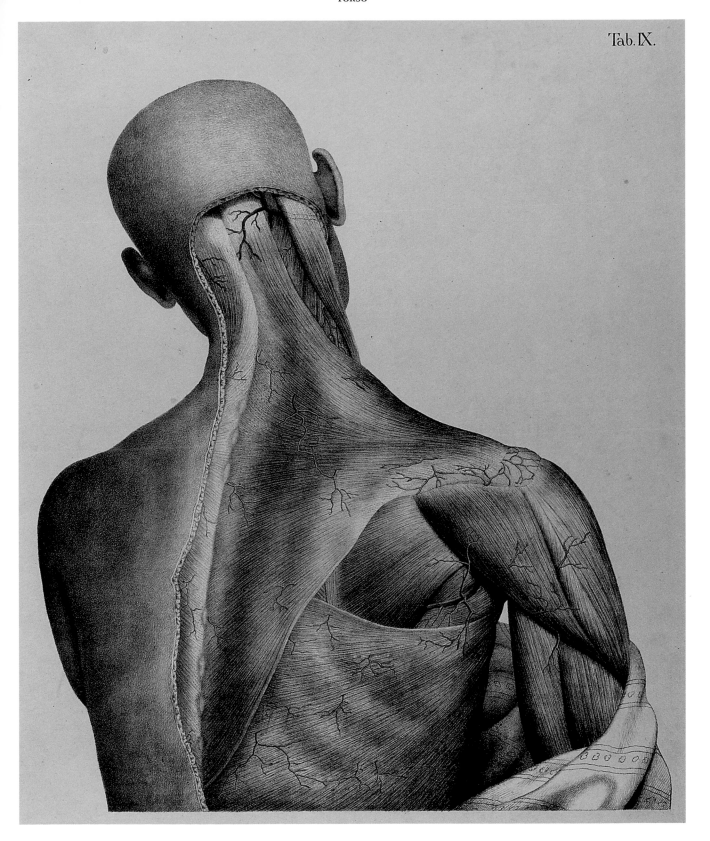

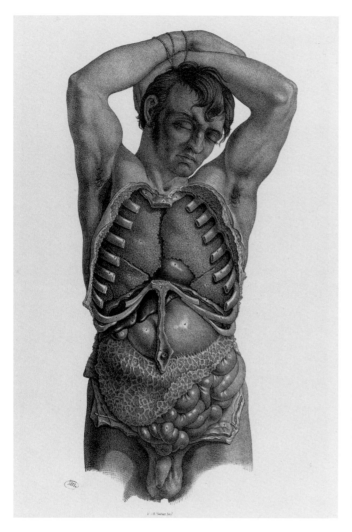

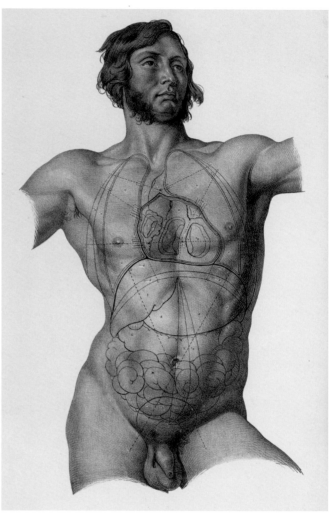

↑ A hand-coloured lithograph of the cadaver of a handsome young man, hands bound, undergoing a dissection of the trunk. On show are the sternum, ribs, lungs, diaphragm, stomach, liver, gall bladder, umbilicus, transverse colon and small intestines. The image comes from Joseph Maclise's *Surgical Anatomy*, 1851.

↗ This hand-coloured lithograph, showing the surgical anatomy of the torso, comes from Joseph Maclise's *Surgical Anatomy*, 1851; the lithographs in that book were made from the author's own drawings of dissected cadavers.

→ A coloured lithograph of the dissected body of 'a youth, aged 18, who died suddenly in a fit ... at St. Bartholomew's Hospital', with the chest opened to reveal the viscera within. The image was created by William Fairland for Francis Sibson's *Medical Anatomy*, 1869. The text notes that the illustrations for the book were rendered by the artist, who drew under the close supervision of the author and directly from his dissections.

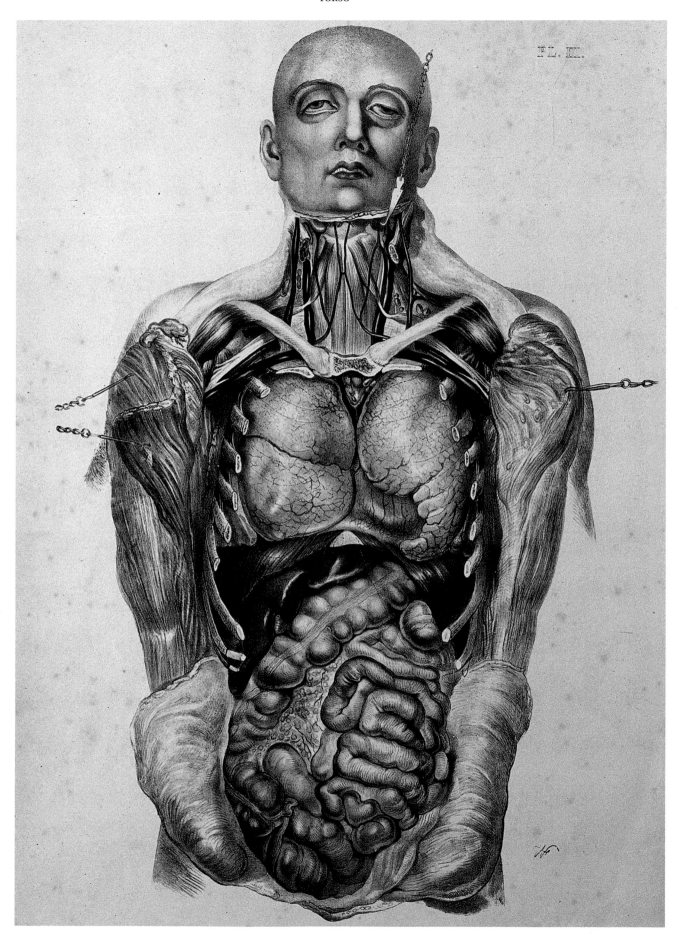

This elegant image of the torso of a man is from Andreas Vesalius's pioneering work of Renaissance anatomy *De humani corporis fabrica* ..., 1543. It showcases the contents of the abdomen including the liver (K), stomach (O and P), and mesentery of the small intestine (I). With this book, Vesalius challenged the unquestioned primacy of the anatomical teachings of Galen, an important ancient Roman anatomist, whose works, along with those of Hippocrates, formed the corpus for anatomical and medical teachings until the Renaissance. Unlike Galen, who was unable to conduct human dissections due to the prohibitions at that time, Vesalius's work was informed by his own studies of cadavers. The illustrations for this book set the standard for anatomical illustrations, and were much copied for centuries after.

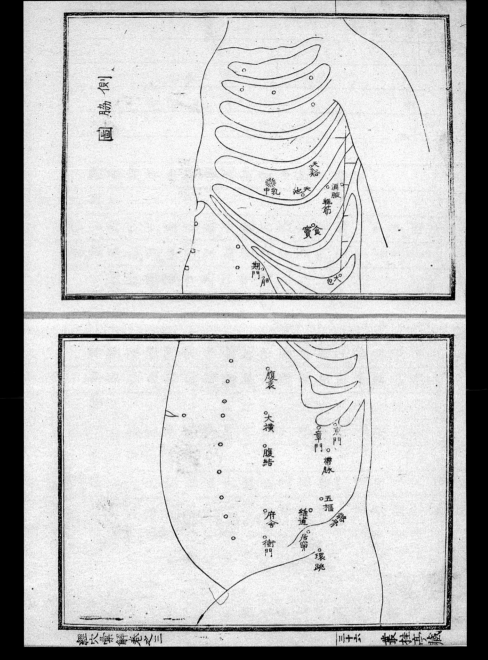

This woodblock illustration shows the points on the side of the torso relevant for moxibustion, a process in which heat is applied to the acupuncture points of the body. Featured in an 1807 book on traditional Chinese medicine by the Japanese physician Hara Masakatsu, the chart details poetically named points, including 'Portal of Times', 'Sun and Moon', and 'Abdomen Sorrow'. Traditional Chinese medicine, like pre-modern Western medicine, was holistic in nature, linking the body to the elements and heavenly bodies, demonstrating the correspondences between microcosm and macrocosm.

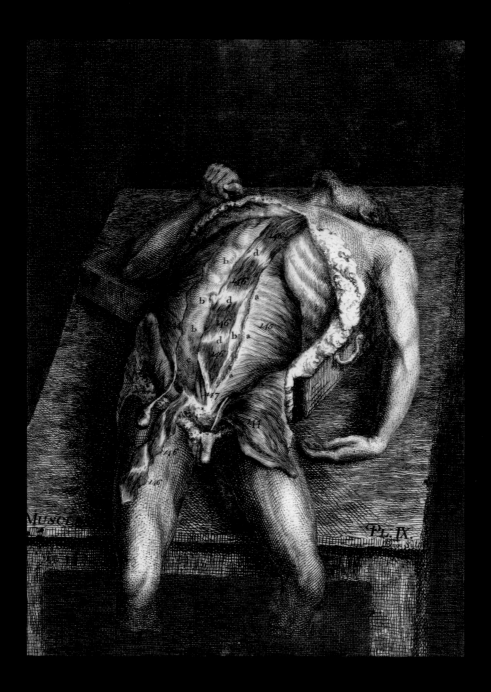

An illustration by the Scottish surgeon, anatomist and artist John Bell from his book *Engravings, Explaining the Anatomy of the Bones, Muscles, and Joints*, 1794. Bell, known for his grim, cadaverous images that might be termed 'dissection room gothic', was a fierce believer in accuracy over idealised beauty in anatomical illustrations. In order to ensure the accuracy of his images, he created his own. In the book, he writes, '...dissection is the first and last business of the student; and when drawings are made for his use, the body should be laid out as he is to order it in dissection; the belly should be displayed as he can display it in his subjects; an arm should be so drawn, that, when he dissects the arm of the subject, it may fall naturally upon the table exactly as he finds it in his book.' He also ran his own anatomy school and was the older brother of Sir Charles Bell, also an anatomist and surgeon who illustrated his own works.

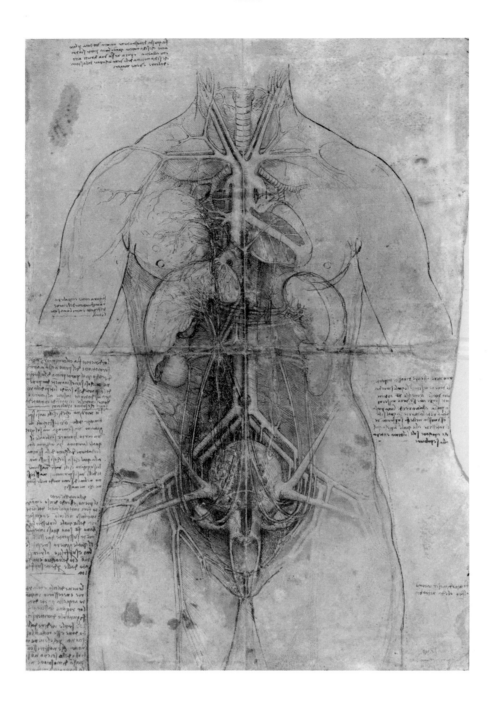

This elegant drawing of the cardiovascular system and principal organs of a woman was rendered on toned paper in black and red chalk, pen and ink, and yellow wash around 1509–10 by Leonardo da Vinci. It is one of his most impressive and detailed anatomical drawings, showing the cardiovascular system of the neck, thorax, abdomen, pelvis and upper portion of the lower limb.

Leonardo is unique in the history of art in that he was interested not just in the superficial anatomy of the musculoskeletal system, but also in how the muscles, bones, joints and ligaments functioned – what is known as functional anatomy, the biomechanics of the body. He was also interested in how the various systems of the body worked together. While other Renaissance masters, such as

Michelangelo and Raphael, limited their anatomical explorations to the musculature, Leonardo explored the workings of everything, from the heart valves to the ventricles of the brain. It is estimated (although scholars disagree on exact figures) that Leonardo dissected 30 bodies during his lifetime, and created hundreds of detailed anatomical studies for a planned but unpublished anatomical atlas.

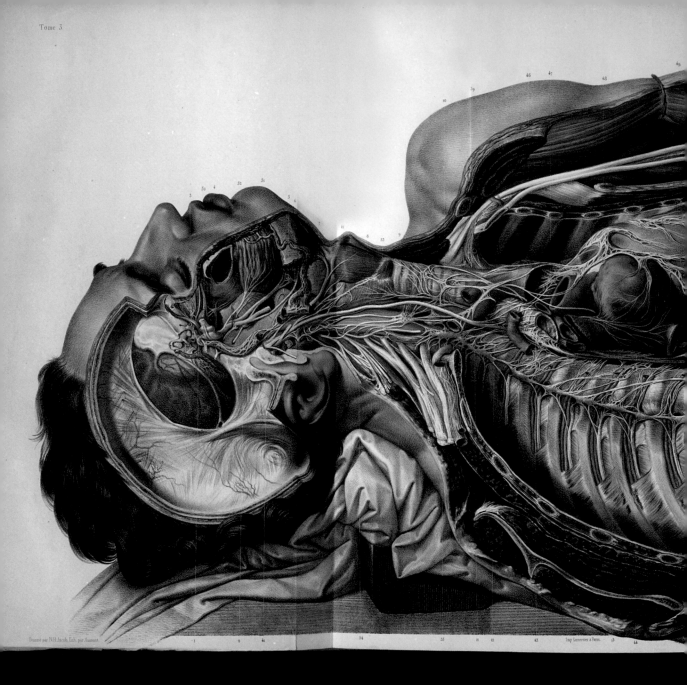

This stunning, incredibly detailed chromolithograph features the cadaver of a man dissected to show the autonomic nervous system. The nerves (identified in white) control involuntary functions, such as heartbeat, respiration and digestion, plus reflexes such as sneezing, swallowing and vomiting. The skull

and part of the face are revealed in sagittal (vertical) section. Although the brain is not visible, it is possible to see the falx cerebri, the layer of connective tissue that separates the left and right hemispheres of the brain. This image was created by Nicolas-Henri Jacob for French anatomist and physician Jean-Baptiste

Marc Bourgery's *Traité complet de l'anatomie de l'homme comprenant la médicine opératoir ...*, 1831–54. This anatomical atlas, published in eight volumes, took the new art of chromolithography to perhaps its greatest heights, and is considered by many to be one of the most magnificent of such atlases.

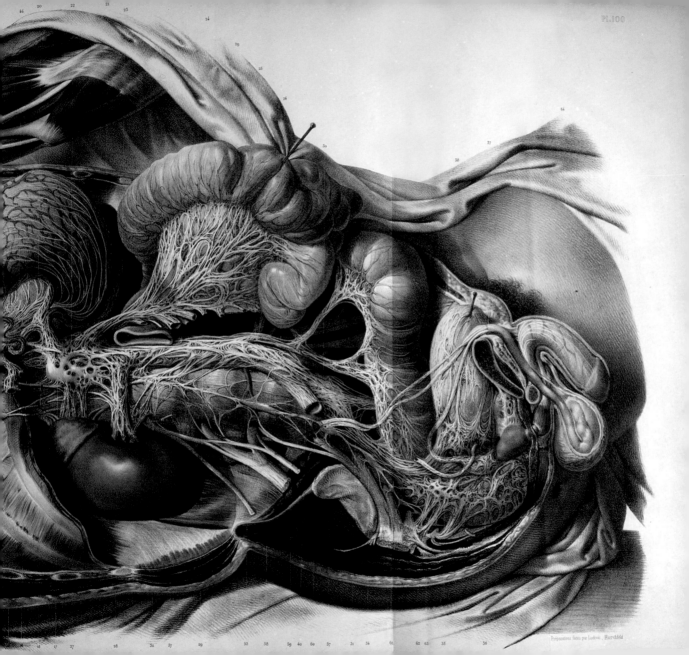

Pl.100

Préparations faites par Ludovic . Hirschfeld

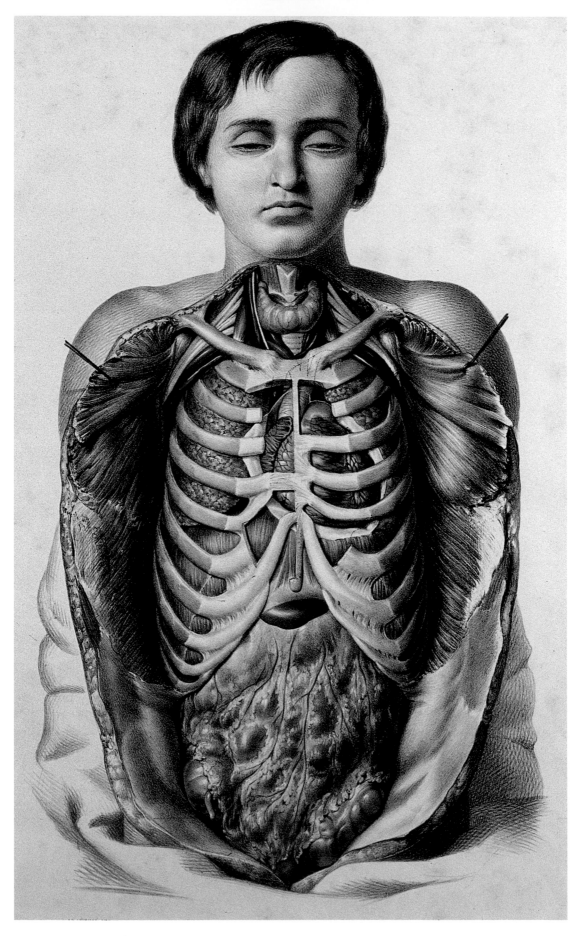

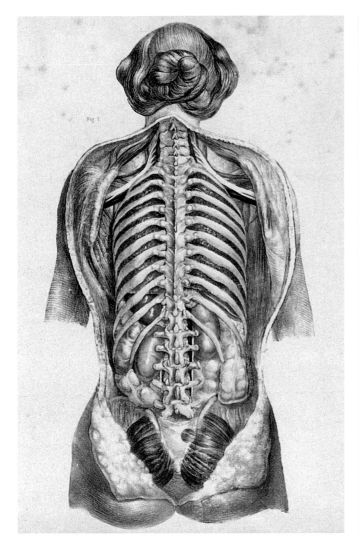

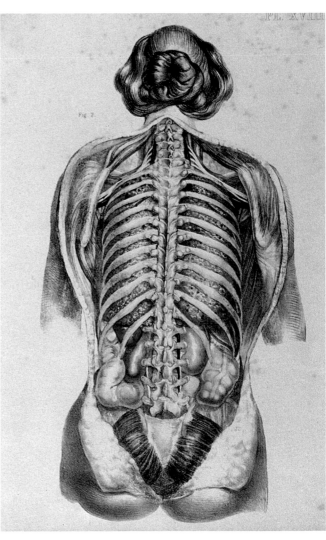

The coloured lithographs on this spread were created from drawings by William Fairland for Francis Sibson's *Medical Anatomy: or, Illustrations of the Relative Positions of the Internal Organs*, 1869. They were all drawn in close association with the author, who oversaw the dissections.

← An illustration of a young man with the skin pulled back to reveal the ribcage and the organs of the thorax and abdomen. At the top of the figure (in the neck) the thyroid cartilage can be seen, and below it the thyroid gland. On either side are the nerves of the brachial plexus. This complex network of nerves travels from the cervical spine, under the clavicle (collar bone) and enters the arms to innervate the muscles of the arm, forearm and hand. Among other anatomical features we can also see the heart and its great vessels (arteries and veins), the lungs, diaphragm, colon and small intestine.

↑ These two images show a dissection of a woman's torso, with the lungs after exhalation (left) and after inhalation (right). Artificial inflation of the lungs was used to achieve this effect.

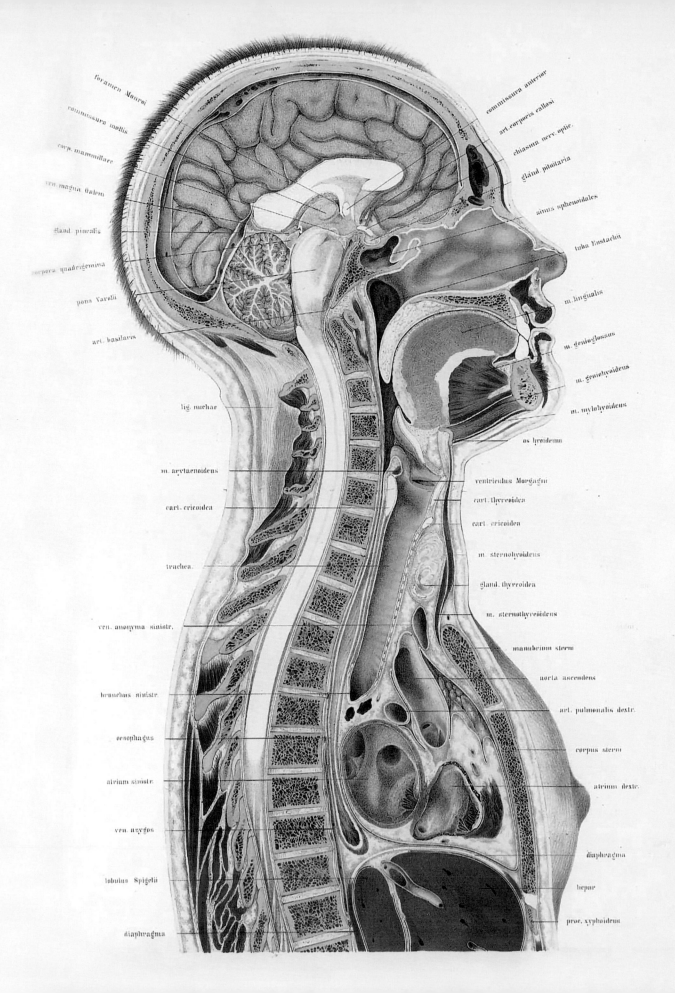

foramen Monroi

commissura mollis

corp. mammillare

ven. magna Galeni

gland. pinealis

corpora quadrigemina

pons Varolii

art. basilaris

lig. nuchae

m. arytaenoideus

cart. cricoidea

trachea.

ven. anonyma sinistr.

branchus sinistr.

oesophagus

atrium sinistr.

ven. azygos

lobulus Spigelii

diaphragma

commissura anterior

art. corporis callosi

chiasma nerv. optic.

gland. pituitaria

sinus sphenoidales

tuba Eustachii

m. lingualis

m. genioglossus

m. geniohyoideus

m. mylohyoideus

os hyoideum

ventriculus Morgagni

cart. thyreoidea

cart. cricoidea

m. sternohyoideus

gland. thyreoidea

m. sternothyreoideus

manubrium stern.

aorta ascendens

art. pulmonalis dextr.

corpus stern.

atrium dextr.

diaphragma

hepar

proc. xyphoideus

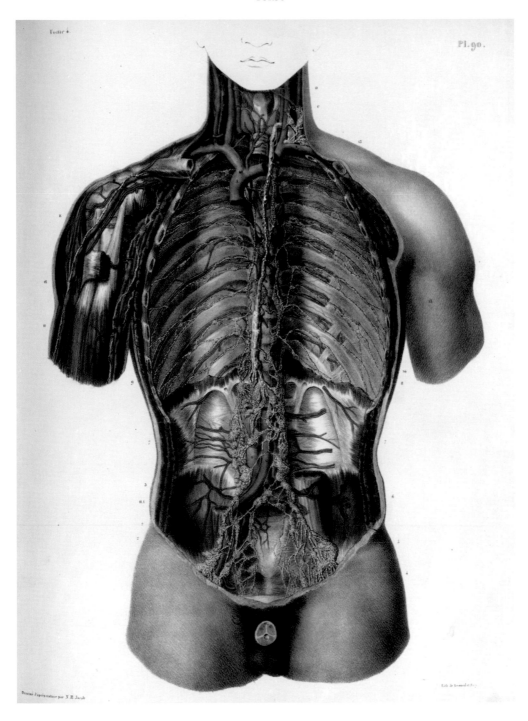

← This striking colour lithograph depicts a sagittal section of the female body; it is drawn from German professor and anatomist Wilhelm Braune's *Topographisch-anatomischer Atlas: nach Durchschnitten an gefrornen Cadavern*, 1867–1872 (A Topographical and Anatomical Atlas of Frozen Cross-sections of Cadavers). To create the images for this publication, Braune froze human cadavers and had them cut into thin slices. These slices were then traced and beautifully redrawn, with relevant anatomical features labelled.

↑ This chromolithograph shows a male torso with the viscera removed to showcase the lymphatic vessels and lymph nodes. The penis has also been sliced through to reveal the structures within. The image, made from drawings by Nicolas-Henri Jacob, are from Jean-Baptiste Marc Bourgery's *Traité complet de l'anatomie de l'homme comprenant la médecine opératoir ...* , 1831–54 (Complete Treatise of Human Anatomy).

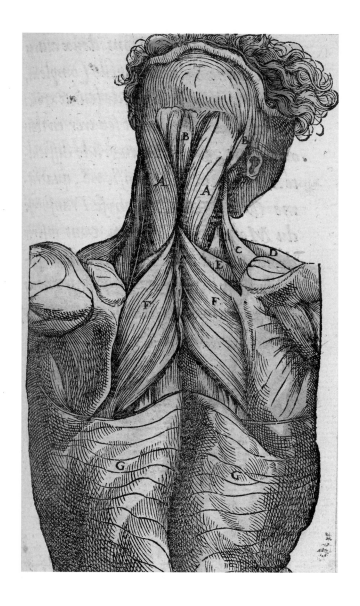

↗ This hand-coloured illustration of a man who has been flayed to display the partially dissected musculature below comes from Ambroise Paré's *La Méthode curative des playes, et fractures de la teste humaine*, 1561 (Curative Methods for Wounds and Fractures of the Human Head). Paré, a founding father of modern surgery, also made advances in prosthetics and obstetrics. Unusually, for his time, he resorted to surgery only when absolutely necessary.

→ Created from observing frozen cross-sections of a human torso, this illustration comes from Wilhelm Braune's *Topographisch-anatomischer Atlas: nach Durchschnitten an gefrornen Cadavern*, 1867–72.

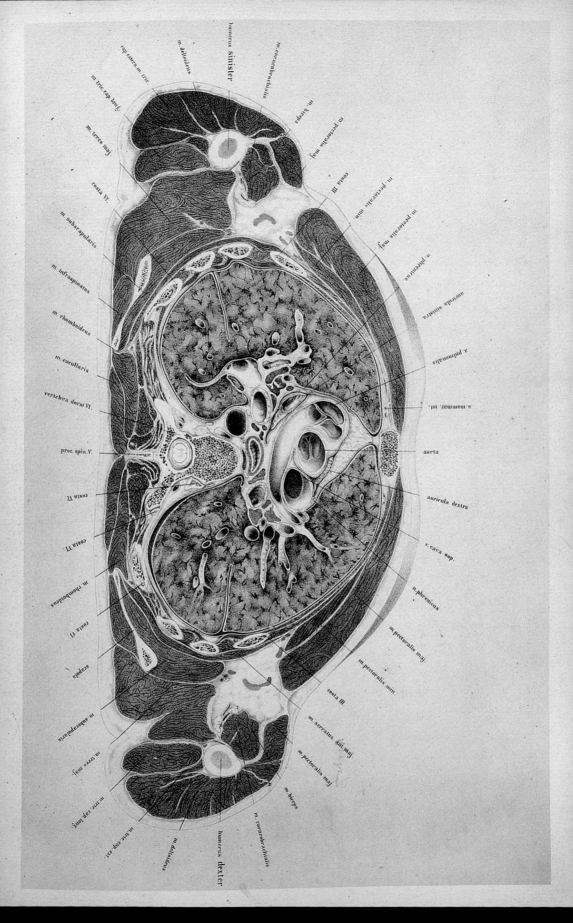

humerus sinister

m. coracobrachialis

m. deltoideus

cap. extern. m. tric.

m. tric. cap. long.

m. biceps

m. teres maj.

m. pectoralis maj.

costa VI.

costa III.

m. subscapularis

m. pectoralis min.

m. infraspinatus

m. pectoralis maj.

m. rhomboideus

n. phrenicus

m. cucullaris

auricula sinistra

vertebra dorsi VI.

a. pulmonalis

proc. spin. V.

a. mammar. int.

costa VI.

aorta

costa VI.

auricula dextra

m. rhomboideus

v. cava sup.

costa VI.

n. phrenicus

scapula

m. pectoralis maj.

m. subscapularis

m. pectoralis min.

m. teres maj.

costa III.

m. serratus ant. maj.

m. pectoralis maj.

m. tric. cap. long.

m. biceps

m. tric. cap. ext.

m. coracobrachialis

m. deltoideus

humerus dexter

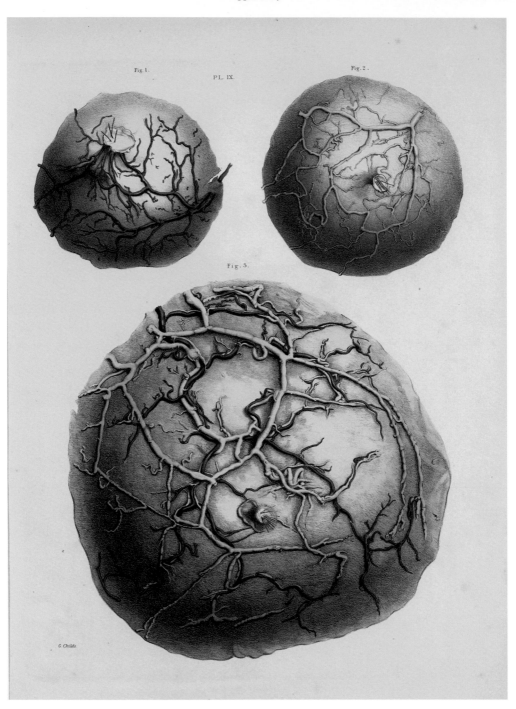

Both of these images are drawn from *On the Anatomy of the Breast*, 1840, by Sir Astley Paston Cooper, a prominent English surgeon and anatomist. Cooper studied with the famous anatomist John Hunter, and served as surgeon to Kings George IV and William IV, and later to Queen Victoria. He also served as president of the Royal College of Surgeons. His book is notable for being the first thorough anatomical analysis of the breast, and it was also his last.

⋏ The illustrations above explore the arteries and veins of different women's breasts; the bottom one is lactating.

⭲ These illustrations showcase the ducts and glands of the breast, visualized by being injected with coloured wax.

PL. VI.

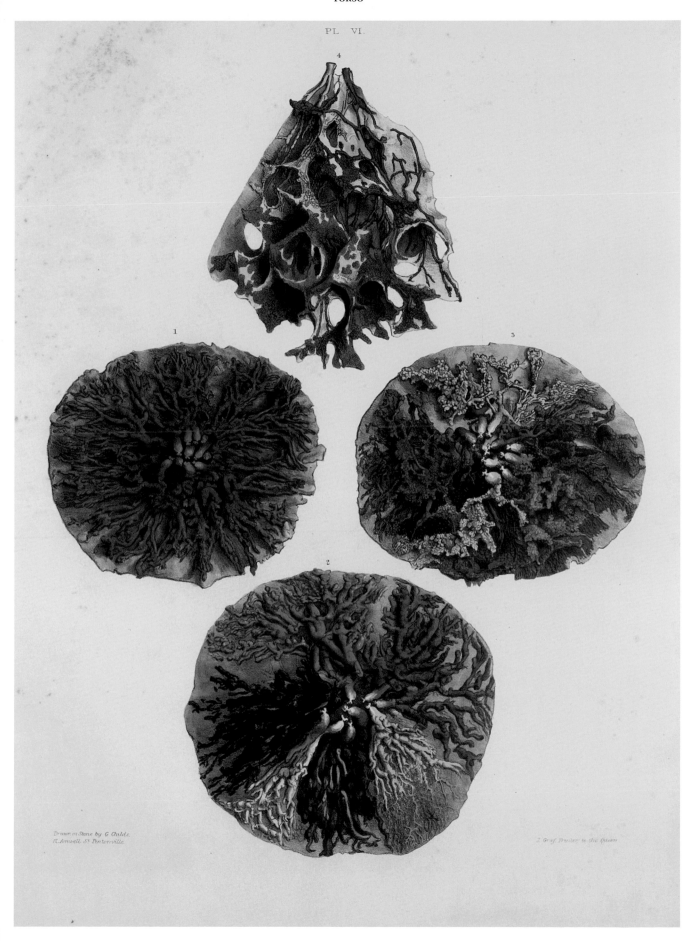

4

1

3

2

Drawn on Stone by G. Childs.
R. Amwell St. Pentonville.

J. Graf, Printer to the Queen

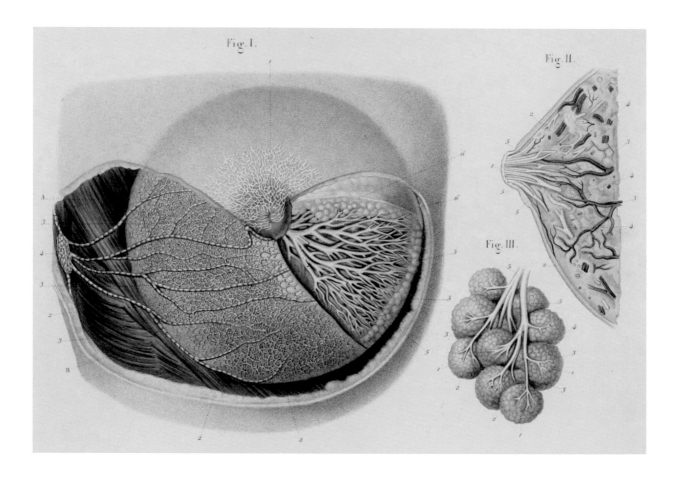

Fig. I.

Fig. II.

Fig. III.

↑ Above is an overview of a breast dissected to different levels. The oval shape on the left-hand side is a lymph node with its web-like lymph ducts supplying the breast tissue. The section on its right-hand side elegantly shows lactiferous (milk-producing) ducts, glandular tissue and fatty tissue. These elements are displayed in cross-section in fig. II, as is the blood supply. Fig. III shows a detail of the lactiferous ducts and their branches, and is taken from Constantin Bonamy, Paul Broca and Émile Beau's *Atlas d'anatomie descriptive du corps humain*, 1844–66.

→ An illustration comparing the nipples of different individuals, ranging from a two-year-old girl to an elderly woman, some drawn from the bodies of the living, and some (figs 8, 15 and 18) from cadavers. Some, such as fig. 16, which belonged to a 40-year-old woman who had nine children, are from older women who have breastfed. It was published in Sir Astley Paston Cooper's *On the Anatomy of the Breast*, 1840.

PL. 1

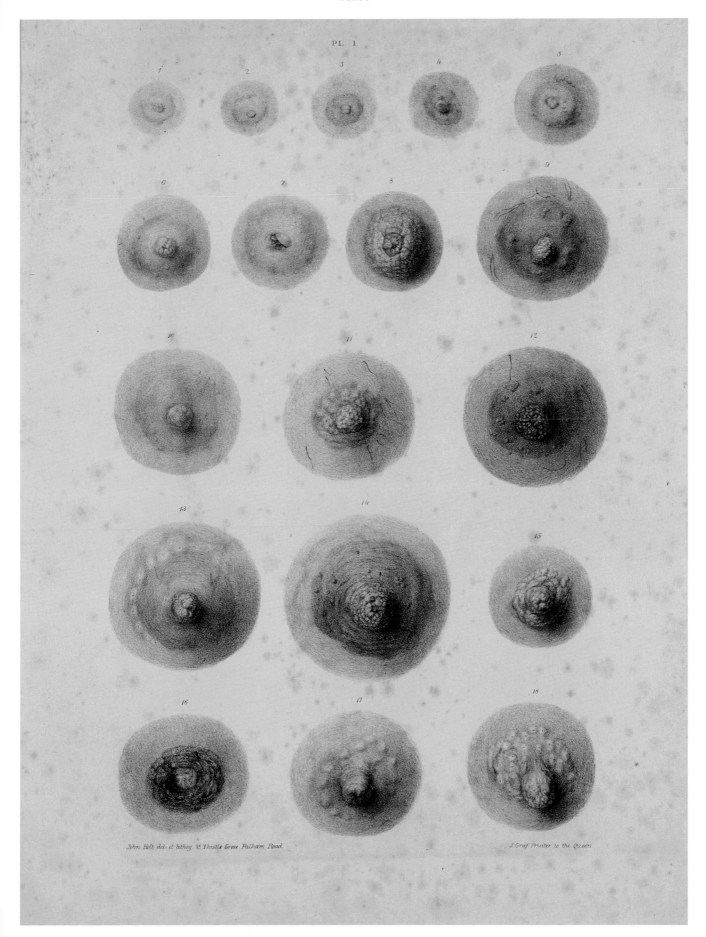

John Holt del. et litheg. 8 Thistle Grove Fulham Road.

J Graf Printer to the Queen

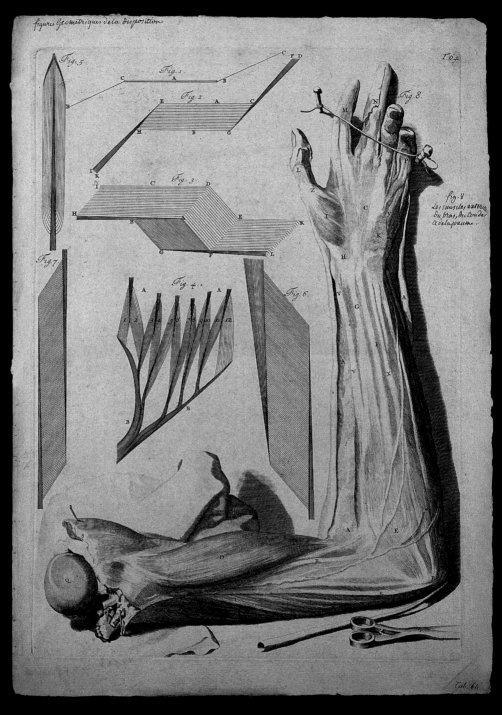

fig. 8.
Les muscles exterieurs
du bras, du Coudes
& de la paume.

Drawn from Govard Bidloo's
Anatomia humani corporis, 1685,
this iconic image by Gérard de
Lairesse shows a superficial dissection
of the anterior aspect of the arm. The
fascia (fibrous tissue that encloses
the muscle) are still intact, as are
some of the superficial nerves.
The flexor muscles are shown in
transparency through the fascia. The
various geometric figures surrounding
the main illustration depict, in a
stylized fashion, the fibre direction in
various types of skeletal muscles.

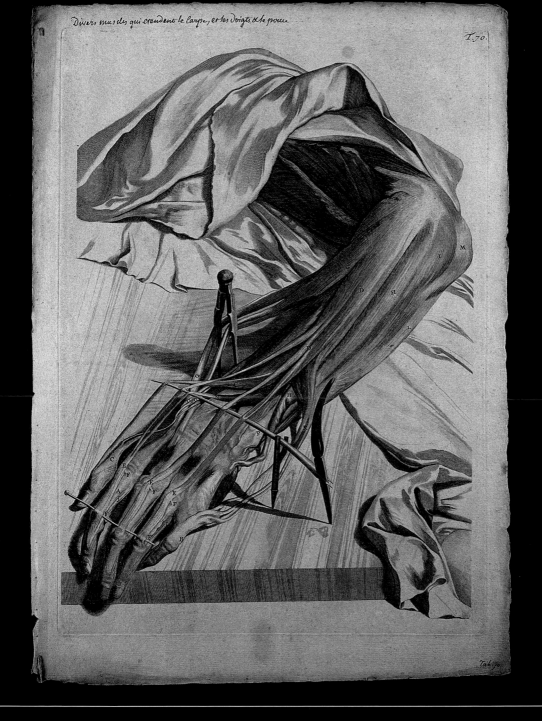

A dissection revealing the muscles of the back of the hand and the forearm, with the tendons raised and separated by various instruments. Taken from the Bidloo work cited opposite, this is an engraving after Gérard de Lairesse, a well-known painter of the Dutch Golden Age (17th century), who, along with Bidloo, also produced work for the popular theatre. The tendons of the extensor digitorum muscle have been elevated so as to follow them back to the muscles coming from the humerus. This elegant extensor muscle allows the fingers to be extended or straightened.

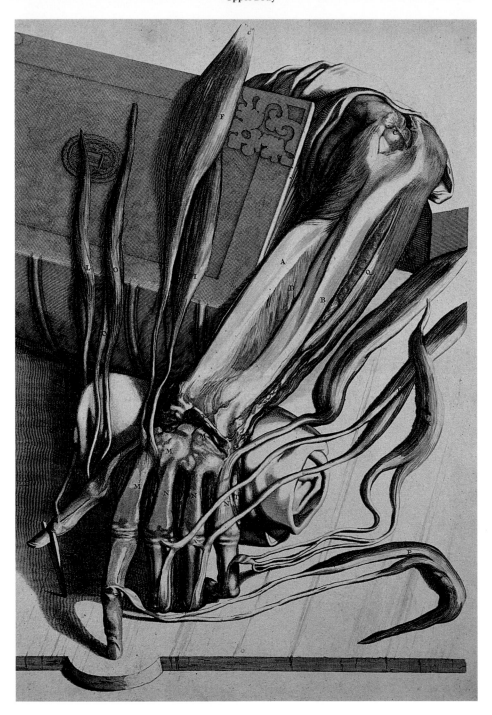

In this handsome engraving we see an arm and hand dissected and resting on various supports, including a book. Like the images on the previous spread, it was copied from a wash drawing by Gérard de Lairesse for the polymath Govard Bidloo's *Anatomia humani corporis*, 1685. This book was famous for the artistic quality of its images, which were somewhat in the Dutch still life or *nature morte* tradition, where things of this world were rendered with great precision to draw attention to their eventual decay. The goal of such images was, *memento mori*-like, to encourage the viewer to reflect on the vanity of earthly pleasures and temporary beauty. This deep dissection of the arm shows the radius and ulna, with the muscles of the wrist and hand stripped back.

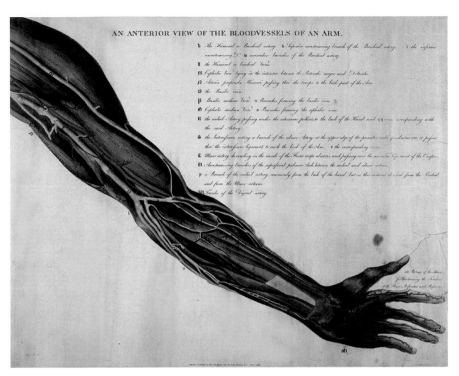

AN ANTERIOR VIEW OF THE BLOODVESSELS OF AN ARM.

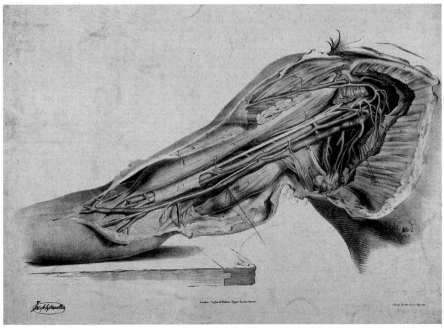

⋏ This powerful watercolour engraving by George Kirtland dates from 1804 and depicts an anterior view of a dissection of the arm, from the axilla (armpit) to the fingers, with an emphasis on the nerves and arteries. The muscles are also shown, but are depicted in less detail.

⋎ Beautifully drawn by the Irish anatomist, surgeon and artist Joseph Maclise, this highly detailed image shows a deep dissection of the upper arm and armpit. Various skeletal muscles have been removed and cut to expose these deep vessels; and the axillary vein (blue) and the axillary artery (red) are revealed with their many branches. The illustration comes from Irish physician Richard Quain's *The Anatomy of the Arteries of the Human Body ...*, 1844.

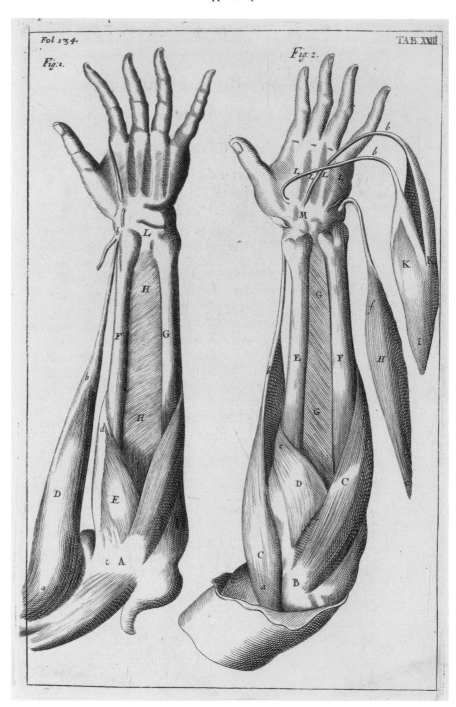

This stately copperplate engraving showing two deep dissections of the anterior (above, left) and posterior (above, right) arm and hand is taken from English anatomist and surgeon John Browne's *A Compleat Treatise of the Muscles: as they appear in humane body ...*, 1681. Browne is most remembered today for the accusations of plagiarism made against him when this book was published, as its text was taken nearly word for word from William Molins's *Myskotomiai or the Anatomical Administration of all the Muscles of an Humane Body*, 1648, and its images were copied from Giulio Casseri's *Tabulae Anatomicae*, 1627 (Anatomical Tables).

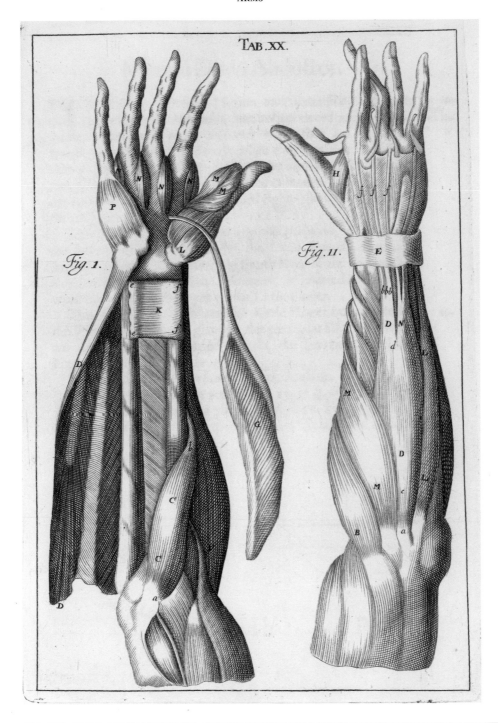

Reproduced from the John Browne book cited opposite, this image shows two superficial dissections of the anterior (above, left) and posterior (above, right) arm and hand. Although Browne's reputation was sullied by charges of plagiarism, it must be remembered that this practice was common during the 16th and 17th centuries, and that laws governing copyright were much less rigorous than those today. Browne was also a trained anatomist and doctor, who eventually rose to become Surgeon Ordinary to Kings Charles II and William III.

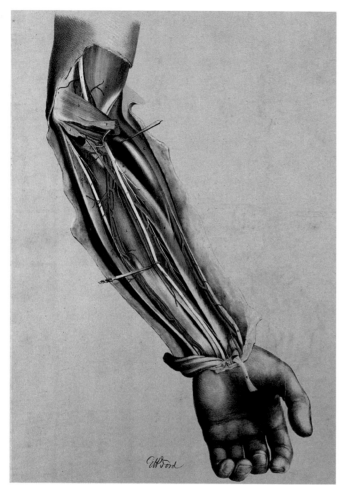

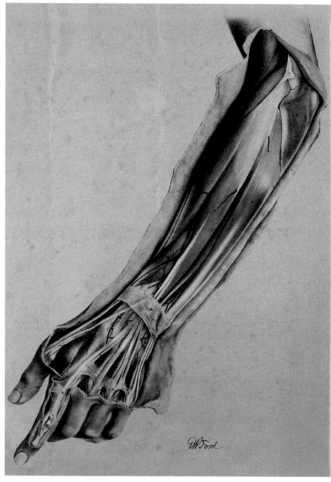

The stunning and sensitively portrayed chromolithographs on these two pages are by George Henry Ford from dissections by George Viner Ellis, British professor of anatomy, and appear in his book *Illustrations of Dissections, in a series of original coloured plates, the size of life, representing the dissection of the human body*, 1867. All the images were drawn life-sized and directly from the cadaver.

↑ A dissection of the arm showing the muscles of the anterior (front) portion of the forearm. The superficial flexor muscles have been removed to better visualize the deep flexor muscles, which allow the fingers to flex and bend, as when making a fist.

↓ A dissection showing the posterior (back) aspect of the forearm and hand, revealing the superficial extensor muscles as they originate from the humerus (arm bone) and insert into the bones of the hand, allowing the wrist and fingers to extend or straighten.

→ Here we enter the dissection room, where we encounter a cadaver bent over a wooden block, hands tied back to give a view into the axilla and posterior aspect of the arm. The nerves are highlighted in bright white as they emerge from the brachial plexus and branch into nerves that supply the upper limb.

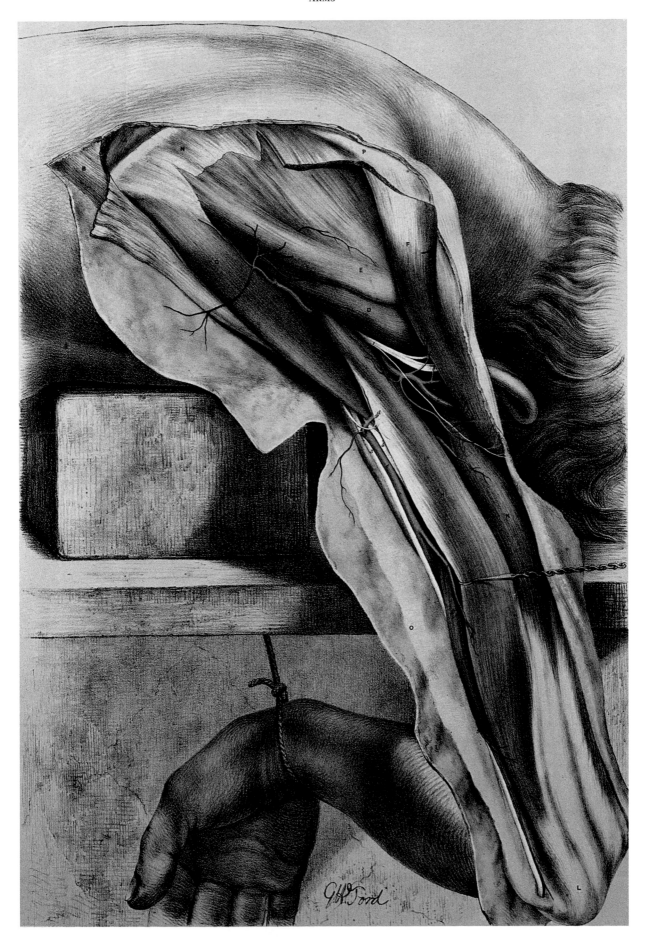

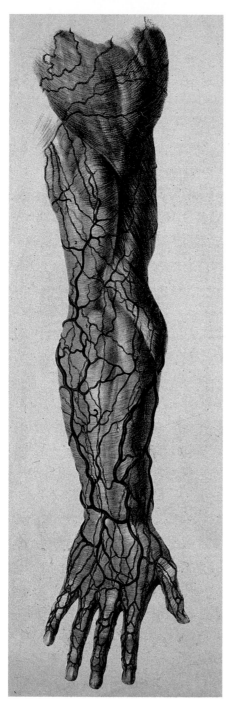
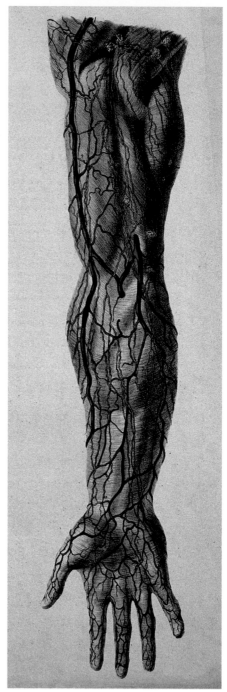

Here we have a coloured lithograph by William Fairland, showing front and back views of the superficial veins and nerves of the human arm, forearm and hand. These superficial vessels lie under the skin and on top of the skeletal muscles, covered in fascia. The image is taken from *The Vessels of the Human Body*, 1837, by the Irish anatomist Jones Quain and the English surgeon Sir Erasmus Wilson. Jones was the brother of Richard Quain, also the author of books on anatomy, and both men taught the subject at University College, London, during the 19th century.

→ These ink and watercolour renderings of the bones of the arm and hand date from about 1830, and were painted after an image in William Cheselden's *Osteographia, or The Anatomy of the Bones*, 1733. The book contained life-sized illustrations of all the bones in the human body, and their extreme accuracy was achieved by using a camera obscura. The images shown here were probably copies made by an aspiring student.

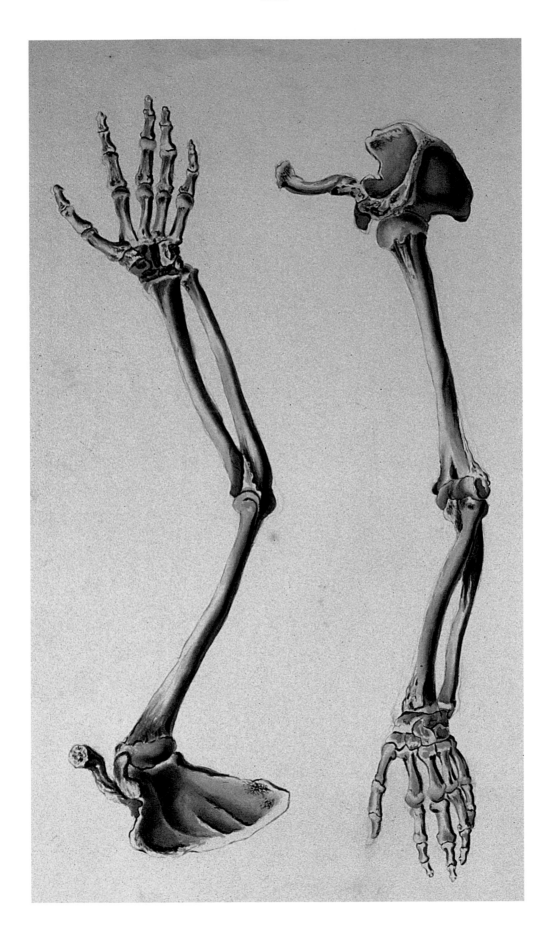

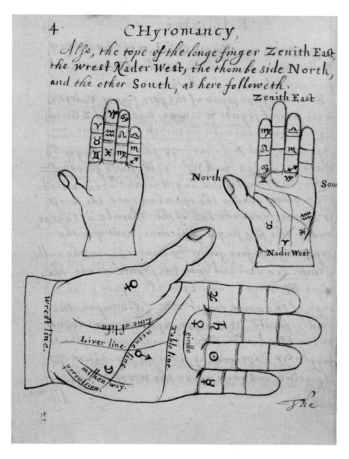

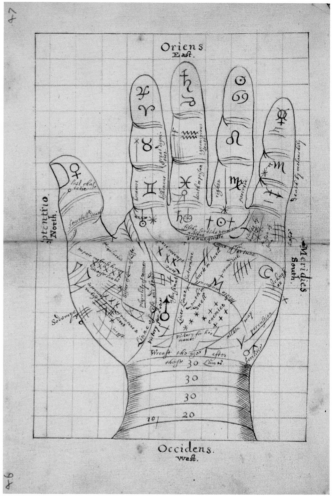

Pen and ink illustrations from a
1648 English manual of practical
chiromancy, also known as palmistry
– the reading of someone's destiny by
analysing the lines on their palms.
The book details the ways in which
planets and astrological signs assert
their influence, how to understand a
person's temperament, and how to read
fingernails. The volume was once owned
by Lord Redesdale, perhaps best known
for fathering the Mitford sisters.

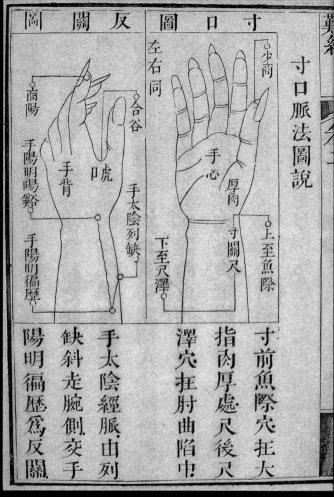

寸口脈法圖說

左右同

少商

合谷

手心

厚肉

上至魚際

商陽

虎

口

手背

寸關尺

下至尺澤

手陽明陽谿

手太陰列缺

手陽明徧歷

寸前魚際穴抂大

指肉厚處尺後尺

澤穴抂肘曲陷中

手太陰經脈由列

缺斜走腕側交手

陽明徧歷爲反關

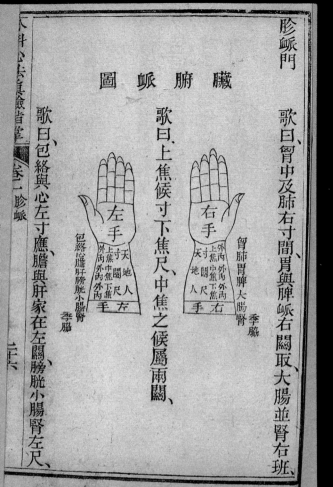

胗脈門

臟腑胗圖

歌曰、腎中及肺右寸間胃與脾�右關取大腸並腎右班、

歌曰、上焦候寸下焦尺、中焦之候屬兩關、

左手

右手

天地人
寸關尺
左

天地人
寸關尺
右手

心肝腎
外肉外肉外肉
上焦中焦下焦

肺胃脾大腸腎
外肉外肉外肉
上焦中焦下焦

季脇

包絡恰應肝膀胱小腸腎

季脇

歌曰、包絡與心左寸應膽與肝家在左關膀胱小腸腎左尺、

二三六

↖ A Chinese woodcut illustrating the correspondences between pulses and organs. It comes from *Waike xinfa zhenyan zhinan* (Guide to Tried and True Methods at the Heart of External Medicine, 1887).

↑ A wrist-pulse chart, from an 1817 edition of Xiong Qinghu's *Bian Que maishu nan jing* (Canon of Problems in Bian Que's Book of the Pulse), originally produced in the early Qing period (17th–18th century). Pulse diagnosis is an important part of Chinese traditional medicine,

Medius

Annularis Index

Auricularis

Angulᵒ

Prima

Juncː
ctura Scða

Tertia Pollex

Mõtes.

linea mensalis

linea naturalis Mensalis

Linea cordis et hic

Tabula

♓ Mons

Mõs venus ... sanguis offensas manus

Restricta

Secūda iūctura

Prima iūctura

The hand, after the face, is the most expressive part of the human body. It is no wonder, then, that people developed systems to 'read' the hand in order to understand an individual's character or destiny, or that artists took such great pains to learn their intricate anatomy in order to depict them with the greatest possible grace and veracity.

← This coloured woodcut is a guide to reading the palm, and comes from Magnus Hundt's *Antropologium de hominis dignitate, natura, et proprietatibus, de elementis, partibus, et membris humani corporis*, 1501 (*An Anthropology of Human Dignity, Nature and Properties, and of the Elements, Parts and Members of the Human Body*).

↑ This prosthetic mechanical hand comes from French anatomist and surgeon Ambroise Paré's *Dix livres de la chirurgie*, 1564 (Ten Books of Surgery). He is considered one of the fathers of modern surgery, and was a pioneer in designing prosthetics. Renowned during his time, he was surgeon to Kings Henry II, Francis II, Charles IX and Henry III.

A sensitive and eloquent chalk drawing
of the muscles and tendon of the hand,
probably sketched by the Italian artist
Antonio Durelli around 1837.

Ext. comm. and ext. indic.

Ext. comm.

Ext. comm. and ext. min. dig.

Ext. sec. inter. poll.

1st dorsal inteross.

2d dorsal inteross.

3d dorsal inter.

4th dorsal inter.

Ext. primi inter. poll.

1ST DORSAL INTEROSSEOUS MUS.

2ND DORSAL INTEROSSEOUS MUS.

3RD DORSAL INTEROSSEOUS MUS.

4TH DORSAL INTEROSSEOUS MUS.

Ext. carpi uln.

Ext. carp. rad. long.

Ext. carpi rad. brev.

This illustration of the bones of the hand is from an unknown anatomical book published around 1900. Its style is strongly reminiscent of the influential illustrations created by English anatomist, surgeon and artist Henry Vandyke Carter for English anatomist Henry Gray's *Anatomy: Descriptive and Surgical ...*, 1858. The work is still used by medical students today, though with the simplified title *Gray's Anatomy*. Its clinical, diagrammatic illustrations – devoid of metaphor and emotion – set the standard language for anatomical visualisation to the present day.

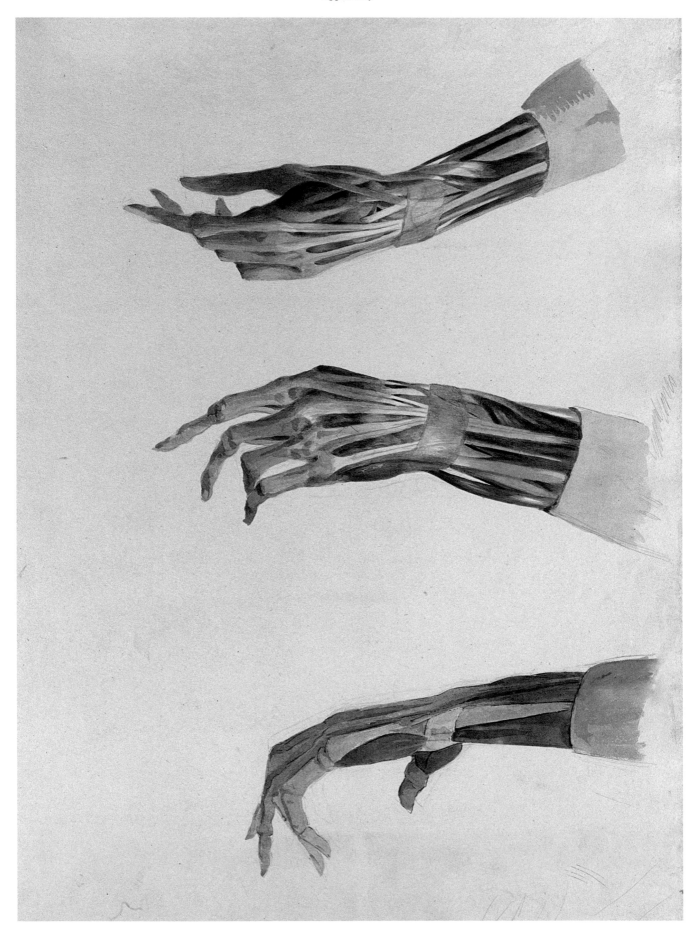

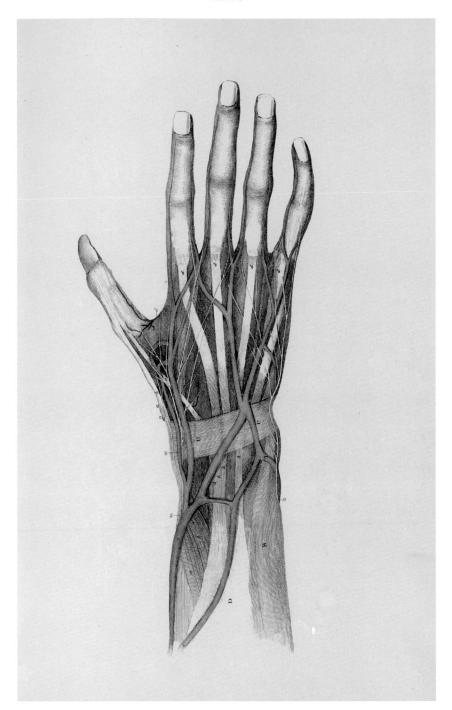

← These lovely dissected hands were painted in watercolour by the Swiss artist Johann Conrad Zeller around 1833. Perhaps they were studies for one of his many portraits, as the care given to depicting hands was second only to that given to the face, because both are so expressive of the personality of the sitter.

↑ This coloured line engraving, with the arteries rendered in red, the superficial veins in blue and the superficial nerves in white, is by William Home Lizars, from his brother John's book *A System of Anatomical Plates of the Human Body*, 1822–6.

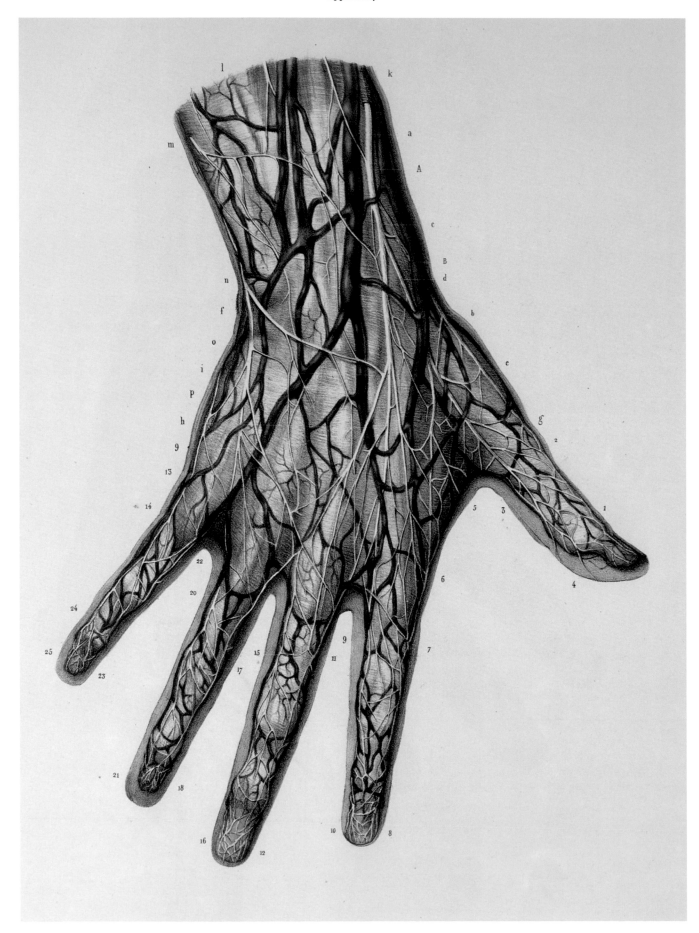

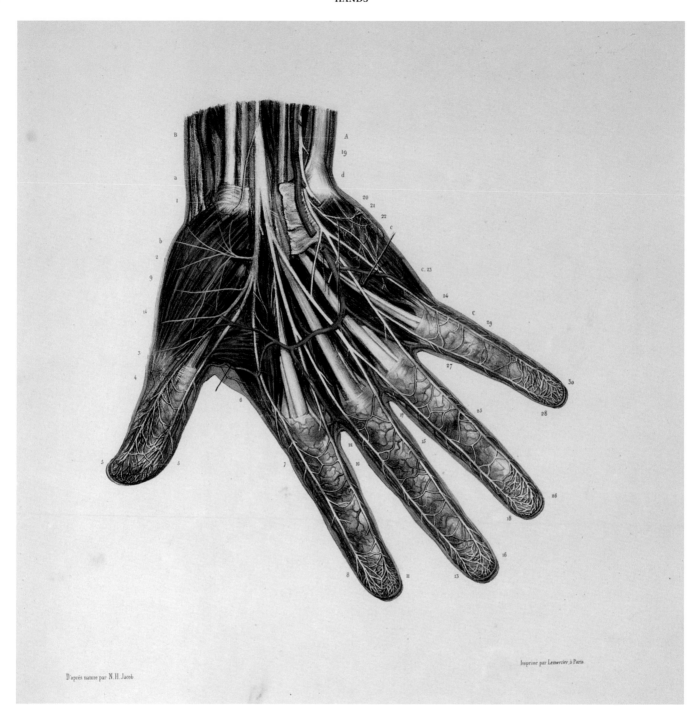

D'après nature par N.H. Jacob

Imprimé par Lemercier, à Paris.

These beautifully rendered illustrations of the hand, by Nicolas-Henri Jacob, are from Jean-Baptiste Marc Bourgery's *Traité complet de l'anatomie de l'homme comprenant la médicine opératoir...*, 1831–54.

← This elegant illustration shows a hand dissected to showcase the nerves and the superficial veins (those just below the skin). These veins merge with the deep veins to bring deoxygenated blood from these tissues to the heart.

↑ A gorgeous illustration of the muscles of the hand, both intrinsic, meaning with an origin and insertion within the structure under consideration, and extrinsic, meaning with an origin outside the structure. The *flexor retinaculum* (which creates the carpal tunnel) has been cut.

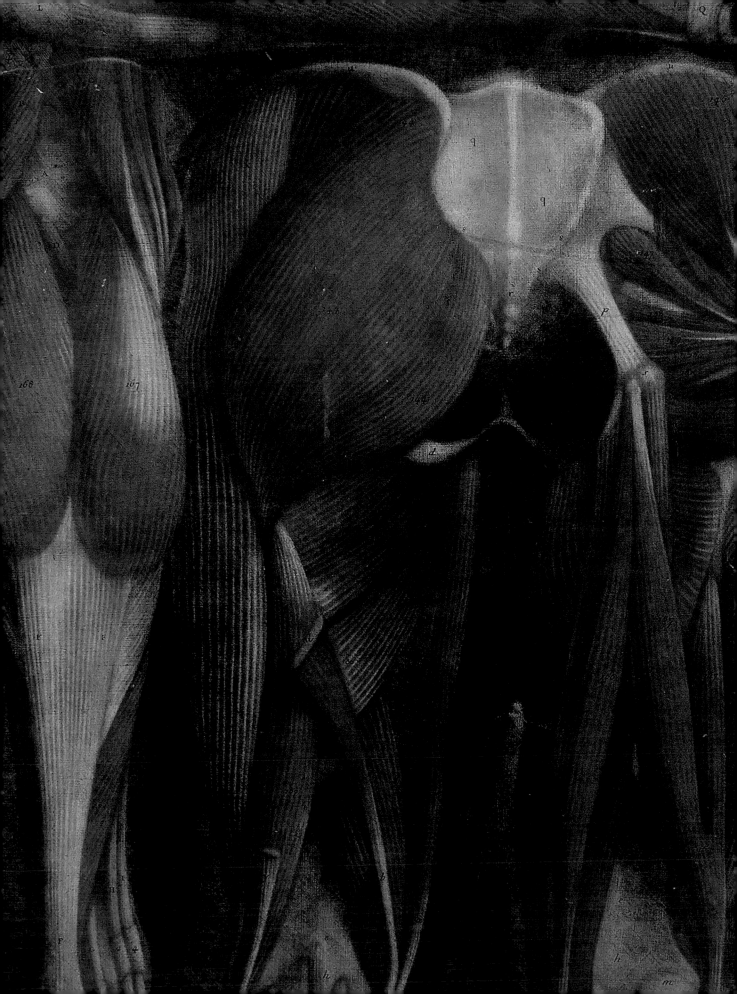

Lower Body

The lower body grounds us, linking us to the earth. In contrast to most animals and all other primates, humans have muscular legs that support our erect stature. They propel us through the world, and thus symbolically represent our mobility.

The feet are extremely complex anatomical structures. They are designed for weight transmission, locomotion, and balance. Leonardo da Vinci famously called them 'a masterpiece of engineering and a work of art'. They are made up of 26 bones and more than 30 joints, and their sensitivity, flexibility and dexterity allow us to traverse a variety of terrains with ease. As the body part closest to the earth, they are a symbol of humility, and groundedness.

The lower body is home to parts of the anatomy that the Western world traditionally considered 'unspeakable' or shameful: namely, the genitals and the anus (see Chapter 3). For this reason, the lower body has historically been associated with our instinctive behaviours – reproduction, excretion and urination – and thus considered less 'noble' than the upper body, with its lofty intellect, humanizing heart and rational brain. Western culture has tended to focus its attentions higher up. In the Eastern chakra system, however, the connection to the base of the body is essential for a sense of rootedness and security, without which enlightenment – symbolized by the crown chakra at the top of skull – cannot be reached.

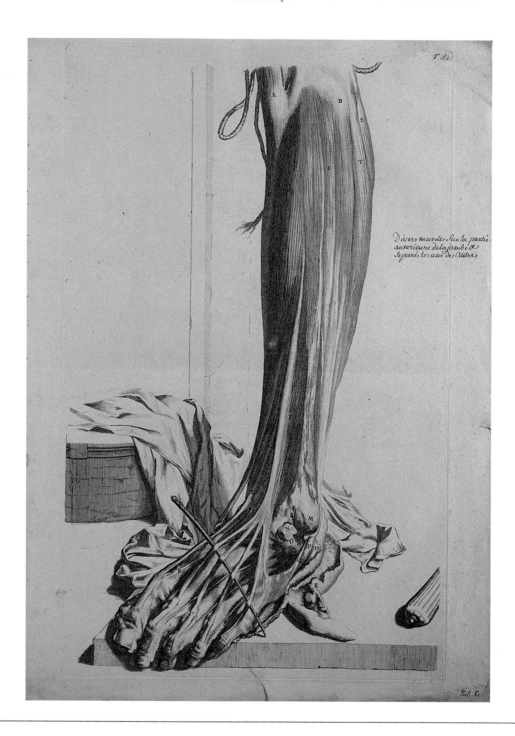

Above and to the right is a human leg
in various states of dissection, from
two engravings drawn by Gérard de
Lairesse for Govard Bidloo's famous
Anatomia humani corporis, 1685. The
image above shows the muscles of the
lower leg, with the tendons separated.

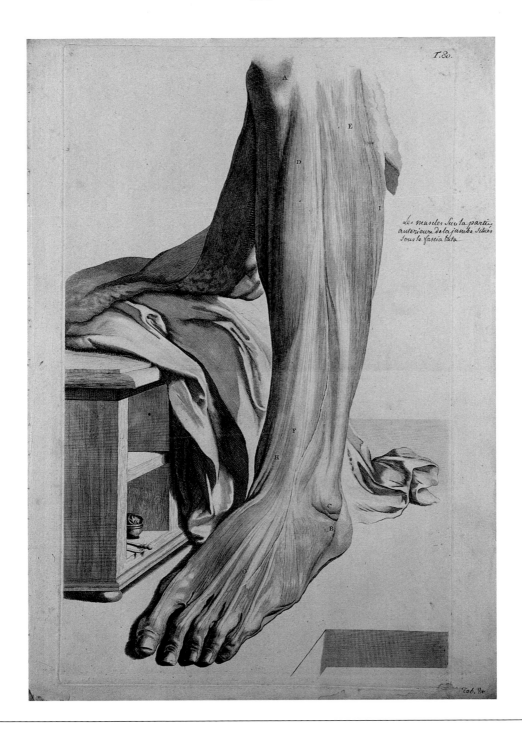

Drawn from the same book as the image opposite, this illustration shows the same leg, but with the skin visibly draping to the left, where it cascades onto a piece of drapery atop a box of surgical instruments. In reference to its illustrations, Bidloo's book has been called 'a key text in the new anatomical realism' of the late 17th and early 18th centuries, as well as 'a disturbing nightmare anatomy'. They could also be seen as products of the Dutch Golden Age of art, particularly of the Dutch still life (*nature morte*, literally 'dead nature') tradition, in which realistically painted objects were meant to remind viewers of the brevity of life and the pleasures of the flesh.

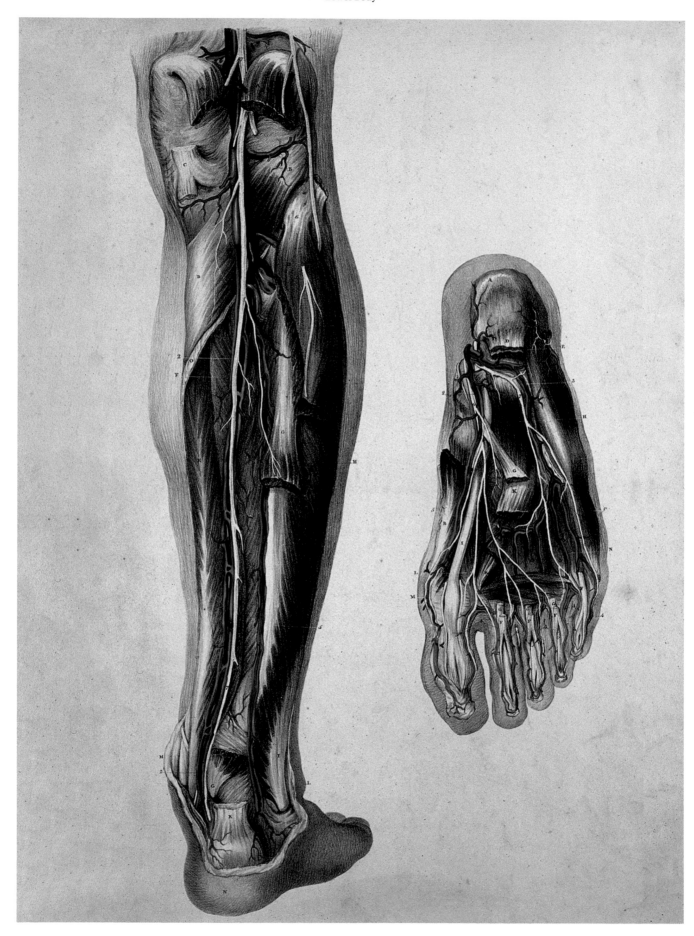

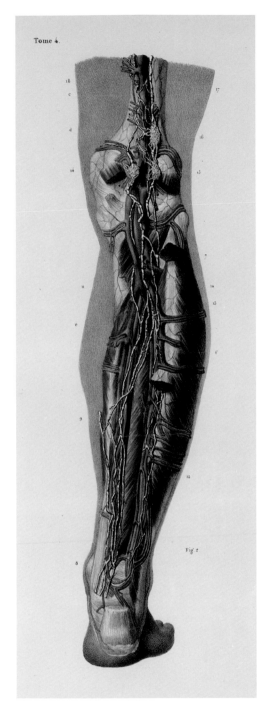

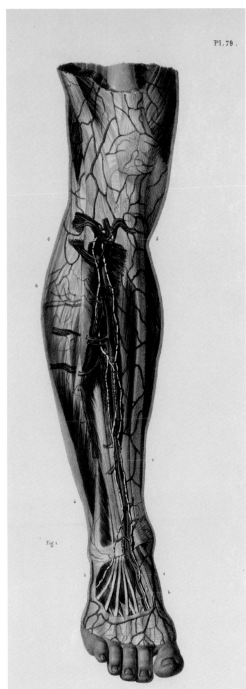

← A coloured lithograph of a dissected leg and foot, showing the blood vessels of the lower limb. The illustration comes from William Bloxam's *The Cyclopaedia of Practical Surgery*, 1834–5.

↑ Two views of a dissected leg, showing the deep lymphatic vessels and lymph nodes. The image comes from Jean-Baptiste Marc Bourgery's *Traité complet de l'anatomie de l'homme comprenant la médicine opératoir...*, 1831–54.

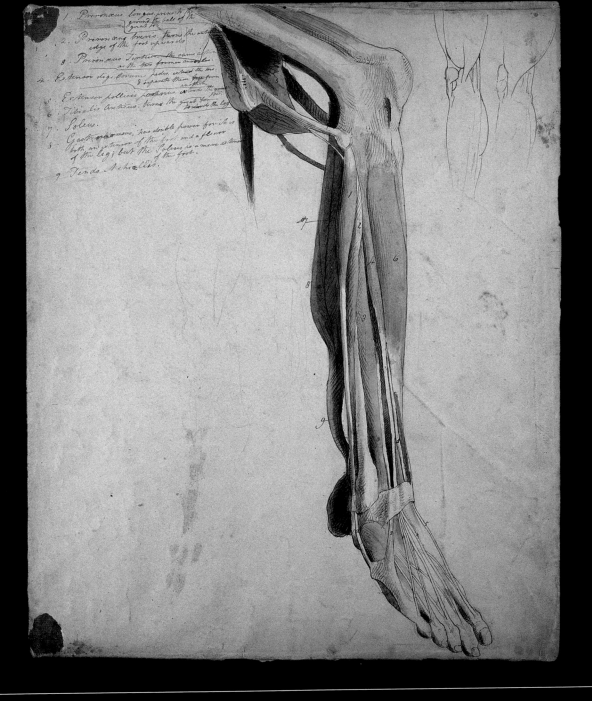

A watercolour painting, with pen and ink detailing, of a dissected leg, showcasing the muscles and tendons. Painted by the English artist Charles Landseer around 1815, it might be one of the anatomical studies he was known to have created while a student with the painter Benjamin Haydon, a staunch believer in the importance of

→ A delicately hand-coloured engraving by William Home Lizars, showing the lymphatic nodes and vessels of the leg and groin. It comes from his brother John's book, *A System of Anatomical Plates of the Human Body*, 1822–6.

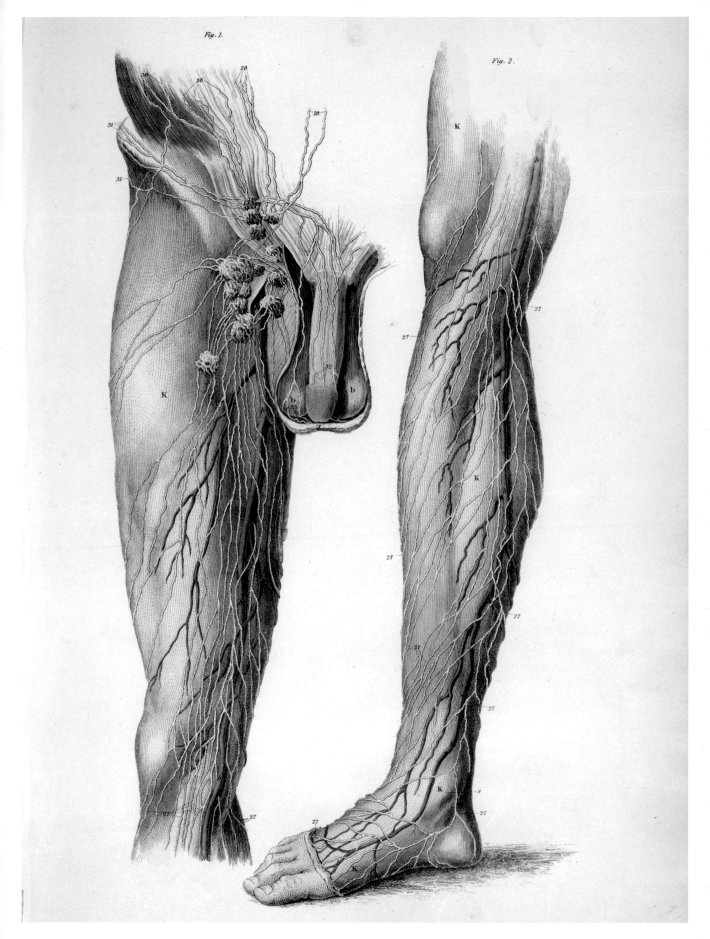

Fig. 1.

Fig. 2.

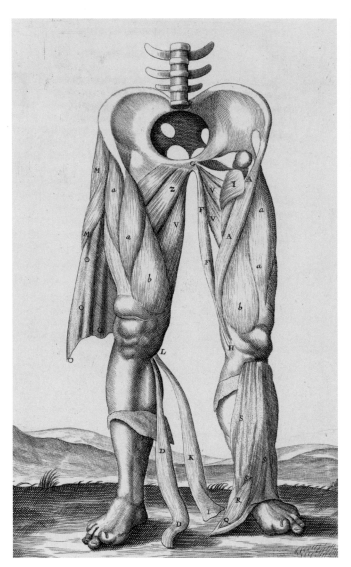
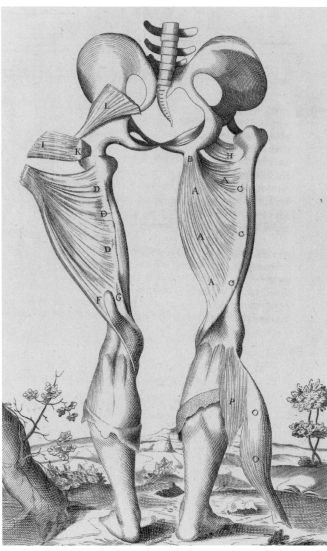

Two fine and fanciful baroque copperplate engravings showing the leg muscles, front and back, from John Browne's *A Compleat Treatise of the Muscles ...*, 1681. These stately legs, animated despite their dissected nature, and set into atmospheric landscapes, draw their iconography from Andreas Vesalius's groundbreaking anatomical atlas *De humani corporis fabrica ...*, 1543. The elegant and regal treatment of the body owes much to the baroque artistic conventions of the time, and the proud understanding of the human body as an object of nature crafted in God's own image.

This elegant illustration, with its fanciful celestial imagery, demonstrates the acupuncture points and meridians of the leg. It comes from *The Golden Mirror of Medicine*, a compendium of medical works commissioned by the emperor to correct errant medical knowledge in China and was first published in 1742.

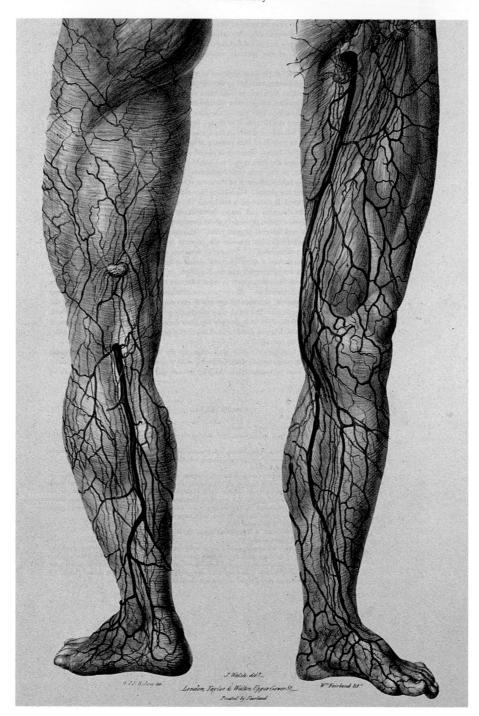

↑ A coloured lithograph from 1837 by William Fairland, after illustrations by J. Walsh and Erasmus Wilson, showing the veins and lymphatics of the leg from the front and back. It comes from Jones Quain and Sir Erasmus Wilson's *The Vessels of the Human Body*, 1837.

→ A colour mezzotint of the muscles of the leg and pelvis from the back. Produced by printmaker Jacques-Fabien Gautier d'Agoty, it comes from the work he made alongside Joseph Guichard Duverney – *Essai d'anatomie en tableaux imprimés ...*, 1746.

PLATE. VI.

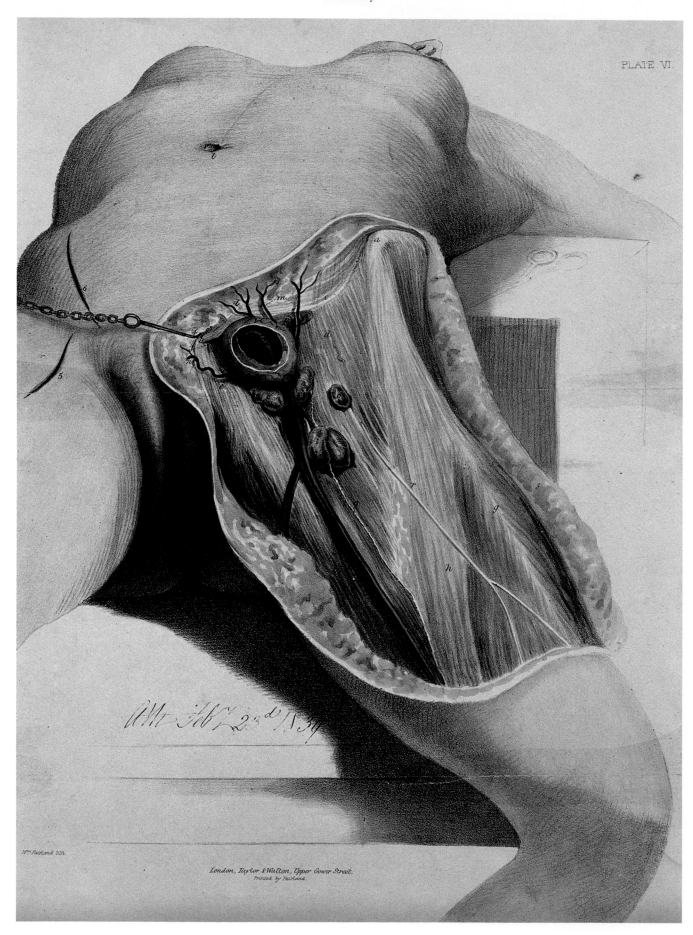

London, Taylor & Walton, Upper Gower Street.
Printed by Fairland.

W.m Fairland Lith.

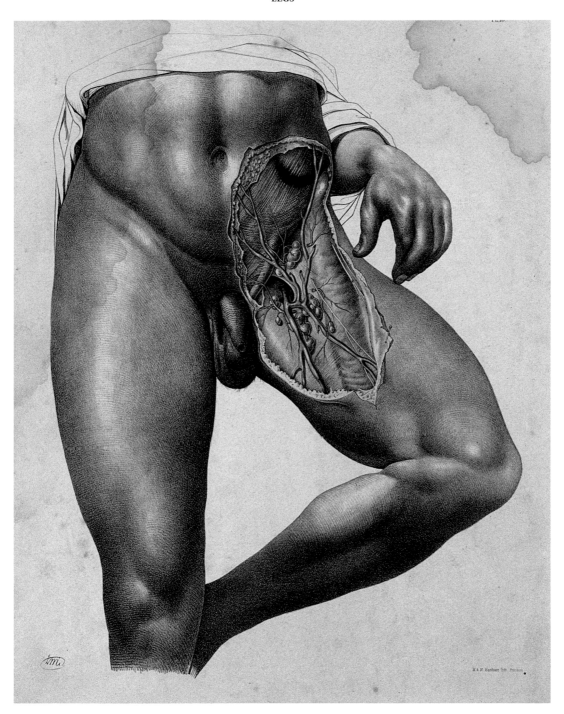

← A beautiful depiction of a reclining female cadaver with the thigh dissected, demonstrating the translucent fascia that covers the musculature, and exposing the muscles of the upper thigh. The saphenous vein is seen traversing the thigh, surrounded by a cluster of large superficial inguinal lymph nodes. The large circular structure near the groin might be pathology (disease). The image is a coloured lithograph by Andrew Morton and comes from Thomas Morton and William Cadge's *The Surgical Anatomy of the Principal Regions of the Human Body*, 1838–50.

↑ A beautifully rendered hand-coloured lithograph of a man with part of his thigh, groin and torso dissected to show the superficial veins of the anterior thigh, including the saphenous vein and its branches. It was copied from an original drawing in *Surgical Anatomy*, 1851, by the artist and anatomist Joseph Maclise.

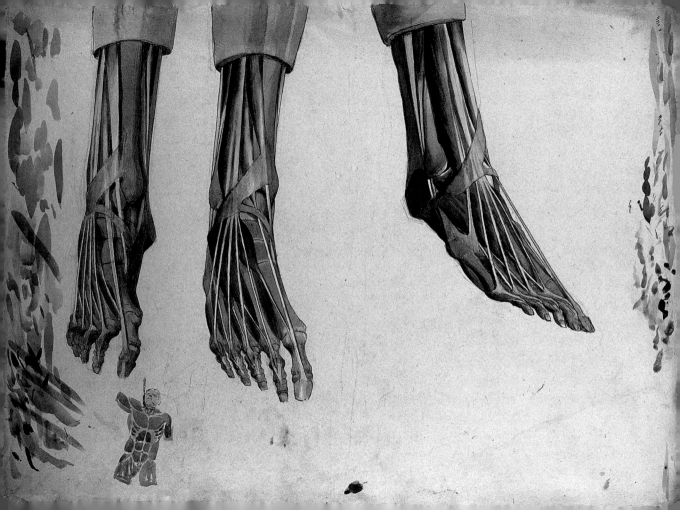

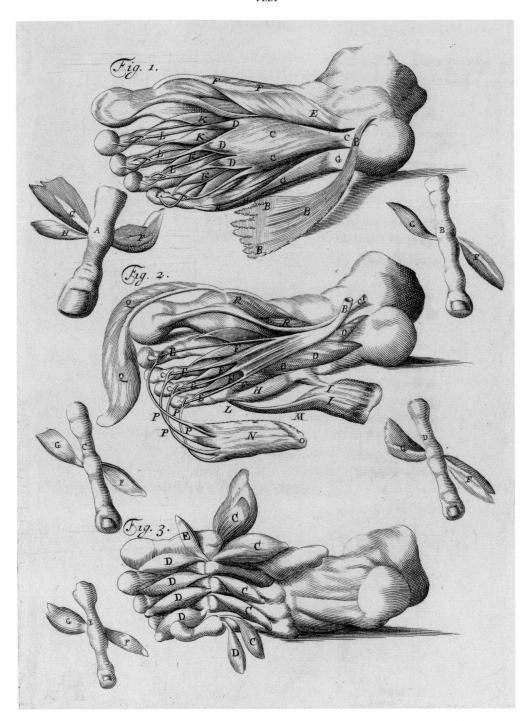

The stately and whimsical baroque copperplate engraving above shows the muscles of the foot, and comes from the anatomist John Browne's *A Compleat Treatise of the Muscles* ..., 1681. Browne was a prominent medical practitioner of his time, even serving as Surgeon Ordinary to Kings Charles II and William III. Fig. 1 shows a foot dissected to reveal the first muscle layer of the foot, with the plantar aponeurosis (fascia) hanging from the heel bone. Fig. 2 shows a deeper dissection, to the second muscle layer. Fig. 3 shows the foot dissected to the fourth muscle layer. The smaller illustrations seem to show the different digits of the foot with the various intrinsic muscles still attached.

Feet are one of the most complex parts of the human body. They are sturdy, intricate structures designed for locomotion, balance, posture and bearing weight.

↑ A chromolithograph showing the superficial nerves of the foot. This beautifully detailed image was created by Neo-classical artist Nicolas-Henri Jacob and appeared in Jean-Baptiste Marc Bourgery's *Traité complet de l'anatomie de l'homme comprenant la médicine opératoir* ..., 1831–54.

→ A coloured illustration diagramming the bones of the foot. It dates from the late 19th or early 20th century.

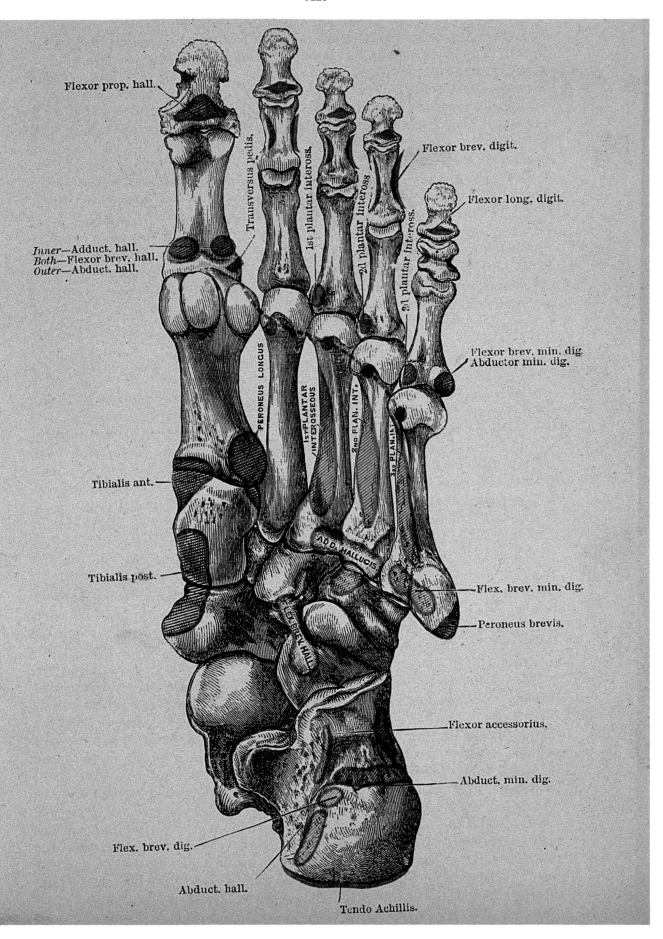

Flexor prop. hall.

Transversus pedis.

1st plantar inteross.

2d plantar inteross.

Flexor brev. digit.

3d plantar inteross.

Flexor long. digit.

Inner—Adduct. hall.
Both—Flexor brev. hall.
Outer—Abduct. hall.

PERONEUS LONGUS

1st PLANTAR INTEROSSEOUS

2ND PLAN. INT.

3RD PLAN. INT.

Flexor brev. min. dig.
Abductor min. dig.

Tibialis ant.

ADD. HALLUCIS.

Tibialis post.

FLEX. BREV. HALL.

Flex. brev. min. dig.

Peroneus brevis.

Flexor accessorius.

Abduct. min. dig.

Flex. brev. dig.

Abduct. hall.

Tendo Achillis.

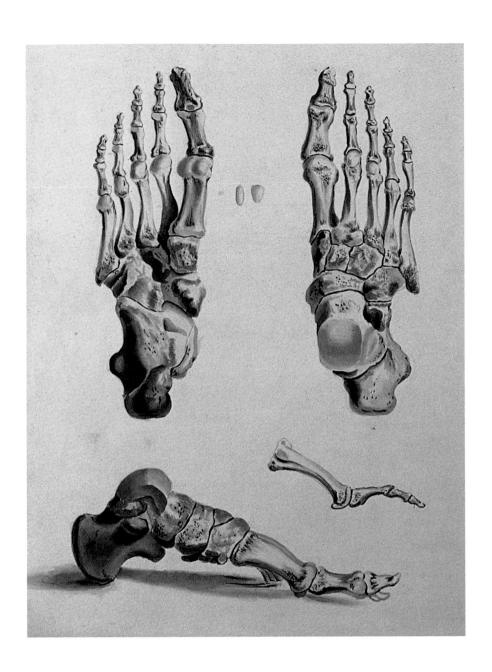

← Detailed annotations accompany this coloured lithograph of the muscles and arteries of the foot. It was rendered by William Fairland (after illustrations by G. Swandale and Erasmus Wilson) and comes from Jones Quain and Sir Erasmus Wilson's *The Vessels of* *the Human Body*, 1837. The top illustration showcases the second muscle layer of the foot. The middle illustration seems to be a modified first muscle layer of the foot. The bottom illustration shows the foot stripped to its fourth layer of muscle layer.

↑ A watercolour and ink copy of an illustration in William Cheselden's *Osteographia, or The Anatomy of the Bones*, 1733. The copy, created by an unknown artist around 1830, features the skeletal anatomy of the foot from a variety of perspectives.

Selected bibliography

Books and catalogues

Cazort, Mimi, Monique Kornell, and Kenneth B. Roberts. *The Ingenious Machine of Nature: Four Centuries of Art and Anatomy.* Ottawa: National Gallery of Canada, 1996.

Clemente, Carmine. *Anatomy: A Regional Atlas of the Human Body.* Baltimore-Munich: Urban & Schwarzenberg, 1981; second edition.

Clayton, Martin, and Ron Philo. *Leonardo Da Vinci: Anatomist.* London: Royal Collection Publications, 2012.

Edell, Dean. *Anatomy As Art: The Dean Edell Collection: Friday 5 October 2007.* New York: Christie's, 2007.

Elder, George. *The Body: An Encyclopedia of Archetypal Symbolism.* Volume 2. Boston: Shambhala, 1996.

George, Rose. *Nine Pints: A Journey Through the Money, Medicine, and Mysteries of Blood.* New York: Picador, 2019.

Gilroy, Anne, Brian Macpherson, and Lawrence Ross. *Atlas of Anatomy.* New York-Stuttgart: Thieme, 2008.

Hansen, Julie V., and Suzanne Porter. *The Physician's Art: Representations of Art and Medicine.* North Carolina: Duke University Press, 1999.

Ebenstein, Joanna. *The Anatomical Venus.* Thames and Hudson, 2016.

Herdeg, Walter (ed.). *The Artist in the Service of Science.* Zürich: Graphis Press, 1974.

Johns, Catherine. *Sex or Symbol: Erotic Images of Greece and Rome.* London: British Museum Press, 2005.

Jordanova, Ludmilla. *Sexual Visions: Images of Gender in Science and Medicine between the Eighteenth and Twentieth Centuries.* Madison: University of Wisconsin Press, 1989.

Karp, Diane R. *Ars Medica, Art, Medicine, and the Human Condition: Prints, Drawings, and Photographs from the Collection of the Philadelphia Museum of Art.* Philadelphia: Philadelphia Museum of Art, 1985.

Kemp, Martin, and Marina Wallace. *Spectacular Bodies: the Art and Science of the Human Body.* Berkeley: University of California Press, 2000.

La Barre, W. *The Human Animal.* Chicago: University of Chicago Press, 1972.

Laurenza, Domenico. *Art and Anatomy in Renaissance Italy: Images from a Scientific Revolution.* New York: Metropolitan Museum of Art, 2012

Loudon, Irvine (ed.). *Western Medicine: An Illustrated History.* Oxford: Oxford University Press, 2005.

Moore, Wendy. *The Knife Man: Blood, Body-Snatching and the Birth of Modern Surgery.* London: Bantam Books, 2006.

Neher, Allister. *Artistic Practice Scientific Vision: British Artistic Anatomy in the Late Eighteenth and Early Nineteenth Century.* Montreal: McGill Library/ Bibliothèque, 2012.

Netter, Frank. *Atlas of Human Anatomy.* Summit: Ciba-Geigy Corporation, 1989.

Patrizio, Andrew (ed.). *Anatomy Acts: How We Come to Know Ourselves.* Edinburgh: Birlinn Limited, 2006.

Petherbridge, Deanna, and Ludmilla Jordanova. *The Quick and the Dead: Artists and Anatomy.* S.l.: National Touring Exhibitions, 1997.

Peto, James (ed.). *The Heart.* New Haven: Yale University Press, 2007.

Pettigrew, Thomas J., Edwin T. Wait, and J.O. Symes. *Medical Portrait Gallery: Biographical Memoirs of the Most Celebrated Physicians, Surgeons, Etc. Etc. Who Have Contributed to the Advancement of Medical Science.* London: Fisher, Son, & Co, 1838.

Porter, Roy, and Simon Schama. *Flesh in the Age of Reason.* New York: W.W. Norton & Company, 2005.

Ronnberg, Ami, and Kathleen Martin. *The Book of Symbols: Reflections on Archetypal Images.* Cologne: Taschen, 2010.

Roberts, K.B., and J.D.W. Tomlinson. *The Fabric of the Body, European Traditions of Anatomical illustration.* Oxford: Clarendon Press. 1992.

Sobotta, Johannes, Helmut Ferner, Jochen Staubesand, and Walter J. Hild. *Sobotta: Atlas of Human Anatomy, Volume 1: Head, Neck, Upper Extremities.* Baltimore: Urban & Schwarzenberg, 1983.

Sobotta, Johannes, Jochen Staubensand, and Helmut Ferner. *Sobotta: Atlas of Human Anatomy: Volume 2.* Baltimore: Urban & Schwarzenberg, 1983.

Sappol, Michael. *A Traffic of Dead Bodies: Anatomy and Embodied Social Identity in Nineteenth-Century America.* Princeton: Princeton University Press, 2004.

Sappol, Michael. *Dream Anatomy: ... Produced in Conjunction with Dream Anatomy, an Exhibition About Anatomy and the Artistic Imagination, Featuring Material from the Collections of the National Library of Medicine.* Bethesda, Md: U.S. Dept. of Health and Human Services, National Institutes of Health, National Library of Medicine, 2006.

Sappol, Michael. *Visionary Anatomies.* Washington, DC: National Academy of Sciences, 2004.

Schoonover, Carl. *Portraits of the Mind: Visualizing the Brain from Antiquity to the 21st Century.* New York: Harry N. Abrams, 2010.

Solos, Ioannis. *Gold Mirrors and Tongue Reflections: The Cornerstone of Chinese Medicine Tongue Diagnosis - the Ao Shi Shang Han Jin Jing Lu, and the Shang Han She Jian.* London: Singing dragon, 2013.

Warner, John H., and James M. Edmonson. *Dissection: Photographs of a Rite of Passage in American Medicine 1880-1930.* New York: Blast Books, 2009.

Articles

Behrman, S. 'Richard Liebreich, 1830–1917. First Iconographer of the Fundus Oculi.' *British Journal of Ophthalmology.* 52.4 (1968): 335-338.

Dunn, P.M. 'Jean-louis Baudelocque (1746–1810) of Paris and L'art des Accouchemens.' *Archives of Disease in Childhood (Fetal and Neonatal Edition).* 89.4 (2004).

Dunn, P.M. 'Perinatal Lessons from the Past - Jean-Louis Baudelocque (1746–1810) of Paris and L'art Des Accouchemens.' *Archives of Disease in Childhood: the Journal of the British Paediatric Association. Fetal and Neonatal Edition.* 89.4 (2004): 370. Pri

Edgerton, Samuel Y. 'The Renaissance Development of the Scientific Illustration.' *Science and the Arts in the Renaissance / Ed. by John W. Shirley and F. David Hoeniger.* (1985): 168-197.

Ghosh, S. K. 'Human Cadaveric Dissection: a Historical Account from Ancient Greece to the Modern Era.' *Anatomy & Cell Biology.* 48.3 (2015): 153-69.

Hajar, Rachel. 'History of Medicine Timeline.' *Heart Views.* 16.1 (2015): 43.

Lagay, Faith. 'The Legacy of Humoral Medicine.' *AMA Journal of Ethics.* 4.7 (2002).

Näsström, Britt-Mari. 'The Rites in the Mysteries of Dionysus: the Birth of the Drama.' *Scripta Instituti Donneriani Aboensis.* 18 (2003).

O'Brien, Kylie A. 'Alternative Perspectives: How Chinese Medicine Understands Hypercholesterolemia.' *Cholesterol.* 2010 (2010): 1-9.

Tang, A.C.Y, J.W.Y. Chung, and T.K.S. Wong. 'Validation of a Novel Traditional Chinese Medicine Pulse Diagnostic Model Using an Artificial Neural Network.' *Evidence-based Complementary and Alternative Medicine.* 2012 (2012).

Web sources
Historical libraries
and collections

Anatomia Collection: Anatomical Plates
1522–1867, Thomas Fisher Rare Book Library,
University of Toronto.
https://anatomia.library.utoronto.ca/

Dittrick Medical History Center
https://artsci.case.edu/dittrick/

Iowa Digital Library: John Martin
Rare Book Room Images
http://www.lib.uiowa.edu/hardin/rbr/

National Library of Medicine: Dream Anatomy
https://www.nlm.nih.gov/exhibition/dreamanatomy/

National Library of Medicine
Historical Anatomies on the Web
https://www.nlm.nih.gov/exhibition/
historicalanatomies/home.html

New York Academy of Medicine Library
https://www.nyam.org/library/

Northwestern University Libraries:
Anatomy of Gender:
https://wayback.archive-it.org/org-1018/20160901195511/
http://digital.library.northwestern.edu/
anatomyofgender/index.html

Princeton University Graphic Arts
https://www.princeton.edu/~graphicarts/index.html

Royal College of Surgeons Library
https://www.rcseng.ac.uk/library-and-publications/library/

Science Museum: Brought to Life:
Exploring the History of Medicine
http://broughttolife.sciencemuseum.org.uk/
broughttolife

The British Museum: Learning:
Bodies of Knowledge
https://www.bl.uk/learning/cult/bodies/vesalius/
renaissance.html

University of Liverpool Faculty
of Health and Life Sciences
https://www.liverpool.ac.uk/health-and-life-sciences/
our-institutes/

University of Oklahoma
University Libraries: Galileo's World
https://galileo.ou.edu/

University of Virginia Vaulted Treasures:
Historical Collection at the Claude
Moore Health Sciences Library
http://exhibits.hsl.virginia.edu/treasures/

Wellcome Images
https://wellcomecollection.org/works

Wellcome Library
https://wellcomelibrary.org/

University of Cambridge:
Making Visible Embryos
http://www.sites.hps.cam.ac.uk/visibleembryos/

University of Virginia: Eugenics:
Three Generations, No Imbeciles Virginia,
Eugenics & Buck C Bell
http://exhibits.hsl.virginia.edu/eugenics

Web sources
Research

American Medical Association Journal of Ethics:
Illuminating the Art of Medicine
https://journalofethics.ama-assn.org/home

Encyclopedia Brittanica.com
https://www.britannica.com/

Pub Med
https://www.ncbi.nlm.nih.gov/pubmed/
https://www.nlm.nih.gov/

Royal Collections Trust
https://www.rct.uk/

Metropolitan Museum of Art
Metmusuem.org

National Library of France: BnF Gallica
https://gallica.bnf.fr/accueil/en/content/accueil-en

Princeton University Library
https://library.princeton.edu/

Stanford University History of the Body
https://web.stanford.edu/class/history13/
earlysciencelab/body/bodymaincopy.html

The Embryo Project Encyclopedia
https://embryo.asu.edu/home

The National Center for Biotechnology
https://www.ncbi.nlm.nih.gov/

The Nobel Prize
https://www.nobelprize.org/prizes/medicine/
1906/cajal/biographical/

The Stanford Encyclopedia of Philosophy
https://plato.stanford.edu/index.html

Index

Picture credits

The author and publisher would like to thank the following institutions and individuals who provided images for use in this book. In all cases, every effort has been made to credit the copyright holders, but should there be any omissions or errors the publisher would be pleased to insert the appropriate acknowledgment in any subsequent edition of this book.

Wellcome Collection: 3, 4, 6, 7, 14, 16, 17, 18, 19, 20, 21, 22, 23, 24, 25, 27, 28, 29, 31 (br, tr) 32, 34, 36, 38 (l, r), 39, 40 (l, r), 41, 42, 44 (tl), 45, 50, 51, 52, 53, 54, 55, 56, 58, 59, 60, 61, 62, 64 (l, r), 66, 67, 68, 70 (l, r), 71, 72, 73, 74, 75, 76, 77, 78, 80 (b, t), 81, 83, 87, 88, 89, 96, 97, 99 (l, r), 100, 102, 105, 106, 107, 108, 109 (r), 111 (l), 112 (b, t), 113, 116, 117, 118, 119, 120, 121, 122, 123, 124, 128, 129 (l, r), 130, 131, 132, 135 (l, r), 138 (b, l), 139, 140, 141, 143, 144, 145, 146, 147, 148, 149, 150, 151, 153, 154, 155, 156, 157, 158, 159, 160, 161, 163, 164, 165, 166, 167, 168–169, 171, 172, 173, 174, 175, 176, 178, 182, 183, 185, 186, 187, 188, 189, 190, 191, 192, 193, 194, 195, 199, 200 (b, t), 202, 203, 204 (l, r), 205, 206, 207, 208, 209, 210 (l, r), 211, 212, 213, 218, 219, 222, 223, 228, 229, 230, 231 (b, t), 232, 233, 234 (l, r), 235, 236 (l, r) 237, 238 (l, r), 239 (l, r), 240, 241, 242, 243, 244, 248, 250, 251, 252, 254, 256 (l, r), 257, 258, 259, 260, 261, 262, 263, 265, 266, 267; **Wikipedia Commons, Museum Boerhaave:** 8; **Private collection, New York:** 9; **The Thomas Fisher Rare Book Library, University of Toronto:** 26, 31 (l), 35, 37, 46, 49, 63, 69 (l, r), 79, 84, 85, 90, 92, 93, 94, 95, 98, 101, 104, 114, 115, 126, 127, 133, 134, 136, 142, 152, 162, 170, 177, 179, 180, 181, 184, 196, 197, 198, 214, 216–217, 221, 245, 246, 247, 253, 255, 264; **Courtesy British Library/Bridgeman Images:** 30; **Mary Oenslager Fund, 2016:** 33; **The Picture Art Collection/Alamy:** 43; **Cajal Institute (CSIC), Madrid:** 57; **INTERFOTO/Alamy:** 65; **Private collection, New York:** 82, 86; **flickr/Emory University, Woodruff Health Sciences Center Library:** 103; **Courtesy of The New York Academy of Medicine:** 109 (l); **History of Medicine Collections/David M. Rubenstein Rare Book & Manuscript Library at Duke University:** 110, 125; **Courtesy of the U.S. National Library of Medicine:** 111 (r); **Josephinum, Ethics, Collections and History of Medicine, MedUni Vienna:** 201; **Royal Collection Trust / © Her Majesty Queen Elizabeth II 2020:** 215; **National Library of Medicine:** 220; **Thomas Jefferson University/Digital Commons Resource:** 224, 225, 227; **Collection Abecasis/Science Photo Library:** 226;

Acknowledgements

I would like to thank my Oma and Opa, Dina and Benno Ebenstein; refugees from Hitler's Vienna, they were art and culture loving doctors who introduced me to the fascinating world of medical illustration. I would also like to thank the rest of my family – my parents, Sandy and Robert; my stepmother Judy; my sisters Donna and Laura; my brother in law Jove Graham; my niece and nephew Clara and Thomas; and my Aunt Judy and my Uncle Dick – for their support, encouragement and inspiration.

I would also like to offer special thanks to Laetitia Barbier, whose help – ranging from French translation to emotional support – was greatly appreciated. Special thanks also to editor Charlie Mounter for reading over many drafts and giving me brilliant and insightful suggestions; to Richard Faulk and Steven Vesecky for Latin and German translation, respectively; and to Cristina Marcelo for organizational assistance. I would like to thank Bill Andrews for sharing his research, and to the Vesalius Trust, the organization of medical illustrators from whom I have learned so much, on buses and in castles around Europe. Very big thanks also to Eric Huang, Eleanor Crook, Laurens De Rooy, Carl Schoonover, Karen Bachmann, Greg Gabel, David Pantall, and Fernando Delgado. Finally, I would like to thank the fabulous team at Laurence King who made this book happen: Zara Larcombe who approached me with the idea; editors Chelsea Edwards and Blanche Craig; designer Alex Coco; copyeditor Trish Burgess; and image researcher Peter Kent. Special thanks to proofreader Ami Uemura.

Immense thanks are also due to the historical institutions who donated their time, images, and expertise. This book simply would not be possible without their incredible holdings, knowledge and generosity. I would specifically like to thank Ross MacFarlane of Wellcome Collection; Elizabeth Ridolfo and Alexandra Carter of The University of Toronto's Thomas Fisher Rare Book Library; Christiane Druml, Martina Peters and Dominika Flomyn at the Josephinum; Arlene Shaner at the New York Academy of Medicine, Rachel Ingold at the Duke University History of Medicine Collection; Paul Dijstelberge at the University of History of the Book Department; and Melissa Rickman of the History of Science Collections, University of Oklahoma.